Introduction to Art

HARPERCOLLINS COLLEGE OUTLINE

Introduction to Art

Arthur F. Jones, Ph.D.
University of Kentucky

HarperPerennial
A Division of HarperCollins*Publishers*

To Diana

An American BookWorks Corporation Production

Project Manager: Judith A. V. Harlan
Editor: Robert A. Weinstein
Illustrations: Diana Heyne

Library of Congress Catalog Card Number 91-58270
ISBN: 0-06-467122-4

92 93 94 95 96 ABW/RRD 10 9 8 7 6 5 4 3 2 1

Contents

Preface . vii

1 What Is Art? . 1

2 Art as Visual Language 8

3 Two-dimensional Media and Techniques 29

4 Three-dimensional Media 49

5 Architecture and Related Design Disciplines 64

6 The Art of Prehistory 80

7 Ancient Art 84

8 Medieval Art 105

9 Renaissance and Baroque Art 119

10 Late Eighteenth- and Nineteenth-Century Art 148

11 Twentieth-Century Art Through World War II 167

12 Art After World War II 186

13 Non-Western Traditions 208

Glossary . 220

Index . 237

Preface

This book is intended to serve the needs of students as well as faculty as a complement to any of the major illustrated textbooks used in introduction to art courses. It might also stand alone as a text if accompanied with selected readings and other sources of photographic information. In addition to its usefulness for introduction to art courses, the book's art history chapters can supplement history of art texts, and provide much benefit to students reviewing for examinations in that discipline.

An attempt was made to condense important points addressed in other major texts in as lucid a way as possible. While other books often rely heavily on illustrations to avoid having to explain ideas more fully in words, here precise verbal descriptions attempt to provide a more exact explanation on major points not illustrated. This model may prove extremely useful to students preparing for essay format examinations in which slides shown on a screen will have to be analyzed in clearly written sentences.

In a number of cases, serious discrepancies exist in content (especially evident in the history of art chapters) among the many texts that this book is intended to complement. General survey course textbooks vary considerably in what they say about art. Often professors as well as students are not aware of this problem when consulting any textbook for information about art or art history. For example, in some texts the Renaissance in Northern Europe is explained as a development of the early fifteenth century, while in others it does not begin as a stylistic period until the sixteenth century. Some texts discuss the Venetian painters Giorgione and Titian as artists of the High Renaissance, while others do not. Some state that Tintoretto was a Mannerist, and others emphatically state that he was not working in this stylistic trend. An attempt was made here to both point out and reconcile these (and other) discrepancies in such a way as to make this book equally serviceable to students using any of the other major illustrated texts. Therefore, this book may not only be useful for summing up and reviewing their content, but even for providing additional insights and a fuller understanding into the various subjects explored.

As both a practicing artist and an art historian (considering myself one and the same to equal degree), I have attempted to provide factual and theoretical information with critical insights, as well as an understanding of the creative process. In doing so, however, I have not departed from a strict consideration of providing a concise text which outlines the major points addressed in any introduction to art course.

I would like to acknowledge the assistance of several individuals who helped to make this book happen. First I would like to thank Diana Heyne, an artist and art critic, who devoted an extremely generous amount of time in assisting me in many ways with the manuscript, including the drawing of attractive illustrations to accompany the text. I would also like to thank Judith Harlan, the publication project manager, who over the course of the past year devoted much attention to encouraging a high level of quality in the preparation of the book. It has also been a pleasure to work with Robert A. Weinstein, whose sharp criticism of early stages of the text further insured quality control. I also wish to thank the copy editor, M. R. Kline, and the proofreader, Tannis McCammon, for helping to bring the book to completion. I am thankful also to musicology professor Ron Pen at the University of Kentucky for encouraging me to consider the writing of such a textbook. And finally, I am grateful to Fred N. Grayson, President, American BookWorks Corporation, for asking me to be an author in this series, and for his patience in waiting for my completed manuscript.

Arthur F. Jones

1

What Is Art?

Art encompasses many meanings. The word art *originates in the Latin term* ars, *meaning skill. Although in this text we are concerned in particular with visual art, especially the fine arts, by definition the title "art" may be applied to various disciplines such as music, dance and theater. In recent years art has increasingly been equated with financial investment and social status. But beyond any material value it may possess, art exists and attains significance as the translation of ideas and feelings into visual form.*

THE MEANING OF ART

Visual Art

Visual art needs a physical medium. It must communicate information on some level in order to be art. In the contemporary world, art and science may complement each other in exploration of theory and concepts, moving artists beyond the boundaries of their traditional roles as skilled manipulators of pigment or mallet and chisel.

FINE ART AND APPLIED ART

Within visual art a distinction may be made between fine art, applied art, and folk art. The concept of fine versus applied art predates the Industrial Revolution, its early formation traceable to Renaissance thought. In an era when handcrafted objects were produced by artisans for everyday use, a distinction was drawn between those arts which served a purpose of utility, such as furniture-making, and those which existed for a more lofty, nonpractical purpose and required lengthy formal training.

The first group were titled "applied" arts and today would include advertising art and industrial design. Those that met the latter intellectual criteria were termed "fine" arts and included painting, sculpture, and architecture. Even though architecture serves utilitarian purposes, the best architecture was considered a manifestation of the intellect and rational order. Thus, architecture transcended to the realm of fine arts. A similarly blurred boundary is evident in art today between contemporary craft and fine art. Traditional craft materials may be used to create intellectually provoking and aesthetically pleasing works which may or may not serve a more practical purpose.

FOLK ART

Hard and fast definitions are also difficult to formulate concerning folk art, the work of individuals who have no specialized training in art. Often the term *folk art* is reserved for works based on traditional techniques and designs. These works, such as handmade quilts, have end results that are of a mostly utilitarian nature. Much of the foundation of this type of art is passed down in families and communities from one generation to the next. Its forms often continue with little change over centuries.

Today the term *folk art* is also applied to works made by unschooled artists who are more innovative and highly original in method. Their unsophisticated styles offer unique and often powerful insights into the human spirit, frequently conveyed with a fresh, creative zeal one seldom sees retained beyond childhood. Though formal training is not a criterion, not just anyone is capable of being a talented folk artist. Often such people are regarded as visionaries, driven by strong feelings of inner necessity to create their art.

Rodia and the Watts Towers. Sabitino "Simon" Rodia, whose hand-built towers in the Watts district of Los Angeles resulted from a thirty-three year effort, had as his only reward the satisfaction of construction and the resultant other worldly structures. Rodia, a tile-setter from Italy, created his fantastic forms from trash metal, tile, pieces of colored bottle glass, broken dishes, and other materials held together with mortar. Working alone, he created towers which rose to a height of a hundred feet without welding metal or the use of any power equipment. Why such an effort? His explanation was that he "wanted to do something nice for the United States."

Perception and Visual Awareness

Art cannot exist without *perception*, in other words, without awareness achieved through the senses. Our sensory awareness is not inborn but is acquired through experience. How we "see" is not determined by objective reality, but by our learned responses to, and filtering of, visual stimuli.

Perception of various colors and shapes requires a highly sophisticated selective process. This "seeing" occurs much more in the realm of the mental than that of the physical as our brains interpret and conceptualize what the eye sees. These interpretations are organized into cognitive systems—classifications of sensory perception into named categories. In turn, these categories allow us to think and communicate about the things we perceive. To a great extent, the individual reflects his or her culture, as different societies develop their own particular cognitive systems considered within them to be the norm.

WESTON'S PHOTOGRAPHIC INSIGHTS

Sometimes an artist can reveal to us how to see something differently than we normally would, as in the case of Edward Weston's photograph *Pepper #30*. Objectively we find what might be described as a straight forward photograph of the vegetable. However, by using a close-up view and illumination achieved by an extended exposure time, Weston has transformed the pepper's connotation of commonplace in the kitchen into a sensuous, abstract form defined by rich tonalities and so altered as to suggest two intertwined figures.

Aesthetics

Aesthetics is a branch of philosophy which studies the arts in terms of concepts of beauty and art's power to exalt human emotion. When art moves us, brings about a feeling of transcendence, or causes us to feel pleasure, we call this an aesthetic response.

For a work to please us aesthetically does not mean it has to represent a traditional image of beauty. A Cubist work by Picasso may distort the human form; in doing so, it would hardly conform to the traditional standard of beauty as established by the ancient Greeks. While this figure may not be considered beautiful, Picasso's intent was to transcend the issue of physical beauty to intensify other aspects of his artistic expression. We aesthetically respond to Picasso's unique perspective in terms of his handling of the composition rather than to the attractiveness of his depicted subject.

Other Fields of Study

In addition to aesthetics, there are other fields that study the visual arts. Art history interprets and records the development of art through time. It includes such fields as connoisseurship (identifying personal styles of the artists), and iconography. Iconography is the branch of art history that studies subject matter in art. This study involves both its underlying and superficial meanings. Symbolic meaning is often a focus of iconographers as applied to particular subjects, motifs, themes, colors, and use of scale.

Art criticism involves the qualitative interpretation and evaluation of art with regard to matters of form as well as the ideas behind the work itself.

HOW ART FUNCTIONS

What Is Creativity?

Often people use the term *creativity* when considering art. This quality, so essential in the successful production of art, is usually viewed as the special province of the artist. In the public's mind, the artist possesses unique powers lacking in most people, such as imagination, originality, and inventiveness. To be creative means that the artist is capable of manipulating visual elements innovatively. Not all artists are creatively equal and some might be so conventional as to hardly indicate any outstanding tendency at all. Normally the ones we study in a college class are recognized in the art world as among the most talented and innovative.

But perhaps the ability to be creative can be found in many people, including nonartists as well. This ability is almost universally recognized as the birthright of all healthy children; however, as they grow older and mature most seem to lose connection with their creative vision. By adulthood few people other than those who call themselves artists are confident about their expressive potential. In recent years, much study has been devoted to understanding the progressive stages of this loss and to programs designed to allow people of all ages to once more access their creative abilities. While there is no universal rule governing what makes people creative, the best artists seem to be in touch with an inner spirit or wellspring of inspiration.

FORMALISM VERSUS EXPRESSIONISM

Some artists approach creativity from an opposite point of view than others, adhering to stylistic methods that stress formal values involving rational thought and discipline. They produce art that tends to be more intellectual in character and much less indicative of emotion. On the other side are artists who are more informal in their stylistic outlook. Their art is motivated less by reason than by feeling. Though one rarely meets an artist who is entirely focused in one direction, there is usually a tendency to incline toward one persuasion more than the other. Just as in the general public there are people who seem to live their lives more through their emotions and others who are directed more by intellect, so there are artists of similar mindsets. Each is capable of being equally creative. Major works of art have resulted from both the expressive and the formal, intellectual modes.

What Are the Purposes of Art?

Art has many possible meanings and purposes in the personal, social, and utilitarian realms. It can appeal to our emotions, stimulate the intellect, reveal profound truth or even minor points. It can also teach us specific lessons, as did the didactic religious art of the Middle Ages (see chapter 9). Art may exist to satisfy the artist's personal desire for self-expression; it may provide a record of history and customs, as do portraits, cityscapes, and

historical paintings. It may express the concept of beauty, religious belief, or social and political causes. Art in its commercial form serves to inform and convince us of the merit of advertised products and services.

Andy Warhol's use of multiple images of Marilyn Monroe (*Marilyn, Diptych,* 1962) may be analyzed in light of several possible meanings or purposes. Normally a portrait of a famous personality can be viewed as an attempt to immortalize its subject. However, Warhol has employed techniques based on those used in advertising media. Monroe's embodiment of the ideal 1950s beauty is reduced to something resembling a mass-produced consumer item. The work, executed shortly after Monroe's death, consists of a multiple arrangement of identical photographs with variations of color so as to offset the otherwise intentionally monotonous repetition of image.

ART AND SOCIETY

In the past, fine art functioned differently in society than it generally does today. Previously it possessed more of an agreed-upon purpose within the societies producing it. Contemporary art is often misunderstood by the general populace, perhaps because they lack such clear guidelines for defining its purposes.

The art public, armed with greater knowledge of the field, may still vary widely in assessing movements and approaches. The nature of present society is complex and diverse. Today's art is equally pluralistic, lacking a clearly dominant direction which would encourage a consensus of opinion. Interestingly, art can produce strongly hostile reactions in regard to various issues ranging from matters of style to subject matter. The possibility of offending community standards of morality, or of an artist showing work so radically innovative that the public cannot comprehend it as art, may raise serious complaints, especially if government funding is involved. Whereas radical changes in contemporary art can be viewed intolerantly by people at large, fast-paced changes in science and technology rarely lead to such public outcry, even when these developments seem as incomprehensible as the most innovative works of art.

What Is Style?

Style can be defined as a characteristic handling of media. For instance, a painter's particular brushstrokes may be so unique that they are recognizable as that artist's alone. When such an observation is made from examination of a painting, it is referred to as an identification of the artist's "hand." Other identifying elements of an artist's personal style might include the distinctive use of aspects of form such as line, shape, color choice, and design. In addition to an artist's individual style, one can refer to a group style such as those identified with particular art movements or trends such as Impressionism, Fauvism, and Analytical Cubism.

Another designation of style is by historical period, such as the Baroque, or by geographical place. Art of a particular region may demonstrate a national character with regard to style, as might German art, American art, or traditional regional African art. Often considerations of these various factors are combined when we discuss an artist's work in terms of designations such as Italian Renaissance or French Gothic art.

Quality In Art

Making value judgments about art is not an objective process. While most art critics agree that Leonardo da Vinci's *Mona Lisa* is a masterpiece, once such an assessment has been fixed over a period of centuries, we are unlikely to alter it in our personal attitude toward the painting. Revisions of judgments do sometimes occur, but they are less likely to happen in regard to established views of the past than in consideration of art nearer to our own time. One reason for this is that prior to the twentieth century there was a more consistent standard in the conceptual basis of art, which stressed such values as order, beauty, harmony, and truth. Opinions on artists whose works are more contemporary to our own time are likely to vary considerably. Regardless of this, subjective responses to art are needed; the experience of viewing works cannot be satisfied merely by an objective description of techniques, color choices, or the subject depicted.

ART CRITICISM

In the art world, critics play an important role as interpreters of artists' works for the public. The art critic provides an educated viewpoint based on a broad understanding of art, usually accompanied by a well-defined personal preference or taste.

A critic may not even have a formal education in the field of art, but often does, and is sometimes an artist as well. By taking a strong stand in favor of a particular stylistic direction in art, the critic is an activist rather than a passive observer, even capable of orchestrating major new art movements through the use of the printed word. Art periodicals, newspapers, and some exhibition catalogs may be forums for critical writing where reviews of artists' works can influence public opinion as well as the art marketplace.

The term art encompasses many meanings and includes disciplines other than visual art, such as dance and music. Visual art's two main categories are fine art and applied or practical art. Folk art is another type of art produced by individuals unschooled in art, following traditional forms or their own eccentric visions.

Perception, or awareness achieved through the senses, is a learned rather than inborn process. The special vision of artists such as Edward Weston can sometimes help us to perceive things in a new way. Creativity in

an artist involves the ability to manipulate visual elements and concepts innovatively.

Art may be divided into two basic approaches: formal and informal. Formalism is the result of rational intellectual planning and produces works in keeping with these qualities. Informal or expressive art relies on more emotional guidance in its creation.

Art has many purposes on the personal, social, and utilitarian levels. In the past, art had a more agreed-upon purpose and clearer meaning. The pluralistic art of today lacks a dominant direction and leaves it open to various interpretations and even hostility. Reaching conclusions about the merit of particular art works or movements is not an objective process. Art critics may help to interpret contemporary art to the public.

Selected Readings

Canaday, John. *What Is Art? An Introduction to Painting, Sculpture, and Architecture.* New York: Knopf 1981.

Edwards, Betty. *Drawing on the Artist Within: A Guide to Innovation, Invention, and Creativity.* New York: Simon and Schuster 1986.

Elsen, Albert. *Purposes of Art.* 4th ed. New York: Holt, Rinehart and Winston. 1981.

Gombrich, E. H. *Art and Illusion.* 12th ed. London: Phaidon. 1972.

Hemphill, Herbert W., Jr. and Julia Weissman. *Twentieth-Century American Folk Art and Artists.* New York: E. P. Dutton and Co. 1974.

2

Art as Visual Language

Art is intended to be a form of visual communication which may appeal to the senses and emotions and/or the intellect. To communicate it must express information through its own visual language, combining various elements such as shapes, lines, and colors in its design.

REPRESENTATION, ABSTRACTION, AND NONREPRESENTATION

In general, art can be considered as representation, abstraction, and nonrepresentation.

Representational Art

Representational art is about depicting tangible things in a recognizable way. *Realism* or *naturalism*, terms which refer to approximating the optical appearance of things observed, are often the goal of a representational artist.

Abstraction

While abstraction has a basis in the concrete world, it involves a process of simplification. The artist abbreviates objects observed or puts into visual form ideas conjured up from the inner workings of the mind. Frequently an abstract work may be based on utilizing geometric equivalents for the actual shapes of observed figures and objects. Today the term *abstraction* is often used more loosely to include both abstraction derived from the concrete and nonrepresentation.

Non-representation

Nonrepresentation involves the use of forms in art that are unrelated to anything real and existing outside of the boundaries of the artwork. In painting, this could mean that arrangements of colors, shapes, and lines may in and of themselves stand as the basis of an artist's expression. In sculpture, solid shapes sometimes suggest nothing but themselves (as in the case of the use of geometric solids such as spheres, cones, and cubes). Instead they stand as forms which are nonreferential; they do not refer to people, events or places outside of the sculptural object itself. In nonrepresentational art the subject of the work is literally what you see: the colors, volume, shapes, texture, and the material used to produce the work. The ideas it conveys are about itself as "art."

FORM AND CONTENT

Normally when we analyze a work of art we do so by discussing it in terms of form and content. *Form* refers to the visual ingredients that are used in designing an art work: not only the visual elements, but also how they are used in composing the work as a whole. Form is what we see visually, while *content* is what we believe the form means emotionally or intellectually. When an art work is concerned with symmetrical balance, logical composition, and a restrained use of color, we would conclude a different meaning (content) from a work that uses bright colors and agitated, haphazardly arranged brushstrokes for emotive effect. The overall technical combination of these elements, the artist's choice of materials and how they are combined, creates the form.

In Brancusi's sculpture, *The Kiss*, geometric form and the choice of material (stone) contribute a quality of stability and permanence to the merging figures of two lovers. Form is used with the intent of creating a specific content conveying the concept of lasting love. In this work we can see that form and content are inseparable from each other.

THE VISUAL ELEMENTS

The visual elements are the ingredients that together make up the form of a work of art. They include such basic characteristics as line, shape, mass, space, light and dark, color, texture, time, and motion. These aspects are to art as words and grammar are to language. Normally we tend to view an art work as a whole, without analysis of its individual elements, just as we often

absorb the meaning of a sentence without dissecting it word by word. In English class we are taught to think beyond this tendency, to become more analytical, noting parts of speech such as nouns, verbs, and adjectives, as well as their structural framework of phrases and sentences. By doing so we can better understand how language functions. Similarly, by analyzing art in terms of its components, we learn to comprehend and more clearly articulate our responses to it.

Points

Points are the smallest and simplest of the visual elements. They can be visible as dots on a two-dimensional surface or they can be implied through forces within an artwork. If a point is moved through space its path is called a line.

Lines

Lines act as directional forces within an artwork, suggesting either movement or stability. They may be slender and delicate or thick and bold. Line may flow in a continuous fluid motion or be broken—staccato—in character. The quality and direction of lines may denote psychological aspects such as dynamic energy (dynamism) or stability. Vertical and diagonal lines often seem more active while horizontal lines are suggestive of a resting state. The implied movement of line becomes dizzyingly real in Bridget Riley's Op Art painting *Current*. Riley used repeated wavy lines in close proximity to effectively produce the illusion of movement.

In two-dimensional art, lines may imply three-dimensional volume, suggest mass, or serve to define shapes. Within an artwork, arrangements of lines into a crosshatched pattern may serve as a device to create the effect of light and shadow. Our perception of the edges or contours of two- and three-dimensional objects in space is as a line.

CALLIGRAPHY

In addition to the importance of line in drawing and painting, line is an essential element in calligraphy, the "art of beautiful writing." In Asian countries, such as China and Japan, calligraphy remains a major form of artistic expression, though its importance in Western culture declined at the end of the Middle Ages. Brush calligraphy can produce poetic visual effects comparable to those found in abstract paintings composed of expressive linear brushstrokes.

Shape

Shapes are two-dimensional forms defined by boundaries. While lines can enclose space so as to produce shapes, shapes can also be created through variations in texture, by value gradations (lights and darks), and by colors which by contrast define an area within a picture space.

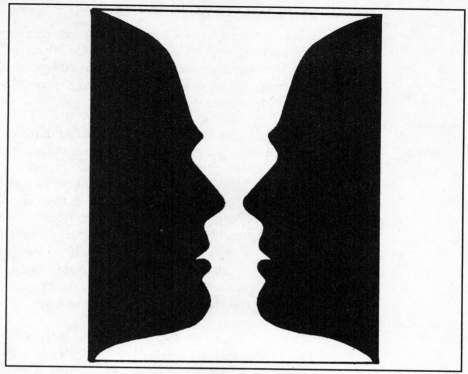

Fig. 2.1 Vases/Faces (figure-ground reversal)

POSITIVE AND NEGATIVE SHAPES

Shapes can be characterized as positive or negative. Positive shapes are visually dominant; they stand out against the negative shapes (also referred to as negative spaces). Visually depicted objects, shapes or lines that appear to lie in front of the "field," or background, are positive shapes while the background is negative shape (or space). The relationship between these two elements, positive and negative, is called the figure-ground relationship. People learn to perceive objects or figures as dominant visual forms and to attach little significance to background, although the negative shapes are also powerful parts of artistic composition.

In looking at a drawing such as the familiar black-and-white optical trick that at first seems to be two silhouetted profiles facing one another, we strive to conceptualize a figure-ground relationship. It becomes very difficult to see both the black forms and the white form as existing together in the same plane. In a case, such as *Vases/Faces*, where these areas are of approximately equal size, the figure and ground relationship appears to shift (Fig. 2.1). Normally we will first identify the black shapes as the figure. But if we continue to stare at the illustration, the white becomes the dominant figure of a convoluted vase and the black "profiles" are read as background.

ORGANIC AND GEOMETRIC SHAPES

Some art works rely on a system of shapes based on geometric forms such as triangles, squares, and circles, while others use shapes of a more flowing or rounded organic nature. Geometric shapes indicate an ordered, rational perception of form. Organic shapes express fluidity and imply the movement of the natural world.

Mass and Volume

Mass is the solid bulk of three-dimensional forms or the illusion of that bulk created on two-dimensional surfaces. Although the terms *volume* and *mass* are used interchangeably, volume denotes a mass-enclosed space. Volume can be defined as positive when applied to a solid object, or negative when applied to a hollow one. Volume differs from mass in that volume can describe the bounded space of a cathedral interior as well as its exterior form. In such a case, the exterior would be defined by its mass as positive volume, but the interior hollow space, or negative volume, would be devoid of mass.

Mass and volume can be implied by manipulating lights and darks to create an illusion of solid forms in two-dimensional works. In painting, large fields of color can also produce an illusion of mass.

Space

Space is the zone or area in which the artist orchestrates forms and colors. Painting, sculpture, and architecture are particularly concerned with the manipulation of space, both real and illusory. This orientation differentiates them from some other art forms which are nonspatial, as is music, or that have both space and time as dual concerns, as do dance, performance, and film.

SPACE IN THREE-DIMENSIONAL ART

Space in three-dimensional art is measured by height, width, and depth. The mass of an art work is measured by the space it occupies; both positive and negative volumes are defined spatially. Three-dimensional art forms, such as architecture and sculpture in the round (meaning sculpture that the viewer can literally walk around and observe from many possible angles), involve the manipulation of solid materials and often hollows or concavities. Here we see the use of real space, while in two-dimensional art, such as drawing and painting, the appearance of three dimensions, if desired by the artist, can only be implied by illusion.

SPACE IN TWO-DIMENSIONAL ART

In two-dimensional art, real space is measured on the flat surface only in terms of height and width. In twentieth-century nonrepresentational art, some painters have actually found the flat restriction of the canvas to be a desirable characteristic. We will see in chapter 11, for example, how Piet Mondrian made a serious attempt to avoid the suggestion of spatial illusion

when he placed flat, geometrically shaped areas of color on the canvas's surface. Throughout most of the history of Western art, however, painters have attempted in varying degrees to overcome the flatness of the actual surfaces they worked upon. In other words, prior to the twentieth century the flatness of the surface was often regarded as an undesirable factor which the painter would transform through his skills as an illusionist. In doing so, over the centuries, artists discovered and used pictorial devices or formulas to better render the quality of actual space on a two-dimensional surface. Such devices are called perspective methods.

PERSPECTIVE

The term *perspective* refers to the illusion of three-dimensional objects in space created on a two-dimensional surface through the use of certain methods of representation. This achievement did not develop all at once. Stages of its progress can be seen throughout the history of ancient art up to the times of the ancient Greeks and Romans. During the Middle Ages interest in implying a three-dimensional depth in painting declined; artists were more motivated by the spiritual and decorative aspects of two-dimensional forms than by a concern with realism. But by the time of the Renaissance, illusionism in painting was on the rise again. It remained the dominant focus into the late nineteenth century.

Positioning Objects in Space. The most basic perspective systems are generally rediscovered by every child who draws. As the child makes the first attempts to go beyond mere scribbling to express a form suggestive of a person or thing, the problem arises of how to position objects in space. The issue of perspective itself is generally not considered at this point by the child. Instead a child's pencil drawing of a man or dog may appear as a stick figure on the open field of the white paper.

While a figure-ground relationship is clearly established, space within the field has yet to be organized and defined. The use of a ground line upon which to rest the feet of a figure is an early solution to the problem. However, perspective is still not evident: the ground line does not make reference to depth. All elements continue to be visually comprehended only in two-dimensions.

Early Perspective. Perspective does not appear in a child's drawing until the attempt is made to show that some objects are closer to the viewer than are others, which are intended to be farther back in the field. This is assisted by comprehending the two-dimensional surface of the paper as a picture plane or "window" through which depth can be defined pictorially. Beyond the picture plane, rendered figures and objects take positions in the foreground, middle ground, or background of that illusionary world of depth known as the picture space.

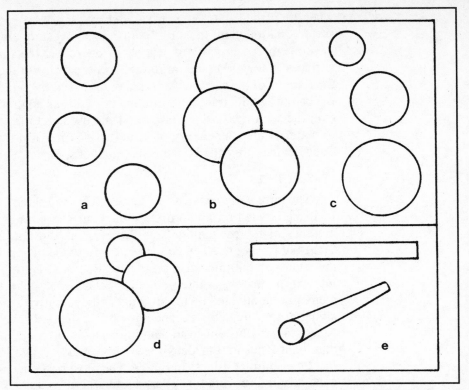

Fig. 2.2 Elementary Perspective Methods: (a) vertical placement, (b) overlap, (c) diminution in size, (d) combination of methods a, b and c, (e) foreshortening.

Among the earliest perspective systems to be developed, both in the drawings of children and historically, are vertical placement of some objects higher in the field than others, the creation of depth by overlap (in which some objects appear to be "behind" those which partially cover their edges), and the successive decrease, or diminution, in size of objects, causing them to appear to recede (Fig. 2.2).

Foreshortening. Another, more difficult, perspective method is called foreshortening. It involves the depiction of an object that is set in the picture space at an oblique (slanting) angle rather than horizontally or vertically in alignment with the picture plane. If a rod is depicted as foreshortened, its one end would be extended forward toward the viewer; the distance between the contour lines of its sides would be shortened continuously as it appears to recede into the depth of the picture space. Foreshortening can be extreme or slight depending on the angle an object is supposed to be positioned in relation to the picture plane.

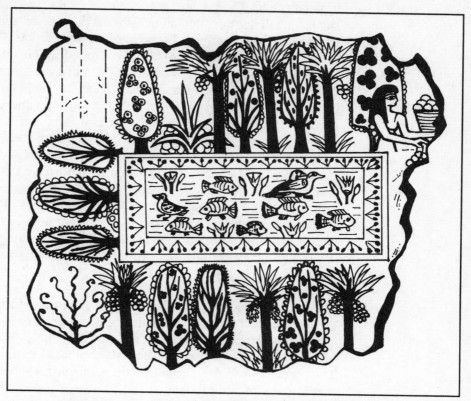

Fig. 2.3 Drawing based on Egyptian tomb painting of a Pond in a Garden (from Thebes, ca. 1400 B.C.)

Perspective in Egyptian Painting. Any of these perspective methods may be used without consideration of the others or in various combinations to create even greater effects of depth than could be achieved singly. The schematic drawing (Fig. 2.3) is based on an ancient Egyptian painting of a garden pond (fragment of a wall painting from a tomb at Thebes, ca. 1400 B.C.). Interesting to analyze with regard to its spatial organization, it uses perspective methods combined with other pictorial devices which have nothing to do with spatial illusion. We can see some use of vertical perspective in the two horizontal rows of trees in foreground and background. In the pond we notice some overlapping of the waterfowl, but nowhere is there a use of diminution in size nor foreshortening to suggest pictorial depth.

Fractional Representation. Within this painting there are some objects whose positions seem incongruous to the perspective systems used. The vertically stacked row of trees at the left and the bird's eye view of the pond do not make sense within the overall scheme of things if interpreted in terms

of perspective. These features are better explained as multiple viewpoints, suggesting that the painter has considered the subject from many points and combined these multiple observations in this picture. The human figure, seen at the upper right, is also observed from different angles, with the head in profile, while the eye is depicted frontally, as are the shoulders. This device, known as "fractional representation," is based on $90°$ shifts in point of view. It is not a perspective system but rather an attempt to eliminate the need to represent things in perspective as foreshortened forms.

By showing us more than one viewpoint at once, this conservative Egyptian convention (which was used for thousands of years), provides more specific information about the things represented. Had this work relied consistently on perspective systems, some of the things depicted might have been hidden by overlapping or reducing their sizes. Though it can be a powerful tool, the use of perspective may not always be beneficial to an artist's concerns. Mastering perspective does not always make for better art. Yet during many periods in art history, successfully conveying a sense of three-dimensional reality on a two-dimensional surface was a very important concern.

Atmospheric or Aerial Perspective. Atmospheric or aerial perspective was developed prior to the Renaissance. It is an attempt to better convey a sense of real space in which objects meant to be more distant are represented with less clarity in focus, as paler and cooler in color, with less contrasts. This concern in art is actually based on observations in nature of the interference of atmosphere, or air, between the viewer and the things observed. It has long been a consideration in both Western and Eastern painting traditions.

Scientific or Linear Perspective. Scientific or linear perspective was invented during the Renaissance. This system is the same as that which defines space in a photograph. As with the camera, the artist stands still and looks at the subject with one eye open. While works of art relying on linear perspective may appear very real because of their similarity to a photograph's recording of the natural world, neither is actually as "real" as it looks. Most of us normally observe the world through two eyes rather than one, and this very much affects what we actually perceive. In any case, scientific perspective, even though an artificial system, provides a means of ordering the position, size, and scale of objects depicted. It provides a more consistent and rational scheme by which to unify space than any used prior to its invention.

Vanishing Points. Pictures produced through scientific perspective are based on the assumption that there is a fixed viewpoint from which the scene is observed. This fixed level of observation establishes what is known as a horizon line upon which all vanishing points in one-point and two-point perspective systems can be located. Vanishing points are formed by the convergence of lines representing the contours of forms. These forms are

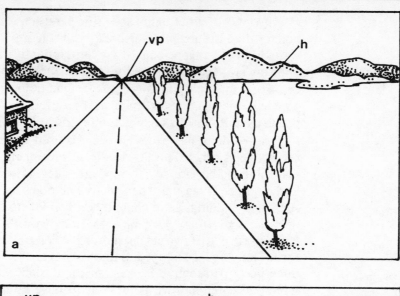

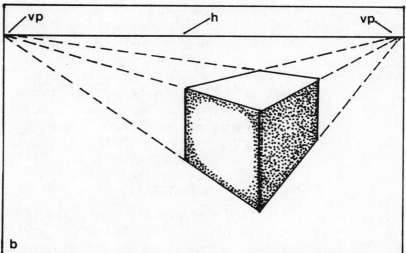

Fig 2.4 Linear Perspective: (a) one-point perspective, (b) two-point perspective
VP = Vanishing point, H = Horizon line.

depicted as if they were set perpendicular to the picture plane. Since we are concerned here with illusionistic space rather than actual space, the lines are set at angles to the picture plane in such a way that they appear to be consistently organized and heading toward the same point. An example would be the apparent convergence in the distance of railroad tracks observed while standing on the ties.

In works of art utilizing scientific perspective, the vanishing points and horizon line are invisible as underlying factors in the composition. They were originally mapped out in a reverse order by extending exterior contour lines inward. Linear perspective can be applied to systems using one, two, or three vanishing points (Fig. 2.4). One-point perspective is used if the objects depicted are represented as if positioned at a 90° angle to the picture plane, as in Raphael's architectural setting of the *School of Athens*.

A two-point perspective system is used when objects are meant to be set at angles other than 90° to the picture plane. In such a case, the two vanishing points are set at opposite sides of the depicted object on the horizon line. Three-point perspective involves the positioning of an object, such as a building, at an angle other than 90° to the picture plane, using a point of view that looks upward from worm's eye position. The lines converge to one of two side points on the horizon line; a third point is formed by the convergence of upward lines. Rarely have artists made serious use of three-point perspective because of the unstable quality it gives to forms. Even one-point and two-point systems have rarely been applied with total dedication because the intentions of art often conflict with consistency in the use of scientific methods.

Light and Dark

Light can be used in art in various ways. Real light can be the basis of a work itself in some twentieth-century examples which use neon tubing or other light sources such as the laser. Light is electromagnetic energy of varying wavelengths which can be separated into different colors. Sunlight, which appears as white, is actually a combination of all of the colors that make up the electromagnetic spectrum.

LIGHT AS ILLUMINATION

In addition to the use of light as the substance of an art work, it is commonly used to illuminate and highlight three-dimensional works. Sculpture, by its own nature, depends on light from external sources to define its mass and give expressive emphasis to its various parts. The same piece of sculpture can be made to appear radically different under varying conditions of light. When lit dramatically or serenely, its volume may be enhanced or flattened and its surface texture enriched or neutralized.

IMPLIED LIGHT

The effects of lighting can also be implied rather than actually present in drawing and painting. Leonardo da Vinci pointed out that a major difference between painting and sculpture was that painting made its own light; sculpture was always dependent on the use of outside lighting to bring out effects which the painter could create at will. In Pierre-Paul Prud'hon's drawing of a nude (drawn in a style which descends from Leonardo's), the

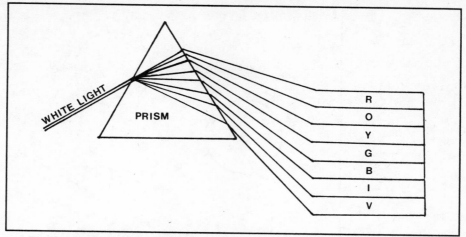

Fig. 2.5 White light refracted by prism: R = Red, O = Orange, Y = Yellow, G = Green, B = Blue, I = Indigo, V = Violet.

figure's form is defined by the soft light which gently envelops her. The fullness of her voluminous body is brought out by the subtle changes in lights and darks which are arranged to imply curved surfaces of flesh. This effect is achieved by the use of value gradations.

LIGHT AND VALUE

Value refers to distinctions of relative lightness or darkness. The term can be applied to the range of grays between white and black or to the darkness or lightness of particular colors, such as light green or dark green. High value colors are light and low value ones are dark. Mixing white into a color produces a tint and so raises its value, while a shade is produced by adding black, which lowers the color's value. When the effect of three-dimensional form is created by the alignment of lights and darks (as in Prud'hon's nude) rather than through the use of lines to define boundaries, we call this *chiaroscuro*, which is an Italian term meaning light (chiaro) and dark (oscuro).

Color

White light contains all of the colors in the spectrum. In nature, the spectrum reveals itself most dramatically in the rainbow, which presents water-refracted sunlight like a prism, its arc containing the spectral sequence of red, orange, yellow, green, blue, indigo, and violet (Fig. 2.5).

Color has great importance in life as well as art. It expresses feelings and contains a wealth of symbolic significance. Some colors such as red are considered warm or even hot, while others like blue are regarded as cool. Warm colors seem to advance and are expansive, whereas cool colors appear to recede and contract. These associations of color extend to the psychologi-

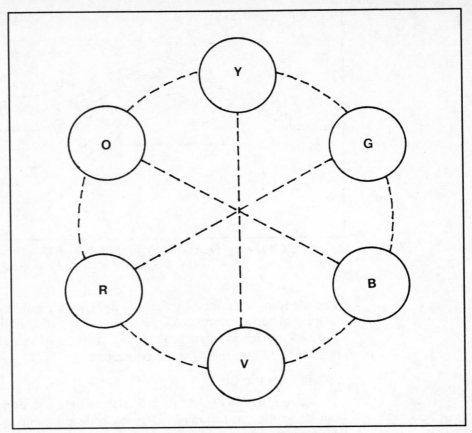

Fig. 2.6 Color wheel: Y = Yellow,
G = Green, B = Blue, V = Violet, R = Red, O = Orange.

cal realm. When feeling depressed we might describe our mood as "blue," and when we are upbeat we are "in the pink." Studies have shown that the colors in our surrounding environment can have a profound effect on our moods, attitudes, and even our physical condition. The houses we inhabit, the stores where we shop, and our places of business are often carefully designed with regard to color's potential to produce certain psychological effects.

Hue, Value,
and Saturation
The properties of color include hue, value, and saturation. Hue gives each color its name. Hue is a color's placement on the visible spectrum, the wavelength which defines it, for example, as blue, red or green. Value refers to the relative lightness or darkness of a color. Saturation, also called intensity or chroma, refers to the vividness of a color. While two colors may have the same value or hue, the saturation or purity of the color may differ.

COLOR WHEEL SYSTEMS

Color wheel systems grew out of Isaac Newton's discovery of the glass prism and his investigations into the spectrum. The color wheel has twelve hues which can be divided into three groups: primaries, secondaries, and intermediates (Fig. 2.6). The primary colors are red, yellow, and blue. They are referred to as primaries because they cannot be produced by mixing other pigment hues together. In art, pigments are defined as the coloring agents used in drawing or painting media (derived both from natural and synthetic sources).

Secondary colors are produced by a mixture of two primaries. The secondary colors are orange, green, and violet. Intermediate colors are between primaries and secondaries, and are a mix of the two, such as red orange and blue green.

COLOR MIXTURES

Color can be produced directly through light itself or by the effect of light on pigment. Light can be the source of optical color mixes through the projection of colored light onto a screen to produce a secondary color. Patches of two different primary colors placed in close proximity to each other also appear to mix in the eye of the viewer. The Pointillist paintings of Seurat are an excellent example of this phenomenon. Both of these methods of color mixing are known as additive mixtures, a name derived from the fact that when all light primaries are combined they add up to white.

When pigments are mixed it is called a subtractive mixture, because pigments absorb light and become duller and darker when mixed. When all pigment primaries are mixed together the result is black, the absence of reflected light.

COLOR SCHEMES

Color schemes are intentional groupings of colors to produce particular effects. These include monochromatic, polychromatic, complementary, and analogous groups. A monochromatic scheme uses a single color and its tints and shades. In a polychromatic scheme many hues are used. Complementary schemes make use of two hues which are directly opposite one another on the color wheel, such as blue and orange. Analogous groupings are made up of hues adjacent on the color wheel, each containing some proportion of the same hue. Red, red violet, and red orange are an example of one possible analogous color scheme.

AFTERIMAGE

An afterimage is the product of fatigue in the retina of the eye, the resulting temporary partial color blindness caused by extended staring at a visual form. If you gaze at the white dot at the center of Jasper Johns's green,

black, and yellow *Flags* painting for about thirty seconds, and then shift your glance away to a white surface, you will observe an afterimage in the color complement of the original (which produces the standard red, white, and blue of the American flag).

LOCAL COLOR

Local color, which is the actual color of a contained area or object, can be modified by the effects of light. For instance, when in bright sunlight colors reflect onto areas and objects near them, they infuse some of their own local color onto the color of the adjacent objects. Areas of local color will also vary in appearance when placed next to or against fields of other colors. For example, a yellow tie when worn against a blue shirt will appear different in color than the same tie contrasted against a pink shirt.

Texture

The term *texture*, which comes from the Latin word for weaving, refers to the surface qualities of various materials. Texture is the rough quality of tree bark or the smooth flowing surface of blown glass. It is the softness of a feather or the coarse bristles of a hog's back. Texture may be perceived both through the sense of touch as well as by vision.

TEXTURE IN SCULPTURE

In sculpture, texture may be literally present as in the hard, smooth surface of a highly polished steel form. The actual material of which a sculpture is made, be it wood, clay, bronze, steel, marble, or fiber, can often determine the particular qualities of surface texture, such as softness and grain.

Meret Oppenheim's *Object*. Meret Oppenheim's *Object* is a fur-covered tea cup, saucer, and spoon. Here the artist has interjected textures which alter our normal response to the utilitarian implements. By altering nothing more than the surface of these familiar objects, she provokes a new range of responses that override our normal sensory association with their use. The thought of sipping tea from a fur-lined cup seems ticklish, if not downright unpleasant.

TEXTURE IN PAINTING

Painting can also be described by its actual surface texture. Some painted surfaces are slick and shiny, while others may have thickly applied patches of paint creating rough textures on their surfaces. In Vincent van Gogh's *Starry Night*, paint with the consistency of a thick paste was applied with a densely loaded brush so as to produce a heavily textured surface that, even visually, appeals to our sense of touch. This type of thick paint application is known as "impasto."

In addition to the actual textures of surfaces in art works, simulated effects that imitate physical properties can also be found in painting and even at times in sculpture. In Jan van Eyck's portrait, *Giovanni Arnolfini and His Bride* we see an attempt made to replicate in oil paint the true-to-life appearance of various material textures. In his handling of the metallic objects, wood surfaces, the mirror, fur-trimmed garments, and even a curly haired dog, the artist tries to convince the viewer of the reality of his painted world.

Texture can be an extremely important issue to a painter when attempting to create an illusion of reality, and at times sculptors may attempt to overcome the physical properties of their media and create textural effects quite contrary to the actual material. For example, a marble statue which is actually hard may yield the effects of soft flesh and gently flowing drapery.

Time and Motion

While time is not a spatial factor, it is not possible to separate it from space. Although we cannot see time, the concept of its passage can be made visible by artists. In some Asian cultures the concept of time is circular and cyclic, but in the Western world, it is regarded as linear in progression.

In a work of art time can be divided into segments. This ordering of time is a well-known convention in comic strips, which we read as framed sequences from left to right. Throughout the history of art many paintings of events suggest the idea of stopped time, where one moment is visually frozen in order to relate a particular segment of a story.

CONTINUOUS NARRATION

At other times a figure is repeated in different parts of the picture to reveal that character's actions through space and time. When this occurs the device is called "continuous narration." We see this convention used in Masaccio's *The Tribute Money*. Within this scene the figure of Saint Peter appears three times within a continuous landscape setting. We see him in the center being instructed by Christ to retrieve a coin from a fish's mouth in order to pay the tax collector. Next we find him on the left at the water's edge with fish and coin in hand. Finally, at the extreme right again, he places the coin in the tax collector's palm.

MOTION IN SPACE: BALLA'S *DOG ON A LEASH*

A different approach to representing the passage of time as well as the concept of motion, is seen in Balla's *Dog on a Leash*.

The repetition of the animal's legs is suggestive of the effect of multiple exposures in a photograph. The painting conveys the impression of the animal's rapid motion across the viewer's path of vision. Balla's concern with capturing the concept of speed and change in two dimensions was in

keeping with the attitude of the Italian Futurist movement of the early twentieth century.

SEQUENTIAL MOTION: MUYBRIDGE

Another example of handling the subject of the animal in motion is seen in Muybridge's sequential photographs, which attempt to investigate more scientifically the subject of animal locomotion. The photographs in this series contain consecutive frames which record the precise positions of the horse's legs and muscles through regular intervals in time.

KINETIC ART: CALDER

In addition to representing the idea of motion within painting, which is itself immobile, other forms of art may be literally kinetic. Alexander Calder's mobiles are suspended abstract sculptures which are activated by air currents. In them we see gentle movements which cause constant change in the visual forms. The chances of observing a mobile with its parts in precisely the same arrangement at any given time, would be mathematically slim. The observation of Calder's mobiles involves our perception of motion through time.

DESIGN AND COMPOSITION

When the visual elements are put to use, we call their arrangement *design*, which means the ordering and composing of form. The term *composition* essentially has the same meaning and is often used interchangeably, but is most often restricted to the consideration of two-dimensional art.

Proportion and Scale

PROPORTION

The term *proportion* refers to the size relationships of parts within a whole. Examples include the relation in size of windows and doors to the height of various floors and, in turn, to the height, width, and depth of the whole structure. The proportions of a person would relate the head size to the height of the body or the width of the shoulders to the length of the torso. Leonardo da Vinci's *Study of Human Proportions* is based on the concept of ideal human form based upon mathematical formulas originated by the ancient Greeks.

Proportion is an important means of creating order. Often it is used to establish standards of beauty and perfection. Ideal standards pertaining to human proportions were essential to the formation of styles during the Classical Greek period and later during the Italian Renaissance. The concept of ideal proportions affected not only sculpture and painting but architecture

as well. It was used in determining what proportions would be used to design a building such as the Parthenon.

Distortion of Proportion for Expressive Purposes. While proportion can be used to create the ideal form of beauty, it can also be used more expressively to distort the human form in art. In Matisse's painting, *Large Reclining Nude* (1935), the human body is stretched and distorted. The diminished head along with the massive torso and elongated arms creates an effect of monumentality. The powerful impact of Matisse's image expressively conveys a concept of beauty and decorative elegance quite different from the Classical ideal of human perfection. Aside from approaching beauty from an alternate perspective, the concept of blunt reality and even outright ugliness can also be assisted through the use of proportion.

SCALE

Whereas proportion pertains to the size relationship of various parts within a whole (to each other and to that whole), scale is the relation in size of one object to another of its kind or to the human figure. Scale can be an important factor in expression. Through scale some parts in a composition are made to appear more dominant than others.

Sometimes scale can determine the relative importance of one figure to another in accordance with a social hierarchy. Saints in religious paintings may be made larger in relation to other human figures surrounding them in order to stress their relative importance within the scheme. Likewise, the Virgin or Christ may appear larger than lesser saints to demonstrate the same principle.

Scale can also be a significant factor in relation to the size of entire art works. A twenty-foot-wide abstract painting presents an imposing presence when situated in a gallery alongside smaller paintings. The sheer size of such a work can hold us in awe. Claes Oldenburg uses scale to elevate mundane objects, normally small in size, to the realm of the monumental, as seen in his *Clothespin*, a forty-five-foot-tall sculpture.

Balance

Balance is the equilibrium among the parts of a composition. Balance can be attained in two ways.

SYMMETRY

Symmetrical balance uses a central axis around which the composition is arranged, with both halves more or less mirroring each other. This type of balance can create a feeling of formality and stability.

ASYMMETRY

Asymmetrical balance is sometimes referred to as informal balance. It is achieved without the benefit of a central axis. Rather than a mirroring of shapes, balance can be produced through color and value which make certain

areas more weighty in harmonious consideration of others. In a painting a small area of dark value might appear as weighty as a larger area of lighter value; it can thus serve to balance the painting while providing contrast and variety within the composition. Asymmetrical balance was a major consideration in the art of Piet Mondrian, who sought a dynamic equilibrium on canvas by balancing opposing primary colors within different size right-angled boundaries.

Unity and Variety

UNITY

Unity is a working together of various visual elements to achieve a sense of order and to balance harmoniously the separate parts of a whole. This can be achieved in various ways. Unity might be approached by repeating a monotonous arrangement of the same element as in Bridget Riley's painting, *Current*. Repetition of similar shapes, colors, or directional movements is another means to achieve unity. Unity often results from subordination of individual parts to the concept of the greater whole.

VARIETY

Variety means diversity in the use of visual elements. Combining different shapes, colors, textures, and contrasts in lighting provides variety, without necessarily working against the concept of unity; other unifying factors can be brought into play, such as a harmonizing of varied colors, or an asymmetrical arrangement of different shapes. Mondrian's compositions depended on an asymmetrical balancing of elements in order to achieve what he considered to be a more vital sense of unity he termed "dynamic equilibrium."

Rhythm

In nature we observe rhythm in such various forms as the regular pattern of waves following one upon another at the seashore, the repetitious surface lines on the back of a scallop shell, or the spots on a leopard's skin. In the visual arts rhythm is the repetition of a design element. It may take the form of a recurring pattern or the use of varied sizes of the same geometric form. Just as rhythm propels music forward in time, so the repetition of certain lines or forms can create a visual force moving across the picture plane. Duchamp's *Nude Descending a Staircase* is an example of this dynamism, created by the use of repetition.

Directional Forces

Directional lines are the skeletal structure upon which compositions are built. Our eye tends to make a connection between lines and forms which may only be implied. Our minds then fill in the blanks. In looking at a picture we are influenced not only by complete lines but by broken ones which we follow out to their logical conclusion.

A line can be an underlying force rather than a drawn visible component. Our perception of directional lines relates to our sense of bodily gravity and personal position in space. The way we look at the movement of a line relates to the idea of standing upright, reclining, or leaning. A directional line can be used to focus our eye, on a particular part of a composition. It can also keep our eyes from wandering outside the format of the work, allowing us to perceive it more fully.

Directional lines can be described as horizontal, vertical, and diagonal in nature. We have already examined these orientations of linear movement in the section on line. Directional forces may serve to establish the mood of a composition, be it serene or highly active.

Emphasis and Subordination

Emphasis within an art work draws and focuses our attention. It is used to underscore the importance of certain visual elements over others in order to more effectively communicate an artist's concepts. Through emphasis certain forms achieve dominance over others. In an abstract painting, a particular shape or color may attract our attention more forcefully and in doing so gain a superior status within the design. When this happens we would notice the other shapes or colors in the painting to a lesser degree because of their subordination. In a composition which uses the idea of emphasis and subordination, the subordinate elements still serve a useful function in completing the whole design. Even though they are not the focus of attention, they may serve other purposes such as creating a background upon which the more active elements play out their contrasting roles.

The three main stylistic modes in visual art are representation, abstraction, and nonrepresentation.

Art may be analyzed in terms of form and content. The visual elements are the ingredients that together make up the form of a work of art. These ingredients include line, shape, mass, space, light and dark, color, texture, time, and motion.

Perspective systems were developed over the centuries to create the illusion of three-dimensional space on a two-dimensional surface. Early methods to imply space included vertical placement of some objects higher in the picture field than others, overlapping, foreshortening, and atmospheric (aerial) perspective. Linear perspective uses vanishing points and a horizon line to plot the angle and convergence of lines in a drawing or painting in order to make the objects depicted appear to recede in "space."

Color wheel systems grew out of Isaac Newton's work with the spectrum. The color wheel divides twelve basic hues into three groups: primary colors, secondary colors, and intermediate colors. Color schemes are intentional color groupings. They include monochromatic, polychromatic, complementary, and analogous schemes.

Texture refers to the surface qualities of various materials. Two-dimensional art can also create the illusion of texture.

Design is the arrangement of visual elements. Proportion refers to the size relationships of parts within a whole. Scale is the relationship in size of one object to another of its kind. Unity is balance within the various visual elements, providing a sense of wholeness. Balance is the equilibrium between parts of a composition. Rhythm in art means the repetition of certain lines and forms. Directional lines are the framework of composition. Emphasis within an art work draws our attention.

Selected Readings

Albers, Josef. *Interaction of Color*. New Haven, CT: Yale University Press. 1971.

Arnheim, Rudolph. *Art and Visual Perception*. Berkeley: University of California Press. 1974.

Berger, John. *Ways of Seeing*. New York: Penguin. 1977.

Birren, Faber. *Color, Form, and Space*. New York: Reinhold. 1961.

Zelanski, Paul, and Mary Pat Fisher. *Shaping Space: The Dynamics of Three-dimensional Design*. New York: Holt, Rinehart and Winston. 1987.

3

Two-dimensional Media and Techniques

The first two-dimensional images recorded by humans were drawn or painted with available media such as naturally occurring earth colors, chalks, and charcoal from firepits. Today's two-dimensional materials and techniques include not only the traditional media used to produce drawings, paintings, and prints, but also innovative approaches and contemporary technology such as computer-generated images. Advertising art, film, and television are also a part of the realm of two-dimensional arts.

In recent centuries developments in two-dimensional techniques have made possible advances such as the mass-production of books, photography, motion pictures, and television. These media in turn have created readily available opportunities for education and information for greater numbers of people and thus have altered the fabric of our society, both socially and politically.

DRAWING

The use of drawing to record and communicate images and ideas stretches back into prehistory and, likewise, to most of our individual beginnings; children normally begin to draw at an early age. Drawings may exist as finished works, record ideas in rough form as in an artist's sketchbook, or function as studies or plans for other works such as a building

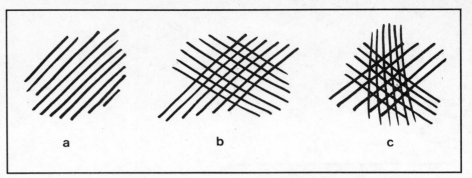

Fig. 3.1 (a) Hatching, (b) Crosshatching, (c) Double crosshatching.

or painting. Full size studies made as guides for another work such as a painting or tapestry are known as cartoons. In some cases artists combine several of these purposes in a single drawing.

Dry Drawing Media

PENCIL AND SILVERPOINT

The pencil is probably the most widely recognized tool for drawing. Its "lead" actually consists of a mixture of graphite and clay which in varying proportions make either a hard or soft drawing point. A harder point produces finer, thinner lines of lighter value; a soft lead creates thicker, darker lines that may more easily be smudged. Pencil lines may be built up to create areas of dark tone or describe contours by the use of parallel strokes known as hatching (Fig. 3.1). They may be further darkened by the addition of another layer of lines running in an opposing direction, a combination termed crosshatching. This method was used with the pencil's more exacting forerunner, silverpoint, a metal stylus used to create delicate silver-gray lines on a prepared surface called the ground.

CHARCOAL

The use of charcoal is evident in prehistoric images found on cave walls. As a material, it has not vastly altered since early people retrieved charred wood or bone from their firepits to use as a drawing tool. The charcoal used today is produced through more controlled means and is available in stick, or other forms, in varying degrees of hardness and texture. It may be sharpened to produce a finer, more controlled line or may be dragged broadside across the paper to create wide areas of rich black. With any drawing, the texture of the paper or other drawing surface is usually evident and can help to determine the character of the work. In the case of charcoal this is particularly noticeable. Charcoal adheres less well to surfaces; it is easier to erase and to manipulate, but it is also more fragile. Today artists normally preserve finished charcoal drawings with a type of spray varnish called fixative.

CHALKS AND PASTELS

Naturally occurring chalks have also been used since ancient times for drawing. Besides white, black, and a red called sanguine, other pigments such as ocher (a dark yellow) and umber (a reddish brown) were derived from earth containing various oxides of iron and other metals. Manufactured pastels consisting of ground chalk, powdered pigments, and a binder were not produced until recent centuries. Their vibrant colors were welcomed by painters as a way of retaining the brilliance of oils (see section on oil painting) combined with the spontaneity of drawing. Like charcoal, chalk can be smudged and blended easily, as in the drawings of the nineteenth-century French artist, Degas. They can also be sharpened to a point and used to create finer lines like those in the red chalk drawings of Leonardo da Vinci or in Michelangelo's studies for the Sistine Chapel frescoes.

CRAYONS

The term *crayon* actually includes any drawing material in stick form, but we most commonly associate it with the wax and pigment version used by children. Conté crayons are actually chalks of a harder nature, manufactured with oil in the binder so that they smudge less easily and may be used in a more controlled manner on finer textured papers. Conté is an ideal tool for building up areas of rich tone and creating strong contrasts between dark and light within a drawing.

Fluid Drawing Media

PEN AND INK, INK WASHES

Ink is the main fluid medium used in drawing. It can produce a wide range of effects from sharply focused linear renderings to softly atmospheric landscapes, depending upon the tool used to apply it and the artist's intent.

Early ink pens were made of reed, bamboo, or bird quills. In the nineteenth century the manufacture of the metal nib provided an array of possible tips in varying widths. Brushes have also been used for centuries; they can produce ink lines of varied width as well as lay down washes of diluted ink to produce areas of varying dark and light value, much like a monochrome watercolor. Today felt- and fiber-tipped pens also provide a range of possible line widths.

The expressive nature of line can perhaps most readily be seen in the broad spectrum of drawings produced over the centuries in ink. Particularly skillful handling of ink and brush is evident in the work of Japanese masters such as Hokusai.

PAINTING

To many, painting is synonymous with the idea of art. It brings with it a long history of intellectual, expressive, and decorative applications ranging from the caves of Lascaux and Altamira through the Egyptian tombs, Greek vases, and Medieval altarpieces, beyond twentieth-century Modernism to the contemporary art of today.

Paint Chemistry

PIGMENTS, BINDERS, AND SOLVENTS

Paint is composed of pigment, binder, and solvent. Pigments are the dry coloring agents which have historically been derived from plant, animal, and mineral sources. Today, pigments are expanded both in range and often durability by chemically produced synthetic pigments. The same pigment colors are used in various media such as watercolor, oils, and colored pencil; however, they may appear slightly different because of the effect of the binders used. The binder holds the pigment particles together and attaches the pigment to the support (or painting surface). Various binders may include egg, oil, wax, acrylic plastic, and gum arabic. Solvents such as turpentine or water serve to spread the pigment over the surface. The terms *vehicle* and *medium* may also be used to refer to this action. Ambiguously, the word *vehicle* may also describe the function of the binder and solvent combined.

SUPPORTS AND GROUNDS

The surface upon which the paint is applied is called the support. Different supports include stretched canvas used in oil painting, paper for watercolor, or other less traditional surfaces such as wood or stone. Before applying paint, artists often create a ground by brushing a gesso or primer coat over the support. The ground allows more controlled absorption of the paint, smooths the surface, and protects the support from the damaging effects of the solvents used.

Painting Media

WATERCOLOR

Contemporary watercolor, also known as aquarelle, is pigment with a gum arabic binder which can be dissolved by water. Normally watercolor block or tube pigments are mixed with water and applied with a soft brush in transparent washes over a paper without a primer coat. This allows light to pass through the thin layers of pigment and be reflected back from the white surface of the paper. Watercolor does not lend itself to overpainting for correction; it loses much of the liveliness and beautiful clarity of color for which it is known if not applied with a deft, skillful hand. Watercolor has long been a favorite medium for landscape artists. Its fluid nature makes it ideal for capturing the rapidly changing effects of light, shadow, and

atmosphere out of doors as can be seen in works such as those by the English painter J. M. W. Turner (1775–1851).

GOUACHE

Gouache is watercolor made opaque (nontransparent) by the addition of white pigment such as chalk. It may be used in combination with transparent watercolor or alone, where its opacity allows for overpainting. Its drawbacks are that it is somewhat limited in value range, can crack easily if applied too heavily, and often has a very dry-looking surface due to the chalk mixture. Colors also dry lighter in value. Brush strokes cannot be blended as easily because of the short drying time of gouache. Nevertheless, it has remained a popular medium for sketches and the work of children.

TEMPERA

Tempera is a traditional medium that was widely used in ancient societies and in particular during the Middle Ages. Egg yolk is its usual binder, with water acting as the thinning agent. Egg tempera lends itself to precise detail. It is usually carefully planned and lightly underpainted because of its transparency and the ensuing difficulty of making corrections. It is a medium capable of portraying rich texture; it can possess great luminosity. Wooden panels primed with gesso provide the best support, since tempera is highly inflexible and would likely crack on a less solid support such as canvas. Because of its exacting nature, tempera is not widely used by contemporary artists, the most notable exception being the widely recognized work of the twentieth-century painter Andrew Wyeth.

OILS

Oil painting was developed by the Flemish out of earlier decorative painting practices and came into more serious use in the fifteenth century in representational painting. Its use continued to be rather limited, at first encompassing only final glazes (transparent layers of thinned paint) over a tempera underpainting on a gessoed panel. The flexibility of oil eventually led to its use as the single medium on supports of linen canvas. Canvas had the advantage of weighing little, and it could also be rolled up for storage or transport.

The versatility of oil also led to its emergence as the prime medium for painting. Oil paint's slow drying time allows it to be reworked over extended periods. It can be applied in thin, transparent glazes or in thicker, textured opaque areas known as impasto. Along with these qualities, the wide range of tones available allows for greater contrasts in oil painting than with some earlier media.

ACRYLIC

Acrylic paints, a twentieth century innovation, provide many similar effects to oil paint while offering the ease of soap and water cleanup. The pigment is suspended in an acrylic polymer medium which may be thinned with water but is water-resistant when dry. Acrylics are highly flexible and adhere to a wider variety of surfaces than many other media, thus making possible the use of more varied supports and techniques like poured pigment on unprimed canvas. Other advantages of acrylic are that it is nonyellowing and may be applied as a thick impasto or thinned to a high transparency. Its quick drying time allows for the effective use of masking (blocking areas with tape or film to create hard edges or protect areas from paint). Thus acrylic is particularly appropriate for producing effects where a hard, clean line is necessary, as was the case with the sixties Op Art paintings of Bridget Riley. Acrylic paints are also frequently used with the airbrush, a precise, small scale paint sprayer used to achieve the near photographic quality of many Photo-realist paintings.

ENCAUSTIC

The technique of encaustic painting uses pigment suspended in wax and heated to a liquid state. The difficulty of keeping the wax at the proper temperature for spreading on the wooden support has caused encaustic to fall out of use, despite its rich color and lustrous surface. The early Egyptian Christians (Copts) used encaustic to create their sarcophagus, or mummy, portraits. One of the few contemporary artists to make use of the medium is Jasper Johns, as in his *Target with Four Faces*.

FRESCO

Fresco painting is done on plaster, normally that of a prepared wall. In *buon fresco*, pigment suspended in water is applied to a damp lime plaster surface. The pigment is chemically bound with calcium crystals formed by the lime. As the wall dries the image becomes permanent and the colors continue to intensify over a period of years. Only the portion of wall that can be painted in a day is prepared; thus, joints occur between the various sections worked at different times. Ideally the artist attempts to place the joints at the edge of major shapes so that they will not be as visible. This is not always possible, as is evident in the sky area of the fourteenth-century fresco *Lamentation* by the Italian painter Giotto. Artists also encounter difficulty with the failure of certain pigment colors to bond chemically with lime, limiting the artist's palette and making tonal transitions more difficult. Once the pigment is applied no changes can be made; careful planning of the design is necessary, usually using a full-scale drawing known as a cartoon.

Another fresco technique is called *fresco secco*. In it, pigment is applied over an already dry lime plaster wall. This method is less permanent than buon fresco, although fresco secco has often been used in conjunction to expand the possible range of effects.

Despite its drawbacks, fresco enjoyed centuries of popularity, falling into disuse only after the Renaissance and the advent of oil painting. Fresco received a revival in the hands of the Mexican muralists of the twentieth century.

Mixed Media

Throughout the twentieth century, artists have experimented with painting on nontraditional supports and incorporating other materials and objects into their paintings, drawings, and other two-dimensional works. At times they have pushed the surface into the realm of three dimensions, blurring the distinction between painting and sculpture. Such mixed media techniques as the inclusion of oilcloth and newsprint in paintings were used extensively by the artists Picasso and Braque in their Cubist works early in the century. These they called *collages*, French for paste or glue. *Assemblage* is another term descriptive of the use of various media, such as metal, fabric, wood, plastic, and three-dimensional objects, both found and constructed, with the painted surface. Its literal meaning (from the French) of "gathering together" is an apt description of the process involved.

PRINTMAKING

Both papermaking and the technology for producing prints came from China to Europe. There, in the fifteenth century, printmaking as we know it today began to develop. Prior to the ready availability of paper and use of movable metal type, books and items such as playing cards and religious images had been produced individually by hand. The ability to mass-produce books and images revolutionized society and began the evolution into today's mass media–oriented world.

The use of printmaking by artists allows multiple copies of the same image, known as an edition, to be produced. Normally an artist will pull (print) proofs as an image progresses to see how it is developing and, upon satisfactory completion, print several copies for personal use and as a record. These proofs are signed *AP* (for artist's proof) and, unlike the rest of an edition, are unnumbered. Prints that are part of the edition are signed by the artist and numbered with a figure such as 16/100, indicating that the individual print is the sixteenth pulled and that a total of one hundred prints were made in that edition. After an edition is printed the artist may intentionally deface the block, screen, or other printing surface and make a print

Fig. 3.2 Printmaking: Cross-section of an inked woodcut block.

from it called the cancellation proof, as an indication that the edition is limited. This prevention of further printing ensures the art collector that the value of purchased prints will be protected by scarcity.

Relief Printing

The oldest method of printmaking is relief printing (Fig. 3.2). It most commonly includes woodcuts, wood engravings, and linoleum cuts. In relief methods the parts of the printing surface that are not to be inked are cut away with tools such as gouges or knives.

WOODCUTS

Woodcuts are relief printing's earliest form, used by the Chinese for designs on fabric and paper. Later, in fourteenth- and fifteenth-century Europe, they were used to reproduce religious images and book illustrations. Cut along the grain of a board, woodcuts can lend themselves to bold contrasts as in the work of the German Expressionists, or to detailed, multicolored prints such as those by Japanese artists like Hokusai. To produce color prints a number of blocks are made, each carrying an individual color and carefully registered (lined up) as they are printed to coincide with the rest of the image.

WOOD ENGRAVINGS

Wood engravings are worked on the end grain of a planed and laminated wood surface with extremely sharp engraving tools. This allows for the creation of lines at various angles unlike the board surfaces used for woodcuts, which are likely to splinter if cut against the grain. The line quality, which can be extremely fine, made wood engravings the method of choice for providing newspaper illustrations during the nineteenth century.

Intaglio

Intaglio printing is the opposite of relief printing (Fig. 3.3). The lines or areas meant to hold the ink are incised into the surface of a metal plate, either by etching with acid or cutting with engraving or drypoint tools. The term *intaglio* encompasses the methods of engraving, drypoint, etching, mezzotint, and aquatint.

Fig. 3.3 Printmaking: Cross-section of an inked engraved plate.

ENGRAVINGS

Engravings are created on polished metal plates by means of a burin (engraving tool) which cuts small grooves into the surface. Any rough edges on these grooves are smoothed with a scraper so that the lines produced in printing the plate are sharp and clean. When run through a press the engraving's lines on the paper actually become raised, or embossed, slightly from pressure into these grooves.

DRYPOINT

Drypoint is similar to etching except that a pencil-like, metal-pointed tool is used to scratch lines into a soft metal plate, leaving a burr, or rough edge, along the groove. When printed this burr holds ink and produces a softer, sketchier line quality. Limited numbers of prints can be made from a drypoint plate since the burr begins to deteriorate after multiple printings.

ETCHING

The lines produced on an etching plate result from a chemical as well as mechanical process. The metal plate is coated with a ground of wax and resin, then the artist draws lines through this protective ground with a pointed metal tool similar in size and shape to a pencil, but without etching them into the zinc or copper of the plate. When the drawing is completed it is placed in an acid bath where the acid eats into the exposed metal of the drawn lines. Line quality can be controlled by the length of exposure to the acid. The plate can also be taken from the bath, have some areas covered with additional ground, and be placed in the acid again to allow it to bite deeper on the uncovered lines so that they will carry more ink.

MEZZOTINT AND AQUATINT

In both engraving and line etching the artist can build up areas of darks only by hatching or crosshatching; the work is essentially linear in nature. The processes of mezzotint and aquatint allow for broad areas of nonlinear tone. Mezzotint involves the working of the plate surface with a tool called a hatcher in order to pit the metal surface. This texture alone would result in a black print, but the artist works by scraping and burnishing to smooth

the plate in varying degrees to produce a full tonal range. The smoother the area, the less ink it will hold and therefore the lighter the tone.

Aquatint plates are made by sifting powdered resin onto the surface and then heating until the resin melts. Areas meant to be of another tone than the one presently being worked are covered with varnish to protect them from the acid bath in which the plate is then placed. As in linear etching, the acid bites into the plate's metal surface according to the length of its exposure, with longer time periods producing rougher surfaces and hence darker tones when printed because more ink is held in the plate. Since aquatint is strictly tonal in nature, it is usually used in conjunction with a linear method such as drypoint or line etching.

Lithography

Lithography is a surface or planographic printmaking process. The artist uses special litho-crayons or an oily ink called tusche to create an image on the finely grained surface of a limestone block or a metal plate with a similar texture. Next the image is chemically fixed with a solution of nitric acid. During the printing process the stone is kept wet. The ink is held by the oily drawn areas, but repelled by the wet undrawn ones. Lithography allows for spontaneity and a variety of effects which include broad areas of brush-applied tone or grainy crayon, and lines produced by either hard crayon or tusche-and-pen drawing on the stone. This variety of techniques was successfully combined in the lithographic posters of nineteenth-century French artist Toulouse-Lautrec.

The lithography method used to produce books and magazines is called offset lithography. It has been used by some artists for hand-drawn images, and although the drawing is done on silver Mylar, the process still relies on the basic fact that water and oil do not mix.

Serigraphy

Serigraphy (also known as screen-printing or silk screen) uses the principle of the stencil to produce images. The artist cuts the stencil from a special film and affixes it to a screen of stretched silk, nylon, or finely woven metal. Alternately the artist may create the stencil directly on the screen with a glue-like varnish to produce a less hard-edged and more gestural print. Photo screens can also be made using light-sensitive gel to reproduce a photographic image.

After the screen is prepared, the ink or paint is forced through the mesh of the screen's open areas with a rubber-bladed Squeegee to make the print. Screenprints may be made on paper, cloth, canvas, glass, and other surfaces, a versatility which allows for a broad range of applications. Multicolored prints are also possible through the use of different screens for various color areas.

The large flat areas of color typical of silk screen have made it useful commercially in printing labels and posters. Andy Warhol used the screenprint to satirize the mass media in his Pop Art images of the sixties, such as his Campbell's soup–can series which relies on literal reproduction of the familiar red and white labeled can.

Monotype

The monotype, unlike other forms of printmaking, produces only a single print. The image is drawn or painted on a nonabsorbent surface with a wet medium such as oil color and then transferred by rubbing or running the plate and paper through a press.

Collographs

Printmakers have experimented extensively with mixed media prints using various print techniques combined in a single image, prints combined with other media such as painting, or methods like collography which particularly lend themselves to experimentation. Collographs are prints made from collages of different materials such as cloth, cardboard, and twine glued to metal or wooden panels. These are then inked and run through a press to produce prints with varied and often fascinating textures and expressive possibilities.

PHOTOGRAPHY

Origins and Development of Photography

CAMERA OBSCURA

The camera has its origins in the camera obscura of the Renaissance, a device used to assist artists in producing accurate renderings. The literal meaning of *camera obscura* is "dark room." In this darkened enclosure light, passing through a small opening in the wall, projected an upside-down image of the outside scene on an opposite wall; this image could then be traced onto surfaces such as paper or canvas. Later smaller, box-like versions, using a lens for the light to pass through, made the camera obscura easier to transport and broadened its usage.

The next steps forward in developing photography concerned the discovery of light-sensitive surfaces on which to record the projected images. In the eighteenth century German physicist Heinrich Schulze discovered that silver salts had light-sensitive qualities, although he did not pursue the image-making possibilities. Somewhat later, Thomas Wedgewood in England used silver nitrate–soaked paper to record projected images, however, impermanently.

DAGUERRE

In 1826, the Frenchman Joseph Nicephore Niepce used a bitumen-coated pewter plate to produce the first photographic image. Niepce used a camera obscura–like device to project the image on the plate, exposing it for eight hours. Over the next decade Niepce's discovery evolved further through the efforts of fellow Frenchman, Louis-Jacques-Mandé Daguerre. The first successful daguerreotype, a view of a corner of the artist's studio, was made in 1837. At this point the daguerreotype required a long exposure time; since there was no negative involved, copies could not be made.

EARLY PHOTOGRAPHY

As the need for long exposure times became less with successive innovations in photography, portraits made by the camera became immensely popular and accessible to the public. Photojournalism was pioneered by photographers like Mathew Brady who used the medium to document the Civil War and record other historical events. These uses laid the groundwork for our intensely media-affected and -oriented contemporary world. They also provided impetus for painters and other artists to work in ways unlike any explored previously. When photography seemed to carry the mantle of responsibility for reproducing an accurate version of reality, artists in other media sought to work in ways that the camera could not, thus insuring their creative place in the world. Ironically, many photographers of the same period emulated the appearance of painting in their work.

At the end of the nineteenth century photographers became more concerned with the recognition of photography as a valid art form in its own right. Photographers like Edward Weston, Paul Strand, and Edward Steichen saw photography not as a less lofty version of realistic painting, but as a media capable of elevating and making expressive the commonplace.

TWENTIETH-CENTURY PHOTOGRAPHY

The decades of the 1930s and 1940s saw photography take on a greater stance of social commentary. During the Great Depression, photographers like Dorothea Lange documented for the public eye the suffering of migrant workers and sharecroppers. Later the hand-held camera made possible candid images of World War II and its aftermath. Margaret Bourke-White's images of the war and its concentration camp survivors, published in magazines like *Life*, brought home the horror in a way not possible before the advent of modern photography.

Since World War II technological advances have been made that allow the photographic recording of molecular structures or as far-flung a view as that of the earth from space. Photography has moved beyond its earlier black-and-white orientation as color methods have evolved and become widely used. Instant photography cameras can produce developed prints

directly after recording an image. Technical advances have automated focus and aperture opening on precision cameras such as the 35 millimeter, enabling the layperson to take higher quality photographs. Artists have produced photographs that were conceived in highly abstract terms as well as employing techniques like collage and color xerography (photocopy process) to produce or alter images. Other noncamera techniques like holography offer three-dimensional records of form and further exciting paths of possible evolution for photography.

How the Camera Works: Lens, Aperture, and Shutter

The camera basically functions much like the human eye. Just as our eyes have lenses to focus light rays passing through them, all but the most simple cameras also possess an optical lens. The opening located behind the lens which admits light into the camera's otherwise lightproof chamber, or body, is called the aperture. Like the eye's changing pupil, the aperture may be opened wider to admit more light or closed (stopped) down to admit less. The smaller the aperture opening, the greater is the depth of sharp focus, or depth of field, perceived by the camera. In turn, a large opening allows for a more shallow depth of field outside the object or area upon which the camera lens is focused. The shutter prevents light passing through the lens and aperture from striking the film or photographic plate until a release is pressed. The speed with which the shutter opens and closes controls the length of exposure of the sensitized surface to light.

Many cameras may also be fitted with various lenses other than the standard lens in order to alter the possible angle of view. Zoom lenses can be adjusted from near to far in focal length. Wide-angle lenses, as the name suggests, provide a broader through-the-lens view, while telephoto lenses make possible close-up views of distant areas or objects.

Film, Development, and Printing

The film contained within the camera is a transparent sheet or long strip of clear material coated with light-sensitive crystals in a layer called the emulsion. After exposure, the images on film are developed through the use of a series of chemicals. With slide film a positive image is produced directly on the film after the developing process and may then be projected. In print film, the areas of light and dark are reversed on the finished negative. It must then be printed in the darkroom by means of an enlarger which projects the image onto light-sensitive paper or other treated surfaces. The lighter areas of the negative allow light to pass through and produce dark tones on the light-sensitive surface, while the dark areas of the negative block light and protect the surface. The image is then made visible and permanent through a series of chemical baths.

Photographers may manipulate the image produced in the darkroom by cropping out certain areas, printing on various surfaces, or by using paper that produces either cool or warm tones. They frequently control the light-

ness or darkness of a print overall or in chosen areas by varying the print surface's exposure to the enlarger's light. Among other possible methods of manipulation is the combining of various negatives to create a single print, thus producing a final image vastly altered from that seen through the camera's lens.

CINEMATOGRAPHY

Origins of Cinematography

Eadweard Muybridge set the stage in 1878 for the development of filmmaking with his *Galloping Horse* sequential photo series. Muybridge used twenty-four cameras placed around a racetrack to record the position of a horse's legs and body at intervals of a few seconds. His studies of locomotion led Muybridge to invent equipment capable of photographing a rapid succession of motions as well as to invent the *zoogyroscope*, a device through which these images could be projected for viewing.

In 1893, Alexander Black made the first motion film to be recognized as public entertainment, a production featuring the president of the United States at the White House. Black used technology perfected by the American inventor Thomas Edison and his assistant, William Dickson to project the film. Edison, along with Dickson, is also credited with the invention of the motion picture camera in 1889.

The Illusion of Movement

Films consist of sequential photographs shot at the rate of twenty-four per second and projected at the same speed. We perceive what we view as motion because of our brains' processes of perception and ordering and also because an afterimage lingers briefly on the retina of the eye. Our perception fills in the space between the individual images so effectively that the gaps are not noticed.

The effect of slow motion is produced by shooting one hundred or more frames per second and playing them back at the normal rate of twenty-four per second. A film shot at less than the normal rate per second and projected normally will appear speeded up.

Early Developments in Filmmaking

Although initially early filmmakers used the fixed view of a seated theatergoer as the camera's exclusive point of perspective, pioneer cinematographers such as D. W. Griffith soon introduced the idea of the moving camera. Just as the human eye could scan the larger scene, observe parts of it, such as groups of people interacting, or focus intensely on close details, it was realized that the camera could also make use of angle, sweeping movement, and varying distance to heighten a film's effect.

Editing

Griffith was also an innovator in the area of film editing. He is credited with the development of many techniques still in contemporary use. The editing process involves selection of film sequences which are cut and reassembled to enhance the concept and composition of the film.

NARRATIVE EDITING

Narrative editing makes use of several cameras filming shots of the same scene from different angles or distances. These close-ups and long shots are then selected and footage combined to best convey setting and emotion.

PARALLEL EDITING

Parallel editing intersperses events occurring in different places at the same time or current events in the story with past or present scenes. The term *flashback* refers to the depiction or narration of an earlier event, often shown to provide more background information. Flash-forwards allow a glimpse into the future.

TRANSITION

Transition from one scene to another may be accomplished by the use of fade-outs, the gradual darkening of a scene, followed by a gradual brightening, or fade-in of the following scene. In contemporary film the dissolve is more likely to be used. In this method two scenes overlap, the first dimming as the next shot gradually appears behind it.

The editing technique of montage uses a sequence of abruptly changing images to convey rapidly the passage of time or to intensify emotion.

Silent Films

Since early film cameras had no means of recording sound, live music, at times including full orchestras, was used to accompany and heighten the emotional and expressive impact of the film. Silent-film actors also learned to use their faces and bodies to effectively communicate without words.

Prior to 1910, filmmakers kept their actors anonymous to the audience as a means of keeping actors' pay low. But the public came to recognize and admire certain favorite performers. The marketing of "stars" soon followed, with Mary Pickford, Douglas Fairbanks, and comedian Charlie Chaplin among the first prominent actors.

Chaplin later became his own director and is credited with being one of the founding "greats" in film direction. He was also the producer, writer, and background music composer for some of his films, and was known for his exacting standards in creating these works.

Silent films were able to communicate internationally, unencumbered by language barriers, enabling filmmakers like Sergei Eisenstein to achieve renown in the West as well as in Russia. Eisenstein used a montage of visual

narration to powerfully recreate the violent experience of a failed revolt in his film *The Battleship Potemkin* (1925).

Early Alternative Films

Painters like Salvador Dalí and others in the visual arts were also producing abstract and surrealistic films which paralleled the development of narrative or story-telling cinema in the twenties and thirties.

Technical Innovations in Film

In 1927 sound films came into use, leaving some actors with satisfactory mime skills but less than compelling voices out of work. The decade of the 1930s saw the introduction of color films. During the 1950s wider screens and three-dimensional imagery gave moviegoers new experiences. In the 1960s, $360°$ projection was used for some films. Some of these innovations have become standard in today's films while others, such as 3-D, are considered oddities used more for the effect itself than to enhance the film's narrative.

Today, contemporary computer technology has served to provide animated effects and make the job of film editing quicker and more efficient. Fantastic special effects such as monstrous creatures and whole environments are made possible through various technological advances made in recent years.

Filmmakers and the Special Power of Film

Filmmakers like Ingmar Bergman of Sweden, Akira Kurosawa of Japan, France's Francois Truffaut, and Italy's Federico Fellini are widely recognized for the skills they have used in exploiting film's special ability to enfold and transport us, to alter our emotions and our perception of time. They are intensely aware of the cinema's power to manipulate the viewer and create a reality all its own.

Animation

Another form of filmmaking, animation, involves drawing and painting figures or abstract forms, varying the images slightly from one depiction to the next so that when these are recorded as separate frames on film they appear to show motion. Cartoons are a popular form of animated film. One of the most artistically serious productions along this popular route was Walt Disney's *Fantasia*. Animation can also involve the use of real objects rather than depicted ones such as the clay figures and backgrounds of claymation. These figures are manipulated slightly between shots and photographed frame by frame to create the illusion of motion.

TELEVISION AND VIDEO ARTS

**Television and
Live Broadcast**

Like cinematography, television makes use of the camera and many of the filmmaker's techniques, such as editing. Fundamental differences are the television camera's conversion of light waves into electricity and the resulting electronic message's ability for live broadcast through the air or by cable transmission to individual television sets. The television reconverts these messages into images and sound. The images on a TV screen actually consist of many lines that are close enough together to give the impression of a continuous picture.

Television has become a way of life in America today. Only about 2 percent of homes in this country lack TV, as compared to 1949's 2.3 percent of homes with television.

Television's live coverage of events, such as Neil Armstrong's first steps on the moon, have been viewed by millions of people worldwide. Broadcasts such as this underscore television's potential to bring greater communication between nations. Worldwide, we are collectively able to savor human triumph or experience the tragedies of distant famines and wars.

**Commercial
Television**

COMMERCIALLY FUNDED TELEVISION

Commercially funded television has been criticized for its programs' low standards of creativity. Certainly sponsors want the largest possible viewing audience for their advertising. Many critics of the medium believe this leads to repetitiveness, shallow story lines, and overly simple dialogue in an attempt to program for the lowest common denominator among audiences. Ironically, many of the commercials themselves are recognized as being highly imaginative and entertaining.

PUBLIC TELEVISION

Public television is funded by various grants and by individual viewers' financial support. This eliminates the need for commercials and allows for more specialized programming in areas such as the arts and sciences.

Video Arts

In recent years the term *video* has been applied to the work of those artists who wish to differentiate between the visuals they create and those of standard broadcast television. The introduction of affordable, portable video equipment in the mid-sixties allowed a blossoming of individual expression in the medium.

Nam June Paik is perhaps the most widely known pioneer in the field of video art. His background in science, music, and engineering has come into play in the creation of devices like the video synthesizer which is capable of changing black-and-white camera input into color abstractions

or altered images. Some videos, such as his *Rondo Electronique* are composed wholly of fluctuating, nonrepresentational light forms.

COMPUTER-GENERATED IMAGERY

**Design and
Fine Arts
Applications**

The use of computer capabilities to produce finished art works, as well as to design and solve problems has become widespread in many art fields such as filmmaking, photography, and architecture. Tools that function much like brushes or drawing instruments may also be used to "draw" or "paint" on the computer to produce original works of art.

Computers possess the capability to store images for further work or alteration. Designers have been freed of some of the more exacting or repetitive aspects of their work by means of the computer. Particularly in industrial design, the ability to rotate images and view them from different angles has proven valuable in assessing the workability of the finished product.

GRAPHIC DESIGN AND ILLUSTRATION

The contemporary environment is saturated with commercial art. Everywhere we turn are billboards, magazines, printed packages, and television advertisements. Graphic designers work through photography, illustration, and typography (the selection and composing of letter forms for printed material) to create designs for reproduction in such commercial forms.

**Logotypes and
Symbols**

Two familiar uses of graphics are the logotype (or logo), and the symbol. As contemporary as both are, these forms have their origins in ancient pictographs (information-conveying picture sequences that were the foundation of later, more abstract alphabets). Technically speaking, symbols are pictorial while logotypes are based on letter forms; however, the term *logo* is often used informally to denote either one. Conceptually, logos and symbols both serve the same purpose of creating instantly recognizable visuals for businesses, products, and organizations. These carefully conceived images convey a message about their company or product that we are meant to remember and associate with certain qualities.

Illustrations

Illustrations differ from fine art in purpose rather than media. Contemporary illustrators may create their work on computers or use drawing, painting, or photography to produce images for reproduction by photomechanical printing processes. Unlike fine art, illustrations seldom exist solely for their own sake; instead they often accompany written text to clarify or add interest. Often they serve a decorative purpose.

ILLUSTRATORS

The work of illustrator Norman Rockwell is among the most widely recognized. Between 1916 and 1963 he created many covers for the *Saturday Evening Post* depicting everyday American life with humor and great detail. While his technical skills and warm presentation earned a wide audience, some found his work overly sentimental and more an appeal to emotion than aesthetic sense.

Other recognized illustrators include the husband-and-wife team of Leo and Diane Dillon, who work jointly on producing images in a variety of media for books, magazines, and records. Maurice Sendak's illustrations for his own and other authors' books for children have brought him tremendous recognition. He believes that the text should take precedence over the visuals. Unlike Sendak, Brad Holland feels that his oddly disturbing work should precede any text it accompanies and ideally ought to be of more importance than the written word.

*T*wo-dimensional art encompasses many materials and methods of working, just as it serves many purposes. Both fine and applied or graphic arts often share the same techniques and media.

Drawing has been practiced since prehistory and includes both the use of dry and wet media.

Painting has traditionally been a highly esteemed art form. Chemically, paint consists of pigment, binder, and solvent. Watercolor, gouache, tempera, oil, acrylic, encaustic, and fresco are paint mediums.

Print technology came out of China and was developed in fifteenth-century Europe. Printmaking allows multiple images to be produced. Relief printing includes woodcuts, wood engravings, and linoleum cuts. Intaglio printing methods include engraving, drypoint, etching, mezzotint, and aquatint. Lithography, serigraphy, monotypes, and collography are other methods of printmaking.

Two-dimensional and three-dimensional media may be combined in a variety of techniques like collage and assemblage to produce works that blur distinctions between media or between sculpture and painting.

The camera originated in the camera obscura of the Renaissance. The next advance was the development of light-sensitive surfaces for recording images. In the twentieth century, social commentary became a prevalent

concern among photographers. Technological advances in recent decades have included molecular photography and noncamera techniques like holography.

Cameras work on principles much like the human eye. The lens focuses light rays and they then pass through the aperture (a pupil-like opening that can be adjusted to admit varying light).

Thomas Edison and William Dickson contributed the motion picture camera. The effect of motion is created by the filming and projecting of images at twenty-four frames per second, causing the illusion of movement.

Pioneer filmmaker D. W. Griffith was one of the first to use various camera angles, close-ups, long shots, and editing techniques like narrative and parallel editing.

Sound films came into use in 1927, followed by color and advances such as wide screen as the century progressed. Today computer technology increases film's possibilities.

TV differs from film in its conversion of images into electricity and subsequent broadcast or cable transmission.

Video is a term generally used to cover the fine arts use of television techniques.

Computers are used to create images, much like painting or drawing, and can also assist designers in various fields in imaging and problem-solving.

Commercial art involves the work of graphic designers using methods such as photography, typography, and illustration.

Illustrations use many of the same media as fine arts but are normally intended to accompany written text.

Selected Readings

Goodman, Cynthia. *Digital Visions: Computers and Art.* New York: Abrams. 1987.

Hind, Arthur. *History of Engraving and Etching from the Fifteenth Century to the Year 1914.* 3rd ed. 2 vols. Princeton: Princeton University Press. 1981.

Mayer, Ralph. *The Artist's Handbook of Materials and Techniques.* New York: Viking. 1981.

Monaco, James. *How to Read a Film: The Art, Technology, Language, History, and Theory of Film and Media.* New York: Oxford University Press. 1977.

Newhall, Beaumont. *The History of Photography.* rev. ed. New York: Museum of Modern Art. 1982.

Nicolaides, Kimon. *The Natural Way to Draw.* Boston: Houghton Mifflin. 1975.

4

Three-dimensional Media

Three-dimensional art works occupy and transform space. Much three-dimensional work also involves movement in space, either of the viewer examining various sides of a sculpture or actual movement within a sculpture. Performance works are also three-dimensional media involving literal transformation of space by the performers' movement and presence.

SCULPTURE

Early Sculpture

The history of sculpture is equally ancient as that of painting. Prehistoric peoples carved small figures and animals of natural materials such as ivory or bone or formed them out of clay. Along with paintings, larger scale relief sculpture was also worked on cave walls, often taking its cue from preexisting rock forms that suggested certain subject matter.

Prehistoric sculpture is believed to have been created for magical purposes, to insure the effectiveness of the hunt and increase the fertility of animals and humans. Out of these early beginnings, sculptural forms evolved further as religious objects and commemoratives of royalty and the honored dead.

Contemporary Sculpture

Today sculpture encompasses more than the traditional materials such as wood or clay. It is as likely to be of vinyl or neon, laser-produced or a combination of found objects. Contemporary sculpture, while still performing functions such as memorializing heroic acts, is also free to exist for its own sake as pure form.

Freestanding and Relief Sculpture

Sculptures that exist as objects may be either freestanding or relief sculptures. Freestanding sculptures are meant to be viewed from all sides and are therefore known as sculpture in the round. In relief sculpture three-dimensional forms project out of a flat background which may be wall hung or part of an architectural element such as a door panel. Relief sculpture is designated as either high relief (haut-relief) or low relief (bas-relief) depending upon how far the forms project outward from the flat surface. High relief forms may be nearly detached while low reliefs are only slightly raised.

Sculptural Processes

Traditional sculptural methods are usually classed as either additive or subtractive processes. In subtractive processes, material is taken away to create the form, as in stone or wood carving. In additive processes, material is built up through modeling, casting, or constructing to form the sculptural work.

CARVING

Carving is perhaps the most widely recognized sculptural process. It is the means by which Michelangelo created works such as his marble *Awakening Slave* and cultures such as the Dogon of Africa have produced compelling figures and masks of wood.

Carving Tools. The subtractive process requires a good degree of technical skill since the material taken away is difficult to properly replace if a mistake is made. Although power tools have reduced the labor involved for those artists using them, carving is still a highly physical act and one that many sculptors prefer to practice with the same type of hand tools used for thousands of years. The chisels, mallets, gouges, and rasps used to shape contemporary wood and stone carvings are little altered from their early predecessors.

Carving and Surface Texture. In carving, the manipulation of surface texture is under the sculptor's direct control. The degree of finish chosen by the sculptor may contrast elements of smooth, high finish with more roughly textured, less altered surfaces. The artist may chose to rasp and sand until the cool elegance of marble or the warm red brown grain of mahogany is fully revealed. Such considerations go beyond surface appearances to the visual impact of the entire sculpture. Texture may be used to direct the eye to certain parts of a work, to underscore and emphasize or to unify the whole.

MODELING

In the additive process of modeling, forms are built up from clay, plaster, or softened wax. Often sculptors use an inner support known as an armature to prevent these pliable materials from slumping or sagging. The armature acts much like a skeleton to give strength and hold the form in the shape

intended. Armatures may be made of a wide range of materials but wire and wood are the most common ones.

Wheel throwing and handbuilding techniques such as coiling and slab construction are used to create ceramic sculptures as well as more utilitarian forms. By building up forms with these methods the artist may often dispense with the need for an armature.

CASTING

Because the materials used in modeled sculptures are often fragile, the works may be cast in longer-lasting materials or in the case of certain types of clay works, fired in a kiln to harden and make them more permanent.

Although casting may be classed as an additive process, it is actually a replacement or substitution process, since one material is substituted for another by means of a mold.

Molds are formed around the original clay or other soft material by enclosing the form in plaster, resin, or other materials that harden. Provisions are made for joints to separate the parts of a mold from around the original. For instance, in casting from clay, thin sheets of metal called shims are inserted in the soft clay to form a protruding "wall" that partitions the form into segments. The material of the mold when set can be split along the lines formed by these walls and thus removed from the form, creating a hollow impression of the original. The mold's sections are then secured together and liquid casting material of the chosen type poured into the cavity. When this has set, the mold is pulled or chipped away to yield the form.

Lost-Wax Technique. One method for casting metal is known as the lost-wax process (or as it is often called by its French name *cire-perdue*). Cast sculptures can either be solid or hollow. Normally, because of expense of metal and its weight, only small sculptures are cast as solid pieces. When casting a solid sculpture, a wax model is made, over which fine clay or plaster is applied as a first step in making the mold. (Styrofoam may also be used in place of wax forms in casting since it will also readily melt.) If the cast sculpture is to be hollow, the wax original is formed over a clay core which is removed at the end of the process. Wax rods are attached to the wax model to create gates or channels, for the molten metal to flow through.

Then the replica is placed in a container and a mixture of silica, clay, and plaster poured around it to form a fireproof mold called an investiture. The investiture is heated in a kiln so that the wax is melted and runs out, hence the name "lost-wax." Molten metal is then poured into the hollow mold left by the wax form. When the metal has hardened, the investiture and core are removed. The extra metal of the gates is taken off and the surface finished as desired by the sculptor. Obviously the task of lost-wax casting is not a spontaneous one and requires careful planning and execution. Only

one original sculpture can be made by this method since both mold and model are destroyed during the lost-wax process.

Sand-Casting. Another method of metal casting, sand-casting, uses molds formed in fine damp sand into which the model is pressed. These preserve an impression of the original into which the molten metal may be poured. A mold for relief sculpture can be made in a bed of sand. In the case of a freestanding sculpture, the model is placed in a sectional metal container and fine damp sand packed around it to form a mold. This sand holds its form even after the sections are taken apart to release the original. The sections are then reassembled with a core to prepare for casting a hollow metal sculpture.

Some casting processes allow for multiples rather than single, one-of-a-kind sculptures. In processes where either the mold or the model remains intact they can be reused to cast additional sculptures of the same form. For example, through sand-casting techniques sculptors are able to create multiple images much as printmakers create an edition of numbered prints. Each sculpture must still be finished by hand and many sculptors choose to vary the finish or bend thin, flexible areas of metal in different directions so that each work is somewhat unique.

CONSTRUCTED SCULPTURE AND ASSEMBLAGE

Another additive method that has become widely used in the twentieth century is constructed sculpture, also known as constructivist sculpture or simply, construction. Constructed sculpture is built by the artist out of varied materials such as metal, cardboard, plastic, wire, or wood. These might be used individually, as in the case of welded steel, or may be combined, using two or more materials. Picasso, an early innovator in the use of construction techniques, was among the first artists to incorporate found objects (preexisting forms selected for use as art but not made by the artist) into his three-dimensional works.

Assemblage. When found objects are combined into a new context, usually as an abstract sculpture, the resulting work is called an assemblage. Both construction and assemblage allowed sculptors to concern themselves with new challenges of spatial division and ordering, where form and space took precedence over mass.

Constructed Metal Sculpture. The advent of oxyacetylene welding in 1895 made possible the development of constructed metal sculpture as we know it. Along with cut metal forms created specifically for a work, sculptors such as David Smith have often incorporated industrial elements such as beams, gears, and other found metal parts into their constructions.

Alexander Calder was an early practitioner of cut and constructed metal forms. Calder created flat painted metal shapes which were often placed in natural surroundings where sky and clouds could interact with the openings

between forms. These fixed forms were called stabiles, but Calder also created metal kinetic sculpture which actually moved in space.

MIXED MEDIA

In the wake of developments such as construction and assemblage, the line between two- and three-dimensional art became increasingly blurred. Just as two-dimensional art media such as photography and painting may be combined to create mixed-media works of a new nature, so two- and three-dimensional aspects may form parts of the same work. Some artists have constructed three-dimensional canvas forms which are then painted in the traditional manner of flat canvases. Other artists, such as Robert Rauschenberg, have combined painting with three-dimensional found objects to create art that is difficult to categorize as either painting or sculpture. Such works are usually categorized as mixed-media.

New Materials

Along with innovative methods in sculpture, many new materials have come into use in recent decades. Neon and other light sources have been used by artists such as Chryssa to create both enduring or temporal works.

John DeAndrea has created startlingly lifelike human figures in cast and painted polyvinyl. Fiberglass and resins may also be cast or built up by various means to produce a variety of effects.

SOFT SCULPTURES

Other artists have constructed sculptures of stuffed fabric or vinyl with results known as soft sculpture. Claes Oldenburg's *Soft Toilet* or *Giant Stuffed Fan* are collapsing, soft satires of their utilitarian counterparts.

Kinetic Sculpture

Sculpture which incorporates motion or moving parts, known as kinetic sculpture, grew out of early twentieth-century experiments by artists fascinated with the unfolding possibilities of technology. Over the years sculptors have used many methods of creating motion in their works including motors, running water, magnetic fields, changing light intensity, and wind.

Marcel Duchamp was one of the earliest twentieth-century pioneers in motor-driven constructions. Duchamp also coined the term *mobile* for a type of kinetic sculpture developed by Alexander Calder, which was suspended and driven by gentle air currents.

Earthworks and Siteworks

In the 1960s some sculptors became interested in the concept of land art or earthworks. Sculptors began to manipulate the earth itself into constructions on a grand scale, harking back to historical precedents such as Stonehenge or zen gardens. Robert Smithson's *Spiral Jetty* was constructed as a fifteen-hundred-foot spiral of earth, rocks, and other natural materials extending into Utah's Great Salt Lake. While Smithson's earthwork was

made by an additive process, some artists, such as Michael Heizer, who literally blasted out sections of a mountain, use subtractive means to achieve their end. Either way the result is usually quite permanent. Earthworks may endure for thousands of years if left undisturbed.

While some land artists manipulate the landscape by relocating natural materials within it, others are site specific and use manufactured materials brought into the landscape, usually on a temporary basis. In such cases, the ephemeral art work exists only as long as viewers are able to participate in interacting within its space/location. An example of this type of project was Christo's twenty-four-and-a-half-mile-long curtain of nylon, entitled *Running Fence*, which for two weeks in 1976 ran from the sea across the landscape of two California counties. Its nylon curtain reflected earth and changing sky as well as being influenced by wind and weather.

Installations and Environments

Another development of the 1960s involved altering interior spaces through installations and environments which often engaged the viewer as part of the piece. Rather than small transportable works of sculpture, pieces took on a grand scale or altered the physical space entirely. Some artists brought quantities of earth and other natural materials such as stone indoors, while others used synthetic or manufactured materials in their installations.

Artist Larry Bell has created large constructions of glass which can be installed in various combinations to produce overlays of reflection which alter the viewer's perception of the planes in space. Other installations, such as those by James Turrel, also challenge the viewer's notion of reality through altered light and space. The viewer participates in the creative process by decisions made about reality and perception—to experience a selective process of perception similar to that made by artists at work, in a sense becoming artist rather than observer.

PERFORMANCE

In performance, the body itself becomes art, its implied expression in all visual art condensed to its basic element. Dance, drama, mime, and performance art also use the basic design elements of line, shape, light, color, and motion. The sculptural concern for space is inherent in these forms as well.

In mime, the artist silently relates events and emotions through exaggerated movement and gestures. The international performance group, Mummenschanz, has extended mime's traditional expression from their early facial masks to soft-sculpture whole-body masks—visual forms such

as giant hands or organic abstracts which the performers activate from within by body movement.

In dance the sculptural and expressive qualities of the body in space may be used to express emotion or to relay other dramatic or narrative content. Some new dance forms use the body strictly as a visual element, much as one would construct a sculpture of other materials. Pilobolus is one such troupe, whose work may be characterized more as static human arrangements rather than standard dance movement.

Performance art draws on drama, dance, sculpture, painting, and other art areas to create new art forms. Early in the twentieth century the art movements of Futurism and Dada began to use performance to challenge public assumptions. Performance has continued to have sociopolitical connections in its themes and execution. Since the 1960s, performance has steadily gained popularity as an energetic, cutting-edge means of expression. Through performance, artists can create hard-hitting commentary as well as cross the boundaries between arts disciplines to create innovative forms.

CRAFT, DECORATIVE ARTS, AND INDUSTRIAL DESIGN

Prior to the Industrial Revolution, the concept of craft was a part of everyday existence. Since ancient times the practical tools of living, such as clothing, furniture, and utensils, were made by hand, often with an eye toward beauty as well as usefulness. Today craft is the basis from which much fine art proceeds as well as those handmade objects produced for practical use.

As in many other areas of the arts, the exact boundaries between craft and fine art are increasingly difficult to define. Handmade objects with utilitarian purposes are generally considered to be craft, but even here the definition may be tricky. Neither is craft strictly defined by materials such as ceramics or processes such as weaving, although these are traditionally associated with the concept of craft. In general we may define craft as those works in which material and function dominate, while in fine art, form and content are primary.

Ceramics

Ceramics, or the art of making objects of fired (baked) clay, was one of the earliest forms of craft. The terms *potter* or *ceramicist* are used to describe a person who works with fired clay. Today, ceramicists may use ancient methods of hand-building and baking in open fires or use electrically

powered potter's wheels and gas-fired kilns or varying combinations of these techniques to produce the desired effects. Artists such as Robert Arneson and Peter Voulkos have expanded the boundaries of the craft into the realm of fine art through their respectively figurative and abstract sculpture in ceramics.

METHODS OF CREATING CERAMIC FORMS

Prior to the invention of the pottery wheel in the ancient Middle East, techniques of hand-building in clay were used by early potters. These methods include coiling, pinching, and slab construction, all of which are still in use today.

Coiling. In coiling, "ropes" of clay are first rolled out and then coiled in circular fashion, one hollow level upon another until the desired height is reached. The potter may then either leave the coils' ridges along the sides of the vessel or, more often, smooth them with a simple hand tool.

Pinching. Pinched pots are created from a circular lump of clay into which the thumbs are inserted. A pinching action between thumb and fingers is used to expand and push the clay outward to the chosen form and thickness. This method is the most primitive and was probably the first means of shaping pots among early people.

Slab Construction. Slab building involves rolling clay out into a flat slab of even thickness, much like creating a pie crust. From this flat slab, shapes are cut and assembled in a box-like method of construction that allows for a variety of forms, among them both rounded and squared-off shapes.

The Potter's Wheel. The potter's wheel was developed in the Middle East at least four thousand years ago. Its development made possible the production of more symmetrical vessels at a greater pace. Foot-powered or kick wheels are still used today, however, the advent of the electrically powered wheel with its continuous speed has greatly aided the production and development of ceramic forms.

Both electric and nonelectric wheels consist of a round tablelike platform on which the clay revolves. A lump of clay is centered on the wheel with even hand pressure and the thumbs are used to open up the center of the form. The clay is then manipulated by hand pressure or tools held steady against the turning action of the revolving clay. The potter pulls up and shapes the clay to form walls of even thickness and the desired size and shape.

FIRING AND GLAZING

After ceramic forms have air-dried they are called greenware. The next step is a baking process called firing. Various types of clay (see next section) have different firing temperatures. The firing process takes place in special

high-temperature ovens known as kilns. The kiln takes various forms and sizes, from transportable models to permanent brick vaults as large as rooms. Potters may also chose from the traditional methods of firing handed down in many cultures. The baking of pots for four or five days in open fires by some Native American artists requires concentration and provides little time to sleep or eat. These artists believe their methods worthwhile since the act is traditionally believed to unite the soul of the potter with the spirit of the pot. Certainly such intense devotion and concentration to any act of creation should logically yield superior results.

Most ceramic ware goes through several firings after air-drying. The first firing evaporates all of the greenware's remaining water and brings it to the stage known as bisque. It is after this first firing that the forms are glazed, or coated, with a liquid mixture of finely ground minerals in water. When fired, the silica in the glaze becomes vitrified, or glassy, and fuses with the clay body. Glazes strengthen, protect, and help to waterproof ceramics; they also provide a wide range of surface colors that may be glossy or matte. Besides simple glazing, ceramic artists may also use glazes, stains, and slip (liquid earth in various shades) to create finishes that are intricately patterned, such as Native American pottery, or richly painted such as the figurative scenes found on ancient Greek vases.

TYPES OF CERAMIC WARES

Clay, the raw material of ceramics, varies in composition according to the type of earth and minerals in the clay deposits. Ceramic wares are classified by the type of clay used and its firing temperature. However, such strict classifications are seldom found in nature, since clay bodies are often composed of a mixture of types.

Earthenware. Earthenware pieces are of coarse clay fired at a low temperature (under 2100° Fahrenheit). Normally red or tan in color, earthenware is porous in nature and suitable for bricks and less refined pottery vessels.

Stoneware. Stoneware is of finer clay and is fired at higher temperatures (between 2100 and 2300° Fahrenheit). It has a dense structure and is usually gray, reddish, or tan in color. Stoneware is suitable for dinnerware and sculpture.

Porcelain. Porcelain contains large amounts of kaolin clay and feldspar. Kaolin is a fine, white clay that along with the mineral elements becomes completely vitrified at a firing temperature of 2300 to 2786° Fahrenheit. Porcelain may be used to create delicate, fine work thin enough to be translucent.

Terra Cotta. Terra cotta usually refers to a fairly coarse, porous type clay which is dull ochre to brick red when fired and is generally left unglazed. It is often used for sculpture and to form the familiar red-brown containers used for houseplants.

Glass

Glass containers have been produced for at least four thousand years. Over the centuries the uses of glass have been mainly utilitarian with decorative overtones. Notable exceptions have been stained-glass windows, particularly those in the great Gothic cathedrals such as Chartres in France, and works of the American glass studio movement begun in the 1960s. The latter emphasizes expressive form over utilitarian purposes as exemplified by the work of Harvey Littleton, one of its leading exponents.

CHEMICAL COMPOSITION OF GLASS

Glass is closely related to ceramic glazes in its chemical compositions of silica and other components. The hardness and color of glass vary greatly and are the product of the addition of hardeners such as lead oxide or color-producing minerals such as cobalt or copper.

METHODS OF SHAPING GLASS

Molten glass can be blown, cast, or molded into a multitude of forms. Most commercial glass containers are produced by pouring molten glass into a mold and pressing into shape with a plunger. Plate glass for windows and mirrors is produced by passing rollers over molten glass.

Hand-blowing of glass is a physical act that requires balance and stamina to create successful forms. A molten glass bubble on a pipe is blown and shaped by the use of wooden tools, calipers, and shears. In order to keep the glass workable it may be necessary to reheat it. Glassblowing is used to produce sculpture as well as utilitarian vessels. In both, the end results are often graceful and exquisitely thin-walled.

After initial forming, glass may be altered by processes such as etching, cutting, sandblasting, enameling, painting, or slumping (heat-softening to produce a controlled sag of the form). Glass may also be spun into filaments used to create fiberglass cloth and molded forms such as auto bodies.

Enamel

In enameling, fine particles of colored glass are applied to metal, glass, or ceramic grounds and fused by firing. The jewel-like colors of enamel have been used for centuries to enliven vessels, jewelry, and plaques.

One of the principle methods used in enameling is cloisonné, in which the enamel is contained in separate color areas by means of thin metal strips outlining the design. In champlevé, or raised field work, the ground is dug away into the metal base, forming reservoirs to retain separate areas of color as the glass particles melt and fuse during firing. Enamels may also be applied like paint, with end results that resemble oil painting.

Metal

While the techniques of working in metal have a lengthy history, they developed later than did those of ceramics and weaving, since metal working is a more complex process technically. Different metals have various weights, strengths, and degrees of resistance to corrosion. The worker in metal must assess these qualities and choose the metal appropriate for the job at hand, whether it be creating jewelry or door hinges.

METHODS OF WORKING METAL

Metal has strength and a great ability to be worked and formed, both in a heated or a cool state. Regardless of the type of metal, the techniques for working it are basically the same. It may be hammered, welded, riveted, cut, drawn out, or cast to make items as diverse as gates or household goods.

The term *raising* refers to the creation of a hollow vessel by hammering. Actual raised work on metal is known as repoussé, and depressed, or indented, work is called chasing. Other methods of decorating metal work include embossing, engraving, and inlay of enamel, other metal, or stones. Metals such as silver or gold may be used to create a thin coat or plate over other types of metal or materials such as wood, creating the external effect of precious metal with less of the actual material.

A noteworthy example of artistry and technique in metal is Renaissance sculptor and goldsmith Benvenuto Cellini's *Saltcellar of Francis I* (1539–1543). An intricate figurative work only slightly over thirteen inches in length, it includes a representation of Neptune, the sea god, watching over a product of his domain—salt. A smaller attached receptacle for pepper is similarly guarded by a female figure personifying earth, the source of plant products. The seasons and divisions of the day are represented on the detailed enameled base, underscoring the technical virtuosity of the work.

Wood

Wood has been a favorite material for centuries, in part because of its abundance in many areas of the world but also because of the rich, living quality of its grain. Trees have held religious significance in many cultures, and on more than one level may be revered as providers and sustainers of life.

Wood possesses a pleasing range of colors and patterns. It may vary in hardness from the airy fragility of balsa to the difficult-to-carve hardness of ebony. Wood provides the craftsperson with raw material suitable for a wide spectrum of uses including musical instrument- and furniture-making and the creation of wooden bowls and other vessels.

WOODWORKING TECHNIQUES

Techniques used in making handcrafted furniture include lamination (layers of wood glued together to form larger shapes) to build up forms and the bentwood method of steam-softening and bending wooden strips into curved shapes such as chair rockers.

Wood surfaces may be decorated with inlay methods known as marquetry (floral designs) or parquetry (geometric designs). Other materials such as metal and mother-of-pearl may also be used to decoratively inlay wood.

Items such as bowls may be hollowed and turned on a lathe, a machine whose turning blade on a stationary base makes the production of symmetrical three-dimensional rounded forms possible. With all woods, basic tools such as rasps, saws, and gouges or power tools may be used to cut and shape forms.

Fiber Arts

Fiber arts straddle the division of two- and three-dimensional art. Although the concerns of weaving technique are basically horizontal and vertical, the finished product may be decidedly three-dimensional, as in basketry. Fabric itself may possess three-dimensional surface texture or be combined with other elements to create three-dimensional forms. Artist Magdalena Abakanowicz made innovative use of burlap and glue to mold a series of curved humanoid forms in her sculpture, *Backs* (1976–1982). Gerhardt Knodel's *Grand Exchange* occupies a large upper area in the atrium of an office building. An installation of handwoven fabric on metal rods suspended in parallel groupings, it explores the relationship of planes in space.

TECHNIQUES OF FIBER ARTS

Techniques used in fiber arts include, but are not limited to: weaving, stitching, knitting, macrame, wrapping, and crochet. All of these techniques use as their basic material fibers or strips from various sources such as animal hair, vegetable fiber, or artificially produced filaments such as rayon and nylon.

Weaving is the basis of much fiber art. It may be worked off-loom or on a variety of available looms (frameworks, often of wood, that hold and organize the warp fibers) varying in size and complexity. The technique of weaving is based on an under-and-over interlace of lengthwise fibers, known as warp, with cross fibers, called the weft or woof. Pattern results from changes in the number of strands crossed over or under.

Types of Weaves. Plain weave is simple pattern of over-and-under repetition. It is used to create strong materials such as muslin and burlap. In satin weave the weft passes over several warp threads at a time to produce a surface with sheen. Twill weave interlaces warp and weft in broken

diagonal patterns. Tapestry weave is a variation of plain weave used to create the rich imagery of tapestries such as the fifteenth-century unicorn series in the collection of the Metropolitan Museum of Art in New York. In pile weave the weft forms loops which are cut to form the plush nap of velvet or of carpets.

OTHER FIBER ARTS

Basketry also uses the principles of weaving to create three-dimensional forms. Rather than a fixed warp, the under/over action of basketry is worked over a center cord or filler which is usually spiraled into the desired shape.

Other techniques in fiber arts include macrame, the knotting together of cords which was originally used to construct fishing nets. Embroidery and other needle work use thread to create surface design and texture. Design may be applied to fiber through techniques such as block stenciling, tie-dye, and the wax-resist method of batik.

Quilting is another important fiber art form. Along with traditionally patterned quilts used for warmth and decorative purposes, many fiber artists in recent years have created powerful narrative quilts and dazzling abstract designs. The image is usually made by stitching together pieces of material to form the quilt top. Normally in quilting, a layer of fluffy fiber, or batting, is placed between upper and lower layers of fabric. The quiltmaker then stitches with heavy thread through all the layers, creating a low relief "stuffed" or raised texture in the surface.

CLOTHING DESIGN

Fashion is a powerful tool for creating identity. The way in which people dress is a visual message which may communicate their tastes, financial standing, and what sort of job they hold. Headgear such as a monarch's crown or a nurse's cap obviously and immediately informs others of the wearer's status. Clothing is also worn for protection, beauty, and—in degrees which have varied with time, place, culture, and the individual—modesty.

Clothing, like sculpture, is seen from all sides, and designers must be aware of this and other issues beyond appearance, such as comfort and durability. Styles often change rapidly and designers are expected to be creatively prolific, presenting new looks each year to a waiting public.

The flamboyant reign of Louis XIV of France (1660–1685) made Paris the capital of *haute couture*, or high fashion. Since then, other design centers such as New York, Tokyo, London, and Milan have also gained importance. However, French designers continue to be looked to by most of the world for the latest word on new trends in fashion.

Costume Design. Another aspect of clothing design is theatrical costume. Costume is used to help establish mood and character. To be seen effectively by the audience, costume must be somewhat exaggerated and stylized. Costume designers must also be familiar with the dress of different historical periods in order to recreate them.

Industrial Design

On many levels the industrial designer extends the concerns of craft into the realm of mass production, designing utilitarian goods for some of the same uses out of some of the same materials. The industrial designer is responsible for the artistic improvement of mass-produced products such as automobiles, food processors, or computers. While engineers deal with most mechanical and functional concerns, designers try to give the products aesthetically pleasing exteriors and make them comfortable to use.

In many cases the form taken by a product is determined by its function. Designers work to create product forms that will be easy for the user to handle and manipulate. The designer also must keep in mind the cost of manufacturing the product and its eye appeal, all of which influence sales and profits.

Three-dimensional works occupy and transform space and may involve movement in space.

Sculpture, an ancient form of expression, takes two basic forms—freestanding (also known as in the round) and relief carving. Sculptural processes include subtractive and additive processes. In modeling, armatures support pliable materials such as moist clay, and prevent sagging. Casting uses molds to produce duplicates of the original clay or other soft material in more durable material. Constructed sculpture is built or assembled out of various materials. Assemblage is the term for constructed works incorporating found objects. Use of mixed media has sometimes blurred the distinction between sculpture and painting.

Kinetic sculptures are sculptures that make use of movement. They may be propelled by means as diverse as motors, running water, or wind. Land art or earthworks are large works from earth and natural materials made out-of-doors. Installations and environments alter interior spaces.

Performance work includes dance, drama, mime, and performance art. All use the body as an element of art, while employing the basic elements of all design such as line, shape, and color.

There is much overlap between fine art and crafts, but crafts may be distinguished as those works in which material and function dominate, while in fine art, form and content are primary. Ceramics was one of the first crafts. Potters build ceramic works by hand by coiling, pinching, or slab building, or by throwing on the potter's wheel. Earthenware, stoneware, porcelain, and terra cotta are types of ceramic wares.

Glass containers have been in use for over four thousand years. Glass may be formed by blowing, casting, or molding and when cooled may be altered by methods such as cutting, etching, painting, and slumping.

Enameling fuses fine particles of colored glass to metal, glass, or ceramic grounds.

Metalworking includes many processes. Metal may be worked in a heated or cooled state and may be hammered, welded, cast, riveted, cut, or drawn out.

Wood is a popular material because of its availability, range of colors, and beautiful grain.

Fiber arts include traditional and nontraditional applications of processes such as weaving, stitching, knitting, knotting, wrapping, and crochet. Weaving is the basis of many two- and three-dimensional fiber forms. Other important fiber arts are basketry, quilting, embroidery, and surface decoration techniques such as tie-dye and batik.

Like sculpture, clothing is seen in the round, but the clothing designer must have at least some practical concerns in its design. Theatrical costume design must be slightly exaggerated and stylized to communicate at a distance to the audience.

Industrial design improves mass-produced products such as automobiles and appliances by making them externally more pleasing to look at and easier to use.

Selected Readings

Dormer, Peter. *The New Ceramics: Trends and Traditions*. New York: Thames and Hudson. 1986.

Goldberg, Rosalee. *Performance: Live Art, 1909 to the Present*. New York: Abrams. 1979.

Irving, Donald J. *Sculpture: Material and Process*. New York: Reinhold. 1970.

Kowal, Dennis, and Dona Z. Meilach. *Sculpture Casting: Mold Techniques and Materials, Metals, Plastics, Concrete*. New York: Crown Publishers. 1972.

Read, Herbert. *A Concise History of Modern Sculpture*. New York: Praeger. 1964.

Smith, Paul J. and Edward Lucie-Smith. *Craft Today: Poetry of the Physical*. New York: American Craft Council. 1986.

Wittkower, Rudolph. *Sculpture Processes and Principles*. New York: Harper and Row. 1977.

5

Architecture and Related Design Disciplines

*T*he need for shelter is among the most basic of human needs. While early humans made use of existing natural shelter such as caves, the urge to alter these spaces within or to construct freestanding shelter with available natural materials such as wood and stone has existed since prehistory.

Of all art forms, architecture is perhaps the one that has the greatest impact on our daily lives. While not everyone is affected by painting or sculpture on a regular basis, architecture normally has daily visual impact on ordinary people. The three-dimensional mass of buildings' exteriors and the negative volume of their interiors are sculptural concerns with which we interact through many hours each day. The surface designs present on many structures interject a two-dimensional artistic or aesthetic element into our day-to-day perception of our surroundings as well.

ARCHITECTURAL PLANS

The architect must be concerned not only with the building's appearance and how it fits into its surrounding environment, but also with the load-bearing capacity of walls and allowance for systems to efficiently provide heating, cooling, electricity, and water. Architectural plans are precisely rendered drawings of these various aspects of a structure which are used for development or presentation of ideas.

Fig. 5.1 (a) Post-and-lintel system, (b) exaggerated diagram of a lintel's upper compression and lower stretching due to the effects of gravity.

Types of Plans

Floor plans (or ground plans) show scale layouts of structure, viewed from above. Elevations provide straight-on scale views of front, side, or rear walls indicating placement of windows and doors and wall heights. Cross sections show details such as plumbing, insulation and wall thickness revealed by a vertical slice through the building. Perspective renderings are pictorial views that show how a building will actually look, including landscaping and environmental setting.

ARCHITECTURAL METHODS

Bearing Wall

One of the earliest and simplest forms of building, known as bearing-wall construction, involves wall construction in which entire wall lengths are used to support the roof. In ancient civilizations or primitive societies, such walls might be of stone, mud bricks, wood or earth.

In ancient Egypt rudimentary building block methods were developed using interlocking stone blocks set together to form walls without the use of mortar. The higher the wall, the thicker it had to be in order to support the roof.

Frame Construction

POST-AND-LINTEL

Fig. 5.1 illustrates one of the earliest architectural systems invented, post-and-lintel (or post-and-beam). This method of construction uses two or more upright forms (posts) which support horizontal beams (lintels). This method is more efficient than using solid-wall construction for roof support.

Sometimes lintels were used within bearing walls to form openings for windows and doors. Within buildings, post-and-lintel construction allowed for larger interiors.

In ancient Egyptian stone construction, posts were closely spaced so that lintels spanned short distances. This was due largely to stone's poor tensile strength (the ability to bend and stretch), which required that supports be located close together. If the posts were widely spaced, the lintel's brittle material might crack and fall from its own weight or the additional weight of the blocks laid perpendicular above the lintel. Later, Greek temple construction used wooden roof beams which had much greater tensile strength and permitted the spanning of greater distances.

Post-and-lintel systems are still in use today, sometimes using steel or reinforced concrete rather than stone or wood.

THE ORDERS

The ancient Greeks invented ornamental schemes to accompany post-and-lintel stone architecture. These decorative systems are called the orders, and they have as much to do with concepts of beauty regulating proportions as they do with the use of particular ornamental motifs (Fig. 5.2). The orders were not a structural system in themselves but regulated how the structural systems in the building around them were proportioned. Although invented specifically with post-and-lintel construction in mind, the orders were later often decoratively overlaid on buildings constructed by methods other than post-and-lintel (as in the case of many Roman buildings such as the Colosseum, which superimposed the classical orders on its facade).

Columns. Columns are cylindrical posts resting upon the stylobate, normally arranged in rows (called columnades) with spaces between them. The column's base is its lowest decorative element, upon which rests a tapered shaft (the longest portion of the column, in Greek architecture usually consisting of stacked short cylinders of stone, finished with decorative flutes so as to appear to be one continuous tall shaft). Topping the column is the capital. This oftentimes highly ornate member of the column provides a visual transition into the upper part of the building or entablature.

Entablature. The entablature consists of all architectural elements above the column. The entablature's lowest member is the architrave, the horizontal stone slab which rests directly on the capital. Above the architrave is the frieze, the middle horizontal member of the entablature. Sometimes the frieze may be left bare, but usually it is decorated and often carved with

Fig. 5.2 The Greek Orders: (a) Doric, (b) Ionic, (c) Corinthian.

various ornaments and sculptural figures, depending largely on which order is followed. Above the frieze is the cornice, which is the uppermost projecting horizontal member of an entablature. In classical architecture two raking (following the sloped lines of the low-pitched roof) cornices accompany the horizontal cornice at the ends of buildings. The triangular area (or gable) formed by this arrangement of elements was often filled with sculpture and is called the pediment.

Distinguishing Features of the Orders. In each order, the various parts of the column and entablature are assigned distinguishing ornamental motifs as well as differing proportions. The distinguishing decorative schemes affect the appearances of all parts of the building including the platform (stereobate and stylobate), column (base, shaft, and capital) and entablature (architrave, frieze, and cornice). The most apparent distinguishing features are noticed in the columns and the entablatures.

Doric Order. The earliest of the orders, the Doric, was invented by mainland Greeks, the Dorians. It is the simplest and least ornate of the orders, consisting of a sturdy and severe shallowly fluted column whose baseless shaft rests directly on the building's stone foundation. The Doric

capital consists of a cushion-shaped, quarter-round molding, called an echinus, above which is the top part of the capital, a simple stone slab called an abacus.

Above the column, a Doric entablature consists of a continuous running, unadorned architrave. Above the architrave is a frieze which is divided vertically into units called triglyphs (sculpted panels marked by vertical cuts into three sections) which alternate with metopes (blank panels often filled with relief sculpture).

The Romans later altered the Doric order when they adopted it from the Greeks. While retaining the triglyph and metope of the Greek Doric frieze, the Romans added a base below the column's shaft, thus distinguishing the Roman Doric from the Greek Doric. Since antiquity, the Roman form of the Doric column with a base has been the type used most often. It can be seen in many Italian Renaissance buildings as well as in later classically influenced designs. An exception was a classical revival style of the nineteenth century known as Greek Revival, which often recalled the baseless Greek Doric column into service.

In addition to the Doric order, another form of column with a base that resembles the Doric in its simplicity, but supposedly derived from Etruscan architecture is the Tuscan order.

Ionic Order. The Ionians, tribes inhabiting the Greek islands and the coast of Asia Minor, invented the more ornate Ionic order. Ionic buildings are much more elegant and gracefully proportioned than are the more sturdy looking Doric ones. The Greek Ionic column has a base and is taller and more slender. In contrast to the Doric's shallowly grooved fluting and sharp vertical ridges, the Ionic column has deeper grooves with flat vertical surfaces in between.

The most apparent distinguishing Ionic features are the volutes (spiral forms that resemble scrolls) of the capitals used in place of the echinus of the Doric. The Ionic abacus is greatly reduced in size compared to its more prominent role in the Doric order. The Ionic entablature is also very different in appearance from the Doric version. The Ionic architrave consists of three horizontal, stacked bands in contrast with the solid slab unit of the Doric. The Ionic frieze is a continuous band, unlike the Doric where it is broken into triglyphs and metopes. An advantage of the Ionic frieze is its allowance for a continuous running scene of relief sculpture around a building.

Corinthian Order. The third and latest order developed by the Greeks is the Corinthian, actually a refined adaptation of the Ionic. Its proportions are even more slender and it is taller and more ornate. The volutes of the Ionic order are greatly reduced in size and the capitals prominently display acanthus leaf decorations. The Corinthian retains the Ionic order's use of a base, the three-part division of the architrave and the continuous frieze.

The Romans favored the use of the Corinthian order, and it continued to be popular in later periods including the Renaissance and more recent periods of classicism.

Sometimes the Corinthian was combined with the Ionic to form the Composite order. The distinguishing feature of this order was the capitals' large Ionic volutes combined with acanthus leaves.

TRUSS

Trusses are cross braces, most commonly composed of three lengths of wood or steel joined in a triangular form. Trusses provide the support necessary to span large spaces without many interior posts.

Wooden trusses were used under the wooden roofs of many Medieval stone churches. In the nineteenth and twentieth centuries iron and steel trusses came into use. Trusses are the basis of the modular, prefabricated systems of building used in constructing many of today's buildings.

SKELETON FRAME

Another form of frame construction is the skeleton frame. Its lightweight parts are combined to create a standing cage or framework on which thin outside walls, usually sheets of material, are attached.

Balloon framing is a particularly light type of skeleton framing of lumber which was developed in the nineteenth century. Most houses built today use balloon frame construction with plywood sheets nailed on to create the outer wall.

Iron and steel may also be used to construct the skeleton frame. The walls attached to the frame are not weight-bearing and thus may include many good-sized windows or be entirely of glass. Walls of this type are known as curtain walls or screen walls, which function to keep out the weather and enclose the structure but provide little or no support.

GEODESIC DOME

The geodesic dome uses the principle of the triangular truss to form a spherical framework of short struts arranged in tetrahedrons (solids with four triangular faces). R. Buckminster Fuller developed the geodesic dome form in the 1940s, out of research into nineteenth-century studies that concluded the basic structure of organic material to be the tetrahedron. Geodesic domes are usually covered with a thin skin of lightweight material such as plastic. The form of the framework of the geodesic dome, which is often of aluminum or other light material, resists pressure through equal distribution of stress throughout the parts of the dome.

Fig. 5.3 Arches and Vaults: Corbeled arch.

Arch, Vault, and Dome

ARCH

The arch, a structural member (usually a curved form) built of interlocking wedge-shaped stone blocks or bricks, provides another means of spanning an opening. Arches allow builders to create larger, more open interior spaces.

Corbeled Arch. "Corbeled arches" are not true arches (Fig. 5.3). Stone blocks are built up from two sides, with each successive one projecting a little farther toward the center until the sides meet at the top of the opening. Corbeled arches are held in place by the weight of the stacked blocks on each side.

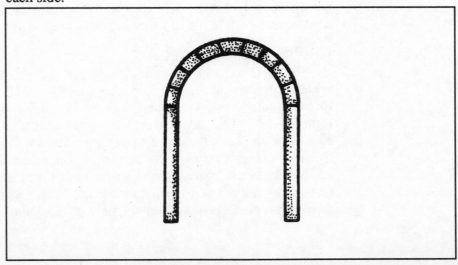

Fig. 5.4 Arches and Vaults: True arch.

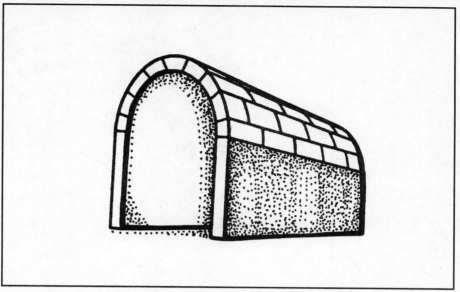

Fig. 5.5 Arches and Vaults: Barrel vault.

True Arch. The true arch was developed in Mesopotamia and later refined by the Etruscans and Romans (Fig. 5.4). The arch is constructed upward from two sides or imposts which frame the opening. At the top of the arch, wedge-shaped masonry units or blocks known as voussoirs hold each other in place through mutual pressure. The wedge-shaped blocks meet in the center top at the keystone, or central block. Prior to the keystone's placement the arch under construction is held in place by wooden scaffolding called centering. The keystone completes the pressure necessary to hold the arch in place and send the weight of the supported wall or roof out and down. Buttresses, or vertical masses of masonry, help to brace the walls against the outward thrust of the arch and play an important role in preventing the arch from collapsing.

VAULT

A barrel vault or tunnel vault may be thought of as a series of curved arches in depth, one behind the other (Fig. 5.5). The barrel vault requires heavy buttressing to absorb the downward thrust of weight and would be structurally weakened by windows, except at the ends.

A tunnel vault intersected at right angles by another tunnel vault of the same size is called a groin vault or cross vault (Fig. 5.6). Since the two vaults support each other, buttressing is required only at the corners, and larger windows may be used without weakening the structure. A building such as a Romanesque church (see chapter 9) may have a number of cross vaults arranged together to form a larger space.

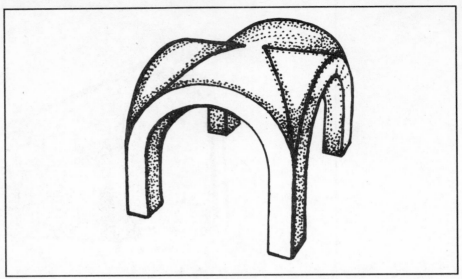

Fig. 5.6 Arches and Vaults: Groin vault.

The addition of stone ribs, or arched supports, across the vault allowed for greater latitude in material and construction, as in Gothic architecture (see chapter 9). Roofs could be constructed of thin stone webbing or other light material.

In the ribbed vaults of Gothic architecture, the ribs formed pointed arches. These pointed arches sent the weight more directly downward, but still needed support against sideways thrust. This was accomplished by stone half-arches or struts known as flying buttresses which carried the outward force to exterior vertical buttresses. The walls of Gothic buildings were relieved of much of their stress by this outside support and could be higher and opened up to include rows of large stained-glass windows.

DOME

Domes are hemispherical forms built above a circular or polygonal base. Normally a dome is visually prominent both on the exterior of a building as a convex feature, as well as a concave form within the interior.

To achieve the transition from the often square space below the dome, a form, such as the pendentive (a curved triangular segment of vaulting), is used to bridge the space from the corners of the square into the base of the dome (Fig. 5.7). To make the dome more visible it may be raised higher from the body of the building by the circular- or polygonal-walled drum.

Cantilever

Used extensively in innovative twentieth-century architecture, the cantilever is a beam or floor slab that extends a considerable distance beyond the wall or post that supports it. The wall or post serves as a fulcrum and the weight of the projecting portion is balanced by the building's weight at the

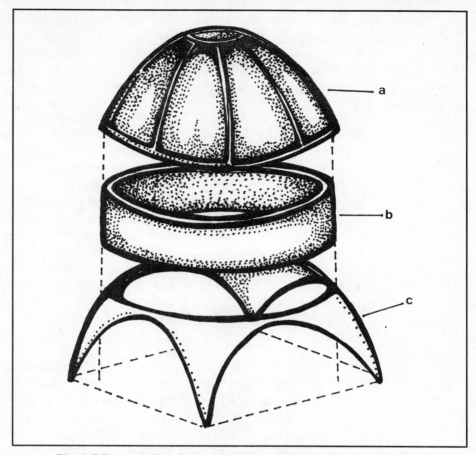

Fig. 5.7 Dome on Pendentives: (a) dome, (b) drum, (c) pendentive.

opposite end. The use of cantilevers can achieve powerful visual effects involving dramatic overhangs and seemingly floating floor sections.

CONSTRUCTION MATERIALS

Wood

In many parts of the world, wood is a plentiful material for building, as it has been for centuries. It is a material which is relatively lightweight and may be worked with hand tools on the building site. Wood is beautiful and can meet a variety of building needs from structural parts to the exterior faces of buildings. Frame construction methods often make use of wood, as in balloon framing, post-and-beam construction, and the fabrication of trusses.

Wood also has certain drawbacks, such as its tendency to crack, warp, and rot. Due to these faults, our insights into early wooden structures are mostly limited to surviving practices among primitive and rural peoples. Modern methods of treating and laminating wood can now prevent many problems and create more enduring wooden structures.

Stone

Stone is a long-lasting material which was often used in the past to create important structures such as palaces and temples. Most of the world's remaining examples of ancient architecture are of stone. Many early stone constructions use the post-and-lintel system, such as the Neolithic construction Stonehenge in England and the temples of ancient Egypt and Greece. The Romans used post-and-lintel and arch-and-vault systems in stone in early structures but later switched to its use as a facing material over brick or concrete. Gothic cathedrals used the elaborate system of buttresses, piers, and ribbed vaulting to achieve height despite stone's weightiness.

Methods of building with stone use both dressed stone, which is cut and shaped, often in block form, and natural stone. Over the years, various types of mortar have been used to cement individual stones together; however, if properly constructed, mortarless dressed stone structures such as those built by the Incas at Machu Picchu, can last indefinitely.

Brick

In areas where clay is abundant, but often wood or stone are scarce, brick, clay, or adobe structures have been built for centuries. Early bricks were often sun-dried and crumbled when exposed to rain or flood, as is still the case with clay construction in primitive and rural societies in some parts of the world. Kiln-fired bricks provide a more lasting material which is highly impervious to weather if its outer surface is not damaged by cleaning methods such as sandblasting.

Concrete

Concrete has been in use for building since Roman times. Beginning in the early twentieth century the addition of metal reinforcing mesh or rods has provided expanded potential for this mixture of sand, cement (powdered lime and clay), gravel, and water. Reinforced concrete may be used to create curving sculptural forms, columns, thin panels, and a variety of other geometric and organic shapes, providing new and creative design possibilities for architects. Layers of steel mesh sprayed with cement may be used to create prefabricated modules that are shipped to the building site and then assembled.

Iron

Iron came into use as a primary building material after the Industrial Revolution and the development of mass production. Iron was easier to work than stone and more long-lasting than wood. It became an important material during nineteenth-century expansion of railways, serving many building purposes including stations and bridges.

Joseph Paxton's 1851 Crystal Palace in London is an early example of iron frame architecture and prefabricated building. The framework of iron carried the structural weight so that the building could be enclosed in large sheets of glass. Paxton set an innovative precedent from which revolutionary forms in architecture would later spring.

Steel

Steel may be used in much the same manner as iron but provides advantages such as greater tensile strength, lightness, and fireresistance.

Towards the end of the nineteenth century, higher steel-framed structures faced with stone or brick began to be built in cities such as Chicago, creating more space through upward rather than outward expansion. This was an advantage where workable building space was limited or costly and led to the development of the skyscraper-filled cities of the present.

Steel is also used to manufacture the cables that support suspension bridges, such as the well-known Brooklyn Bridge in New York. The roofs and walls of certain types of structures such as sports pavilions may also be supported by huge steel cables.

ENVIRONMENTAL DESIGN

Environmental design includes the visual planning of cities and their outlying areas, respectively known as urban design and regional design. These disciplines are closely related to the fields of architecture and landscape architecture; environmental designers work in conjunction with other urban planners, including transportation designers, to develop pleasant communities meeting the needs and demands of the populace. Often community groups are consulted by the environmental designer in an attempt to better understand the concerns of residents on the possible effects of planned development.

The idea of city planning has a history that extends back into antiquity, to the use of plans in Babylon and Nineveh. The concept of zoning was developed in city plans by the ancient Romans.

Rectangular Plan

In planning cities, the Greeks and Romans used rectangular grids of intersecting streets; this concept of design extends into the modern age, sometimes in combination with other forms.

Circular Plan

In addition to the rectangular gridiron used to lay out intersecting streets, circular radial plans also have a long tradition. Within a circular plan streets are laid out radiating from the city center, connected at intervals by intersecting streets arranged within a concentric circular scheme.

WASHINGTON, D.C.

Pierre-Charles L'Enfant's design of 1792 for Washington, D.C., basically combines the gridiron system with the radial, using the Capitol Building as the center. The city plan overlays radiating streets with others arranged along the rectangular grid.

L'Enfant's design set Washington between two branches of the Potomac River, establishing an irregular diamond shape for the city. Within this form, streets were oriented in the directions of north-south and east-west. Approximately central within the irregular diamond form of the city plan is a large, open-lawned space or mall. Bordering the east of the mall is the Capitol Building; north of the mall's west end is the White House. From these two buildings, broad streets radiate outward, crossing other streets which were arranged with a gridiron scheme.

The plan for Washington included open public areas at intersections along the grand diagonal boulevards. These were designed as sites for grand monuments. Though impressive in concept, the Washington city plan best served the needs of a pre-automobile age with slower moving transportation.

Problems in Modern Environmental Design

The growth of some cities in recent years has been so rapid that a consistent design has not been maintained. This lack of planning can cause serious problems in metropolitan areas, leading to unpleasant and dangerous transportation patterns and a decline in overall living conditions.

Preexisting environmental plans can also be obstacles to changes needed by modern societies. In contemporary society, the automobile is the main form of commuter transportation, and urban centers have declined and been replaced by expansion into the suburbs. Superhighways have helped to further the reliance on motor vehicles. Transportation designers as well as environmental designers have had to consider this issue as a crucial factor in design. Large areas of land need to be set aside for limited access highways and interchanges. But without proper planning a freeway can create barriers between neighborhoods, isolating communities by preventing easy movement from one to another.

There are differing points of view among contemporary environmental designers regarding how to resolve today's urban and regional problems. Some urge the restoration of good public transportation systems to reduce automobile traffic. This would allow for denser development of urban areas, but other environmental designers advocate suburban growth and feel that concentrated urban centers are outdated and unnecessary in today's world. Still others urge the development of planned towns incorporating the best features of urban and regional concepts of design. In these, people are concentrated in communities where all basic needs are met including stores, schools, and places of employment. Apartments are combined with

townhouses, clustered private homes, and generous open public spaces for recreational activities.

PARKS

In the past, towns were often built around a public square or common. The recognition of a need for recreational areas in cities led to the establishment of large parks within metropolitan areas. As cities expanded, more land needed to be put aside for additional parks. Simultaneously land was becoming increasingly valuable and scarce. The concept of the vest-pocket park originated in response to this need. Such parks are liberally scattered around cities, allowing workers, shoppers, and children areas for recreation and relaxation. Vest-pocket parks may appear on lots formerly occupied by old buildings that have been demolished.

ZONING

Environmental designers must take into consideration zoning laws, but they also help to establish them. Zoning laws regulate such matters as population density, specific use of land areas, designated open spaces, height restrictions of buildings, distances of buildings from property lines, and the establishment of city boundaries to prevent surrounding rural areas from being overrun by city growth.

PAOLO SOLERI'S ARCHOLOGY

In the visionary drawings of Italian architect Paolo Soleri an attempt is made to solve contemporary urban problems through what is called archology. Soleri's term combines architecture and ecology. He conceives of vast self-sufficient and self-contained singular structures which function as entire cities. Consolidating human beings into these densely populated city structures would allow the natural environment to be relatively undisturbed, since people would be separated from the land. Of course the enactment of Soleri's ideas on a grand scale would seem impractical and perhaps undesirable to most people in today's world. In the future, however, such a plan might be suitable for establishing human communities on other planets.

LANDSCAPE ARCHITECTURE

Landscape architects design outdoor spaces, using plants and natural materials such as stones to create gardens, golf courses, and parks. The landscape architect often designs the areas surrounding buildings, at times integrating one structure with another through exterior landscaping.

Landscape design may range from formal geometry applied to nature (using organized spaces and plant forms such as shrubbery manicured into rigid or unnatural forms) to the creation of a more natural and informal appearance in landscape sites. A good example of the formal approach is the seventeenth-century design for the surrounding garden at the Palace of Versailles. The more natural informal approach was developed for English gardens beginning in the eighteenth century.

Frederick Law Olmsted

A noted writer as well as urban park planner, Frederick Law Olmsted (1822–1903) was the principle designer of Central Park in New York City (1857–1887).

His plan, which followed the informal English garden tradition, was one of the earliest attempts in the United States to design a natural-looking public park. The 840-acre site, developed in the midst of city buildings, still provides a two-and-a-half-mile-long and nearly mile-wide recreational area. It includes artificial lakes and ponds, restructured hills, grass and wooded areas, bridle paths, roads, bridges, a zoo, an outdoor theater, a romantic castle and even a formal garden within the otherwise informally natural appearance of the park. Following his success with Central Park, Olmsted was commissioned to design other major American recreational sites in cities such as Washington, D.C., and Boston.

INTERIOR DESIGN

Interior design involves the visual planning of interior spaces. The interior designer selects colors for painted walls, and chooses wallpaper, carpeting, window drapery, furniture, and other accessory details that affect the overall aesthetic appearance of rooms, hallways, and other interior spaces. Designers must understand artistic styles, including that of the architecture of the space involved. Objects brought into a space should be compatible with the existing architectural style, though not necessarily of the same style.

In a sense, an interior designer visually manipulates objects, textures, and colors within an interior space much as a painter or sculptor manipulates materials in designing art. However, an interior designer also considers the client's personal or professional needs as related to the purpose of the space. Interior design for a nursery will require a different aesthetic judgment than that appropriate for the office of an attorney.

Architecture evolved out of the basic human need for shelter into a discipline with both practical and aesthetic concerns.

Architectural methods for construction include the bearing wall, frame construction, arches, vaults, domes, and cantilevers. Throughout history, succeeding societies have used these forms, altering, embellishing, and adapting them to new materials. The materials of construction include wood, stone, brick, clay, concrete, iron, and steel frames. The availability of material has often been an important factor in determining forms of building developed by various civilizations.

Environmental design includes the visual planning of cities and their outlying areas. Environmental designers work in conjunction with other planners such as transportation designers to create pleasant and efficient places in which to live and work. Landscape architecture uses plants and other materials to alter the environment around buildings and to create parks and other recreational areas. Interior design is the planning of interior spaces in terms of color choices and furnishings, in keeping with aesthetic choices and practical considerations of use.

All of these factors (type of construction, materials, design of interior and exterior space, and landscaping) combine to make architecture a continually vital art form.

Selected Readings

Bacon, Edmund N. *The Design of Cities.* rev. ed. New York: Penguin. 1976.

Hitchcock, Henry-Russell. *Architecture: Nineteenth and Twentieth Centuries.* 4th ed. Baltimore: Penguin. 1977.

Pevsner, Nikolaus. *A History of Building Types.* London: Thames and Hudson. 1987.

Stierlin, Henri. *Encyclopedia of World Architecture.* New York: Reinhold. 1983.

Stratton, Arthur. *The Orders of Architecture: Greek, Roman, and Renaissance.* London: Studio. 1986.

6

The Art of Prehistory

ca. 35,000 B.C.	Last stage of the Paleolithic; earliest known art work appears
ca. 25,000 B.C.	Venus of Willendorf
ca. 15,000–10,000 B.C.	Lascaux cave paintings
ca. 8000–6000 B.C.	Beginning of Neolithic period in Near East
ca. 2000–1500 B.C.	Stonehenge in England; dolmens in France

The art of prehistory can be divided into two major periods: the Paleolithic and the Neolithic. The origins of the Paleolithic, or Old Stone Age, extend back about two million years to east-central Africa. The Neolithic, or New Stone Age, began about 8000 B.C. when people made the transition from nomadic hunter-gatherers to farmers. The beginning of agriculture marks the start of the Neolithic period.

THE PALEOLITHIC PERIOD

The beginnings of visual art might be found in carvings and paintings produced toward the end of the Paleolithic period, about thirty thousand years ago. This time period corresponded with the end of the last ice age in

Europe. As the massive glaciers retreated to the north, hunters pursued their prey northward and left behind evidence of their travels in the form of stone and ivory carvings. Possibly these were made for magical purposes, to gain power over their prey.

Fertility Figures

In addition to small carvings of animals, Paleolithic people produced small carved female figures with swollen abdomens, breasts, and thighs but little indication of facial features. These appear to have been made as fertility figures, representing the principle of regeneration, the Great Mother from which all life emerges. One of the best-known examples of such figures is the so-called *Venus of Willendorf*, a tiny stone figure less than five inches in height, carved ca. 25,000–20,000 B.C.

Paleolithic Art

No one really knows exactly why such objects were made. Paleolithic people did not record their history through writing; any interpretation of the meaning of their artifacts can only be conjectural. Sometimes speculative interpretations are supported by recent comparative studies with so-called primitive societies in which representations of animals have been produced to acquire magical power over them in the hunt.

Another question pertinent to the study of Paleolithic carvings and paintings is, are they really art? Most likely the concept of art as we understand it today was not in existence during the Old Stone Age, and without written records one can only speculate about this issue. However, it would appear that the sensitivity and refinement evident in some of the surviving works would indicate that they were produced not merely to be functional, but also to please (at least the maker) visually.

LASCAUX

Cave paintings depicting a variety of animals were created within the Lascaux Cave in Southern France during the late Paleolithic period from about 15,000 to 10,000 B.C. These vary greatly in size from very small renderings to a painted bull eighteen feet in length. Some of the images overlap; the animals are not rendered with regard for an overall scheme, rather their placement seems random. They were rendered in a variety of styles and were apparently executed over a period of thousands of years.

Process. The painting process involved outlining the animals' contours and filling in the outline with earth pigments such as ocher. A variety of primitive tools and techniques were used to apply the colors. These included application by hand, sticks, bundled grasses, and by blowing dry powdered pigment through hollow bones or reeds (producing effects similar to modern spray painting).

The paintings of animals at Lascaux show an impressive regard for realism. The animals appear convincingly lifelike due to the use of modeling (shading), the fluid, energetic contour lines that describe the forms, and the occasional foreshortening. The creators of these sensitively painted animals must have carefully observed their subjects, and retained keen visual memories when they entered the deep recesses of the cave to create their images. Alongside the depictions of animals on the cave walls and ceiling are some abstract motifs and abstracted human figures that show less regard for realism.

Purpose. The purpose of the Lascaux paintings (and paintings at other late Paleolithic sites) is unknown, but it is widely believed that they served a ritualistic purpose related to hunting. Some of the images appear to have been symbolically "killed" by being struck with spears. If they served as magical images, one might question whether they were done before the hunt to enhance the effectiveness of the hunters, or afterward, to replenish the herds by "planting" animals deep in the earth (and appeasing their spirits so that others of their kind would thrive). Other theories concerning initiatory or ritual uses have been suggested for this cave sanctuary. Whatever the original purpose of these paintings, they are appreciated today as powerful visual art.

THE NEOLITHIC PERIOD

The art of the Neolithic or New Stone, Age mirrored the different lifestyle that arose between 10,000 and 8000 B.C., when agricultural communities began to provide people with more stable lives. Settlements arose, such as the walled city of Jericho (ca. 7000 B.C.), where people lived in stone houses with plastered walls. Along with the development of architecture during this period, new art forms appeared, such as kiln-fired clay storage pots decorated with abstract designs.

Abstraction

The naturalism of Paleolithic art characterized by the cave paintings at Lascaux gave way to abstract patterning, often based on geometric forms. In sculptured fertility figures, as well as in painted images, abstraction was favored over realism. Abstract animal and plant motifs were painted on clay vessels, sometimes with highly stylized pictographic characteristics. These picture-writing forms anticipated the later development of alphabets.

Megaliths

Neolithic people also built impressive monuments of large stones called megaliths, which weighed several tons apiece. In northern Europe, little survives of Neolithic farmers' dwellings, yet megalithic monuments, ap-

parently made for ritualistic purposes, survive by the thousands. These include the dolmens of Brittany, which are made of large upright stones supporting a slab roof, and menhirs, which are upright stones placed singly or arranged in rows or circles. These circular arrangements of menhirs (also called monoliths) are called cromlechs.

STONEHENGE

The best known of cromlechs is Stonehenge in southern England, ca. 1800–1400 B.C. It is formed by two concentric circles of large upright stones topped by horizontal stone slabs, in the method of post-and-lintel construction. It appears that the stones were arranged according to astronomical concerns, such as the alignment of some of the stones with the sun's position on the summer solstice. Some theories suggest that the monument might have served as the Neolithic equivalent of a calendar. No one knows for certain, though there is general agreement that Stonehenge was used for some type of religious purpose.

The two major periods of prehistory are the Paleolithic (Old Stone Age), and the Neolithic (New Stone Age), which is marked by the transition from hunter-gatherer societies to the beginnings of agriculture and more settled existence.

Existing Paleolithic art includes small figures of animals and human females carved in stone and ivory, including the "Venus" figures. These may have served magical purposes.

Paleolithic people painted on the walls of cave sanctuaries such as Lascaux in France.

New forms of expression emerged with the changing lifestyle of the Neolithic age including clay storage pots decorated with abstract motifs and stylized animals and monuments made of huge stones called megaliths. The best known of these is Stonehenge in Britain.

Selected Readings

Ruspoli, Mario. *The Cave of Lascaux: The Final Photographs.* New York: Abrams. 1987.

Sandars, Nancy K. *Prehistoric Art in Europe.* 2nd ed. New York: Penguin. 1985.

Wainwright, Geoffrey. *The Henge Monuments: Ceremony and Society in Prehistoric Britain.* London: Thames and Hudson. 1990.

7

Ancient Art

ca. 3500 B.C.	Sumerians in Mesopotamia; pictographic writing in Sumer
ca. 3000 B.C.	Old Kingdom begins in Egypt; hieroglyphic writing
ca. 2500 B.C.	Great Pyramids at Giza
ca. 2300 B.C.	Akkadian period in Mesopotamia
ca. 2100 B.C.	Middle Kingdom begins in Egypt
ca. 1760 B.C.	Babylonian Dynasty; law code of Hammurabi
ca. 1580 B.C.	New Kingdom begins in Egypt
ca. 1360 B.C.	Akhenaton establishes monotheism in Egypt
ca. 1340 B.C.	Tomb of Tutankhamen
ca. 1000 B.C.	Hebrews develop monotheism
ca. 1000– 612 B.C.	Assyrian Empire
ca. 540–525 B.C.	Persians conquer Babylon and Egypt
ca. 510 B.C.	Athens becomes a democracy
509 B.C.	Roman Republic founded
ca. 460–429 B.C.	Age of Pericles in Athens; building of the Acropolis
356–323 B.C.	Alexander the Great
49-44 B.C.	Julius Caesar dictator of Rome
27 B.C.–**14** A.D.	Augustus is Emperor of Rome
ca 30	Crucifixion of Jesus

79 Eruption of Mt. Vesuvius buries Herculaneum and Pompeii

324–337 Constantine is Emperor of Rome; capital moved to Byzantium

410 Rome sacked by Visigoths

476 Western Roman Empire falls to Goths

The Neolithic revolution transformed people from wandering hunter-gatherers into stable community dwellers engaged in agriculture. As populations increased, a need developed to protect communities, not so much from the forces of nature as from other people. As cities developed, more sophisticated forms of social organization emerged that eventually produced civilizations encompassing broad territories under centralized administration. The earliest civilizations to develop were in Mesopotamia and in Egypt. Later in antiquity civilizations flourished in the Aegean area, in Greece, and in Italy with the emergence of Rome.

MESOPOTAMIA

The beginnings of urban civilization can be traced to the region between the Tigris and Euphrates rivers, Mesopotamia (which means "land between the rivers"). The emergence of civilization in this area occurred approximately at the same time as in Egypt, between ca. 3500–3000 B.C., but the geographic conditions in Mesopotamia were quite different. Egypt developed along the narrow line of the Nile River, which made defense easier, while in Mesopotamia, the open geography provided little natural defense. As a result, Mesopotamia was continually overrun by various invaders, each bringing successive leaders into power.

The Sumerians

The first prominent civilization of the Tigris-Euphrates Valley was Sumer, which developed in southern Mesopotamia. The Sumerian civilization began about 3500 B.C. and continued until 2300 B.C. The Sumerians were among the earliest people to develop a written language (called cuneiform). Their civilization consisted of separate, independent theocratic city states, each "ruled" by its own local god. Governmental authority was administered by priests who served as stewards of the gods.

ZIGGURATS

The temple was of major importance in this society. The most important type of construction involved the building of ziggurats (massive platforms symbolizing sacred mountains) on top of which temples were placed. The ziggurats were constructed out of sun-baked brick faced with fired bricks which were sometimes colored with glazes. Clay was very abundant in Mesopotamia while stone was scarce. The availability of material best explains the type of brick construction developed in this region. The construction system relied heavily on the use of the arch and vault, which could easily be formed in brick.

Worshipers climbed to the tops of ziggurats by means of zigzag ramps. Some ziggarats were nearly three hundred feet in height. The best known of the large ziggurats is referred to in the Bible as the tower of Babel. This, however, was not built by the Sumerians and dated from a much later period in Mesopotamian history. A good example of a surviving Sumerian site is the greatly eroded ziggurat at Ur (ca. 2100 B.C.).

SUMERIAN SCULPTURE

The Sumerians carved figures in stone, representing their gods such as Anu (the god of the sky) and Abu (the god of vegetation). Marble was probably imported through trade to provide the material for stone carving. The figures of gods were portrayed as stiffly upright, frontal figures with highly stylized hair and beards. Their eyes are large and staring, the arms folded across the midsection with hands clasped in a gesture resembling that of prayer. The figures are abstracted geometrically and the severity of this geometry is reinforced by their conical skirts.

Other types of sculpture developed by the Sumerians were made of hammered gold inlaid with the deep blue stone, lapis lazuli, depicting religious images of goats, bearded bulls, hybrid animals, and composite human-beasts. These hammered gold sculptures were less rigid and more fluid in form.

The Akkadians

About 2300 B.C. the Sumerian city-states were brought under the control of the Akkadians, who had migrated to the region from northern Mesopotamia. Sargon of Akkad and his successors were the first Mesopotamian rulers to boldly proclaim themselves as kings, replacing the earlier Sumerian theocratic concept.

AKKADIAN SCULPTURE

Art works from this period convey the Akkadian concept of absolute monarchy. The bronze *Head of an Akkadian Ruler* (ca. 2300–2200 B.C.) retains some Sumerian characteristics such as patterned repetitions in the stylized beard. However, it conveys a sense of likeness and a naturalism

based on careful observation of the subject, along with an air of divine authority. Dating from the same period is the *Victory Stelae of Naram-Sin*, commemorating the ruler as a victor in war. The figure of the ruler, Naram-Sin, is formally depicted in a stiff posture, as if frozen in time, with frontal shoulders and head and feet in profile view. He is positioned higher in the composition, which represents him with his army climbing a mountain and defeating the enemy at its summit. The fact that he is placed higher than other figures and is larger in scale enhances the idea of his power and importance. The art of the Akkadians stresses the concept of the ruler's power rather than paying homage to the gods.

The Babylonians

Following the end of Akkadian rule, there emerged a brief revival of Sumerian independence and a period of turbulence in Mesopotamia. A short period of central authority returned when the Babylonian Empire emerged in the eighteenth century B.C. This reunification was brought about under Hammurabi, a competent military leader who had profound respect for Sumerian customs. Setting himself up as the favorite "shepherd" of the sun god Shamash, he established a law code for which he is best known today. The code of Hammurabi was the first written record of a uniform law code. A stele (an upright stone slab or pillar) inscribed with the law code of Hammurabi (depicting Hammurabi and Shamash) continues visual traditions established earlier by the Sumerians and Akkadians. Both figures are represented in relief with feet and face in profile; however, the shoulders are depicted frontally. The cylindrical figure of Hammurabi bears strong resemblance to earlier Sumerian figures.

The Assyrians

The Assyrians, who inhabited the upper region of the Tigris River, established control over all of Mesopotamia and, at their height, surrounding regions as well. Though establishing their culture largely on Babylonian example, they were obsessed with war. Their art was almost entirely devoted to depictions of Assyrian conquests. These are usually depicted in a matter-of-fact, repetitious way, without any feeling of drama. The devotion to war and conquest was so strong that it overextended the Assyrians' resources, eventually collapsing their empire (which lasted from about 1000 to 612 B.C.).

ASSYRIAN ART

The Assyrians relied on brick vaulted construction but faced their elaborate palaces with stone slabs bearing relief carvings. Within the palace grounds was the ziggurat, though much smaller in scale than the form established by the Sumerians. Aside from carving records of conquests, commemorative reliefs glorified kings engaged in ceremonial hunting.

Dying Lioness. Related to this subject is the portrayal of a *Dying Lioness* at Ninevah. The sculptor has sensitively portrayed the wounded animal, shot with arrows. She appears half paralyzed, bleeding, and roaring in pain. The musculature of the animal and other details of realism suggest a careful observation of the subject by the artist.

Guardian Bulls. The Assyrians created awesome hybrid, winged bulls with human heads as guardian figures at palace gateways. These show less preoccupation with compassion and naturalism and more concern with formal convention and stylization.

The Persians

The Persians originated in what is now Iran. By the sixth century the Persians had become heirs of the Assyrian empire, eventually conquering Egypt and continuing to advance until prevented from conquering Greece at the Battle of Marathon in 490 B.C.

PERSIAN ARCHITECTURE

Persian architecture, which was largely devoted to grand palaces, synthesized traditions from various parts of its immense empire, including Assyrian and Egyptian as well as Greek stylistic elements. The Palace at Persepolis, in its grand scale, derives from Assyrian sources. The closely spaced columns in the *Audience Hall of Darius and Xerxes* seem to be Egyptian-influenced in their density, but their slender proportions show greater relationship to the style of the Ionian Greeks.

PERSIAN ORNAMENTATION

Aside from architecture, other Persian art can also be explained in light of its synthesis of diverse stylistic elements. Largely preoccupied with ornamental aspects of design, the Persians retained a decorative sensibility which extended back thousands of years to nomadic times when decorative metal work featured stylized hybrid animals on small scale ornaments. When this inherent Persian concern was synthesized with other elements, the decorative features took precedent in design, whether on a large or a small scale. This is apparent in the Double Bull Capital and Column from Persepolis. The upper section of the capital features paired bulls, facing opposite directions, their bodies joined in the middle back. Here we see more concern for decorative aspects and stylization than realism. This ornamental tradition endured throughout the history of the Persian Empire with little change.

EGYPT

Most of Egypt consists of arid desert. Only the narrow fertile region surrounding the Nile provided encouragement to the development of civilization. Unlike Mesopotamia, which was open to invasion on all sides, Egypt could enjoy relative isolation. Surrounded by desert on both sides of the Nile and approachable by invaders only at its northern boundary, Egypt had greater opportunity for stability and defense.

Perhaps these factors, which led to long periods of centralized political administration (in contrast to the less stable situation in Mesopotamia), might also help to explain why Egyptian art changed so little over a period of three thousand years. Once established, the Egyptian style in architecture, painting, and sculpture endured with strong reliance placed on convention.

Egyptian art was primarily funerary (related to funerals and the cult of the dead) in function. Much of it was oriented around tombs and funerary temples and was especially developed for the ruling class so that they might perpetuate life in the hereafter. Most impressive were the tombs and funerary complexes of the pharaohs.

The history of Egypt can be divided into three main periods, the Old Kingdom, which begins about 3000 and continues to 2155 B.C., the Middle Kingdom from 2134 to 1785 B.C. and the New Kingdom, ca. 1500 to 1152 B.C. After this time, Egyptian civilization continued, although without central authority and often under foreign domination. Within the main periods of Egyptian history, the rule of various pharaohs is divided into dynasties.

The Old Kingdom

The Old Kingdom includes dynasties I–VI. Its beginning is marked by the unification of the nation when Upper Egypt (the southern or upper Nile region) conquered Lower Egypt (the northern or Nile delta region).

NARMER PALETTE

Perhaps this historic event is depicted in the *Palette of King Narmer* (ca. 3000 B.C.). Both sides of the relief carving picture Narmer, the king of Upper Egypt, as victorious in his conquest. In one depiction he is ready to slay a captive. In another, a falcon symbolizing Narmer stands on a human-headed cluster of papyrus plants which symbolize Lower Egypt. On the opposite side of the palette, a bull, symbolizing Upper Egypt, penetrates a citadel.

FRACTIONAL REPRESENTATION

Representations of the pharaoh on both sides of the Narmer palette show him in a pose which will become an Egyptian convention for representing the human figure (especially prominent people) in wall painting and relief

sculpture. The shoulders are frontal, while the head and feet are in profile. A frontal eye appears on the profile face. Through this device, called fractional representation, foreshortening of the body has been avoided. The same idea was incorporated later in Mesopotamia as seen in the Akkadian stele of Naram Sin. However, the practice was not as strongly fixed in Mesopotamia as in Egypt, where it endured, strictly adhered to as a convention for thousands of years.

This convention was often used in tomb reliefs and wall paintings. The basic idea was to record the most familiarly remembered angles that identify the human form. The shapes of various parts of the body are most familiar from certain angles of view. The eyes and shoulders are better comprehended when seen frontally, while the legs, feet, face, and nose are better conceptualized in profile. Rather than base the painted depiction on visual observation, rendering things as actually observed in perspective, the Egyptians took a conceptual approach, based on what the mind "knows."

GROUNDLINE AND SPATIAL ORGANIZATION

In Old Kingdom tomb paintings and relief sculptures (as in the Narmer palette) figures are placed on ground-lines arranged in registers, stacked one upon the other. Within this context 90É angle shifts in viewpoint are observable not only in the frontal/profile juxtapositions of body parts in figures, but sometimes in scenes combining straight-forward ground level views with aerial ones. In the Narmer palette, the ruler and his standardbearers are observed on ground level, placed on a ground-line within a register, but the viewpoint shifts upward by 90Éto show their decapitated enemy from above.

HIERARCHICAL SCALING

Another convention established early in the history of Egyptian wall painting and relief sculpture is the enlargement of some figures (such as in the Narmer palette) within scenes, so as to stress the social prominence of some in contrast to others. This device, hierarchical scaling, is observed in Mesopotamian art as well.

OLD KINGDOM SCULPTURE

A concept of divine kingship was established during the Old Kingdom. Much attention was devoted to perpetuating the life of the "immortal" pharaoh after death. Egyptian statues of pharaohs were essential funerary objects, given magical significance through inscriptions written in hieroglyphics. Like the representations of pharaohs in painting and relief sculpture, statues of Egyptian kings, though carved as volumes, were conceived in terms of right-angle shifts in viewpoint. In portrayals of Old Kingdom pharaohs, such as the statues representing the standing figures of

Mycerinus and His Queen, or the seated *Khafre* (Chefren), the sculptor first outlined the contour of the figure in profile and in frontal view on the sides of a rectangular stone block. This block was carved (probably using hard stone tools) on each of its surfaces as though they were individual views (rather than working around the block). The resulting sculpture displays a strong regard for frontality, making the pharaoh appear immobile. This aspect is reinforced by a strong geometric quality. The figures are idealized rather than portrayed as real human beings. They were not entirely freed from the stone blocks from which they emerge. Spaces between the legs as well as the arms and torso were not carved out completely. The figures' stances are stiff, without regard for ponderation (weight distribution) in the body. One tends to observe the figures either head on, from the front, or from the side, in profile. Other angles of viewpoint seem less satisfying.

OLD KINGDOM ARCHITECTURE

Mastaba. Architecture of this period was also oriented around the tomb. The earliest form used for burial was the mastaba, a low, flat-roofed building with sloping walls, placed as a monument over tomb shafts.

Pyramids. The concept of stacking mastabas led to the monumental Step Pyramid of King Zoser at Saqqara in Dynasty III. Soon after, the smooth-sided pyramid shape was developed, as seen in the Great Pyramids at Giza in Dynasty IV. These huge pyramids (the largest measuring 450 feet in height and 775 feet along a side of its base) were the tombs of Khufu (Cheops), Khafre (Chefren), and Menkure (Mycerinus).

Funerary temple districts were developed around the pyramids. There religious rites were undertaken to perpetuate the spirit's life after death, insuring immortality for the deceased pharaoh. Unfortunately, tomb robbers posed a great danger to a departed pharaoh's future, threatening to rob him of the necessary possessions needed to sustain him in the afterlife. Over the years, pyramids were routinely sacked by grave robbers.

The Middle Kingdom

At the end of Dynasty VI, centralized pharaonic power ceased and Egypt fell into disunity. During Dynasties XI and XII a sense of centralized control was restored, though the pharaoh did not fully regain his Old Kingdom status as a divine ruler.

During the Middle Kingdom, for the most part the established art conventions of the Old Kingdom endured, but some inventiveness appeared.

ROCK-CUT TOMBS

Instead of pyramids, less conspicuous rock-cut tombs were carved into cliffs to insure further protection against grave robbery (though most of them were found and sacked anyway). Experimentation in wall paintings within the rock-cut tombs relaxed some of the strict conventions established during

the Old Kingdom. More freely drawn figures and attempts at foreshortening are evident in these paintings.

MIDDLE KINGDOM SCULPTURE

Changes also appear in portrait statues of the pharaohs whose individualized faces are more sensitively and realistically portrayed.

The New Kingdom

Following the Middle Kingdom, Egypt was invaded by the Hyksos, an Asiatic tribe whose bronze weapons gave them military advantage. After this introduction to bronze weapons, the Egyptians adopted their use and eventually turned them on the Hyksos, expelling the invaders.

The Egyptians then restored unity for the next five hundred years, establishing the New Kingdom. This period was a very vital stage in Egyptian history. At its height, Egypt was expanded into an empire, its borders extending to the east as far as Palestine and Syria. The divine kingship concept was also restored, but with some complications. The pharaoh's link to divine status was associated with Amun, who was now united with the sun god Ra, as Amun-Ra. The priests of Amun-Ra gained such significant power that the pharaoh could not retain power without their approval.

One pharaoh, Akhenaton, challenged priestly authority by introducing a new religion centered around worship of a single god, the sun disk Aton. During his reign the capital of Egypt was moved from Thebes to Tel el-Amarna. During this short episode in Egyptian history, called the Amarna period, a number of innovations appeared in art which defied long-standing conventions. But following Akhenaton's rule, these were largely abandoned; many of the older artistic rules were restored, along with the supremacy of Amun-Ra.

ART OF THE NEW KINGDOM

Art of the New Kingdom was quite diverse in style compared to earlier Egyptian art; it was not as conservative. In many respects, it combined aspects of Old Kingdom with Middle Kingdom characteristics, allowing some room for experimentation and growth.

New Kingdom Temples. The New Kingdom was a great age of temple building. Early pharaohs of the period built funerary temples as places to worship in life, as well as for use after their deaths to perpetuate the afterlife. Later temple building concentrated more on great imperial temples of Amun, which were places of public worship.

Unlike Mesopotamia, Egypt had abundant supplies of stone available. Because of this natural supply of stone, the post-and-lintel system was the favored method of construction (in contrast to the use of the arch and vault in Mesopotamia). Because stone is very heavy material with poor tensile

strength (lack of capacity to stretch and bend without easily cracking), columns were closely spaced. Characteristic of the temples of Amun, which were constructed by this method (such as the temples at Karnak and Luxor), were hypostyle halls where columns were very densely spaced.

Funerary Temple of Queen Hatshepsut. The Funerary Temple of Queen Hatshepsut dates from early in the New Kingdom. It was rock-cut into the cliffs at Deir el-Bahari, ca. 1480 B.C. In front of the deep-cut sanctuary in the cliffs were three stepped courtyards faced by colonnades. The courtyard terraces could be ascended by means of long ramps forming a processional route from the valley to rock-cut openings in the cliffs.

THE AMARNA PERIOD

During the reign of Akhenaton, a temple dedicated to one god, Aton, was built at Tel el-Amarna. Soon after the pharaoh's death, it was demolished as the priests of Amun quickly restored the status of their god.

Left from the reign of Akhenaton, however, are some examples of portrait sculpture as well as fragments of wall reliefs and paintings. These display a revolutionary stylistic break from the status quo. The new approach might be called realistic, as in the individuality evident in the representations of Akhenaton, Queen Nefertiti and their children. There is also a more human sense of emotion, and a more animate quality in their personalities. But the expressive exaggerations in scale, elongation of certain features, and curvilinear contouring of bodies might seem cartoon-like by today's standards, rather than real.

Bust of Queen Nefertiti. More convincingly realistic is the beautiful bust of Queen Nefertiti, whose natural image is refined through the graceful, elegant use of elongation of the neck and head.

TUTANKHAMEN

Akhenaton's successor was Tutankhamen, whose reign was brief. After his death at age eighteen he was entombed with a great assortment of valuable treasures, consisting of gold sculpture and jewelry, furniture, clothing, and pottery. His tomb was not unusual for a pharaoh. It is exceptional, however, because it was not sacked by grave robbers but remained undiscovered and undisturbed until archaeologists uncovered it in 1922.

Although Amun had been restored as the supreme god of Egypt, and most traces of Akhenaton's existence destroyed, some characteristics of the Amarna period style are retained in the art from Tutankhamen's tomb. The pharaoh's face in the cover of the coffin of Tutankhamen (ca. 1340 B.C.) appears to combine formal idealism (as observed in traditional Egyptian portrait sculpture) with naturalism and a sense of likeness. The relief image of the pharaoh and his wife, embossed in inlaid gold on the throne of Tutankhamen, also displays influence from the Amarna period. This is seen

in the curvilinear contours and the tenderness of expression between the figures.

THE AEGEAN

There are three civilizations encompassed by the term *Aegean*, which refers not only to the region, but also to the historic time period preceding the arrival of the Greeks in the same area.

Until the late nineteenth century, many believed that the Aegean civilizations described in the *Iliad* by Homer were merely a Greek myth. Then a German archaeologist, Heinrich Schliemann, unearthed Mycenae, and soon after Sir Arthur Evans discovered Minoan sites on the island of Crete.

Aegean civilizations occupied three regions: the Cycladic islands (north of Crete), Crete, and the Greek mainland. The Minoan civilization developed on the island of Crete and the Mycenaean civilization on mainland Greece. All three civilizations are historically divided (similar to Egyptian history) into three phases called Early, Middle, and Late, but significant artistic developments are concentrated in the later Middle and Late periods.

The Cycladic Islands

Little art and architecture survive from this civilization which thrived from about 2600–1100 B.C. Of its remaining art the marble tomb figures reminiscent of fertility goddesses from Paleolithic and Neolithic times are most impressive. These vary greatly in size and convey a sense of elegance that separates them from their prehistoric antecedents. They are highly abstracted and simplified, stressing solid geometric forms such as the cylinder. Their faces are featureless and overall their surfaces are smooth.

The Minoans

Little is known about the Minoans in comparison with what is understood about the Mesopotamians and Egyptians. Part of the problem results from our inability to read their written inscriptions. They invented a written language about 2000 B.C., and in the fifteenth century B.C. developed a later version of Minoan script called Linear B. In 1953, Linear B was deciphered. It is early Greek and was in use at a time when the mainland Greeks dominated Crete. Its main use was for business records, rather than to record information on customs and history. Unfortunately, the earlier Minoan script has never been deciphered.

The Minoans were a sea power who depended on trade by ship. Their history can be divided into three periods, but rather than evolving consistently, it appears to have developed sporadically in a cycle of building and destruction. Palace building began in the Middle period, about 2000 B.C.

Palaces were suddenly destroyed about 1700 B.C. due to unknown causes. New palaces were built about a hundred years later, but these were also destroyed about 1500 B.C.

PALACE AT KNOSSOS

The three storied palace at Knossos (ca. 1500 B.C.) was so large and its many small rooms so spread out that it is thought to be the origin of the labyrinth in the minotaur legend. The palace's post-and-lintel construction used stone lintels supported by brightly painted wooden columns topped with large cushion-shaped capitals. The columns' shafts tapered downward, rather than upward as they customarily did in Egypt or later would in Greece.

The palace walls were decoratively painted and included animate scenes of such subjects as dolphins and youths leaping over the backs of bulls.

Mycenae

The Mycenaeans flourished on the Greek mainland from about 1600 to 1100 B.C. Although their art was strongly influenced by the Minoans, it displayed a different character. Living on the Greek mainland subjected them to the constant risk of invasion, unlike the Minoans, who were offered protection by the sea surrounding Crete. The hilltop palaces built by the Mycenaeans were heavily fortified, and had little in common with Minoan palaces in this regard.

LION GATE AT MYCENAE

The Mycenaean citadel was constructed of massive stone blocks assembled without mortar. For building in stone, the Mycenaeans used the post-and-lintel system along with corbeled arches as seen in the Lion Gate at Mycenae (ca. 1250 B.C.).

In a custom borrowed from Minoan palaces, Mycenaean citadels were decorated with paintings and sculpture. The muscular lions carved in stone above this entry gate served as symbolic guardians.

GREECE

About 1100 B.C. the Dorians, a Greek tribe, entered the Greek mainland from the north. The Ionians were another Greek tribe who migrated westward, settling in the Greek islands and along the coast of Asia Minor. As these Greeks evolved culturally, they assimilated influences from their surroundings. The Dorians absorbed ideas from the Mycenaeans and the Ionians from Mesopotamia. While synthesizing cultural values they developed significant new concepts of their own, such as the concept of democracy which developed in ancient Athens. Today in the Western world,

we are culturally indebted to the Greeks more than to any other ancient people up to their time.

The Greeks developed architectural styles around the system of the orders (discussed in chapter 5). Greek architectural ideas have continued to be used to the present day, especially in banks and government buildings that are designed with Classical columns and porticos. The Greek concept of beauty in sculpture and painting has also been inherited by today's Western world.

Greek Aesthetics

The concept of humanism, a belief in the human being's capacity to reason, and a profound reverence for the beauty of the human body, was a Greek invention. The Greeks created the images of their gods in human form. They conceived of them as perfected versions of mortals. Among mortals, the athlete was admired in terms of physical beauty, and the concept of the perfect mind was merged with the perfect body to contain it. The idea of forming the perfect human form by combining the most perfect features and parts of several into a combination as one idealized whole originated with the Greeks. They applied it to male and female representations, including statues, relief sculptures, and paintings of athletes and gods.

Stylistic Periods in Greek Art

Greek art is divided into several periods. The formative stage is called the Geometric style and dated from about 900 to 700 B.C. At this time, abstract geometric patterns dominated design in art. Next came the Archaic period, from 700 to 500 B.C. After this a transitional stage called Early Classical (480–450 B.C.) preceded the Classical period of 450 to 400 B.C. The period that immediately follows (ca. 400–325 B.C.) is sometimes called Late Classical. It preceded the Hellenistic period which occurred from the late fourth to the second century B.C. This last stage extended the Greek mode into its surrounding non-Greek world.

THE ARCHAIC PERIOD

During the Archaic period major developments occurred that seemingly shaped the future in architecture and sculpture.

In vase painting of the early Archaic period Mesopotamian motifs, such as hybrid animals, were incorporated into Greek designs (which still retained geometric patterning). In time, figures were enlarged to the point where they were dominant and a narrative tradition emerged in painting on pottery.

Black-Figured and Red-Figured Styles. Eventually a technique of vase painting emerged called black-figured because black designs or figures were painted on a lighter natural clay; the clay then turned orange red after firing.

A more natural and realistic appearance resulted after the development of the red-figured style in the sixth century B.C., in which the background was painted black and the figures remained the orange red of the clay.

Architecture. The basic form of the rectangular Greek temple with a pitched roof and columns running around all four sides of its base developed during the Archaic period. The Greeks built their temples in stone, relying on the post-and-lintel construction method, but during the Archaic period a stylistic system was developed for architecture in the form of the orders (chapter 5). The Doric order was dominant in the designs of large temples.

Architectural Sculpture. A tradition emerged in sculptural decoration for Greek temples. It designated certain architectural spaces such as pediments (the triangular shape contained within the temple's horizontal and sloping cornices), to be filled with stone carvings.

At first, pedimental sculpture was set into place haphazardly, often with figures out of scale due to the problem of placing sculpture in a triangular format. Later in the Archaic period, figures were positioned in poses that allowed them to fit the space and still appear natural and in harmony with surrounding figures.

Kouros and Kore. Life-size male and female free-standing figures were developed during the Archaic period. An Egyptian influence is evident in their stiff frontal postures. The depiction of the male figure, or Kouros, looks particularly Egyptian, with his left leg forward and both hands clasped tightly to his sides. However, unlike Egyptian statues, Kouros figures are nudes who display their bodies without shame. Although they represent an idealized nude, early Kouros figures display strong geometric characteristics rather than natural ones.

The Kore, in contrast, is always a clothed female figure. Early examples of these subjects are also rather geometrically abstracted. As the Archaic period advanced, free-standing figures were rendered with a greater concern for naturalism. They were given a happy expression to enliven them, known as the Archaic smile.

THE CLASSICAL PERIOD

Athens dominated Greek culture in the Classical period. In the age of the leader Pericles, Athens flourished in philosophy, literature, architecture, and the visual arts as Greece celebrated its victory over the threat of Persian conquest. The major cultural project of the period was the rebuilding of the Acropolis, the religious district of Athens which had been destroyed by the invading Persians.

The Parthenon. Designed by the architects Ictinus and Callicrates, the Parthenon has long been regarded as one of the most beautifully conceived structures. It is a highly refined and elegantly proportioned Doric temple built to house a forty-foot-tall statue of the goddess Athena.

The Parthenon was decorated with architectural sculpture on its exterior; the entire building was planned to be externally beautiful from all sides. Like other Greek temples, it was only to be entered by priests. Other worshippers were intended to surround it outdoors.

None of the Parthenon's main lines are exactly straight. There are many other features that are usually explained as optical refinements, such as the slight tilting back of the columns as they rise upward, the slight convex shape of the stylobate and the entablature, and the entasis (the gentle bulging) in the middle of the column's shafts, intended to make them look straighter than they might otherwise. It is believed by some people that all of these features were intended to correct optical distortions, but whatever the reason they do visually affect the building's overall elegant appearance.

Architectural Sculpture. The figures of the *Three Goddesses* were originally contained in the Parthenon's east pediment; their ascending arrangement from left to right fitted into the right corner of the pediment's triangular shape. With their graceful poses and their swirling drapery (the folds of which cling over bodily forms as if wet), they are good examples of the Classical style in sculpture.

The sculptor Phidias oversaw the production of sculpture adorning the Parthenon. Though he did not execute the *Three Goddesses* personally, their serene style is often called Phidian.

Free-Standing Sculpture. During the Classical period freestanding sculpture that was highly naturalistic emerged, often with implied motion in the figure. Assisting this effect was a move away from the Egyptian-influenced frontality of the early Kouros and Kore figures. Weight distribution in the body (ponderation) was a sculptural consideration; artists keenly observed human anatomy and realistically translated their observations to stone. Contrapposto was developed in which the head, torso, legs, and arms are counterpoised, indicating that the figure stands firmly on one leg while relaxing the other. This causes the weight-bearing hip to be higher, while countershifts occur in the shoulders and along other axes crossing the upright torso. Visually this relaxes the appearance of the figure and allows for greater naturalism, as seen in the *Doryphorus* (spearbearer), a sculpture by Polyclitus. In extreme cases the principle of contrapposto was applied to figures twisting in space, as in the case of Myron's *Discus Thrower*.

During the Classical period fixed rules of proportions were established for representing the human figure. This representation was not based on merely copying a model from nature, but on creating perfect ratios between bodily parts to produce an idealized form.

Mural and Vase Painting. During the Classical period, vase painting was not the only expression of painting. Mural painting was also developed, although none survives. Some copies of Greek murals, made by the Romans,

may reveal the great extent of illusionism developed by the Greeks in this art form.

In contrast to mural painting, vase painting, though considered an important art form in which artists signed their works, adhered to conventions established earlier by the red-figured style. In this period vase paintings do incorporate on a two-dimensional plane the developments in stylistic principles found in sculpture, such as implied movement and classical contrapposto. Also, since the red-figured style provided an opportunity to freely paint anatomical and other details directly upon the form of the red figure, a more graceful and free style of rendering was developed. Naturalism evolved considerably in vase painting during this period.

THE LATE CLASSICAL PERIOD

A transitional stage known as the Late Classical occurred in the fourth century B.C. prior to the development of the Hellenistic period. The visual ideal of the Classical period was replaced with one that was more sensual as well as emotionally expressive.

Praxiteles. The statue of *Hermes* by Praxiteles is a good example of the Late Classical style. Its proportions differ greatly from statues of the Classical period, with the figure more slender and the head smaller in proportion to the body. The musculature based on the model of the athlete in the Classical period has been replaced with a softer and more sensuous regard for the flesh, perhaps based more on natural observation than adherence to a canon. The use of contrapposto continues with the figure's body given an elegant sway in the form of an S curve.

THE HELLENISTIC PERIOD

Beginning in the late fourth century B.C., at the time of Alexander the Great (a Macedonian king whose empire encompassed Greece, Egypt, Mesopotamia, and Persia), the ideals of Greek civilization became enshrined, affecting stylistic developments beyond Greece itself. The term *Hellenistic* means "Greek-like" and often Hellenistic sculptors were Greek artists working for non-Greek patrons.

The style of the Hellenistic period continues and extends the emotionalism and sensuality of the Late Classical period. It was also an age marked by greater interest in naturalism. A wide stylistic range is evident, with some works stressing dramatic action and powerfully expressed emotion, while others continue the Greek tradition of serene idealism exemplified in such works as the *Venus de Medici* and *Aphrodite of Melos (Venus de Milo)*.

The Laocoön Group. The free-standing sculptural composition called *The Laocoön Group* was executed by Agesander, Athenodorus, and Polydorus of Rhodes in the second century B.C. It depicts Laocoön, who

warned the Trojans not to accept as a gift the horse that brought about their downfall in war, and his two sons, being punished by a large serpent set upon them by an angry god. As the serpent entangles the figures, they struggle to set themselves free. The emotional expressions are extreme, especially the anguished torment of Laocoön himself, whose tense musculature enforces the idea of his hopeless struggle. Along with the expressive gestures, there is a sense of writhing movement. The figure of Laocoön is enlarged in proportion to his sons, stressing his importance in the composition. The style of this work differs greatly from the ideal conception and serenity expressed in sculpture of the Classical period.

THE ETRUSCAN CIVILIZATION

Prior to the emergence of Rome, the Italian peninsula was inhabited by other peoples. The most significant civilization was that of the Etruscans, whose civilization began about 700 B.C. Like the Greeks, they inhabited independent city states. During the time corresponding with the Archaic period in Greece, the Etruscans were influenced by Greek art. At the same time, Etruscan art had a much different character that was more oriented around the afterlife than life itself.

Etruscan Tombs Other than the foundations of temples (the upper parts were built of wood), Etruscan architecture survives only in the form of tombs, which were constructed to resemble domestic settings on the interior. Their walls were covered with low reliefs representing household implements and weapons.

Within the tombs the Etruscans placed clay cinerary urns or sarcophagi (coffins). Some of the terra cotta figures sculpted on sarcophagi dating from the sixth and seventh century B.C. resemble stylized Greek sculptures of the Archaic period, but Etruscan forms were more elastic, stressing smooth, rounded contours. Clay figures also appeared more lively, even while poised above the sarcophagi. A similar sense of liveliness was found in Etruscan tomb paintings.

ROME

Rome first emerged as a city-state on the Tiber River, but in time it expanded into a vast empire occupying not only the Italian peninsula and Greece but the Near East, North Africa, and Western Europe, including the

British Isles (excluding Ireland). By the third century B.C. the Romans had overrun and assimilated the Etruscans into their civilization, as they later did (in the second century B.C.) with the Greeks. As Rome expanded, it established a policy of allowing the peoples under its control to retain their own traditions; in time they were even extended the benefit of Roman citizenship. The Romans were a practical and pragmatic people. They were problem solvers, able in military matters and government.

In architecture, painting and sculpture, the Romans were strongly affected first by the Etruscans and, more importantly, by the Greeks. As they expanded their realm, the arts of other civilizations provided additional influences.

Roman Periods

Roman history can be divided into two major periods: the Republic, ca. 510–60 B.C., and the Empire which followed. The city of Rome continued to function as the capital of the empire into the fourth century A.D. when the Emperor Constantine (who established Christianity as the official state religion) moved the capital to Byzantium (present-day Istanbul). By this time the empire had been divided into eastern and western sections. Soon the western section, which included the city of Rome, fell prey to invading barbarians. After the fall of the Roman Empire in the West, the Byzantine Empire (chapter 8) continued to function as a sort of Rome in the East, until eventually conquered by the Turks in the fifteenth century.

Architecture

The Romans were highly inventive in engineering and architecture. They poured concrete, a mixture of sand, cement, and rubble, into brick-molded vaults and domes to create buildings on a grand scale. The vast, open interior spaces in their vaulted and domed constructions were unparalleled in architectural history up to that time. The Romans also undertook extensive projects involving the construction of roads, bridges, and aqueducts.They built temples, forums, and public baths throughout the empire.

THE COLOSSEUM

Dating from 80 A.D., the Colosseum was an immense arena which seated fifty thousand people, the largest public structure constructed up to its time. Built of concrete faced with stone, it had groin-vaulted corridors and three levels of arched openings running around its exterior. To decorate the exterior, the Romans made use of the Classical orders adopted from the Greeks. These were applied as ornamental detailing, rather than as structural support, with attached columns and entablatures. The Colosseum actually relied on the principle of the arch and vault for support. The use of the orders was decorative, a fake post-and-lintel system superimposed on exterior walls.

The engaged columns were placed in between the arches of the Colosseum's three levels of arcades. The Doric order was used at street level, the Ionic at the second level, and the Corinthian on the third. Although the proportions were not made progressively more slender from the street to the second and third levels, the use of ascending Ionic and Corinthian capitals over the lower Doric ones made sense psychologically. The Doric is traditionally the heaviest and sturdiest order, the Ionic more elegant and slender, and the Corinthian even more so.

TRIUMPHAL ARCH

Engaged post-and-lintel forms decorated with the Corinthian order were also combined with arched openings in triumphal arches. These were built to commemorate Roman victories, as was the Arch of Titus (first century A.D.) and the Arch of Constantine (fourth century A.D.). Aside from the use of such arches along major processional avenues in Rome, they were placed throughout the empire in cities under Roman administration.

THE PANTHEON

Concrete construction allowed the development of large public buildings with massive domes, opening up vast interior spaces uninterrupted by interior supports. Conceived of as a dome set upon a cylinder, the Pantheon (second century A.D.) has an immense interior space.

The main circular block of the building has a 144-foot diameter. Attached to the circular portion is a pedimented portico (as derived from the Greek temple), which makes use of the Corinthian order (favored by the Romans in their architecture). Here the post-and-lintel system is in use as it was in the earlier Greek portico. The dome was constructed in such a way that the thickness of its circular walls (which are twenty feet wide at the base) diminish as it rises upward to its top. To lighten the weight of the dome, its interior is coffered, or carved with decorative recessed squares. Topping the dome is a circular opening thirty-three feet in diameter called an oculus, which allows natural light to enter.

THE BASILICA OF CONSTANTINE

The Romans used a building plan called a basilica for their assembly halls. Normally these civic buildings were collonaded wooden-roofed halls. Their low-ceilinged side aisles flanked higher central naves (wide central aisles). At the ends of the central aisle or nave were raised semicircular niches called apses.

The Basilica of Constantine (fourth century A.D.) was unusual in its use of concrete vaulting. A huge structure, its ground plan measured about 300 by 215 feet, and its central aisle rose to a height of 114 feet, making it even larger than the Pantheon.

Sculpture

Much Roman sculpture was greatly influenced by the Greek tradition. In fact the Romans were avid copyists of Greek works, so much so that the most famous of Greek sculptors' works of the Classical period are only known through copies made by their Roman admirers.

Despite the strong link to Greek tradition, during the Republican period the Romans also produced highly individualized realistic portraits in marble. Some of these go to extremes in analyzing facial topography, stressing wrinkles, sunken cheeks, sagging skin, and stern expressions. These might be regarded as realistic records, describing the physical characteristics of specific individuals rather than idealized conceptions based on an attempt to show perfection and beauty. Through their stern expressions they also suggest an air of authority and power in keeping with the practical and pragmatic Roman personality.

During the period of the Empire, the tradition of realism in Roman portraiture endured. However, realism was often fused with the Greek sense of idealism, as in the statue of the Emperor Augustus.

By the fourth century, portraiture and other forms of sculpture had evolved toward a more abstract aesthetic. Proportions based on Greek standards were replaced with less natural ones, as seen in the head of Constantine from his colossal statue. The frontality reinforced by the enlarged, staring eyes gives the image a stern and powerful presence.

Roman Painting

The Romans were strongly influenced by the Greeks in their painting style. Since Greek murals did not survive, it is not clear to what extent this influence was felt. Roman painting included several styles; among these were highly illusionistic frescoes and mosaics representing people and architecture in deep landscape settings. A highly sophisticated use of modeling (shading) to suggest roundness of forms, accompanied by foreshortening, effective use of diminished size for receding objects, overlapping, and atmospheric perspective yielded a convincing sense of reality. Good examples of this highly illusionistic painting style are found in well-preserved frescoes at the ancient city of Pompeii.

In addition to landscape views, Roman paintings included the subjects of still lifes, architectural views, mythological figures, and more intimate scenes.

The study of ancient historic art begins in Egypt and Mesopotamia. It continues through the development of Greek civilization until the collapse of the Roman Empire.

In Mesopotamia, the Sumerians built massive ziggurats. Later, the Akkadians produced the first stone carvings depicting kings, and the Assyrians glorified warfare in stone reliefs. The Persians, who conquered a

large empire beyond Mesopotamia, were mainly concerned with grand palaces.

Egyptian art is divided into the periods of the Old Kingdom, Middle Kingdom, and the New Kingdom. Most Egyptian art was funerary in function and followed conservative conventions of style for thousands of years. Old Kingdom tombs were mastabas and pyramids. During the Middle Kingdom rock-cut tombs replaced pyramids. Under Akhenaton's rule (New Kingdom), art became more innovative, but soon returned to some of its older conventions.

The Aegean civilizations include those of the Cycladic islands, Crete (where the Minoans built grand palaces), and Mycenae on the Greek mainland.

Greek art can be divided into Archaic, Classical, and Late Classical periods. During the Classical period, there were important architectural achievements (such as the Parthenon), and figurative sculpture became more natural (yet followed a fixed canon of idealized proportions). Late Classical and Hellenistic art continued naturalism with greater emphasis on expressiveness.

The Etruscans were the most significant civilization of the Italian peninsula prior to Rome.

Rome had two main periods, the Republic and the Empire. Many fine examples of Roman architecture are still standing, such as the Colosseum and Pantheon. Roman art developed traditions in realism and classicism, influenced by Greek art.

Selected Readings

Amiet, Pierre. *Art of the Ancient Near East.* New York: Abrams. 1980.

Brilliant, Richard. *Arts of the Ancient Greeks.* New York: McGraw Hill. 1973.

Groenewegen-Frankfort, H. A., and B. Ashmole. *Art of the Ancient World.* New York: Abrams. 1975.

Krautheimer, Richard, and Slobodan Curcic. *Early Christian and Byzantine Architecture.* 4th ed. New York: Penguin. 1986.

Smith, William Stephenson, and W. K. Simpson. *The Art and Architecture of Ancient Egypt.* rev. ed. New York: Viking. 1981.

Strong, Donald, and Roger Ling. *Roman Art.* 2nd ed. New York: Penguin. 1988.

8

Medieval Art

313 Edict of Milan legalizes Christianity in Rome

ca. 333 Old Saint Peter's begun in Rome

527–565 Justinian is Byzantine Emperor; San Vitale is built in Ravenna and Hagia Sophia in Istanbul (Constantinople)

600–800 Golden Age in Ireland

726–843 Iconoclastic Controversy in Byzantium

768–814 Charlemagne; Holy Roman Empire founded

1068 Saint Etienne at Caen begun

1095–1099 First Crusade conquers Jerusalem

ca. 1140 Abbot Suger designs the Abbey Church of Saint Denis

1145–1220 Building of Chartres Cathedral

1202–1204 Fourth Crusade conquers Constantinople

The term Medieval *refers to the period called the Middle Ages, spanning the years between the Ancient period and the Renaissance (ca. A.D. 400–ca. 1400). Normally the study of art of the Middle Ages concentrates on developments in the West, after the fall of Rome. Christianity came to dominate and spirituality replaced the material emphasis of the earlier Roman world. The centers of cultural importance shifted in Western Europe away from Rome and Italy to the northern European provinces of the former Roman Empire.*

In addition to Christian developments in Europe, the Islamic world emerged in the Middle East and its impact was felt stylistically in the Christian West (see chapter 13).

EARLY CHRISTIAN AND BYZANTINE ART

The later years of the Early Christian era through the Byzantine period correspond in time to the Middle Ages in Western Europe. However, textbooks differ with regard to their proper placement in art history. (Some argue that rather than being considered part of the new Christian era along with other developments of the Middle Ages, they might instead be viewed as the final, Christian phase of antiquity).

The term *Early Christian art* refers to any Christian art produced during about the first five hundred years following the religion's origin. It is not a stylistic designation, as is the term *Byzantine art*, which refers specifically to the style of the Eastern Roman Empire. There are no sharp lines marking the stylistic boundaries between Early Christian and Byzantine art, but some Early Christian art anticipates the stylistic emergence of the Byzantine style.

Early Christian Art

Little survives of the early Christians' art prior to the fourth century, when the Emperor Constantine declared Christianity the official state religion of the Roman Empire.

CATACOMBS

Before this time, Christians worshiped privately in homes and in chapels within the catacombs, extensive secret underground tunnels used as cemeteries. Catacomb chapels were decorated with frescoes that were stylistically similar to Late Roman murals, though they were generally sketchy and less skillful in execution.

EARLY CHRISTIAN PAINTING

Frescoes adorning chapel domes, featuring modeled and foreshortened figures in classical garb and landscape details, bear evidence of the influence of earlier Roman illusionism; but the symbolic content was altered by assigning new meanings to earlier Roman motifs.

SYMBOLISM

Grapes, for example, originally associated with Bacchus, the god of wine, now referred to the blood of Christ and the promise of salvation. The fish was the symbol of Christ. Birds represented Christian souls. A lamb might represent Christ, his Apostles or his Christian followers in general.

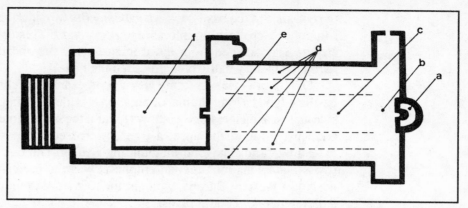

Fig. 8.1 Early Christian Basilica (diagram based on plan of Old Saint Peter's in Rome, ca. early 4th century): (a) apse, (b) transepts, (c) nave, (d) side aisles, (e) narthex, (f) atrium.

These and various other subjects were incorporated from Roman art and redefined into a Christian context. The cross by itself (an instrument of Roman executions rather than an attribute of pagan art) became a symbol of Christ and his crucifixion. In general, the paintings and mosaics which adorned Early Christian chapels and churches related to the theme of Christ's life, death, and resurrection.

The Good Shepherd. The subject of a young, beardless Christ as the Good Shepherd is often found in Early Christian paintings, mosaics, and sculptures. The theme sometimes depicted a young man standing with a lamb draped over his shoulders (an image which can be traced back at least to Greek times). At other times Christ was depicted as a shepherd surrounded by his flock of lambs, as in the fifth-century mosaic of *The Good Shepherd* at the Mausoleum of Galla Placidia in Ravenna. In this Early Christian mosaic, much of the three-dimensional character of earlier Roman painting has been retained in the use of modeling and foreshortening, as well as in the naturalistic handling of the drapery folds of Christ's Roman tunic.

OLD SAINT PETER'S IN ROME

After Christianity was recognized as the official state religion in Rome, there was a need for new places of public worship. Christianity required congregational meeting halls which, unlike Roman temples, were large enough to allow many worshipers within their interiors. Therefore, instead of relying on the form of the Roman temple as the basis of Christian church design, the basilica (a secular Roman public hall) was adapted for use.

The Church's Plan. Originally the Roman basilica had apses at both the eastern and western ends, and the main entrance was on the long side. The Christian basilica, however, retained only the eastern apse to hold the altar; the main entrance was placed at the western end (Fig. 8.1). Preceding

the entrance to the basilica was a gateway (its form derived from the Roman triumphal arch) leading into an open courtyard. This courtyard, called the atrium, was adapted from the Roman house. Beyond the atrium was the narthex, an entry hall which preceded the nave.

Old Saint Peter's in Rome was a good example of this type of Christian basilica. It had a longitudinal orientation, a wide, high nave flanked by lower side aisles, and clerestory windows to light the nave's interior. At the eastern end, just prior to the apse, a transept crossed the nave and side aisles, extending "arms" beyond the building's sides. The result is called a Latin Cross plan. This longitudinal emphasis was the preferred form of church design in Western Europe, while in the Eastern Byzantine world there was a preference for central plans.

Byzantine Art

Following the fall of the Roman Empire in the West, the Eastern realm continued as the Byzantine Empire. The name Byzantine is taken from that of the ancient city of Byzantium (present-day Istanbul), renamed Constantinople after the Emperor Constantine moved the Empire's capital there in the fourth century. The transition from Early Christian to Byzantine art occurred during the fifth and sixth centuries. A more flat, abstract, and symbolic style, stressing otherworldly spiritual qualities, emerged in contrast to the naturalism retained from the Roman past in Early Christian art.

SAN VITALE IN RAVENNA

Ravenna, a city on Italy's Adriatic coast, was a major center of development in Byzantine art. During the reign of the Byzantine emperor Justinian, an impressive building campaign was undertaken in Ravenna. The church of San Vitale was constructed in the sixth century.

San Vitale's Plan. San Vitale is a domed, octagonal church with a central plan. As was characteristic of Byzantine churches, the exterior of San Vitale is rather plain and nonornate, but on its interior there is a lavish display of mosaic decorations, including a portrait called *Emperor Justinian and His Attendants*.

Mosaics. The abstracted figures are elongated, with dangling feet. The illusion of volume is deemphasized in favor of a more spiritual effect with less regard for tangible physical reality. The shimmering light reflected off the glass mosaic reinforces this dematerialized quality.

HAGIA SOFIA IN CONSTANTINOPLE

Also built in the sixth century during the reign of Justinian, Hagia Sophia was constructed on a grand scale comparable to the great monuments of ancient Rome.

Hagia Sophia's Plan. Hagia Sophia was built with a central plan and a massive dome measuring about 108 feet in diameter and rising about 180 feet from the floor. The great dome rests on four corner piers set within the squared space below it, connected by means of a pendentive system (see chapter 5).

Despite the immense scale of the dome, it appears to hover gracefully in the air due to the ring of arched windows around its base. These admit light in a way that creates the illusion of the dome floating on a glowing cushion. Throughout the building, light entering Hagia Sophia's interior creates an airy effect which reinforces its spaciousness.

ICONOCLAST PERIOD

In 726, the Byzantine emperor issued an edict banning religious images. For more than a hundred years, only abstract symbols, such as the cross and floral patterns, were officially permitted in Byzantine church decorations. The imperial ban ended in 843.

LATER BYZANTINE ART

Churches. While Hagia Sophia's grandness of scale reflected an imperial quality, later Byzantine churches were generally more modest in scale and monastic in spirit. The favored design form was the Greek cross, a central plan in which the main focus on the interior remained the centralized dome. Around the dome projected four "arms" of equal length which formed the Greek cross. The largest and most elaborately decorated of later Greek cross plan Byzantine churches was Saint Mark's in Venice, begun in 1063.

Religious Art. Following the lifting of the imperial ban against religious art, the formal and abstract traditions of Byzantine style were at times united with more emotionally expressive qualities in figurative images.

Christ as Pantocrator. This trait is evident in the images of Christ as Pantocrator (stern judge of humanity) decorating interior domes. A good example is the eleventh-century dome mosaic in the monastery church at Daphni, Greece. Here Christ the Pantocrator stares down at the worshiper, as if in judgment of the soul. His awe-inspiring nature seems more suggestive of a stern God the Father than of a sympathetic and kind Jesus, whose traditional physical characteristics are portrayed in this mosaic.

THE DARK AGES

The entire Medieval period was once referred to as the Dark Ages. The basic concept behind this term was negative. It defined the period when Classicism dimmed in Europe, following the decline of the Roman Empire,

through its reemergence in the Renaissance. Today the period of the "Middle Ages" is viewed more positively as an "age of faith" and the term *Dark Ages* is narrowed to include the sixth and seventh centuries, defining the period between the end of Justinian's rule to the time of Charlemagne. During this time the center of European culture shifted north of the Alps, away from Italy.

Early Medieval Art

During this period, the nomadic crafts traditions of migratory Germanic and Celtic peoples were reapplied in Christian art. This art was developed, for example, in the Hiberno-Saxon style by Irish monks who incorporated Pagan motifs with flat, interlacing patterns in manuscript illuminations, as well as in small metal and enamel crosses. Large scale art virtually disappeared (with the notable exception of large stone crosses produced in Ireland). Realistic or elegantly stylized portrayal of the human figure was not a part of Celtic and Germanic art.

The sources for this art are traceable to the animal style of ancient central Asia. The Scythians and other nomadic peoples brought the traditions into Europe from the east in the form of small-scale art forms, such as jewelry.

HIBERNO-SAXON STYLE

The Lindisfarne Gospels (ca. 700) and the Book of Kells (late eighth century) are good examples of Hiberno-Saxon style illuminated manuscripts. Their flat, decorative pages are filled with intricate linear patterns interlaced with snakelike hybrid animals, birds, and humans. The pages illustrate such subjects as jewel-colored crosses or large decorative letters. They are totally free of the illusionistic and realistic concerns of earlier Roman art. Perhaps this was because the Irish people who produced them had never been subjected to Roman rule and cultural influence.

CAROLINGIAN ART

In the late eighth century, a Germanic ruler, Charlemagne, attempted to restore the Western Roman Empire. He chose the German city of Aachen as his capital. This city was roughly centered in his new Holy Roman Empire, which at its height encompassed present-day France, Germany, Belgium, the Netherlands, and a large part of Italy.

While dedicated to a rebirth of Roman classicism in the arts, the Holy Roman Empire was also unified through belief in Christianity. The Pope crowned Charlemagne Holy Roman Emperor in the year 800. The period of Charlemagne's rule was the first important attempt to fuse the Celtic and

Germanic world with that of the Mediterranean found in Byzantine as well as earlier Roman civilization.

The unity that Charlemagne achieved, however, did not last long. His empire was divided by his grandsons. Only after the death of the last Carolingian monarch in 911 was a sense of effective, centrally administered rule reestablished. At that time the Saxon kings (919–1024) transformed present-day Germany into the leading political and cultural center of Europe. During this Ottonian period (named after the Saxon kings: Otto I, Otto II, and Otto III), a serious attempt resumed to restore Charlemagne's imperial ambitions regarding a revival of classicism in the arts.

Carolingian Architecture

PALATINE CHAPEL OF CHARLEMAGNE AT AACHEN

Charlemagne's Palatine (palace) Chapel was built between 792 and 805. It was designed with a central plan and dome, reminiscent of the sixth-century Byzantine church of San Vitale in Ravenna. Unlike the Byzantine church, however, its interior did not convey a sense of light and airy openness. Instead there is a blocky quality in the heavy stone arches and supports. The Carolingian building's massive forms are sharply articulated in contrast to the spatial fluidity evident in Byzantine architecture. The ambulatory in Charlemagne's Palatine Chapel is more distinctly a circular passageway than is the ambulatory at San Vitale. The stonework defining the architectural interior space of the Carolingian building is more geometrically solid in character. The massive and monumental qualities are very unlike those found in Byzantine architecture, and appear more like those of earlier Roman architecture.

Illuminated Manuscripts

The copying of Late Roman and Early Christian manuscripts was actively encouraged during the Carolingian period.

CHARLEMAGNE'S GOSPEL BOOK

In Aachen a classical style was developed as seen in Charlemagne's own gospel book, the *Coronation Gospels* (ca. 800–810). On its pages are representations of toga-clad Evangelists, confidently foreshortened and modeled to create an effective illusion of three dimensionality.

EBBO GOSPELS

Sometimes the semi-barbaric traditions of Celtic and Germanic art interfaced the classical style in manuscript illuminations. *The Gospel Book of Archbishop Ebbo of Reims* conveys a sense of restless, nervous energy in emotionally charged renderings of the Evangelists. The effect is more expressive of religious feeling than of the classical restraint evident in Charlemagne's gospel book.

ROMANESQUE ART

The term *Romanesque* applies to the art produced in Western Europe from about 1050 to 1200. In a feudal society, monasteries had become increasingly important, offering shelter from the hostile world and the promise of salvation. At the same time they became centers for education. At a point when Europe lacked strong centralized administration, the Church took on major importance, helping to bring about unity through Christianity. It partially achieved this by means of the Crusades. Also, large portions of the population now traveled great distances because pilgrimages to religious shrines had become an important part of Christianity. Large pilgrimage churches were constructed along the routes of such journeys. In general, churches were enlarged to accommodate larger groups of worshippers.

Romanesque Architecture

Considerable regional variations developed as Romanesque churches were built in France, Germany, Italy, Spain, England, and elsewhere in Europe. In France, the Church of Saint-Sernin in Toulouse appears quite different in many aspects of its design from the Norman Romanesque church of Saint Etienne in Caen. Overall, there is a heavier quality observable in the massive, round vaulted interior at Saint-Sernin. At Saint Etienne ribbed groin vaulting creates a skeletal support system (see chapter 5) that lightens the weight of the ceiling. Despite their differ-ences, both buildings appear basically Romanesque in style because of key stylistic features in common with each other, as well as other Romanesque churches throughout Europe.

CHARACTERISTICS OF ROMANESQUE CHURCHES

Romanesque churches were designed with a wide nave and side aisles that favored the basilica plan of Early Christian times. Instead of a flat nave ceiling, a stone barrel vault (see chapter 5) was used. Generally, round, heavy stone arches and vaults are indicative of Romanesque construction, but pointed arches and vaults were sometimes used. As attempts were made to build to greater heights, the stone walls of Romanesque buildings had to become very thick. Window openings were small and limited so as not to weaken the strength of walls needed to support the heavy stone vaults. This made the interiors of Romanesque churches rather dark, though an attempt was made to provide light with clerestory windows in the upper nave walls (made possible because the nave rose higher than the roofs of the side aisles).

Following the precedent of earlier Carolingian architecture, the Romanesque church looked Roman in its massive heaviness, its clear articulation of separate parts, and its use of vaulting to open large interior spaces.

Romanesque Sculpture and Painting

Most Romanesque sculpture took the form of relief carvings for architectural decoration. These often served an important function in the adornment of Romanesque churches.

While narrative religious scenes were sometimes painted on interior nave vaults, the major form of painting continued to be manuscript illumination. Painting did not undergo as significant a change from the earlier Carolingian and Ottonian traditions as did sculpture.

ARCHITECTURAL SCULPTURE

Romanesque sculpture functioned interdependently with the architecture. Such sculpture was found on the capitals of columns and on the jambs and other spaces around doorways. Especially important was the tympanum, the large semicircular space above the entrance to churches. Within these spaces, sculptors illustrated lessons from the Bible and other Christian sources, as art became an important teaching tool of the Church to communicate with a largely illiterate public.

Most significant in relation to the Roman past was the impressive productivity in large-scale stone carving. This art form had virtually vanished during the Middle Ages until its revival in the Romanesque period. Stylistically, however, most Romanesque art does not look Roman in its basic character. The rules of classicism were largely abandoned in favor of a more emotionally expressive approach to style.

The Last Judgment at Autun. With classical canons regarding proportion and scale put aside, sculptors were free to stretch limbs and distort bodily form indiscriminately. They created grotesque demons torturing damned souls in Last Judgment scenes, as in the west tympanum of the church at Autun, in Burgundy, France (ca. 1130–1135). The figure of Christ appears in the center of the scene, enlarged through hierarchic scaling to indicate his importance on Judgment Day. Around him the damned are condemned to hell while the blessed enter heaven.

Christ of the Pentecost at Vezelay. In the tympanum at the Abbey Church of La Madeleine at Vezelay, France (ca. 1120–32) the subject is Christ of the Pentecost. Here the expressively elongated and twisted figures of the Apostles appear to be in a frenzied state. Surrounding them is the enlarged central figure of Christ, whose outstretched hands project rays of light, powerfully communicating the message to spread the word of the Gospels throughout the world.

GOTHIC ART

The growth of cities continued at an ever-increasing rate. Eventually universities and cathedral schools replaced rural monasteries as centers of education. The city's importance as the pathway to the future was soon reflected in major building projects such as larger, taller Gothic cathedrals which echoed the civic pride of competing towns. They were also indicative of the growing power of the city clergy, especially bishops.

The Gothic was at first only an architectural style, and the developments in this area remained its most vital ones until about 1250. Then major developments followed architecture in sculpture, and eventually painting, especially in the fourteenth century in Italy.

Gothic Architecture

While the Gothic style played a major role in urban developments, its actual invention was associated with an abbey church outside the city of Paris. Originating in the Ile-de-France region (the vicinity of Paris) about 1140, the Gothic style spread from there to all of France and within a hundred years it covered Europe.

STYLISTIC CHARACTERISTICS OF THE GOTHIC

Gothic architecture acquired more diverse regional characteristics as it spread across Europe. Despite regional variations, there are general characteristics denoting the Gothic mode. These include the use of pointed arches and pointed ribbed groin vaults along with flying buttresses. With these structural elements, buildings could be erected beyond any heights achieved in the Romanesque period. The use of a skeletal support system allowed for a considerable lightening in the weight of stone ceiling vaults and of the walls between engaged piers that bore the weight of ceilings. This system permitted the opening up of walls for large stained-glass windows. At times this created the effect of walls of translucent color rather than windows. As light filled the interior of a Gothic church, it radiated a transcendent spiritual glow. This created an atmosphere very different from the dark and austere quality of Romanesque interiors.

LATE GOTHIC

Late Gothic architecture (called the Flamboyant Gothic) is not so highly rated critically as are the earlier developments within this medium. In the later stage of the Gothic style, churches were very fanciful and profusely decorated with flamelike patterns of tracery and other intricate ornamental stonework carving. However they were not as impressive in scale as the major cathedrals of the twelfth and thirteenth centuries.

FRENCH GOTHIC ARCHITECTURE

Abbey Church of Saint-Denis. The invention of the Gothic style is credited to the Abbot Suger who conceived a more unified design for his abbey church about 1140. All that survives today of the original concept is found in the church's ambulatory. The design of this space included pointed ribbed vaults and light upright supports that suggested a continuous open space quite unlike the articulated, segmented quality of a Romanesque interior. Suger also made generous use of stained-glass windows to convey the idea of divine light.

Notre-Dame de Paris. The Cathedral of Notre-Dame in Paris was begun in 1163 but was not completed until about 1250. Unlike Saint-Denis, which was an abbey church intended to serve the needs of rural monks, Notre-Dame was erected for an urban community. Relying on a longitudinal plan, it retains the form of a basilica. Its interior space, which includes a double ambulatory, is conceived as a unified organic whole rather than an arrangement of segmented parts (as in the Romanesque tradition). On the exterior, flying buttresses support the interior skeletal framework, while playing an important decorative function.

Chartres Cathedral. Begun in 1145 in the Early Gothic style, Chartres was largely destroyed by fire in 1194. All but its western facade was reconstructed, mainly over the next twenty-six years—a rather brief construction period for this type of building. The interior nave is regarded as the first masterpiece of the High Gothic style. Its architectural supports and arched openings are proportionally more graceful and slender compared with those of Notre-Dame de Paris. Also, the idea of verticality is more emphasized at Chartres.

Chartres is unique among the major Gothic cathedrals in that most of its original stained-glass survives. Here, a magical sense of poetic lighting is conveyed upon the interior space.

GOTHIC ARCHITECTURE OUTSIDE OF FRANCE

England. As the Gothic style spread to areas outside of France, it acquired regional differences. In England, the Early Gothic style seen in Salisbury Cathedral retained some of the segmented blockiness of Romanesque architecture, despite its use of pointed ribbed vaults. Furthermore, its orientation stressed the horizontal more than the vertical.

The later High Gothic mode in England was called the Perpendicular style. It was more like the French Gothic in its emphasis on verticality and a unified (rather than segmented) interior space, but it still looked different from the French style. The ribbed ceiling vaults used in French Gothic architecture multiplied in the English Perpendicular style. Intricate decorative networks of ribs unified vaulted nave interiors, as seen in Gloucester Cathedral (1332–1357).

Italy. The Gothic style in Italian architecture resisted many aspects of the French Gothic style. In Italy, pointed arches were often used in conjunction with flat nave ceilings. While pointed ribbed vaults were used at Florence Cathedral (begun 1296), the classical exterior still did not look Gothic. Instead, the inlaid geometric patterns adorning its solid walls seem more inspired by the Roman past. (The impressive dome of Florence Cathedral will be discussed in the next chapter because it was constructed in the fifteenth century, during the Early Renaissance).

Gothic Sculpture

Sculpture continued to play an important role as architectural decoration in the Gothic period. While the Last Judgment remained an important theme, overall the religious message communicated to the public in Gothic sculpture was more positive and optimistic. Unlike the Romanesque period, when dogmatic instruction in stone carving stressed the idea of damnation, Gothic sculpture emphasized the hope of salvation. Naturalism emerged in sculptural representation, in contrast to the distortions of form often found in Romanesque carvings.

CHARTRES

Early Gothic sculpture at the west portals of Chartres Cathedral survived the fire of 1194 and continued to serve as architectural adornment after the rest of the church was rebuilt in the High Gothic style. Unlike the crowded and disjointed compositions of Romanesque sculpture, there is a sense of symmetry and order in the relief carvings at Chartres' west portals. The arrangements of weighty figures are more rationally conceived. The jamb statues (representing prophets and Biblical kings and queens) attached to the columns of doorways depart from Romanesque tradition in the way they protrude, deeply carved away from the columns behind them. They seem almost ready to detach themselves and become sculpture in the round. Yet, at the same time, the sculptures are elongated and abstracted. As rigid cylindrical figures, they visually echo the shapes of the columns to which they remain attached.

Although the west portals at Chartres survived destruction by fire, the rest of the cathedral had to be rebuilt. Here we can observe the development of sculpture, as well as architecture, from the Early Gothic into the High Gothic. During the High Gothic period, a greater sense of naturalism developed. Jamb figures protrude so strongly that they tend to hide their column supports. Sometimes stone canopies were placed above the figures, to highlight and suggest the sculptures' autonomy from the architecture they adorn. An S curve resembling classical contrapposto is sometimes evident in the figures' torsos.

Visitation and Annunciation Groups at Reims. The full blown development of Gothic classicism is evident in the Visitation group at Reims Cathedral (ca. 1225–45). Here a sense of weightiness appears in the classically draped figures of the Virgin and Saint Elizabeth. Next to the Visitation group the Virgin appears, accompanied by the angel of the Annunciation. The rather rigid figure of the Virgin is done in an earlier thirteenth-century style than that of the angel. The angel, who was done in what has been called the elegant style, has its characteristic small head, sensitively rendered tight-lipped smile, and a gentle S sway to the slender body.

Gothic Painting

Gothic painting became more innovative during the thirteenth and the fourteenth centuries. This was particularly evident in Italy. While in northern Europe, Gothic painting was primarily confined to small-scale illuminated manuscript pages, the Italians developed a tradition of large-scale panel and fresco painting. Some of the painters of this period might be viewed as forerunners of the Renaissance, among them Cimabue, Duccio, and Giotto. Since their work might be considered proto-Renaissance rather than Gothic, it will be discussed in the next chapter.

INTERNATIONAL STYLE

After Italian Gothic painting began to influence Gothic art north of the Alps, there occurred a period of stylistic unity in the art of northern Europe and Italy. During the time of this so-called International Style, Gothic art both to the north and south of the Alps began to look rather similar. Important innovations in realism occurred at this time as can be seen in the work of the Limbourg brothers, Flemish painters who will be discussed in the next chapter.

Even prior to the development of the Early Medieval period in northern Europe, Early Christian art had emerged within the Roman Empire. It was perpetuated in the Byzantine Empire (the Roman Empire's eastern half), which endured throughout the years of the Middle Ages. In Byzantine art, the naturalism of Roman art was replaced with a more abstract style that emphasized the spiritual rather than the material world.

Early in the Medieval Period, during the so-called Dark Ages, migratory Germanic and Celtic peoples produced a decoratively flat and abstract art, very unlike earlier Roman art. Attempts were made later to revive illusionistic and other classical aspects of the Roman aesthetic in art and architecture during the Carolingian, Ottonian, and Romanesque periods. The basic character of this Medieval art, however, was not classical. During the last stage of the Middle Ages in northern Europe, the Gothic period introduced new ideas regarding architectural construction and ar-

tistic style. A style of architecture favoring pointed vaults developed, along with greater naturalism in sculpture and painting.

Selected Readings

Beckwith, John. *Early Medieval Art: Carolingian, Ottonian, Romanesque*. New York: Oxford University Press. 1974.

Holt, Elizabeth G., ed. *A Documentary History of Art Vol. 1: The Middle Ages*. Princeton: Princeton University Press. 1981.

Male, Emile. *Religious Art in France: The 13th Century—A Study of Medieval Iconography and Its Sources*. Princeton: Princeton University Press. 1984.

Snyder, James. *Medieval Art: Painting, Sculpture, and Architecture: 4th–14th Century*. New York: Abrams. 1989.

Stoddard, Whitney. *Art and Architecture in Medieval France*. New York: Harper and Row. 1972.

Zarnecki, George. *Art of the Medieval World*. New York: Abrams. 1975.

9

Renaissance and Baroque Art

ca. 1305–1306	Giotto paints Arena Chapel frescoes in Padua
1309–1376	Exiled Popes in Avignon, France
1347–1350	Black Death in Europe
ca. 1400	Beginning of Renaissance in Florence
ca. 1425	Masaccio paints the *Trinity Fresco* in Florence
1425–1432	*Ghent Altarpiece* begun by Hubert van Eyck and completed by his brother Jan van Eyck
1430-32	Donatello executes his nude *David*
1453	Constantinople falls to Turks
1492	Columbus sails to America
1495–1498	Leonardo da Vinci paints the *Last Supper* in Milan
1508–1512	Michelangelo paints the Sistine Ceiling in Rome
1517	Martin Luther posts 95 theses in Germany
1534	Henry VIII founds Anglican Church in England
1534–1563	Council of Trent to reform Catholic Church
1597–1601	Annibale Carracci paints Farnese Palace ceiling
1609	Galileo invents the telescope
1625	Bernini executes his *David*

1661–1715 Louis XIV is absolute monarch in France

1687 Isaac Newton proposes his theory of gravity

1717 Watteau is the first rococo painter admitted to the Royal Academy in France

The period called the Renaissance began in the fifteenth century when a more rational sensibility challenged the spirit of faith that had characterized the Middle Ages. The Renaissance was in a sense a revival of artistic forms developed in ancient Greece and Rome. It was also a period of great inventiveness, both technically and stylistically. In contrast to the Renaissance, the Baroque was a development of the seventeenth century which embellished upon stylistic inventions of the Renaissance, transforming them into a more dynamically expressive mode. While Renaissance art was meant to be comprehended by the mind, Baroque art appealed more directly to the viewer's emotions.

In the broadest sense, the Renaissance can be viewed as a development occurring simultaneously in Northern Europe and in Italy and continuing until the dawn of the Modern period in the mid-eighteenth century. With this in mind, a continuity can be drawn between Renaissance and Baroque art. In a narrower sense, however, the Renaissance can be viewed more specifically as a stylistic period that originated in Tuscany, especially in Florence, in the early fifteenth century.

EARLY RENAISSANCE IN ITALY

Italians living on ancient Roman soil were especially interested in the rebirth of the classical traditions found in earlier Roman art and architecture. In adopting this new view, there occurred a break with the Gothic past. A different attitude also affected the concept of the artist, who in Italy was now elevated in status. No longer was the artist regarded as a mere artisan or craftsperson—as was the case in the Middle Ages. Visual art now began to be categorized among the liberal arts, rather than the mechanical arts.

This change in attitude soon spread to other parts of Italy. During the fifteenth century, this Italian development produced many significant painters, sculptors, and architects.

The Proto-Renaissance in Italy

Prior to the actual beginning of the Renaissance, Italian painters of the late thirteenth and fourteenth century pioneered new methods in the treatment of pictorial space. Some of their work might be viewed as anticipating the Early Renaissance.

CIMABUE

In Florence, Cimabue (ca. 1240–ca. 1302) was a major painter in the fresco medium. He also produced large-scale panel paintings, using tempera paint with gold leaf as the unifying background color. His severe and formal mode was referred to in Italy as the Greek manner, or the Neo-Byzantine style.

Madonna Enthroned **(ca. 1280–1290).** Cimabue's panel painting, *Madonna Enthroned*, represents the Virgin as the Queen of Heaven. The painting incorporated abstract Byzantine elements, as well as some Gothic traits (such as the gable shape of the panel) into a large-scale format. In its large size, it was unlike the smaller paintings executed in the Byzantine East. The weighty inlaid throne upon which the Virgin is seated looks very Roman in character.

DUCCIO

Siena rivaled Florence as an art center during the proto-Renaissance. Duccio of Siena (ca. 1255–ca. 1318) was a major innovator in panel painting who relaxed the conventions of the Neo-Byzantine style. Stressing a deeper pictorial space, he combined Gothic characteristics in his brightly colored and decorative panel paintings. In his placement of figures within architectural settings, Duccio was truly one of the major innovators of his time.

Maesta **(ca. 1308–1311).** Duccio's major achievement was an enormous altarpiece entitled the *Maesta (Majesty Altarpiece)*. It consisted of many panels arranged together. On its front, the main large panel represented the Virgin Enthroned, surrounded by many saints. On its back, and surrounding the main image on its front, were many smaller panels.

GIOTTO

Following Cimabue in Florence, Giotto (ca. 1267–ca. 1337) revolutionized the fresco medium. His painted figures were very solid and heavy in appearance. They were placed in the immediate foreground of his compositions to make them seen closer to the viewer, giving the impression that the spectator was at the event depicted. Giotto's paintings were considered very realistic and illusionistic for their time.

The Lamentation **at the Arena Chapel.** Giotto was a master of narrative drama, and there is a strong feeling of emotion evident in his paintings, as seen in the *Lamentation* from the fresco cycle at the Arena Chapel in Padua (ca. 1305–1306). Both the emotional quality and the weightiness of his figures were influenced by the Gothic tradition in sculpture.

SIMONE MARTINI

Duccio's student, Simone Martini (ca. 1284–1344) was a Sienese painter whose style combined the weightiness and emotional aspects of Giotto with the decorative color and spatial depth of Duccio. Martini

introduced his Italian style to northern Europe when he resided in Avignon, France (where the popes resided in exile through most of the fifteenth century). In doing so, he played a major role in the development of the International Style (discussed earlier in chapter 8).

The Fifteenth Century

The Early Renaissance was born in Florence, a mercantile and banking center, where growth in the arts was greatly encouraged by prominent families, especially the Medici. Humanism contributed much to a new spirit of the age. Florentines likened themselves to the ancient Greeks, and conceived of their city-republic as the "new Athens."

HUMANISM

The Early Renaissance in Italy was characterized by a new philosophy called humanism. This was based on a belief in the human being and on the worth of human achievements throughout history. Works produced by the ancient Greeks and Romans might be valued for their own sake, despite their pagan origins.

Sculpture

The first major developments of the Early Renaissance occurred in sculpture as the Gothic style gave way to a revival of classicism. Roman sculpture provided greater inspiration as naturalism and realism reemerged.

THE NUDE

Throughout the Middle Ages, the idea of "nakedness" had prevailed, suggesting that shame accompanied being unclothed. With the Early Renaissance a new humanistic attitude emerged that viewed the beauty of human anatomy with appreciation. This idea of the "nude" implied the unclothed state as a normal and healthy one.

GHIBERTI

A transition from the International Style to the Early Renaissance can be seen in the work of Ghiberti (1378–1455). His gilt bronze panel, *The Sacrifice of Isaac* (ca. 1401–1402), was the winning entry in a competition for the bronze doors of the Baptistry of Florence. This panel exemplifies Ghiberti's development into the Early Renaissance style. The Classical concept of the nude was revived in the torso of Isaac.

DONATELLO

The most important innovator of the Early Renaissance style in Florentine sculpture was Donatello (ca. 1386–1466). He studied the human form carefully and his early marble sculptures restored the true essence of Classical contrapposto. His weighty figures, even when adorning architecture as statues in niches, were freestanding and no longer seemed dependent on their architectural settings. Donatello's draped figures were conceived as

"clothed nudes," their drapery handled in a convincingly natural way, appearing to flow over bodily structure.

David. Donatello's bronze statue *David* (ca. 1430–1432) was the first freestanding lifesize nude since Roman times. It was idealized, but departed from the Greek concept of the mature male athlete. Instead David appears as a softer-fleshed young boy standing on the head of Goliath. His nudity is reinforced by his being clad only in boots and a fancy hat. A representation such as this would have been inconceivable during the Middle Ages.

Sculpture After Donatello. Donatello greatly influenced the future of Renaissance sculpture, but after his departure from Florence to seek employment in Padua in 1443, no other sculptors of Tuscany took his place in importance.

VERROCCHIO

The only later Early Renaissance sculptor to compete with Donatello's broad range and productive accomplishment was Andrea del Verrocchio (1435–1488). His art, produced in the second half of the fifteenth century, was molded by a different aesthetic than that of Donatello's day. Emphasis was placed on representing the body in motion. Anatomical details were also stressed more, sometimes to the extreme of defining veins, muscles, and sinews beneath the flesh. This probably resulted from investigations of anatomy through dissections of cadavers.

Architecture

Architecture of the Early Renaissance was inspired by Roman antiquity. The Classical orders were fully restored and the pointed forms of the Gothic were no longer used for arched openings. Classicism had remained a strong force in earlier Italian Medieval architecture, especially in the Romanesque period, and Italian architects had only halfheartedly embraced the Gothic style (see chapter 8). Aside from reviving architectural forms of the Roman past, the Renaissance also introduced new architectural concepts and methods.

BRUNELLESCHI

The Renaissance style in architecture was originated by an individual, Filippo Brunelleschi (1377–1446). Originally a sculptor, he abandoned the medium after he lost to Ghiberti in the competition for the Florence Baptistry bronze doors in 1402. Turning attention to the study of ancient Roman monuments, he may have been the first to do careful measurements of them. His new Renaissance style emerged out of his study of earlier Roman buildings, but his conceptions involved much more than merely copying Roman sources. Brunelleschi's original designs for churches were based on a rational regard for harmonious proportions, combining inventiveness in engineering with architectural forms derived from the classical past. In

addition to designing architecture, Brunelleschi is historically credited as the inventor of scientific perspective, which had a major impact on Italian Renaissance painting.

Florence Cathedral Dome (1420–1436). Though it was begun in 1296, Florence Cathedral remained unfinished in the early fifteenth century. Brunelleschi was commissioned to design its huge dome, which was so immense that it posed construction problems. It was a major engineering feat, requiring creative solutions. Brunelleschi invented a double-shell construction method by which a smaller interior shell helped to suspend the larger exterior dome. This plan marked a break in attitude from that of a Medieval builder who would have relied more on conventional practices in attempting the construction of a single heavy, massive dome.

Other Designs by Brunelleschi. The full blown Early Renaissance style is more evident in Brunelleschi's churches such as San Lorenzo (begun in 1421) and the Pazzi Chapel (begun 1430). The Hospital for Foundlings (1419–1424) is another good example. Characteristic features are the use of round arches, barrel vaults, and domes. Careful regard for pleasing proportions is also evident in his use of graceful Classical columns, such as the slender Corinthian order he often favored. In an interior designed by Brunelleschi, one is pleased by the calm and serene beauty of Classical arcades, inlaid marble paneling and other detailing arranged with a cool, disciplined regard for orderliness and stability. It is very unlike the warm, emotional quality found earlier in Gothic architecture.

ALBERTI

A major figure in the mid-late fifteenth century, Leone Batista Alberti (1404–1472) was the most important architect following the death of Brunelleschi. Alberti did not begin to practice architecture until he was in his forties. He was a true humanist, highly educated in classical literature and philosophy. He carefully studied ancient Roman monuments, as had Brunelleschi earlier. In addition to designing churches and palaces, Alberti composed the earliest Renaissance treatises on architecture and on painting.

Palazzo Rucellai (1446–1451). Alberti's Palazzo (palace) Rucellai made use of superimposed orders (Classical orders placed one above another on the surface of the wall of a building of several stories). The Doric order was used on the first level for flattened columnlike forms called pilasters. On the second story the capitals of the pilasters were Ionic. Above them on the third level were Corinthian pilasters. The basic scheme was taken from the use of superimposed orders on the ancient Colosseum in Rome (see chapter 7).

Painting

Early Renaissance painting did not appear until the 1420s, after painters began to look seriously at Donatello's sculpture. The architecture of Brunelleschi also contributed to the development of the new style in painting, as painters depicted Classical buildings in their art.

FRESCO AND TEMPERA

The major painting media emphasized by Italian painters were fresco and tempera (for use in panel painting). Oil painting, a preferred medium in northern Europe at this time, was not developed in Italy until the end of the fifteenth century.

MASACCIO

The emergence of a new style in Renaissance painting can be seen in the work of Masaccio (1401–1428). Building upon the Florentine tradition in fresco painting going back to Giotto, Masaccio rekindled the growth of illusionism. Masaccio made use of solidly modeled figures, which had a very weighty appearance. He painted his figures as though lighted from a single consistent source and used cast shadows to heighten his three-dimensional illusion. From Donatello he took the idea of the clothed nude and applied it to painting. His figures display contrapposto as do Donatello's statues.

Trinity **Fresco (ca. 1425).** The *Trinity* fresco at Santa Maria Novella in Florence presents the figures of God the Father standing behind Christ on the cross, flanked by the Virgin and Saint John. They appear within the painted illusion of a vaulted niche, derived from Brunelleschi's architecture. The figures are three-dimensionally solid, and their draped forms bear resemblance to statues by Donatello. The space in the *Trinity* fresco was constructed by means of the newly invented scientific perspective. Using one-point perspective, an exact and consistent rendering of depth was achieved whereby the scene appears to be a logical extension of the viewer's own space.

FRA FILIPPO LIPPI

Fra Filippo Lippi (ca. 1406–1469) was among the panel painters in Florence who were influenced by Masaccio. While Lippi's painting bears similarity to Masaccio's in the solidity of form given to figures, linear qualities are more apparent; so, too, is a sense of movement in the figures.

PIERO DELLA FRANCESCA

The solidity of form found in the work of Masaccio is reinforced in the art of Piero della Francesca (ca. 1420–1492). Piero's frescoes in San Francesco in Arezzo indicate his allegiance to Masaccio's aesthetic yet reveal a greater passion for geometric structure. The human figure is

rendered with solid geometric shapes such as the sphere, cylinder, and cone in mind.

MANTEGNA

The early Renaissance style of painting as begun by Masaccio in Florence gradually spread to other parts of Italy, eventually affecting Andrea Mantegna (1431–1506) in the northern Italian city of Padua. Mantegna was the major heir of Masaccio's style in the second half of the fifteenth century. He, too, conceived of his painted figures as nudes who were clothed, and he made strict use of scientific perspective. Both concerns were apparent in his fresco *St. James Led to His Execution* (ca. 1455) in the Ovetari Chapel of the Church of the Eremitani in Padua (destroyed 1944).

Also indicative of Mantegna's regard for perspective is his extremely foreshortened depiction of the *Dead Christ* (ca. 1466), which displays the subject with startling realism, conveying a strong emotional impact to the viewer.

BOTTICELLI

In the second half of the fifteenth century, much of the solidity of form favored in the figurative style of earlier Renaissance painters had given way to a preference for a more linear style. Figures in painted compositions gave an illusion of depth more like relief sculpture than that of solid figures in the round. This can be observed in the work of Sandro Botticelli (1445–1510).

The *Birth of Venus* (ca. 1480). Botticelli was the heir of Fra Filippo Lippi's linear handling of the figure in motion. A sense of movement is conveyed by Botticelli's mythological figures in his *Birth of Venus*. Modeling in lights and darks is de-emphasized and the figures' forms are defined more through contour line.

The mythological theme was an important issue at this time, reflecting a new philosophy called Neoplatonism (which was strongly affecting humanist circles in Florence). According to this philosophy, all human thought, Christian or pagan, was regarded as divinely inspired. This permitted Botticelli to paint the subject of a life-size nude Venus, although the theme derived from Roman mythology and was therefore pagan. Another interpretation of the theme is as an allusion to Christian equivalent subject matter. For example, Venus might be seen as the pagan equivalent of the Virgin. Prior to Botticelli's time themes outside of straightforward Christian subject matter would have been unthinkable. Even in Botticelli's day pagan themes were still controversial outside of humanist circles.

THE HIGH RENAISSANCE

The period from about 1495 to 1520 is called the High Renaissance. During this time a small number of artists dominated Italian art. They were considered creative geniuses and were thereby able to achieve fame during their lifetimes.

Leonardo da Vinci

In addition to being a painter, Leonardo da Vinci (1452–1519) had capabilities as a sculptor as well as an architect. He was also a practicing engineer, surveyor, and inventor. A person of high intellectual capacity, his notebooks recorded many scientific observations of the natural world. These included anatomical drawings that laid the foundation for modern medical illustration. He truly characterized the concept of the creative genius during the High Renaissance.

CHIAROSCURO

Leonardo invented a new concept of form in painting. Instead of defining a figure by first drawing its linear boundaries, as a contour within which modeling could embellish the appearance of solidity, he used lights and darks alone to give definition to his forms. This method is called chiaroscuro.

THE MADONNA OF THE ROCKS (ca. 1485)

In Leonardo's two versions of *The Madonna of the Rocks*, the Virgin and Child, accompanied by an angel and the infant Saint John the Baptist, are arranged within a stabilizing triangular composition.

Sfumato. The figures are painted against a dark background suggestive of a rocky grotto, their softly defined forms gently emerging as if enveloped by a mist. The term *sfumato* (meaning "up in smoke" in Italian) is used to describe Leonardo's very subtle form of chiaroscuro. Another example of Leonardo's sensitive use of sfumato is his most familiar painting, *Mona Lisa*.

THE LAST SUPPER (1495–1498)

Leonardo's *Last Supper* at Santa Maria delle Grazie in Milan, though an artistic success, was a technical failure. Painted on a dry wall with an experimental mixture of tempera and oil paint, it began to deteriorate very shortly after its completion. In spite of this, the *Last Supper* is one of Leonardo's most important works.

Composition. The composition's architectural space was organized within a one-point perspective system. The solidly modeled figures of Christ and his disciples appear as if they are reliefs within a frieze. The decision to place all of the disciples on one side of the table with Jesus was a

compositional invention of Leonardo. Traditionally, Judas appeared on the opposite side of the table. Here he is identified because he leans slightly forward with his face in shadow. The disciples, grouped in threes, communicate through gestures. Christ is situated in the middle of the composition. The vanishing point of the one-point perspective scheme falls upon his head, which is also the focal point of the picture. Christ's importance in the composition is further reinforced by his placement against an open window which encompasses him like a halo.

Bramante

The major architect of the High Renaissance was Donato Bramante (1444–1514). His grand conception of vast architectural space was innovative. It was also rather Roman in character. A major project, which was not completed according to his original plans, involved the design in 1506 of a new Saint Peter's (replacing the fourth-century building from the Early Christian period).

Michelangelo

The Florentine sculptor Michelangelo Buonarotti (1475–1564) was also extremely gifted as a painter and architect. While the concept of artistic genius might apply equally to him as to Leonardo da Vinci, in many respects they were opposite personalities as well as rivals.

Painters and sculptors have traditionally been rivals. Painters like Leonardo were masters of illusion (making two-dimensional surfaces appear three-dimensional), while sculptors were concerned with real space. A painter such as Leonardo took pride in the genteel nature of his craft. Unlike Leonardo, a sculptor such as Michelangelo had to handle heavy stone slabs and chisel the material away. This generally involved intense labor, requiring the wielding of heavy hammers to chip away the marble blocks.

DAVID (1501–1504)

The marble statue *David* was commissioned when the artist was twenty-six years old. The thirteen-foot-tall nude figure was placed outside on public view as a patriotic symbol of the Republic of Florence. The athletic appearance of the heroic figure conveys a very different feeling than does the earlier boyish *David* by Donatello. The expressive treatment of the muscular torso suggests the influence of Hellenistic art (see chapter 7). Michelangelo placed emphasis on an active contour line that conveys a sense of restlessness in the still figure.

THE SISTINE CEILING (1508–1512)

Michelangelo was called to Rome by Pope Julius II to execute the frescoes on the ceiling of the Sistine Chapel. He completed the project in four years. The scenes depicted relate to the Book of Genesis in the Bible. Nine main scenes illustrate the story of the creation of the world and the creation of Adam and Eve through the drunkenness of Noah. The narrative

scenes are surrounded by painted illusions of architectural forms, seated nude youths, biblical prophets and Sibyls (pagan prophetesses related to Greek and Roman mythology).

Painting Style. The contour lines of Michelangelo's painted figures capture the essence of his sculptural forms (for example, as compared to his *David*). In other respects, Michelangelo's technique as a fresco painter stems from the Florentine tradition of Giotto and Masaccio.

Recent Controversy. Michelangelo's painting style has recently become a subject of controversy in the art world. The Sistine Chapel ceiling has undergone extensive restoration and the frescoes' new look may cause a reevaluation of them as art. They now appear much brighter and more decorative in color.

SAINT PETER'S (1546–1564)

After the death of Bramante, Michelangelo took over the project to rebuild Saint Peter's in Rome. He simplified Bramante's complex scheme, favoring a more compact sense of spatial unity. The dome planned by Michelangelo was not constructed during his lifetime.

Raphael

Raphael Sanzio (1483–1520) synthesized aspects of the art of Leonardo, Bramante, and Michelangelo to create a style of his own. More than any other single artist of the time, Raphael's painting style embodied the spirit of the High Renaissance.

THE SCHOOL OF ATHENS (1510–1511)

Raphael was commissioned to execute frescoes for a series in rooms at the Vatican Palace. *The School of Athens* was painted in a room called the Stanza della Segnatura. The fresco represents the Athenian school of philosophy, with the figures of Plato and Aristotle in the center of the composition. Their heads appear as if framed by the distant archway, suggesting a circular halo shape around them.

Stylistic Influences. The composition and grouping of the figures were influenced by Leonardo's *Last Supper*. The immense architectural space suggests an awareness of Bramante's designs. But perhaps most apparent is the relationship of the figures and the overall painting style to Michelangelo's Sistine Chapel frescoes, which were also in the process of execution within the Vatican during the same time period.

VENETIAN ARTISTS OF THE SIXTEENTH CENTURY

The Renaissance also affected Italian artists outside of Florence and Rome. Painters in Venice were gradually influenced by the advent of oil painting in northern Europe. Toward the end of the fifteenth century Venetian artists developed an independent approach to the medium that anticipated techniques of later Baroque art.

Giorgione's The Tempest (ca. 1505)

Giorgione (1478–1510) contributed a sense of poetic feeling in his softly rendered atmospheric oil paintings. The subject of *The Tempest* has never been deciphered. Its present title refers only to the storm depicted in the background. In the foreground is an unclothed woman suckling an infant while a young soldier stands nearby. Perhaps the subject is of pagan origin. Regardless of the picture's meaning, a mysterious and poetic mood surrounds the image.

Titian

Venetian painting matured in the art of Titian (ca. 1488–1576), the most outstanding colorist of the sixteenth century. Titian expanded the oil medium's technical possibilities, placing emphasis on color and brushwork. In his mature style, lush paint application, including impastos (see chapter 4), added a sensual richness to the surfaces of Titian's colorful paintings.

VENUS OF URBINO (1538)

Based on the figure of a reclining Venus by Giorgione, Titian's *Venus of Urbino* helped to set a standard for future depictions of the idealized female nude. In its color, Titian's painting offers a feast to delight the senses.

MANNERISM AND PRE-BAROQUE TRENDS

Following the High Renaissance, several artistic trends emerged in Italy. Mannerism was one of the dominant directions, though its influence was not unrivaled.

The intentions of the Mannerists were quite different from those of the High Renaissance artists after whom their styles were "mannered." Beginning in the 1520s, an antiClassical style emerged, rejecting the basic tenets of High Renaissance art.

Another trend, among the several to develop in this period, anticipated the dynamic compositional devices of the later Baroque style.

Mannerist Painting

The major achievements in Mannerist art occurred in painting. The concept of the movement was defined largely through this medium.

PONTORMO AND FIORENTINO

Jacopo da Pontormo (1494–1557) and Rosso Fiorentino (1495–1540) were Florentine artists working in Rome in the antiClassical Mannerist mode. In their paintings, the normally ordered and stable compositions of High Renaissance painting gave way to instability and an ambiguous treatment of space. Irrationality replaced the rational concerns typical of the High Renaissance. For example, poses borrowed from Raphael might be exaggerated and used in artificial ways, without their original purposes. Until the early twentieth century, the works of such Mannerists were criticized harshly because they failed to live up to the standards set during the High Renaissance. Today, these Mannerists are interpreted more in terms of their own intentions, which were in deliberate violation of the High Renaissance aesthetic.

PARMIGIANINO

While Parmigianino (1503–1540) made use of antiClassical devices in his paintings they also possess a certain elegance based on Raphael's graceful figure style.

Madonna With the Long Neck **(ca. 1535).** Parmigianino's painting, *Madonna With the Long Neck*, distorts figures through elongation, but attempts to pose them in an elegant fashion. The soft modeling of the flesh and the facial type (as seen in the head of the Madonna) are derived from Raphael's art. AntiClassical characteristics include the irrational crowding of the angels in the foreground, the Christ child who looks dead on his mother's lap, the small, out-of-scale man holding a scroll to the right of the Virgin and a column which supports nothing. This appears to be a single column at its top, but becomes a row of columns at its bottom.

Painting in Northern Italy and Spain

TINTORETTO

In Venice the style of Tintoretto (1518–1594) combined aspects of Titian's painterly style with Mannerism (Tintoretto borrowed poses from Raphael and Michelangelo).The dynamism of his active compositions might also be considered pre-Baroque.

The Last Supper **(1592–1594).** Tintoretto's painting *The Last Supper*, creates a striking contrast to Leonardo's earlier work of the same subject. The table is set into space by use of an exaggerated perspective. Christ is a small figure set deeply in the space, distinguished only by his halo. The scene is made dramatic through the use of bright flashes of light set against dark. Here the supernatural world of angels mingles with the real world of

attendants, food containers, and domestic animals in the composition's foreground.

EL GRECO

Doménikos Theotokópoulos, called El Greco (1541–1614), combined aspects of High Renaissance, Mannerist, and Byzantine art. Prior to working in Spain, he traveled to Venice from his native Crete and absorbed influences from Titian and Tintoretto. Later, in Rome, he was affected by the art of Michelangelo, Raphael, and central Italian Mannerists. These influences combined with his earlier training in the Byzantine tradition of Crete. Characteristic features of his painting include elongated figures with flamelike contours, creating a style of great emotionalism. His style, like Tintoretto's, combined aspects of mysticism and realism. Accompanying these qualities was his dazzling color, derived from Titian.

Mannerist Sculpture

Achievements in Mannerist sculpture were not as noteworthy as they were in painting. Characteristics defining the trend appear in the art of sculptors whose works convey a sense of elegance that can be likened to Parmigianino's painting.

BENVENUTO CELLINI

Benvenuto Cellini (1500–1571) was a Florentine goldsmith and sculptor. His art stressed the idea of technical facility and virtuosity as ends in themselves. Like many other Mannerists, his art elevated form over content. Employed by King Francis I, he helped to establish Mannerism as the dominant mode in France.

Saltcellar of Francis I **(1539–1543).** Cellini's intentionally charming gold saltcellar made for the King of France demonstrates an extreme regard for skillful craft. The graceful elongation of Cellini's artificially posed small-scale figures recalls the Mannerist painting style of Parmigianino. (Cellini's saltcellar is also discussed in chapter 4 under "Metal.")

GIOVANNI BOLOGNA

Giovanni Bologna (1529–1608) was the Italianized name of French artist Jean de Bologne. Settling in Florence, he became that city's most important sculptor of the late sixteenth century.

Rape of the Sabine Women **(completed 1583).** Giovanni Bologna's thirteen-and-a-half-foot-tall marble sculpture, *Rape of the Sabine Women*, combines three figures twisted in space to form an upward spiral composition. The sculptor's basic problem was to try to make a large-scale sculpture which could be viewed equally well from all sides, rather than having a major viewpoint from one side as was customary. This problem had never been tackled on so large a scale. The subject of the piece was an afterthought, the primary concern being the technical problem itself. Technical facility as

an end in itself (rather than a means to an end) was a characteristic concern of Mannerists of Giovanni Bologna's generation.

Architecture and Mannerism

It is more difficult to define Mannerism as a style of architecture than it is for painting and sculpture. Some buildings of the period exhibit excessive decorative and elegant qualities that can be likened somewhat to Mannerism.

PALLADIO

Andrea Palladio (1518–1580) was Italy's most important architect of the late sixteenth century. There is debate regarding whether Palladio should be viewed as a Mannerist or as a Classicist whose work continues the tradition of the Renaissance.

Villa Rotunda (ca. 1567–1570). Palladio's Villa Rotunda in Vicenza, Italy, was designed as an aristocratic country house. Basing his ideas on ancient literary sources, he believed that the villa's appearance conformed to that of a Roman residence. He was incorrect, however. Roman houses were not domed buildings with pedimented porticoes projecting at all four sides. The porticoes are related to Roman temple fronts, however. The building's detailing certainly reveals Palladio's classical knowledge, but since it resembles no building ever built in antiquity, the Villa Rotunda is also a testament to the architect's originality.

RENAISSANCE IN NORTHERN EUROPE

While the Renaissance was affecting developments in Italy, important changes were occurring in northern Europe as well. Scholars differ with regard to when the term *Renaissance* can be properly applied to developments north of the Alps. Some would date the beginning of the Renaissance in northern Europe as late as the beginning of the sixteenth century, arguing that the tradition of humanism did not take root there in the fifteenth century. While the Late Gothic style in fifteenth-century northern architecture was not progressive, northern European painting was highly inventive.

International Style Beginnings

The roots of the Northern Renaissance might be traced to artists who worked north of the Alps in the International Style. (For an explanation of the meaning of this term, see chapter 8 under "International Style.") Innovations appearing in their art from ca. 1400 to ca. 1420 anticipated a new style in later fifteenth-century Northern painting.

SLUTER

Claus Sluter (1380–1406), a sculptor of Netherlandish background, worked for the Duke of Burgundy at Dijon, France. In his emphasis on solid form, he advanced sculpture toward greater naturalism.

The *Moses Well* (1395–1406). In Sluter's *Moses Well* the large stone figures of Moses and other biblical prophets display softly draped, but heavy, bodies. The individual treatment of heads conveys much in the way of realism, especially as seen in the head of the prophet Isaiah (but not so apparent in the face of Moses).

THE LIMBOURG BROTHERS AND MANUSCRIPT ILLUMINATION

The Limbourg brothers were Flemish artists who worked in the International Style. Their manuscript illuminations appearing in *Les Tres Riches Heures du Duc de Berry* (ca. 1413–1416) contain several innovative features, especially in the pages representing peasant life, such as those for February and October. Illusionism is heightened by the employment of a deep spatial setting along with the use of cast shadows and clouds floating in blue skies. Those pages depicting aristocrats, such as those for January and May, were more conventional and decorative in their Gothic character.

The Development of Oil Painting

About 1420 major innovations occurred in northern European painting. These were based on the use of the new oil medium. Although oil paint had existed prior to this time, it had not been used in panel painting. The introduction of this painting medium led to much experimentation, especially by Flemish painters. Slow-drying oil paint was capable of producing realistic effects never thought possible by painters using tempera.

THE MASTER OF FLEMALLE (ROBERT CAMPIN)

Robert Campin (ca. 1378–1444), who is thought to be the same artist as the Master of Flemalle, was one of the first Flemish painters to experiment with the oil medium in his panel paintings.

***Merode Altarpiece* (ca. 1425–1428).** In Campin's *Merode Altarpiece* the physical properties of oil paint are exploited in an attempt to realistically describe the material world. Though the subject is an annunciation scene, its setting is that of a middle-class Flemish home. Cast shadows are sensitively treated, along with luminous reflective surfaces of metallic objects. Emphasis is placed on describing the subject in meticulous detail. The *Merode Altarpiece* is a tryptych, or set of three panels, hinged together. The subject runs as a continuous space from one panel to the next.

Disguised Symbolism. A major characteristic of the *Merode Altarpiece* and of other panel paintings of the period is the use of disguised (or hidden) symbolism. This term refers to the symbolic meaning of ordinary objects, such as the vase with flowers or the water basins with towels on nearby racks

depicted in the center panel. These particular examples communicated the hidden message of the Virgin's "purity."

HUBERT AND JAN VAN EYCK

Hubert van Eyck (ca. 1370–1426) and his brother, Jan van Eyck (ca. 1390–1441) were even more important as pioneers of the oil medium in Flanders. Much more is known specifically about Jan, who outlived his brother and produced later works which can be clearly identified as his alone.

The *Ghent Altarpiece* (completed 1432). The *Ghent Altarpiece* was an enormous grouping of panel paintings begun as a project about 1425 by Hubert van Eyck. After Hubert died in 1426, his brother Jan took over the job of completing the superaltar. In its various panels, oil paint has been used to capture realistically the physical appearances of various surfaces, including cloth, fur, metal, and gems. In the landscape of the panel representing the *Adoration of the Lamb*, a very deep space has been defined. The van Eycks used atmospheric perspective, as can be seen in the dull blue coloring near the horizon. Throughout the vast landscape an attempt was made to record in minute detail individual leaves on bushes and an abundance of flowers. This interest in meticulous detail is typical of northern European painting of the period.

The almost lifesize figures of Adam and Eve, on the inside of the altarpiece, were the first large-scale nudes of northern panel painting.

***Giovanni Arnolfini and His Bride* (1434).** Jan van Eyck executed a painting that appears to represent a couple performing their marriage ceremony. It may have actually served as a wedding document and was even signed by van Eyck in the manner of a witness at the event. Like other paintings of the period, it contains hidden symbolism.

The foreshortening of the space in Jan van Eyck's painting *Giovanni Arnolfini and His Bride,* looks more convincingly real than does the extreme angle observed in Campin's *Merode Altarpiece*. Unlike Italian painters of the time, however, Jan's handling of space was intuitive rather than scientific. He did not use one-point perspective, nor did other Northern painters of his time.

The Sixteenth Century

During the sixteenth century, the Italian Renaissance began to exert a stronger stylistic influence on the development of northern European art. The philosophy of humanism also spread northward from Italy.

GRÜNEWALD

The German painter Matthias Grünewald (ca. 1480–1528) was a free-spirited artist very unlike the craftsman-painters that most northern European artists had remained up until his time. Like some of the Italian

artists, Grünewald worked not only as a painter, but also as an architect and an engineer.

The *Isenheim Altarpiece* (ca. 1510–1515). In addition to mastering the techniques established by early Northern oil painters, Grünewald was capable of boldness beyond their tradition. In the *Isenheim Altarpiece*, Grünewald ran the range of extreme Gothic emotionalism in his darkly painted *Crucifixion* scene to a light, bright-spirited *Annunciation*. In the latter panel, the brilliance of color seems almost Venetian.

DÜRER

Albrecht Dürer (1471–1528), a German, was the Northern artist most affected by the spirit of the Italian Renaissance. As a young man, he traveled to Italy and was directly influenced by Italian art. He also cultivated the attitude of a humanistic scholar. Interested in art theory, Dürer carefully studied Piero della Francesca's writings on perspective and even wrote his own treatise on geometry.

Dürer achieved renown as a important artist during his lifetime. In addition to being a painter, he played a major role in the history of printmaking. His prints were distributed throughout Europe.

***Adam and Eve* (1504).** The engraving of *Adam and Eve* demonstrates Dürer's interest in human anatomy. The nude figures are carefully proportioned as idealized perfect specimens, in keeping with the classical concept. Despite this relationship to Italian Renaissance art, Dürer's nudes are placed within a highly detailed forest setting that relates to northern European landscape tradition.

CRANACH THE ELDER

Lucas Cranach the Elder (1472–1553) was another German artist who sometimes painted nudes as well as pagan mythological subjects. His style, however was not so indebted to Italian sources as was Dürer's. He delineated form, stressing minute detail in a traditional Northern way, and his classical themes did not look Classical in style.

BOSCH

Hieronymus Bosch (ca. 1450–1516) was a provincial Dutch artist about whom little is known. His art stands in contrast to Dürer's humanism and classicism. In a sense, Bosch's moralistic religious art represented the end of the Medieval tradition.

***The Garden of Earthly Delights* (ca. 1510–1515).** Many fanciful interpretations have been given to Bosch's triptych, *The Garden of Earthly Delights*; most plausible would be that it represents the thinking of a devout Catholic. The left panel represents the Garden of Eden before original sin. In the large center panel, life on earth is a continuous process of sinning,

and the right panel is a hell scene, where sin is punished. Unclothed men and women abound throughout the panels. Rather than being idealized nudes, they are naked sinners.

The landscape space continues the van Eyck tradition, but the pale modeling of figures reveals a departure from illusionism.

BRUEGHEL

The Flemish painter, Pieter Brueghel the Elder (ca. 1520–1569), though influenced by the art of Bosch, was of a much different spirit. He was well educated and associated with prominent humanists of his day. Although he traveled to Italy, Brueghel was much more interested in drawing mountain landscapes than he was with Italian Renaissance art.

Hunters in the Snow (1565). Brueghel depicted Alpine mountains in the background of this Flemish scene, integrating figures and landscape to convincingly convey an aspect of life during the cold winter. However, in many of his other works, illustrating proverbs, people rather than nature, dominate.

BAROQUE IN ITALY

The Baroque style originated in Rome. In the late sixteenth century, the Roman Catholic Church launched a major campaign, commissioning art on a large scale, to make Rome a magnificent Christian city. A similar attitude had prevailed in Rome during the High Renaissance. In a number of respects, the Baroque style restored aspects of the Renaissance style which had been superseded by Mannerism. However, classical elements were given a new purpose as an aesthetic of dynamism replaced the static serenity of the earlier Renaissance. In general, Baroque art tended to excite the eye and stir the spirit. It evoked the viewer's emotions by appealing directly to the senses, unlike earlier Renaissance art which tended to be more rational and formal in this regard.

Painting

Two main directions emerged in Italian Baroque painting, which departed from Mannerism. One direction initiated by Caravaggio stressed realism, while the other, exemplified by Annibale Carracci, treated its subjects in a loftier manner. Although the expressive content of Baroque painting was different from that of earlier classical styles, artists of the new movement were greatly influenced by the High Renaissance.

CARAVAGGIO

Caravaggio (1573–1610), an artist from northern Italy, was one of the most innovative artists to arrive in Rome during this period. His paintings helped to launch the Baroque movement. Though his work was greatly appreciated by connoisseurs, it met with public resistance because of certain realistic features that were considered undignified. In his *Calling of St. Matthew* (ca. 1599–1602), for example, Christ and a Disciple appear barefooted and dressed in the garments of common people within a low-life tavern. Such a portrayal of Christ was new in Rome and proved controversial. Caravaggio's realism was especially influential outside of Italy, affecting many important artists throughout Europe.

Conversion of Saint Paul **(1600–1601).** *The Conversion of Saint Paul* exhibits the basic features of Caravaggio's theatrical style, which made dramatic use of lights and darks to convey the idea of capturing the instant. A flash of light suddenly appears, stunning the Pharisee Saul, whose specific moment of conversion (into the Apostle Paul) is depicted in the painting. As a realistic feature, an attendant appears to move the horse away from its fallen rider.

GENTILESCHI

Artemesia Gentileschi (1593–ca. 1652) was an Italian painter whose unique personal style combined the influence of Caravaggio with her own violent and dramatic vision. Among her major themes were a series of paintings related to the subject of Judith who saved Israel by decapitating her people's Assyrian enemy, Holofernes.

Baroque Ceiling Painting

During this period a major development occurred involving decoration of the great palaces of Rome. Artists of the new mode were interested in returning art to nature, and away from the artificiality of Mannerism. They also looked back to antiquity and the artists of the High Renaissance for inspiration.

ANNIBALE CARRACCI

Annibale Carracci (1560–1609) was most important among the young artists in Rome who were given major commissions involving palace decoration. Carracci synthesized elements derived from the art of Raphael, Michelangelo, and Titian with his own observations of nature. In doing so, his style of decorative ceiling painting represented a very different approach from Caravaggio's realism. Carracci spearheaded an important Baroque painting tradition, and his style exerted great influence on his Italian contemporaries.

Farnese Palace Ceiling (1597–1601). Carracci's major achievement was his painting on the ceiling of the Farnese Palace, a project considered in its day only second in ambition to the Sistine Ceiling by Michelangelo.

The theme of Carracci's ceiling was pagan, involving the love life of the gods. Carracci's boldly foreshortened figures appear to be lighted from below, conveying a dramatic sense of movement framed within a painted illusion of architecture and sculpture.

Later Baroque Ceiling Painting. As Carracci's influence spread, ceiling paintings became increasingly illusionistic, often breathtakingly conveying a sense of continuous space soaring upward into the heavens. This tradition climaxed in a ceiling fresco painted by Pietro da Cortona (1596–1669), *The Triumph of the Barberini*, at the Barberini palace in Rome (1633–1639).

Architecture and Sculpture

Baroque architecture, while relying on the orders and Classical ornamentation, underwent a considerable transformation during this period. The rational and stable character of Renaissance architecture gave way to a more dynamic emphasis.

Sculpture during the Baroque period underwent similar development to painting. During this period, both media shared common goals, and could even be harmoniously blended with architecture to create multimedia art works. Sharp lines of distinction between the media were not drawn.

MADERNO

Perhaps the beginnings of the Baroque in architecture can be seen in the work of Carlo Maderno (1556–1629) who was commissioned to design the nave and facade of Saint Peter's in Rome. In his facade, Maderno departed from the traditional idea of a wall as a flat continuous surface, replacing it with a sculptural and rhythmic regard for projections and recessions—which gave dramatic emphasis to the entrances.

BERNINI

Gianlorenzo Bernini (1598–1680) is the most highly acclaimed among the sculptors and architects of the seventeenth century, but he also worked as a painter. Perhaps more than any other painter, sculptor, or architect, Bernini might be considered the quintessential Baroque artist because of his ability to harmoniously blend all three disciplines into a unified whole.

Saint Peter's Colonnade (designed 1657). In Bernini's design of the vast oval piazza, he enclosed the space with two curved colonnades which appear to reach out to the embrace the onlooker. This Baroque gesture visually communicates the idea of the arms of the church drawing the public within its fold. The colonnade is given a classical emphasis through the use of the orders. Classical temple fronts cap the ends of each colonnade.

David **(1623).** Bernini's *David* provides a striking contrast to Michelangelo's earlier conception of the same subject. Bernini's figure is engaged in dramatic action, frozen at the exact moment that he will reverse

direction and hurl the sling toward Goliath. The twisted body and extended arms of David activate the space around the statue, incorporating the air itself into the open composition. Though no statue representing Goliath exists, the viewer still senses the giant's presence.

The Ecstasy of Saint Theresa, **Cornaro Chapel (1645–1652).** Bernini's portrayal *The Ecstasy of St. Theresa* goes even further than his *David* in activating its spatial surroundings. The statue represents an angel piercing the heart of the saint as Theresa swoons in the spiritual pleasure of her pain. But Bernini conceived the work as more than just a sculpture but a combining of architecture, sculpture, and painting into the unified whole of the Cornaro Chapel. Above the sculpture is a ceiling fresco representing the heavens, toward which the figures ascend. Balconies on both sides of the chapel contain statues representing Cornaro family members, who observe the event as if at the theater.

BORROMINI

Francesco Borromini (1599–1667) was very unlike Bernini in temperament as well as artistic style. His expressive architectural mode departed from Classicism, ignoring the rules of proportion that most of his contemporaries, including Bernini, favored.

San Carlo alle Quattro Fontane (1665–1667). San Carlo alle Quattro Fontane in Rome exemplifies the dynamism of Borromini's style. Its stone walls undulate as if formed with a elastic material. Convexities and concavities are dramatically combined so as to convey a sense of movement along the facade.

BAROQUE IN SPAIN AND NORTHERN EUROPE

Although the Baroque began in Rome, it soon spread throughout Europe. At first the influence of Italian artists, such as Caravaggio, was especially strong, but soon more independent developments occurred. The Baroque style was adaptable to varied conditions in Catholic and Protestant countries; it took on a different character when it was controlled by the absolutist government in France under Louis XIV than it did in the republic of Holland.

Spain

In addition to affecting northern Europe, the Baroque spread to Spain. Mannerism had been a strong force in sixteenth-century Spain, where El Greco had settled. The Baroque style emerged in Spain largely due to Caravaggio's influence.

VELÁZQUEZ

The early paintings of Diego Velázquez (1599–1660) were Caravaggesque in style. After investigating the work of Titian, Velázquez's style lightened; his brushwork became more fluid and his color more vivid.

The Maids of Honor **(1656).** Velázquez's large painting *The Maids of Honor (Las Meninas)* depicts the Spanish princess Margarita accompanied by dwarfs of the court, the maids of honor, and a dog. Images of the king and queen appear as reflections in a mirror on the back wall, and Velázquez himself is seen at work painting a large canvas.

The painting, with its theatrical lighting, exemplifies the full development of the artist's mature Baroque style. The fluidity of his paint application and the sensual richness of his color appear Venetian influenced.

Flanders

During the sixteenth century, the Netherlands, consisting of Flanders (corresponding approximately with present-day Belgium) and Holland, were owned by Spain until Protestant Holland broke ties and established the Dutch Republic. Catholic Flanders remained under Spanish control, and its Baroque style shared something in character with that produced in other Catholic counties, particularly Spain.

RUBENS

Peter Paul Rubens (1577–1640) was the most important Flemish Baroque artist. Rubens had studied art in Italy before resettling in Flanders in the early seventeenth century. His early style combined characteristics of Annibale Carracci and Michelangelo in its figures' musculature and expressive poses. Fused with these influences were Caravaggio's dramatic lighting and his sense of immediacy. As his style matured, it became much lighter and more colorful, owing much to the Venetian tradition of Titian.

The Rape of the Daughters of Leucippus **(1617).** The mythological subject of *The Rape of the Daughters of Leucippus* depicts two young nude women being abducted by gods. Emphasis is placed on diagonal axes in the orientation of the figures. This creates a sense of dynamism suggesting movement. The use of bright color intensifies the active composition.

The *Garden Of Love* **(1632–1634).** In Rubens' *Garden of Love*, his brushwork has become even more lushly applied and flowing, indicating the influence of Titian. Rubens' lyrical handling of this theme of lovers in a garden is aimed at delighting the senses through his use of color and brushwork. Rubens' ideal seems to be the glorification of sensual pleasure itself.

Holland

Having won its freedom from Spain in the sixteenth century, Holland developed a Baroque style quite different from that of Flanders. The Baroque in Holland was affected by its Protestant religion. It also reflected the social values of its economically strong middle class. Religious and mythological subjects were superseded by new traditions in group portraiture, landscape, genre, and still-life painting.

HALS

Frans Hals (ca. 1581–1666) was first influenced by the style of Caravaggio but soon developed a brighter style, perhaps influenced by Rubens.

The Jolly Toper (ca. 1628–1630). In *The Jolly Toper*, Hals captures the instant in a style which appears Rubens-inspired in its color, but Caravaggesque in its dramatic emphasis. Especially noteworthy is Hals's sketchy brushwork which heightens the sense of immediacy captured in a picture of a man lifting his drinking glass.

LEYSTER

Judith Leyster (1609–1660) was one of the few artists to capture something of the same sense of immediacy found in the work of Hals. Leyster's *The Jolly Companion* (1630), though more complex in its composition, bears some similarity to Hals's *The Jolly Toper*. Although a substantial number of works by her survive, her career as an artist was cut short (as in the case of many women, particularly before recent times) by motherhood.

REMBRANDT

Rembrandt van Rijn (1606–1669) might be considered the greatest of the Dutch old masters. His early work was influenced by Caravaggio's lighting. Early themes, such as *The Blinding of Sampson* (1636), stress violence and dramatic turbulence as well as theatrical lighting. In his later years his work became more quiet and sensitive in mood. Rembrandt is renowned for the richness of his brushwork and his warm golden tones, especially evident in his later works. In addition to his importance as a painter, Rembrandt (like Dürer before him) contributed much to the history of printmaking.

Group Portraits. One of the new subjects demanded by middle-class Dutch citizens was the group portrait. Sometimes these involved portraits of members of guilds, administrators of institutions, or military companies. Rembrandt developed novel solutions for compositions involving this new subject. In his *Syndics of the Cloth Guild* (1662), it seems that the viewer has just entered the room and caught the subject's attention, distracting them briefly from their business records. In *The Night Watch* (1642) Rembrandt creatively sought a solution to portraying a large number of figures within

an active composition. Stressing Baroque lighting and figures in motion, he painted the military company as if observed candidly, with some figures obscured by shadow and overlapping.

Self-Portraits. In addition to group portraits, Rembrandt is especially appreciated for his scrutiny of his own image in self-portraiture. Rembrandt's telling self-portraits were painted throughout his long career and reveal the full range of his stylistic development.

Etchings. Rembrandt played an important role in the development of etching. His work in this medium is noted for its sensuous and sensitive handling of lights and darks. Often his subjects reveal his compassion for humanity. In his etching, *Christ Preaching* (1652), the models of the poor people surrounding Christ might have been based on observations made in Amsterdam's Jewish ghetto.

VERMEER

Light gently activates the serene genre scenes of Jan Vermeer (1632–1675). Hardly any story is told in these quiet pictures. They depict ordinary middle-class people engaged in quiet activities, often involving domestic scenes and utilitarian objects, as in Vermeer's *Young Woman with a Water Jug* (ca. 1665).

France

During the reign of Louis XVI, an attempt was made to bring all of the arts under the king's control in an effort to serve his political interests. This may partly explain why the Baroque in France was a more restrained version of the style. Sometimes the term *Baroque Classicism* is used to distinguish it from the more dynamic modes elsewhere in Europe.

POUSSIN

Nicolas Poussin (1595–1665) spent most of his career as a painter in Italy, but he still exerted a major influence on art in France. He believed that the highest aim of painting should be the depiction of noble and serious human action. He advocated a rational and intellectual approach to painting and stood in opposition to the type of sensual and emotive art produced by Rubens and his followers.

Poussinistes versus Rubenistes. Eventually a struggle emerged in France between the followers of Poussin's linear, intellectual style in painting (called Poussinistes) and those who favored Rubens' more painterly and emotional aesthetic (called Rubenistes). The followers of Poussin remained dominant into the beginning of the eighteenth century.

Rape of the Sabine Women (ca. 1636–1637). Poussin's *Rape of the Sabine Women* illustrates his basic attitude toward art. Its statuesque figures are frozen in their poses. The forms are defined by a more linear style rather

than lush, colorful brushwork. The painting displays compositional influences from Raphael, while rejecting the dynamic aspects of Rubens' style.

ARCHITECTURE

Baroque Classicism was particularly expressed in architecture during the time of Louis XVI. Typical of this style were the rationally conceived classical facades, which lacked the dynamic aspects of the Italian Baroque. More exciting Baroque qualities, however, were found in decorative interiors.

Garden Front, Palace of Versailles (1669–1685). Louis Le Vau (1612–1670) and Jules Hardouin-Mansart (1646–1708) designed the Garden Front of the Palace of Versailles. A sense of formality prevails in the design of the long facade. The interior of the palace, however, contained rooms more lavishly decorated in a thoroughly Baroque fashion. A magnificent formal garden, designed by André Le Nôtre (1613–1700), extended for miles from the palace's garden front. Here nature was controlled and made to conform to the rational design of the facade, making the garden (with its manicured vegetation and formal basins) a logical extension of the palace architecture.

England

In painting, the Baroque style was imported to England during the 1630s when Rubens' student Anthony van Dyck was hired as court painter to Charles I. In architecture the Baroque did not develop until the late seventeenth century.

ARCHITECTURE

The Gothic tradition in English architecture endured into the early seventeenth century. The English Renaissance was introduced just prior to 1620 by Inigo Jones (1573–1652). His style was greatly influenced by the sixteenth-century Italian architect Palladio.

A somewhat restrained version of the Baroque style developed during the second half of the seventeenth century.

WREN

Development of the Baroque style by Sir Christopher Wren (1632–1723) was encouraged due to the great London fire of 1666. Many of London's Gothic churches burned and were redesigned by Wren in the Baroque style.

Saint Paul's Cathedral (1675–1710). Wren's major project involved the rebuilding of Saint Paul's Cathedral in London. Some of the classicism of Jones' Renaissance style was retained, but Baroque influences are also apparent in his design. Wren was influenced both by French Baroque restraint (as seen in the design of Saint Paul's facade) and by Italian Baroque traditions, including the work of Borromini (as seen in the dynamic design of the Cathedral's two towers).

ROCOCO ART

The Rococo style emerged about 1715, during the age of King Louis XV in France. During this time, the social life of the aristocracy gravitated toward the city, moving away from Versailles. Town houses were built in Paris in which the Rococo first appeared as a decorative mode of interior design. Lighter and more delicate than the earlier Baroque, the style soon affected painting and sculpture. Within a couple of decades, characteristics of the Rococo spread outside France, affecting Late Baroque art elsewhere in Europe.

Painting in France

Rococo painting in France was characterized by the use of lighter colors and more sensuous brushwork. Its main purpose was to titillate the senses and entertain the viewer. This marked a break with the academic tradition of Poussin and the triumph of the Rubenistes.

WATTEAU

Jean Antoine Watteau (1684–1721) was the first Rococo painter admitted to the Royal Academy in France. This was a major accomplishment because the subjects he painted were considered trivial by Poussiniste standards.

Embarkation for Cythera **(1717).** The painting that won Watteau admission to the Academy, *Embarkation for Cythera,* recalls Rubens' work in its sensuous color and brush work. The theme is also similar to that of Rubens' *Garden of Love*.

BOUCHER

Francois Boucher (1703–1770) was a follower of Watteau who became the major Rococo painter following Watteau's death. His subjects included portraits as well as mythological allegories, both handled in a decorative and playful manner.

FRAGONARD

Later in the eighteenth century, the Rococo style continued in the work of Jean-Honore Fragonard (1732–1806). An outstanding colorist, his fluid paint application and sense of immediacy show him to be a true heir of Rubens' art. He was noted for his whimsical scenes of aristocrats, often men and women in sensual pursuit of each other.

VIGEE-LEBRUN

Elisabeth Vigée-Lebrun (1755–1842) was primarily known for her portraits of the French aristocracy, especially women. She painted several portraits of Queen Marie Antoinette, some of them with her children. Her

Rococo portrait style conveys a sense of informality and spontaneity in capturing the moment.

CHARDIN

Jean-Baptiste Chardin (1699–1779) painted still lifes and genre subjects. Scenes of everyday life, depicting kitchen interiors convey a serene quality, reminiscent of Vermeer. However, his forms were softer and more atmospheric than Vermeer's. In Chardin's still-lifes, light softly envelops common objects, such as kitchen utensils arranged around meat and fish. Chardin's sensual style poetically elevates the commonplace objects it depicts.

Painting in England

Portraiture remained the major source of income for painters in England during the Baroque period. The most important developments in English Baroque painting occurred during the eighteenth century. These appear to have been strongly affected by the French Rococo style.

The "morality plays" (such as *The Rake's Progress*) painted by William Hogarth (1697–1764) and the portraits of Thomas Gainsborough (1727–1788) though drawing on different aspects of Rococo style, both exhibit French Rococo characteristics.

REYNOLDS

Another artist influenced by French Rococo painting was Sir Joshua Reynolds (1723–1792), whose overall artistic vision was also affected by Classicism. His somewhat decorative style fused elements stemming from the earlier opposing traditions of Rubens and Poussin. Supporting adherence to the more academic and formal approach of the latter, Reynolds helped found and was first president of the English Royal Academy.

The Renaissance began in Italy. In the fourteenth century, the art of Cimabue, Duccio, and Giotto may have anticipated the fifteenth-century Renaissance in Florence. The Renaissance revived aspects of earlier Roman art, but it was also a time of great inventiveness with regard to concepts and methods. Some of the most important artists of the Early Renaissance were Donatello, Brunelleschi, Masaccio, Mantegna, and Botticelli.

The concept of the artist as a "creative genius" originated in the High Renaissance. Artists who attained this status were often proficient in varied media involving important projects in sculpture, painting, and architecture. The major artists of the High Renaissance included Leonardo da Vinci, Michelangelo, Raphael, and Bramante. During this time, Giorgione and Titian developed an important independent painting tradition in Venice.

The Mannerists followed in the wake of the High Renaissance, reacting to the examples set by such artists as Raphael and Michelangelo. The Mannerists challenged classical values of High Renaissance art, such as compositional stability.

The Renaissance also affected northern Europe, where the development of oil painting led to a new trend in realism, as seen in the work of the van Eycks. In the sixteenth century, the concept of the Renaissance matured in the art of Dürer.

The Baroque began in Italy in the art of Caravaggio, Annibale Carracci, Bernini, and Borromini. It spread to northern Europe and Spain, affecting Rubens, Rembrandt, and Velázquez. The Baroque style was characterized by such features as diagonal movements and dramatic lighting to stir the emotions. In French art, Poussin represented a more restrained approach (Baroque Classicism). The Rococo challenged French formalism and brought sensuality back into art, as can be seen in Watteau's paintings.

Selected Readings

Friedlander, Walter. *Mannerism and Anti-Mannerism in Italian Painting*. New York: Schocken. 1985.

Haak, Bob. *The Golden Age: Dutch Painters of the Seventeenth Century*. London: Thames and Hudson. 1984.

Hartt, Frederick. *History of Italian Renaissance Art: Painting, Sculpture, Architecture*. 3rd ed. Englewood Cliffs, NJ: Prentice-Hall. 1987.

Held, Julius, and Donald Posner. *17th and 18th Century Art*. New York: Abrams. 1974.

Holt, Elizabeth G., ed. *A Documentary History of Art, Volume 2, Michelangelo and the Mannerists*. rev ed. Princeton: Princeton University Press. 1982.

Snyder, James. *Northern Renaissance Art*. New York: Abrams. 1985.

White, John. *Art and Architecture in Italy: 1250–1400*. 2nd ed. New York: Viking Penguin. 1987.

10

Late Eighteenth- and Nineteenth-Century Art

1775–1785	American Revolution
1789–1802	French Revolution
1799–1804	Consulate of Napoleon in France
1804–1815	Napoleon becomes Emperor of France; after failing to conquer Russia, he is exiled to Elba; he escapes, but is defeated at Waterloo
1830	July Revolution in France
1837	Victoria becomes Queen of England
1848	Communist Manifesto by Marx and Engels
1861–1865	Civil War in the United States
1863	Manet paints *Luncheon on the Grass*
1870–1871	Franco-Prussian War
1874	First Impressionist exhibition
1876	Bell invents the telephone
1877–1879	Edison invents the phonograph and the incandescent lightbulb
ca. 1880–1890	Cézanne, Seurat, Gauguin, and Van Gogh emerge as Post-Impressionists

The late eighteenth century marks the beginning of the modern age. It was characterized by a more scientific and rational regard toward social, economic, and political concerns. This was the Age of Enlightenment (Age of Reason) and the Industrial Revolution, as well as the American and French Revolutions. During this period, the concepts of republicanism and democracy challenged the monarchies of Europe.

In art, these ideals were expressed in Neo-Classicism and Romanticism. Later in the nineteenth century, realism and an "art for art's sake" philosophy led the way into the periods of impressionism and Post-Impressionism.

NEO-CLASSICISM

Rational and scientific interests contributed to the development of Neo-Classicism in art. Much of the reemergence of interest in the classical past stemmed from archaeological excavations at Pompeii and Herculaneum in the eighteenth century. New information was provided for artists regarding Classical design and ornamentation. Revival of interest in ancient Rome became associated with republican ideals which were applicable to contemporary political thought during the era of the French Revolution.

A discrepancy exists between scholars (and textbooks) regarding the classification of Neo-Classicism in art history. While it is sometimes viewed as a part of Romanticism (rather than a separate movement), here it will be contrasted to Romantic art.

France

In France, the Neo-Classical style sharply contrasted with the Rococo preceding it. Emphasis was now placed on a linear definition of form rather than on their loose definition through painterly brushwork. Subject matter again became more thematically serious (stressing classical mythology and other historical themes). In opposition to the Rococo, the new rational approach in painting revived the ideals of Poussin and rejected the sensuality of Rubens' aesthetic.

DAVID

Jacques-Louis David (1748–1825) was the major proponent of Neo-Classicism in France during the late eighteenth century. Employed as painter to King Louis XVI, his paintings nonetheless reflected republican ideals. When the French Revolution began, David played an active role politically and artistically. After Napoleon replaced the French Republic with the Empire, David worked for Napoleon and adapted the Neo-Classical style

for the new cause. After the defeat of Napoleon and the restoration of the French monarchy, David lived his last years in exile in Brussels.

Oath of the Horatii (1774). David's *Oath of the Horatii*, though painted for Louis XVI, is thought to have anticipated the republican ideals of the French Revolution. The subject of the painting involves three brothers about to engage in combat. They take an oath to support Rome before swords held by their father, pledging their devotion to high ideals and moral principles. This theme demonstrates Neo-Classicism's tenet of reason as superior to emotion. In many respects the style of this painting repudiates and contrasts with the Rococo aesthetic. The color is somber, the figures static (frozen like statues) and the perspective is rationally contrived. The composition is geometrically structured and the main action occurs in the immediate foreground. The sharp directional lighting is derived from the Baroque tradition of Caravaggio (this is not a Classical characteristic).

The *Death of Socrates* (1787). In David's *Death of Socrates*, the figure of the Greek philosopher appears with one hand extended toward a cup of poison while the other arm is raised as if to proclaim allegiance to high principle. Socrates, unjustly sentenced to death, expresses belief in upholding the law. In keeping with Neo-Classical principles, vertical and horizontal forms stabilize the composition, with the statuelike figures of Socrates and his disciples placed within the foreground.

INGRES

A student of David, Jean-Auguste-Dominique Ingres (1780–1867) became the leader of the Neo-Classicists in France through the mid-nineteenth century. Unlike David, Ingres was not devoted to Napoleon's interests, nor was he old enough to relate to the republican ideals of the French Revolution.

Ingres, even more than David, upheld the notion that line was the most important element of art. Though he was capable of being a very sensitive colorist, he stood in opposition to other painters of his time who adhered to the painterly tradition of Rubens. In a sense he helped to revive the battle between the Poussinistes and the Rubenistes.

Grande Odalisque (1814). Ingres' *Grande Odalisque*, though a Near Eastern subject depicting a harem slave, was done in the Neo-Classical style. In its smooth surfaces and its regard for sculptural form, it shares characteristics in common with David's painting. Unlike David's work, however, the figure's form is elongated and abstracted, almost resembling a Mannerist painting. The odalisque's form is pushed forward to the immediate foreground of the picture space, giving her the illusion of relief sculpture.

Neo-Classicism Outside France

KAUFFMAN

Outside of France, one of England's major Neo-Classicists was Swiss-born Angelica Kauffmann (1741–1807). Along with Sir Joshua Reynolds, she was one of the founders of the Royal Academy. She often was commissioned to adorn the Neo-Classical interiors designed by Robert Adam in England.

JEFFERSON

In addition to being the third president of the United States, Thomas Jefferson (1743–1826) designed architecture in the Neo-Classical mode. As the United States minister to France from 1784 to 1789, Jefferson had the opportunity to study recent European as well as ancient Roman architecture. He applied this knowledge to designs of American government buildings (such as the Virginia State Capitol) and to institutional architecture (such as the University of Virginia).

Monticello. Monticello, Thomas Jefferson's home was based on Palladio's sixteenth-century designs. In its second version (1796–1806), Monticello acquired characteristics reminiscent of Palladio's Villa Rotunda. These included a dome placed on an octagonal drum preceded by a Roman Doric portico.

ROMANTICISM

Romanticism was a literary and artistic movement that began in the late eighteenth century. In visual art sensuality and emotion were favored over intellectual response and reason. However, Romantic painters, sculptors, and architects cannot be characterized as working within a single mode. Unlike Neo-Classicism (which may be defined as a style), Romanticism is more a philosophy or attitude that encourages people to experience emotion through the senses and to trust intuition over reason. Romanticism expressed itself through various styles, but in French painting it was most often characterized by a Neo-Baroque mode indebted to Rubens' influence.

France

GERICAULT

Theodore Géricault (1791–1824) was one of the most important Romantic painters in France. His active compositions and dramatically lighted sculpturesque figures displayed his admiration for Michelangelo and David as well as for earlier Baroque art.

The Raft of the "Medusa" **(1818–1819).** Géricault's most ambitious composition was a very large canvas, The Raft of the "Medusa". The subject was based on the sinking of a government ship (the Medusa) off the African coast. Hundreds aboard perished but a handful were saved, some by constructing a raft out of the ship's debris. The event led to a government scandal.

Géricault's painting depicts the moment of rescue for those on board the raft, many of whom are already dead or dying. The composition relies on the diagonal arrangement of the raft and figures to stress movement. Lights and darks are boldly juxtaposed to further stir the emotions. Géricault does not spare the viewer any of the grisly details of his scene. In an effort to intensify his realism he even visited morgues to study cadavers. The painting also reveals Géricault's interest in the nude as depicted in the art of Michelangelo.

DELACROIX

A major proponent of Romantic painting in France was Eugène Delacroix (1798–1863). Influenced by Géricault, Delacroix also turned directly to Rubens for inspiration. In contrast to Ingres, Delacroix upheld color and brushwork as the essential qualities of his emotive painting style. Some of Delacroix's paintings upheld ideals by taking a stand on political issues of his day. Scenes such as those in *The Massacre at Chios* (1821–1824) encouraged sympathy for the Greeks in their war of independence against the Turks. *Liberty Leading the People* (1830) upheld the spirit of the Revolution of 1830. Many of Delacroix's other paintings, however, were inspired by literature.

Death of Sardanapalus **(1827).** Delacroix's *Death of Sardanapalus* was based on a poem by Lord Byron, about an Assyrian ruler's decision to kill himself and have all of his property destroyed, rather than have it fall into the hands of the enemy about to overrun him. As Sardanapalus watches from his deathbed, the women of his harem and his horses are killed as they struggle before his eyes. Romantic painters were often fascinated with themes mixing sensuality with cruelty. Delacroix's explicit violence is emphasized by dramatic lighting, emotive color, sensuous brushstrokes, and diagonal movements of figures through the composition.

Spain

GOYA

In Spain, Francisco Goya (1746–1828) was the most important painter of the period. He was also a significant printmaker. Goya's work exhibits many characteristics derived from art of the earlier Baroque period, such as dramatic lighting, painterly brushwork, and diagonal forces within the compositions.

A republican at heart, Goya supported the invasion of Napoleon's troops into Spain. Even though Goya had been employed by the king of Spain, he hoped that Napoleon would bring about needed reforms in his country; soon

after the French occupation, such hopes faded. After the defeat of the French in Spain, Goya embarked on an important series of etchings related to his observations of atrocities committed by Napoleon's army, *The Disasters of War.* He also created important paintings concerning the subject.

The Third of May, 1808 **(1814).** Goya's painting, *The Third of May, 1808*, commemorates the executions that followed an uprising against Napoleon's troops in Madrid. Goya treats the subject with much emotional intensity in his manipulation of lights and darks to highlight the specific moment as robotlike French soldiers aim their weapons at their hopeless captives. The Spaniards do not appear heroic but instead are pitiful victims of injustice.

England

CONSTABLE

John Constable (1776–1837) was an English painter whose Romantic style was rooted in naturalism. A painter of familiar scenes of the English countryside, Constable developed a love of nature and carefully observed its fleeting qualities, such as clouds and changing weather, which became his primary considerations. He often did small landscape studies from direct observation out of doors, but his "finished" paintings were always done in the studio.

The Hay Wain **(1821).***The Hay Wain* is a familiar country scene, painted with poetic sentiment generated by the artist's love of the English landscape. The painting captures a sense of immediacy involving the movement of clouds and light over the countryside. A regard for naturalism is combined with Romantic feeling for the subject.

Constable introduced a new method of setting down broken strokes of varied color, rather than solid areas of a single mixed color. He also applied flickering impastos of white to suggest light reflections off the landscape. Both of these practices might be considered an anticipation of French Impressionism.

TURNER

The Romantic landscapes of Joseph Mallord William Turner (1775–1851) are very different in character from those of his contemporary, Constable. Turner's approach was more transcendent of naturalism. While he favored depictions of mountains, the sea, and sites with historical associations, he translated his subjects into poetic statements that often departed greatly from his preliminary sketches. Sometimes the works appear to approach total abstraction as atmospheric studies of light and color. For this reason, Turner's paintings are often viewed as forerunners of Impressionism. His interests, however, were more subjective and linked to the tradition of Romanticism than were those of the later French Impressionists.

American Art COLE

In the United States, Thomas Cole (1801–1848) was a leading painter in the Hudson River School. Cole's landscapes were panoramic views of nature that combined naturalism with an idealized grandeur. In the United States, the theme of wilderness provided landscapists with a subject very different from anything found in Europe. Cole took trips into the forests to record nature directly in sketches, but then reassembled his studies in finished studio paintings.

The Oxbow (1836). In *The Oxbow*, Cole provides a visual description of a site on the Connecticut River. Clouds dramatically move in from the left of the composition, suggesting a sense of immediacy.

REALISM

The term *Realism*, as applied to nineteenth century art, describes a movement which rejected the subject matter of Neo-Classicism and Romanticism. Instead of basing their subjects on Greek and Roman mythology or Near Eastern themes, Realists depicted the here and now. They based their styles on real, everyday observations.

France DAUMIER

The Romantic artist Honoré Daumier (1808–1879) might also be considered a Realist with regard to the relevancy of his themes. His art addressed major social and political issues of his time. He worked as a satirical political cartoonist for most of his life, and also produced oil paintings in his later years.

The Third Class Carriage (1862). The subject of *The Third Class Carriage* depicts poor people traveling in the crowded coach of a French train. Daumier's sympathy for the plight of the masses is strongly conveyed in this caricaturelike rendering of peasants who appear locked both into their own solitary thoughts as well as into a social class from which there is no upward escape.

COURBET

The leader of the Realist movement in the mid-nineteenth century was Gustave Courbet (1819–1877). His concept of Realism involved a rejection of subjects not directly related to real-life experience of one's own time and place. He is quoted as saying, "Show me an angel and I will paint one." His insistence that artists should paint only the real and existing led him to write

a manifesto on Realism and to exhibit his work in a "Pavilion of Realism" in 1855.

The Stonebreakers **(1849).** *The Stonebreakers* was Courbet's first painting to include all of the basic characteristics that defined his concept of Realism. The subject, representing an old man and a young boy working on a road, was based upon a real observation by the artist. Courbet asked the actual subjects to pose in his studio and re-create the scene of a boy too young and a man too old for the type of labor in which they are engaged. The theme was criticized as "socialistic" in its day.

MANET

Edouard Manet's (1832–1883) style of painting anticipates later developments in Modernism. He broadly applied his paint in flat areas, avoiding the subtle halftones of traditional chiaroscuro. The subjects of many of his paintings stem from Courbet's Realism. He was also one of the first artists to advance the cause of art for art's sake, believing that brushwork and color were the essential qualities of a painting's reality.

Manet was especially important to the young painters around him who became known as the Impressionists. While he was never formally an Impressionist, in his later years his colors brightened under their influence.

Luncheon on the Grass **(1863).** In *Luncheon on the Grass*, Manet represents fashionably dressed men seated on the ground with a female nude. The subject is clearly not elevated as an allegory, but is instead placed within the viewer's real world. It was considered scandalous by many French critics of the day because of its "shocking" content.

Interestingly, Manet's composition and his unclothed figure had a classical source. It was based on a Renaissance engraving by Marcantonio Raimondi, which in turn derived from a drawing by Raphael of the *Judgment of Paris*. Raphael's source was a Roman relief sculpture depicting reclining river gods. The original concept of ideal nude figures had partially survived in Manet's realistic portrayal of an unclothed woman.

Olympia **(1863).** Manet's *Olympia* similarly presents the unclothed woman in a realistic context. Though the work recalls Titian's *Venus of Urbino*, it actually portrayed a well-known Parisian prostitute, who glares frankly and without shame at the viewer while reclining on her bed.

American Art

EAKINS

In the United States, Thomas Eakins (1844–1916) combined scientific and artistic interests in photography as well as painting. He received training in Europe under the academic painter Jean-Leon Gerome. He was also affected by the art of Velázquez, Rembrandt, and Courbet. His interest in the human body in motion resulted in photographic studies where he stopped the figure in action.

Eakins was one of the first American artists to advocate the study of the nude model in classes he taught at the Pennsylvania Academy of Fine Arts. This displeased the conservative critics of his time.

TANNER

Henry O. Tanner (1859–1937) was an African American painter who studied with Eakins in Philadelphia in the 1880s. *The Banjo Lesson* (1893) is Tanner's most famous painting, produced after he moved to Paris, where he remained permanently. As a scene of everyday life, its objective Realism bears Eakins' influence.

IMPRESSIONISM

Impressionism grew out of the Realist movement, continuing the idea of representing subjects observable in everyday life. However, unlike earlier Realist paintings, Impressionist paintings were characterized by the use of vivid color. Impressionist painters recorded their observations with quick sketchy brushstrokes, often suggesting out-of-focus effects.

The term *Impressionism* was coined at the time of the group's first exhibition in 1874, by a critic who ridiculed their paintings' sketchy or unfinished quality.

Painting Out of Doors

The Impressionists were the first painters to consistently make a practice of painting out of doors. The term *plein-air* describes this method of working in the open air. In its purest form, Impressionism was about capturing the fleeting moment, recording on canvas the immediate visual sensations as observed by the eye. While Impressionism might be considered primarily a landscape style, some Impressionists were more concerned with the human figure.

MONET

The central figure within the Impressionist movement was Claude Monet (1840–1926). He was the quintessential Impressionist painter whose art was based on the capture of fleeting visual sensations. Monet was primarily a landscapist. Among the many subjects he painted were fields of poppies, haystacks, city views, a Gothic cathedral facade, and a modern train station.

Impression-Sunrise (1874). *Impression-Sunrise* was probably the work from which the term Impressionism was coined. In the painting, boats are observed against the blue water on a foggy morning as the sun rises. The

physical appearance of boats and water dissolves into a flattened and blurred arrangement of pigments on the surface of the picture plane.

Rouen Cathedral **Series (1894).** Monet's *Rouen Cathedral* series focuses attention to the cathedral's stone facade observed at different times of the day and under different atmospheric conditions. His interest in how different lighting and seasonal conditions affect color perception is revealed in the variety of effects in hue from painting to painting in the series. The actual form of the cathedral wall was of no interest to Monet. Its solidity is dissolved by light in his Impressionist paintings.

Waterlilies **Series.** *Waterlilies* was the title of a later subject of Monet, which he continued into the 1920s. Monet loosely captured the colors of the lily pads and flowers themselves, along with the reflections of the sky, clouds, and other surrounding forms upon the lily pond's surface.

RENOIR

Unlike Monet, Pierre-Auguste Renoir (1841–1919) preferred the subject of the human figure (especially the female nude) to landscape. His involvement with Impressionism did not last as long as Monet's. By the early 1880s, Renoir had largely abandoned Impressionism, preferring to define his figures more solidly.

During his Impressionist period in the 1870s, Renoir's color and brushwork were similar to Monet's. However, he preferred the subject of ordinary people, generally those of the middle class enjoying themselves at leisure activities.

Le Moulin de la Galette **(1876).** Renoir's *Le Moulin de la Galette* depicts people enjoying themselves in an outdoor entertainment spot. They are observed casually as they flirt, dance, and converse with one another. Light filters through the trees creating a dappling effect of radiance and colored shadow over the figures and their surroundings.

Luncheon of the Boating Party **(1881).** In *Luncheon of the Boating Party*, Renoir depicts a group of people enjoying food, wine, and conversation around their tables. It continues to make use of the bright Impressionist palette, though there is a greater emphasis on the solidity of the figures.

DEGAS

Edgar Degas (1834–1917) stands apart in many respects from other painters in the Impressionist movement. He did not use the vivid colors associated with the more orthodox version of Impressionism, but generally favored a darker palette resembling the pre-Impressionist color of Manet. Unlike other Impressionists, Degas retained an allegiance to the classical tradition and sound draftsmanship as major ingredients in his art. He even outlined his figures.

Degas was, however, preoccupied like the other Impressionists with scenes related to everyday observations. His work reveals the influence of Japanese prints in its tilted perspectives. His snapshotlike compositions might be based on his study of photography.

In addition to paintings, Degas created sculpture and was highly accomplished in pastel drawing. Among Degas' favorite subjects were ballet dancers and, in his later pastels, nude bathers.

MORISOT

Several women were involved in the Impressionist movement, including Berthe Morisot (1841–1895), who was a member of the movement from its beginnings. She was influenced by Manet, who later became her brother-in-law and in turn was influenced by her art. Her work primarily involved scenes related to her own world of upper-middle-class domestic life. Her brushwork was sketchy and her pastel color was applied with great sensitivity.

CASSATT

Mary Cassatt (1845–1926) was an American painter from a wealthy Philadelphia family. It was much more difficult for women to become serious artists during her lifetime than it is today. Being of a privileged economic background, however, permitted Cassatt the opportunity to be independent and to devote her life to painting. She joined the French Impressionists in 1877 after having become a close friend of Degas. Combining her knowledge of Degas' work with a serious study of Japanese prints, Cassatt developed her own style, often depicting women and children.

In addition to being a painter, Cassatt was important as a liaison between wealthy American art collectors and her French Impressionist associates.

***The Boating Party* (1893–1894).** In Cassatt's *Boating Party*, the artist displays the influence of Japanese prints. The tilted ground along with the simplicity and boldness of the flattened-out design are indicative of this influence.

WHISTLER

The art of the American expatriate, James Abbott McNeill Whistler (1834–1903) also reveals the strong influence of Japanese art. Since he worked in England, however, Whistler was not part of the French Impressionist movement. Unlike Impressionists in France, Whistler tended to avoid bright colors, favoring muted grays and browns along with touches of gold and red.

Whistler drew analogies between the abstract qualities of painting and music when he titled his paintings nocturnes, symphonies, and arrangements.

Arrangement in Black and Gray, No. 1 (The Artist's Mother). Beyond being a picture of something, to Whistler painting was an arrangement of shapes, colors, and values within a composition. He carried this philosophy so far as to title his own mother's portrait *Arrangement in Black and Gray, No. 1*.

POST-IMPRESSIONISM

Post-Impressionism emerged as a movement in the 1880s. As its name suggests, it followed in the wake of Impressionism, but the term implies something even more specific. The Post-Impressionists were artists who at first fell under the influence of the Impressionist movement, but then rejected it in part while retaining some of its basic features (such as bright colors).

There was no singular Post-Impressionist style. Instead there were several directions in the movement. Some of the Post-Impressionists (such as Cézanne and Seurat) revived aspects of Classicism in their art, while others (such as Van Gogh and Gauguin) fused aspects of earlier Romanticism into the context of their styles.

Modes of Post-Impressionism

Several art movements developed which can be seen within the general trend of Post-Impressionism, including Divisionism (also called Neo-Impressionism and Pointillism) and Symbolism (also called Synthetism in painting). Some artists within Post-Impressionism are difficult to classify in the context of broader art movements, and their art developed more independently.

Classicists of Post-Impressionism

SEURAT AND DIVISIONISM

Georges Seurat (1859–1891) was the major painter within the movement called Divisionism (or Neo-Impressionism). The basic idea behind the movement involved optical mixture of color. Related to the broken color of Constable and Delacroix, as well as the intuitive color patches of the Impressionists, Divisionism presented the color within a more structured framework.

Seurat's Divisionist style grew out of Impressionism, retaining its realistic subject matter along with its bright color. The color, however, was tightly regulated within a formal scheme. Exact proportions of varied color were calculated in comparative ratios to achieve specific optical color mixtures.

Pointillism. The brush strokes were also regimented as uniform color dots, through a method called pointillism which helped produce compositions that were static and formal in design. While final compositions were preceded by many preliminary works, often executed as informal Impressionist color studies, the final painting was meticulously executed in the studio.

A Sunday Afternoon on the Grande Jatte **(1884–1886).** The color and theme of *A Sunday Afternoon on the Grande Jatte* relate to Impressionism. The painting depicts Parisians enjoying themselves at a park on the outskirts of the city. The pointillist brushwork and the calculated use of optically mixed color depart from the sketchy and fleeting aspect of Impressionism. The figures appear geometrically solid and immobile.

CÉZANNE

The paintings of Paul Cézanne (1839–1906) also display a greater regard for compositional structure than for expression of feeling. Cézanne is credited with saying that he wanted to do "Poussin over again after nature" and to make "Impressionism into something solid and durable like the art of the museums." Unlike Monet, Cézanne was not interested in color at the expense of solid form. He did not allow light to disintegrate and dissolve forms in his paintings as did Monet. His art used forms observed in nature but conveyed through solid geometric simplification based on the cone, sphere, and cylinder.

Cézanne also invented a new method of defining space called color modeling. This involved making color work independently as a perspective method, which Cézanne offered as an alternative to the Renaissance approach of linear perspective. The basic idea involved manipulating warm and cool colors, creating a spatial system of juxtaposition where some color forms advanced while others receded.

Mont Sainte-Victoire **Series.** Cézanne did many paintings of Mont Sainte-Victoire. In them, one can trace his stylistic development after he departed from Impressionism. However, Cézanne never abandoned the plein-air method of painting landscapes.

Romantics of Post-Impressionism

VAN GOGH

Vincent van Gogh (1853–1890) was also affected by Impressionism's bright colors and by the plein-air method, but his subjective feelings prevented him from remaining an orthodox Impressionist. Most of his paintings had a basis in nature, but he expressively interpreted his observations, interjecting feelings based on his inner vision.

Starry Night **(1889).** In *Starry Night*, Van Gogh presents the scene of a town set against the sky at night. Swirling patterns formed by directional brush strokes appear to roll in from the right of the composition, encircling stars and the crescent moon. A similar sense of wavelike movement is

developed in the mountains beneath the sky. Counteracting the rhythmic flow are vertical forms of a cypress tree in the left foreground and a church steeple rising in a similar way through the surging forms of the mountains. The evening landscape departs from the objective vision of Impressionism, replacing it with a mystical vision.

GAUGUIN AND THE SYMBOLIST MOVEMENT

Paul Gauguin (1848–1903) began painting as a hobby while working as a stockbroker in Paris. Eventually he left the business world and his family behind to devote his life to art. Gauguin became the central figure within the Symbolist movement in painting.

The Symbolist Movement in Art. Symbolism, a movement in literature as well as art, sought a more subjective response to the world, rejecting naturalism and Impressionism. *Synthetism* is another term given to Gauguin's stylistic approach in Symbolist painting, which might be described as a synthesis between real experience and inner vision.

Gauguin sought to abandon the material interests of the industrial age and return to simpler values based on faith in the value of human emotion. He felt that the complexities of modern life had led people to neglect their feelings in pursuit of false material values. The style he developed retained the bright color of Impressionism but it departed from naturalism. Symbolist painting by Gauguin relied on flat, simplified color shapes outlined by black lines reminiscent of Medieval stained glass. His colors were unnatural.

Among the subjects of Gauguin's earliest Symbolist paintings were the peasants of Brittany in western France, who lived their lives simply and relied strongly on religious faith as a part of their daily lives. In his later years, Gauguin resided in the South Pacific and painted canvases depicting the simple life of the Tahitian people.

The *Vision After the Sermon* (1888). Gauguin's *Vision After the Sermon (Jacob Wrestling with the Angel)* depicts peasant women in Brittany experiencing a vision. Its bright color derives from Impressionism and its tilted ground is an Impressionist device often found in Japanese prints as well. The red color of the ground is unnatural and results from the artist's inner feelings rather than his observation of nature. Gauguin's style relies heavily on flat, curvilinear patterns with a minimal use of shadows further flattening the space.

Tahitian Paintings. Gauguin's decision to move to the South Pacific represented his rejection of European civilization. The paintings he executed in Tahiti continued to use flat curvilinear patterns, unnatural colors, and spatial devices related to Japanese prints.

TOULOUSE-LAUTREC

Henri de Toulouse-Lautrec (1864–1901) was influenced by Degas' art. Although born into an aristocratic family, Toulouse-Lautrec's life was overshadowed by an accident during adolescence in which both his legs were broken. They never healed properly, and as a result remained short and stunted. He developed into an artist of unique talent but lived a sordid life, frequenting the nightclubs and brothels of Paris. He died of alcoholism. His art is characterized by his sensitive portrayal of people who lived in the seamy world that he inhabited. Unlike the Impressionists, he did not provide the viewer with merely an objective "slice of life." Instead his work was much more expressive of his feelings.

***At The Moulin Rouge* (1892).** A rather oppressive realm is depicted in Toulouse-Lautrec's *At the Moulin Rouge*, a nightclub scene which frankly portrays his world. The influence of Degas is evident in the realist subject and the arbitrary cropping effect of the composition. The curvilinear lines indicate Gauguin's influence, as does the expressive color such as the green face of the woman to the right.

MUNCH

Edvard Munch (1863–1944) was a Norwegian who arrived in Paris in 1899, where he was influenced by the styles of Van Gogh, Gauguin, and Toulouse-Lautrec. He synthesized these influences into a highly personal style that anticipated later Expressionism.

***The Scream* (1893).** *The Scream* is perhaps Munch's best-known work. It communicates the idea of extreme anxiety combined with despair and a feeling of terror. The wavy pattern of swirling forms of figure, water, and sky is reminiscent of Van Gogh's *Starry Night* but are horrific in effect. The arbitrary color relates to Gauguin's symbolism but the macabre sense of the subject may stem from the psychological impact of Toulouse-Lautrec's art.

ROUSSEAU

Henri Rousseau (1844–1910) was a retired customs collector who began painting in middle age. He was untrained and was not part of the Parisian art community. He might be described as a folk artist or so-called primitive painter. Picasso was one of the first artists to discover Rousseau. While Rousseau's paintings, such as *The Sleeping Gypsy* (1897), fall outside of the fine art tradition of the Post-Impressionists, his flat and decorative style anticipates the spirit of much twentieth-century art.

THE ORIGINS OF MODERN SCULPTURE

In the late nineteenth century, sculpture began to undergo a redefinition similar to that of painting during the era of Manet and Monet. While parallels can be drawn between Realism and Impressionism in sculpture and painting beginning in the 1860s, developments in sculpture did not parallel those in Post-Impressionist painting until about 1900.

Rodin

Auguste Rodin (1840–1917) departed from the academic conventions of his time, leading sculpture toward Realism and later Expressionism. Often his work is compared to Impressionist painting, but his interest in broken light captured on the surfaces of his bronzes seems more emotive and expressive of inner feeling.

Maillol

Aristide Maillol (1861–1944) began his career in art as a Symbolist painter but became a sculptor around the turn of the century. He departed from Rodin's aesthetic, and, like Cezanne, favored solid forms based on the cone, sphere, and cylinder. Maillol was attracted to early Greek sculpture, from the period preceding the Classical. Along with Rodin, Maillol set the foundation upon which Modernist sculpture would emerge in the early twentieth century.

ORIGINS OF MODERN ARCHITECTURE

In the late nineteenth century, developments occurred in architecture that pioneered Modernism. Most significant were the trends of Art Nouveau in Europe and the Chicago School in the United States.

Art Nouveau

Art Nouveau emerged mainly as a style of decoration that relied on curvilinear patterning, often suggesting plant and flower forms. Around the turn of the century it strongly affected designs of furniture, jewelry, and glass as well as architectural decoration and wrought-iron work.

Art Nouveau represented a modern solution to design, challenging other more traditional trends that relied heavily on the revival of earlier styles such as Classicism or the Gothic mode.

GAUDÍ

Antoni Gaudí (1852–1926) was a Spanish architect who embraced the basic principles of Art Nouveau. He avoided flat surfaces and symmetry as well as straight lines and right angles, favoring a more organic quality.

Casa Mila (1905–1907). The Casa Mila was a large apartment building designed by Gaudí in Barcelona which appears to have been formed of a malleable material. Actually it was constructed of cut stone, though its walls seem to move in a fluid wavelike manner and its broad chimneys swirl upward, like forms dispensed from a soft-serve ice-cream machine.

Chicago School

Major developments occurred in the nineteenth century, as iron became an important building material in the construction of greenhouses, large exposition halls [such as Joseph Paxton's Crystal Palace in London (1851)], and other engineering feats (such as the Eiffel Tower in Paris designed by Gustav Eiffel in 1889). It was also widely used in the construction of bridges, railway stations, and factories. Iron was used to create skeletal support systems that permitted taller structures; after the invention of the elevator in the mid-nineteenth century, a new form of building, the skyscraper, was developed. The Chicago fire of 1871 offered opportunities for a major rebuilding in a new mode of skyscraper design.

RICHARDSON

Henry Hobson Richardson (1838–1886) was a leading proponent of a Romanesque revival style in the United States, but he was also a pioneer of Modernist design.

Marshall Field Wholesale Store (1885–1887). The interior of Richardson's Marshall Field Wholesale Store in Chicago contained seven floors supported by an iron skeleton, but the massive exterior walls were self-supporting. The austere and simple appearance of the building's exterior and its many window openings gave it a very modern appearance, despite its reliance on round arches to form arcades along its walls.

SULLIVAN

Louis Sullivan (1856–1924) was the most important architect of the Chicago School. He expressed the idea that "form follows function" and used this concept as a guiding principle in his architectural designs. He rejected old methods and revival styles in favor of new technological solutions as well as modern design principles.

Wainwright Building (1889). Sullivan's Wainwright Building in Saint Louis, Missouri, was his first skyscraper. Sullivan did not use a freestanding wall. Instead his steel skeletal frame supported the outer wall (attached to it as if it were skin over bone). He also invented his own architectural ornamentation, resembling Art Nouveau design, while rejecting all influences from revival styles.

The basic scheme of the Wainwright Building divides the structure vertically into three sections, in accordance with Sullivan's idea of form following function. The bottom two floors contain storefronts and the

mezzanine. Above them are office floors which are visually identified by the use of vertical piers rising between their windows. The uppermost floor is set off visually by a horizontal ornamental band. It was designed to serve utility purposes. The three sections are reminiscent of a Classical column. The bottom section is like the base, the office spaces rising above it resemble a fluted shaft, and the top section is like a column's capital.

ADVANCES IN PHOTOGRAPHY

During the second half of the nineteenth century, photography became an important visual medium in its own right. Mathew Brady (1823–1896) made photographic records of the Civil War. Photodocumentary also sought to convey the harsh realities of the industrial age, focusing attention on the plight of the poor and other social issues. There were also attempts to imitate painting in photographic images and thus elevate the status of photography to fine art. Some photography presented posed figures in classical compositions based on historical and mythological themes. In contrast, naturalistic photography recorded landscape scenes that were similar to Constable's paintings.

By the turn of the century, the issue of whether photography should be considered art on a similar level to painting led to the Secession movement. Photographers such as Alfred Stieglitz (1864–1946) and Edward Steichen (1879–1973) approached photography as art for art's sake and their photographs even acquired the soft focus characteristics of Whistler's art.

This trend did not endure long into the twentieth century. Photography's future did not rest in competing with painting but in finding its own artistic path.

The late eighteenth through the nineteenth centuries comprised an age of major artistic change. The period began with the parallel movements of Neo-Classicism and Romanticism. In France, David and Ingres were leading Neo-Classical painters, while Gericault and Delacroix were Romantics who revived aspects of the dramatic Baroque style. Outside of France, Goya, Constable, Turner, and Cole also made significant contributions to Romanticism.

Realism affected the subjects artists painted, as well as their growing interest in naturalism. Courbet was the leading Realist, who advocated that painters should only depict the existing world of everyday experience. Manet used Realist subjects but was more interested in art for art's sake, as was Whistler. Japanese art exerted strong influences on the art of this period.

The practice of consistently creating finished landscapes out of doors, directly from nature, began with the Impressionists. Monet was the leading proponent of this plein-air method. Other Impressionists such as Cassatt, Degas, Morisot, and Renoir preferred figurative subjects.

The Post-Impressionists inherited various aspects of Impressionism, but moved away from its basic tenets. There were several different directions of Post-Impressionism. Cezanne, Seurat, Gauguin, and Van Gogh were among the major painters within this trend, which included such movements as Divisionism and Symbolism as well as independent styles.

The origins of Modern sculpture can be seen in the work of Rodin. Modern architecture has its origins in buildings such as those designed by Sullivan. Significant advances also occurred in photography during the same period.

Selected Readings

Herbert, R. L. *Impressionism: Art, Leisure, and Parisian Society.* New Haven, CT: Yale University Press. 1988.

Holt, Elizabeth Gilmore, ed. *From the Classicists to the Impressionists: A Documentary History of Art and Architecture in the Nineteenth Century.* Garden City, NY: Anchor Books/Doubleday. 1966.

Honour, Hugh. *Romanticism.* New York: Harper and Row. 1977.

Nochlin, Linda. *Realism, Style, and Civilization.* Baltimore: Penguin. 1972.

Roberts, Keith. *The Impressionists and Post-Impressionists.* New York: Dutton. 1977.

Rosenblum, Robert, and Horst W. Janson. *Nineteenth-Century Art.* New York: Abrams. 1984.

11

Twentieth-Century Art Through World War II

1900	Freud writes *Interpretation of Dreams*
1903	Wright brothers first flight
1905	Einstein's theory of relativity
1905–1908	Fauve movement in France
1909	Ford develops assembly line for manufacturing automobiles
1909–1914	Picasso and Braque develop Cubism
1914–1918	World War I
1917	Communist revolution in Russia
1920	Woman suffrage enacted in the United States
1922	Facism in Italy; Mussolini's rise to power
1924	Hitler writes *Mein Kampf*; Andre Breton writes *Surrealist Manifesto*
1933	Roosevelt becomes President in the United States; Hitler becomes Chancellor in Germany
1936–1939	Spanish Civil War
1939	Germany invades Poland; beginning of World War II
1941	Japan attacks Pearl Harbor; United States enters the war
1945	Atomic bombs dropped on Japan; end of World War II

The twentieth century has been an age in which many scientific and technological advances have occurred at an accelerated pace. Early in the century the Wright brothers developed the power-driven airplane. A few years later Albert Einstein startled the world with new theories regarding matter, time, and space. Two world wars interspersed with world-wide economic depression inflicted horrors upon humanity. The atom was split, nuclear weapons were developed. Up to World War II the century also saw the development of global communication through radio and the advent of television. Throughout this period new art forms and new artistic concepts challenged traditional values of the past. The major stylistic thrust within art of this period falls under the heading of "Modernism," a term which describes the development away from naturalism into abstraction and nonrepresentation.

MOVEMENTS PRIOR TO WORLD WAR I

Major developments occurred in art during the first two decades of the twentieth century. Most of these developments grew out of Post-Impressionism. Many important artistic movements such as Cubism and Expressionism emerged at this time. While Paris remained the art capital of the world, important advances occurred elsewhere, especially in Germany, Italy, and Russia.

Pioneers of Modernist Sculpture

One of the distinguishing characteristics in twentieth-century art was the general shift from naturalism into abstraction and nonrepresentation. The main current within these new directions in sculpture was formalist abstraction (abstraction based on a rational approach of structured visual relationships). Expressionism was not so important a trend in early twentieth-century sculpture as it was in painting.

BRANCUSI

Romanian-born Constantin Brancusi (1876–1957) arrived in Paris in 1904. With his abstract simplification of forms, Brancusi took a decisive step beyond Maillol's and Rodin's art to advance the cause of Modernism in his medium.

Sleeping Muse. Brancusi did several versions of the *Sleeping Muse* theme, beginning in 1906 with faces carved in a manner reminiscent of Rodin's romantic naturalism. In later versions of the subject, Brancusi departed from naturalism and simplified his faces into abstract sculptures. He was affected by the simplicity of traditional African sculpture as well as by Cycladic and Archaic Greek sculpture.

Bird in Space (1928). *Bird in Space* is a very simple, gently curved but dynamically thrust upright form which might be interpreted as being about the concept of flight itself. The work is not an abstraction of a bird, but a nonrepresentational polished bronze sculpture intended to convey the dynamism of the age in which Brancusi lived, the age of aviation.

Fauves and Expressionists

Expressionism is a term that describes art that conveys emotional feeling. Its development in the early twentieth century stemmed from Post-Impressionist sources. In Europe it might be classified into French Expressionism and German Expressionism. In France, Expressionism developed a different character than in Germany. French Expressionists tended to be preoccupied more with structure and formal composition and less with deep human emotion. In Germany, Expressionism was more an outpouring of disturbed psychological states and intense human feeling.

The Fauves in France

The group of artists known as the Fauves emerged in France in 1905. In that year they exhibited in the Salon d'Automne, an independent showing of radical artists which drew critical scorn for the boldness of its colors and brushwork. One critic made reference to the artists as "*fauves,*" which means "wild beasts" in French. Despite the critic's derogatory intent, the artists then adopted the term for their movement, which lasted from 1905 to 1908. The Fauves were primarily influenced by the earlier paintings of Van Gogh, Gauguin, Cézanne, and Seurat.

MATISSE

Henri Matisse (1869–1954) was the leading painter within the Fauve movement. He continued Cézanne's structuralist approach to color arrangement in his paintings. Matisse also used unnatural color and an outlining of curvilinear forms reminiscent of Gauguin's Symbolist work. As an Expressionist, Matisse did not comment on the human condition or on his inner anxieties. Instead his Expressionism celebrates the act of painting itself. Matisse's channeling of Expressionism into a formalist style is typical of a French Expressionist's attitude. Matisse remained aligned to the major principles of the Fauve movement throughout the rest of his life.

The Joy of Life (1905–1906). *The Joy of Life* was probably Matisse's most important painting. It sums up the basic concerns of Fauvism as an arrangement of rhythmic lines and colors on a flat surface. The painting's simplified shapes and composition transcend its Post-Impressionist sources.

The Red Room (Harmony in Red, 1908–1909). *The Red Room (Harmony in Red)*, continued Matisse's interest in color structure. Basic shapes and colors are repeated in various parts of the composition so as to bring them into balance with one another. While the overall effect of the painting is flat and decorative, Matisse strove to achieve a harmony between two-

dimensional and three-dimensional qualities by means of a few lines to suggest foreshortened space.

DERAIN

André Derain (1880–1954) was, with Matisse, a founding member of the Fauves. The bright, unnatural, and expressive color of his flat, decorative painting is also characteristic of the movement. Unlike Matisse, however, Derain later abandoned these principles of Fauvism and returned to a more traditional form of representation.

London Bridge (1906). Derain's *London Bridge* strikes a balance between the use of traditional perspective to establish a deep pictorial space (as seen in the foreshortened bridge) and a new regard for flat color application and expressive brushwork. The color is unnatural as well as discordant.

ROUAULT

Although he exhibited alongside them, Georges Rouault's (1871–1958) work stands apart from that of other members of the Fauve movement. Unlike his peers, he inherited the emotional as well as the formal elements of Van Gogh and Gauguin. A devout Roman Catholic, his paintings reflect his religious feelings.

Head of Christ (1905). Rouault's *Head of Christ* is painted in violent brushstrokes, communicating the artist's inner feelings about the suffering of Christ. In his use of expressive color and slashing, energetic brushwork, Rouault creates an image with great emotional intensity. Its expressive content differs sharply from that of Matisse and Derain.

The Old King (1916–1937). As a young man Rouault received training in stained-glass making. In *The Old King*, heavy black outlines border expressive color shapes, reminiscent of a Medieval stained-glass window. The king's face communicates an inner pain.

German Expressionism

German Expressionism included several movements as well as independent directions by individual artists. It generally differed from French Expressionism in its regard for intense human feeling.

DIE BRÜCKE AND DER BLAUE REITER

Two important movements of German Expressionism were Die Brücke (The Bridge), which originated in Dresden in 1905, and Der Blaue Reiter (The Blue Horseman) which was founded in Munich in 1908.

Die Brücke, founded the same year that the Fauves first exhibited in Paris, attempted to link like-minded young artists who used intense colors similar to those used in Fauve painting. Der Blaue Reiter advanced Expressionism even farther, and in the case of its major exponent, Kandinsky, it developed into a nonrepresentational style of painting.

EMIL NOLDE

Though he briefly joined the Die Brücke movement, Emil Nolde (1867–1956) was older than most of the German Expressionists around him. Largely inspired by Gauguin and other Symbolists, he strove for a direct approach to expression using thickly applied brushwork and highly emotive color.

KIRCHNER

Ernst Ludwig Kirchner (1880–1938) was one of the founders of Die Brücke in Dresden, Germany. His mostly figurative work was influenced by the flat color of the Fauves in France as well as by the earlier art of Van Gogh, Gauguin, and Munch. Art of the Gothic period was another source of influence for his emotionally charged work. By 1913, Kirchner's art also exhibited angular Cubist qualities related to concurrent developments in that style in France.

KANDINSKY

The major figure in Der Blaue Reiter movement in Munich was the Russian artist Wassily Kandinsky (1866–1944). He took a bold step beyond fauvism in his Expressionist paintings, which evolved from abstraction into nonrepresentation. He felt that line and color by themselves could communicate strong emotional feeling without any reference to subject matter. Drawing analogies between art and music, he gave his works musical titles such as "Composition" and "Improvisation" (Whistler had earlier used such titles for his works—see chapter 10).

Sketch I for "Composition VII." In *Sketch I for "Composition VII,"* Kandinsky uses bold colors and directional linear movements to evoke a visual response analogous to rhythms and melody in music. He freely applied the expressive color of Fauve painting without regard for any subject matter.

With the Black Arch No. 154. The title *With the Black Arch No. 154* refers to a dominant visual element in the nonrepresentational composition. Otherwise, the title is similar to that which might be assigned by a composer to a musical composition, such as "Symphony No.7." Like other nonrepresentational paintings of this period the composition communicates feeling through line and color alone.

MODERSOHN-BECKER

Paula Modersohn-Becker (1876–1907) was a German painter who sought primitivism of the same type advocated by Gauguin's art. She worked in the artists' colony village of Worpswede, and her works (often related to the theme of motherhood) stood at the crossroads between the Symbolism of Gauguin and later Expressionism.

KOLLWITZ

Käthe Kollwitz (1867–1945) worked primarily as a lithographer but also created a body of drawings primarily in charcoal. Though inspired by Munch and other Expressionists, her representational work was intensely independent in its powerful expressive qualities. Her art exhibited strong social and political concerns, regarding starvation, the exploited masses, and the grief of war.

Cubism

Cubism was a formalist abstract trend that first developed alongside Expressionism prior to World War I. The term *Cubism* might be used generally to describe all of the geometric abstract styles of the twentieth century, or it might be used more restrictively to describe the earliest movements within this trend (especially Analytical Cubism and Synthetic Cubism).

PICASSO

Pablo Picasso (1881–1974) was a Spaniard who spent most of his artistic years in Paris. He was one of the greatest artists of the twentieth century. Picasso explored a broad range of styles, at times working in more than one at the same time. Early in the century, after evolving out of his blue and rose periods, Picasso pioneered the development of Cubist painting. He continued to work in and out of the Cubist mode throughout his career.

Les Demoiselles d'Avignon (1907). Picasso's *Les Demoiselles d'Avignon* was influenced by Cézanne's Post-Impressionist paintings of bathers, but it extended abstraction further in its distortion of the human anatomy. The geometric simplification seen in the nude figures anticipates the slightly later development of Cubism. The two masklike faces were influenced by African sculpture.

Analytical Cubism

In Analytical Cubism, objects were observed from different angles; the painting became a record of the artist's analysis of the varied viewpoints simultaneously combined. The form of a figure, for example, might be shattered and its various parts reduced to simplified geometric shapes arranged within tilted planes in the composition. Analytical Cubist paintings were painted within a limited color range of muted browns, greens, and blues. The formalism of these paintings represented an aesthetic opposite to Expressionism.

BRAQUE AND PICASSO

Picasso worked alongside the French painter Georges Braque (1882–1963); together they developed Analytical Cubism in a series of experimental paintings executed between 1909 and 1912. In Braque's painting, *Houses at L'Estaque* (1908), houses were abstracted as cubic forms and painted

within a restricted color range of dull greens and beige. The mature stage of Analytical Cubism was reached in Braque's *The Portuguese* (1911), as well as in many more radically abstracted and fragmented figure and still-life subjects painted by Picasso during the same period.

Synthetic Cubism

PAINTERS

Picasso and Braque invented Synthetic Cubism in 1912. This style restored color and texture to Cubist painting. In this mode they also introduced cut-out shapes as collage elements in paintings, and even constructed compositions that were entirely collage. As Synthetic Cubism developed further, paintings were sometimes executed to imitate collage effects, without actually containing collage elements.

Picasso's *Three Musicians* (1921). Picasso's *The Three Musicians* was painted in the Synthetic Cubist mode, using flat shapes and decorative colors. While it mimics collage in its resemblance to cut-out paper shapes, it is entirely a painted image.

LEGER

Fernand Léger (1881–1955) was influenced by Synthetic Cubism. His work also responded to the issues of the modern industrial age. Mechanical forms appear within his Cubist paintings, revealing a preoccupation with a machine iconography.

***The City* (1919).** In Léger's *The City*, brightly colored geometric shapes suggest industrial forms associated with modern urban life. These shapes are set into the composition in overlapping planes. Even the human figure is abstracted to look robotlike.

Cubist Sculpture and Picasso

The new Cubist concept extended to sculpture as well as painting and collage. Picasso's *Guitar* (1912) made a significant break with sculpture tradition because it was not made by modeling, carving, or casting. Instead it was constructed out of sheet metal and wire.

LIPCHITZ

Jacques Lipchitz (1891–1964) was one of the most important Cubist sculptors in Paris. In a sense, he transformed the flat shapes of Synthetic Cubism into solid forms that receded in planes. *Man with a Guitar* (1915), a limestone constructed sculpture, is one of his best known early Cubist works. His later *Figure* (1926–1930), while remaining basically Cubist in style also has an expressive presence that was perhaps influenced by Oceanic or African sculpture.

Cubism and Architecture

Cubism also provided a challenge for architects to reassess traditional notions of form in three-dimensional space. The major emphasis in twentieth-century architecture has been geometric and rational rather than organic and emotive.

WRIGHT

Frank Lloyd Wright (1867–1959) was one of the most important American architects of the modern age. He incorporated Cubist principles in his "prairie houses" at the beginning of the twentieth century and his architectural designs exerted considerable influence on other Modernists, such as Rietveldt.

Robie House (1909). The design of Wright's Robie House in Chicago was conceived in terms of abstract blocks of space jutting out in various directions. His basic concept of design, using interpenetrating geometric forms, was essentially the same as that used by Cubist sculptors as well as later Synthetic Cubist painters.

Italian Futurism

In 1909, the Italian poet Filippo Thommaso Marinetti wrote the *Futurist Manifesto* which advocated radical change in the arts, reflecting the dynamism of the new age. The Futurists called for an art exalting the machine and the concept of dynamism in general. In their art works, movement and mechanization are important themes. Ironically, many of the leading Futurists were killed in World War I by the very same machines of destruction they exalted in their art.

Futurist paintings were often characterized by the use of multiple images to suggest the movement of objects or people through time and space. The effect achieved was similar to that observed in motion-picture film from frame to frame. These multiple images also related to developments in experimental photography such as the earlier photographs of Muybridge (see chapter 3). Among the Italian painters using multiple images to show motion were Giacomo Balla (see "Time and Motion" in chapter 2) and Gino Severini (1883–1966) in his Dynamic Hieroglyph of the Bal Tabarin (1912).

BOCCIONI

Painter and sculptor Umberto Boccioni (1882–1916) was one of the most innovative of the Italian Futurists. His early work developed out of Post-Impressionism, but he later adopted the compositional structure of Analytical Cubism. His paintings were often studies of the dynamism of the human body in motion, such as that of a cyclist (*Dynamism of a Cyclist*, 1913) whose form is abstracted in the manner of Analytical Cubism. In Boccioni's painting, the figure's movement through time and space is captured as it journeys across the artist's path of vision.

Unique Forms of Continuity in Space **(1913).** Boccioni applied the same principle of the human figure in motion to sculpture as well as painting. In his bronze sculpture, *Unique Forms of Continuity in Space,* the concept of speed is communicated through a highly abstracted running figure. The runner's rapid action is conveyed in flamelike projections which suggest its fleeting presence in time and space.

SUPREMATISM AND CONSTRUCTIVISM

Suprematism and Constructivism in Russia

Major developments occurred in Modernist art in Russia just prior to World War I and during the Russian Revolution. These developments within the Russian avant-garde continued until about 1920. Russian Modernists incorporated basic concepts of Cubism and Futurism. They also further developed Picasso's idea of construction in sculpture, gaining international leadership in this form of art.

MALEVICH AND SUPREMATIST PAINTING

Kasimir Malevich (1878–1935) was one of the major innovators of the Russian avant-garde. He developed a form of Cubist painting called Suprematism. Work composed in this style consisted of simple, geometric shapes of color, usually arranged diagonally to convey dynamism. Malevich considered his work to be about the supremacy of feeling, yet it was very formal in design.

White on White (ca. 1918). Perhaps the most extreme form of Suprematist painting was a series of compositions entitled *White on White*. The most simplified work was a painting of a white square set obliquely and slightly off-center on a white field.

Constructivist Sculpture

Constructivist sculpture was developed in Russia by a group of artists who applied Cubist principles to three-dimensional forms. Constructivists rejected the traditional notion of sculpture as a volume defined by its mass. Instead they conceived of it as an arrangement of negative as well as positive space. In place of traditional techniques (such as carving stone or modeling in clay), constructivists assembled various materials (such as wood, metal, plastic, and glass), sometimes wiring them together or fitting them into place by other nontraditional methods. Often their art was kinetic, with movable parts stressing the concept of dynamism.

TATLIN

Vladimir Tatlin (1895–1956) was the leading figure in the development of Constructivism in Russia. He was influenced by Picasso's early experiments in constructed Cubist sculpture, but not by Picasso's preference for the traditional subjects of the figure or still-life compositions.

Monument to the Third International (original model-1920). Tatlin's greatest project, the *Monument to the Third Communist International*, was too costly to build. It was to be a 1300-foot-tall tower of iron and glass to serve as Communist party office and meeting spaces. Its rooms were planned to revolve at three different speeds corresponding to once a day, once a month, and once a year.

GABO AND PEVSNER

The brothers Naum Gabo (1890–1977) and Antoine Pevsner (1886–1962) were also attracted to Picasso's Cubism. They believed that sculpture should align itself with engineering and technology. They combined nontraditional materials such as clear plastic assembled with wood and metal to create dynamic arrangements of planes in space. Their *Realist Manifesto* of 1920 summed up their ideas on Constructivism which they felt represented a new reality based upon the art itself (rather than on imitating things outside the art in nature).

After the Soviet Union stopped supporting experimental avant-garde art, Gabo and Pevsner left their native land and exerted a strong influence in the West.

De Stijl

The De Stijl movement originated in neutral Holland during World War I. This idealistic movement sought new solutions in painting, sculpture, and architecture through the logic of Cubism. The followers of De Stijl developed a purely nonobjective (or non-representational) mode, based on right-angle geometry.

MONDRIAN

Piet Mondrian (1872–1944) was a leading painter within the De Stijl movement. He gave the name Neo-Plasticism to his non-objective style of painting, which was restricted to the use of the primaries (red, blue, and yellow) along with black, white, and sometimes gray. He consistently arranged his compositions within a horizontal and vertical format, avoiding diagonals. Another De Stijl artist, Theo van Doesburg (1883–1931), introduced diagonal lines into his severely geometric paintings.

Composition With Red, Yellow and Blue (1930). Mondrian often assigned his works titles such as *Composition in Red, Yellow and Blue* (if he used fewer colors the title would be adjusted accordingly). Flat colors were arranged within the geometric structure of a black grid, which outlined and

zoned areas of pure primary colors and white. The idea was to prevent colors from directly bordering each other, so that they did not appear to advance or recede through their interaction with each other. Instead, the isolated colors are held in check on the surface of the picture plane. Mondrian's compositions are studies in proportion and asymmetrical balance.

Broadway Boogie-Woogie **(1942–1943).** In *Broadway Boogie-Woogie*, the black lines of the grid are replaced by small squares of color which become the grid itself. Since the color squares are placed directly next to each other, a pulsating rhythm emerges. The work has a livelier appearance than that found in his earlier, more static paintings. Created after the artist had relocated in New York, the painting seems to reflect the tempo of the city as well as the impact of American music (especially jazz) on the artist.

RIETVELDT

Gerrit Rietveldt (1888–1964) was a Dutch architect within the De Stijl movement. His architectural designs incorporated principles of Mondrian's painting, translating them into a three-dimensional format. He was also influenced by the Cubistic aspect of Frank Lloyd Wright's architecture.

Schroeder House (1924). Rietveldt's Schroeder House in Utrecht was one of the most important architectural achievements of the De Stijl movement. Its design included white rectangular panels accented by black, yellow, and red vertical posts as well as thin horizontal elements. Its geometric design approximates Mondrian's painting. Projecting slabs along the roofline reveal Wright's influence.

DADA AND FANTASY

Dada

The term *Dada* is a nonsense word (the origins of which are uncertain). The Dada movement produced artworks which communicated the concept of absurdity. Dada can be categorized within the broader context of Fantasy (as opposed to Realism). The movement originated in neutral countries during World War I. Its centers were Zurich, Switzerland, and New York (prior to the entry of the United States into the war). It affected literature, theater, and music, as well as visual art. Dada artists rejected reason, believing that rational thought was ineffective for solving the world's problems. Dada was a reaction to the horrors of World War I, which artists in the movement saw as a consequence of so-called rational behavior. The art of the Dadaists sought to shock the middle-class public by presenting absurd concepts. At the conclusion of World War I, Dada spread into

Germany. The movement continued until 1924 when it was declared dead by the Surrealists (discussed below).

DUCHAMP

Marcel Duchamp (1887–1968) was one of the founders of the Dada movement. He left France to escape World War I, and established the New York wing of Dada.

Duchamp began his career as a painter. He was influenced by Analytical Cubism, Futurism, and by the theme of mechanization. Turning to Dada, he abandoned painting and devoted himself to making what he called "Ready-Mades." This was actually a form of "nonart" or antiart. He took discarded, mass-produced utilitarian objects and presented them within the context of art exhibitions. For example, he presented a urinal turned on its side as one of his Ready-Mades entitled *Fountain* (1917).

Nude Descending a Staircase. Prior to becoming involved in the Dada movement, Duchamp incorporated the geometric structure and limited color range of Analytical Cubism, combined with the Futurist concept of dynamism, in his painting *Nude Descending a Staircase*. The picture suggests, in multiple-image fashion, the fragmented forms of a descending figure. Duchamp did two versions of the subject, the second of which caused something of a critical uproar when presented at the Armory Show in New York in 1913.

Bicycle Wheel. In 1913 Duchamp created a Ready-Made by placing a bicycle wheel on top of a kitchen stool, rendering both objects useless. Since the wheel could be spun, the work was also an early example of kinetic art.

L.H.O.O.Q. In 1919 Duchamp took a reproduction of Leonardo da Vinci's *Mona Lisa* and drew a mustache and goatee on the subject's face. Underneath the image he inscribed the letters "L.H.O.O.Q." The sound of these letters when pronounced according to the French makes the words of an off-color pun in that language. In treating the image of one of the most highly acclaimed masterpieces in the history of art with such disrespect, Duchamp challenged established cultural standards. When Duchamp added graphic details to alter a found object, the resulting work is sometimes referred to as a corrected (or rectified) Ready-Made.

MAN RAY

The American artist Man Ray (1890–1976) was influenced by Duchamp's Dada works. He created paintings and photographs and also assembled Dada objects. He spent most of his career working in Paris.

The Gift (1921). Man Ray's *The Gift* was an assemblage consisting of an iron which had tacks glued to its bottom surface, rendering it useless for utilitarian purposes. It conformed to Marcel Duchamp's concept of the ready-made and to Dada's penchant for absurdity.

ARP

Hans (Jean) Arp (1887–1966) was one of the major artists in Zurich Dada. One of his most interesting ideas was to make collages by tearing up pieces of paper and letting them fall on a whole sheet of paper. After manipulating them somewhat he glued them in place. He referred to his compositions as being arranged "according to the laws of chance."

ERNST

The German artist Max Ernst (1891–1976) was a major figure in the Cologne Dada Movement. His art was influenced by the earlier Metaphysical Painting of De Chirico (discussed below) as well as by his association with Marcel Duchamp. Ernst was highly innovative. One of his inventions was the process called frottage by which rubbings made off of various objects were included in his art.

Fantasy Outside of Dada

DE CHIRICO

Giorgio De Chirico (1888–1978) developed a form of painting called Metaphysical Painting. It was based on dream images and irrational fears, especially of the unknown.

The Mystery and Melancholy of a Street (1914). The theme of fear of the unknown is conveyed in De Chirico's *The Mystery and Melancholy of a Street*. In this work, the dark silhouette of a girl twirling a hoop appears in the bottom half of the picture while the cast shadow of a large menacing figure looms from behind a building in the picture's upper half. De Chirico's preoccupation with fantasy exerted a strong influence on the Surrealists.

CHAGALL

The paintings of Marc Chagall (1887–1985), while often structured by Cubist principles, can be placed in the category of Fantasy. Chagall, a Russian-born artist who worked in Paris, conveyed a nostalgic, dreamy quality in his art. Some of his figures appear to float ecstatically in the air, surrounded by bright primary colors, as can be seen in *I and the Village* (1911) and *The Birthday* (1915).

KLEE

The German-Swiss artist Paul Klee (1879–1940) is difficult to categorize. Although he at times joined art movements, he remained primarily an independent artist throughout his life. While he was never a Dadaist or a Surrealist (discussed below), his work shares something of their unreal qualities. Influenced by ethnographic (so-called primitive) art and children's art, he was also affected by Cubism and German Expressionism. He fused these with his lively imagination to create works that at times combined whimsy and intellect.

Twittering Machine **(1922).** The watercolor and pen-and-ink image of the *Twittering Machine* suggests small, mechanized birds attached to a crank that when turned produces the sounds of songbirds. It is a thought-provoking yet absurd invention. In this regard, it resembles the work of a Dadaist.

ART BETWEEN THE WORLD WARS

Cubism, Expressionism, Fantasy, and Realism all played a part in developments in art in the 1920s and 1930s. The major new developments were Surrealism, and the growth of Constructivism in the West. A strong tradition in Modernist architecture also emerged that was fueled by the Bauhaus in Germany (an influential art school which was best known for its Formalist philosophy in design). Many important twentieth-century artists taught at the Bauhaus.

International Style in Architecture

The major trend in Modernist architecture was called the International Style. The origins of its developments extended back to the Chicago School, Frank Lloyd Wright, De Stijl in Holland and the Bauhaus in Germany. International Style architects sought modern solutions to architectural design through Cubist principles. This formalistic style abandoned the traditional notion of architectural ornamentation in favor of forthright formal simplicity.

GROPIUS AND THE BAUHAUS

Walter Gropius (1883–1969) was one of the leading architects of the International Style. Cubist principles were applied to his designs for the classroom, shops, and studio buildings of the Bauhaus in Dessau, Germany (the famous art school for which Gropius was the Director). In a building such as the school's Shop block, Gropius formed a curtain wall of glass over the steel skeletal inner frame to achieve a new sense of unity between exterior and interior space. His concept of the building as a glass box was later applied to skyscraper design.

LE CORBUSIER

The leading proponent of the International style in France was Swiss-born Charles Edouard Jeanneret, who was called Le Corbusier (1886–1965). He conceived of the private residences he built during the 1920s as "machines for living." Although Le Corbusier helped to develop the International Style, after World War II he moved away from the mode's cool formalism toward a more romantic approach based on organic rounded

forms, as seen in his sculptural design of Notre-Dame-du-Haut (1950–1955), a pilgrimage church at Ronchamp, France.

Villa Savoye (1929-1930). In his Villa Savoye at Poissy, France, Le Corbusier conceived of the house in terms of positive and negative blocks of space. The main mass of the house consists of a second level of flat white walls and glass, supported by slender reinforced concrete columns surrounding the deeply recessed entrance on the smaller first level. A curtain of glass separates the living room from an open interior terrace on the second level.

MIES VAN DER ROHE

Ludwig Mies van der Rohe (1886–1969) was a talented architect associated with the Bauhaus and the International Style. He escaped Hitler's Germany and played an important role in establishing the International Style in the United States. He stressed verticals and horizontals, using the steel frame and glass as basic components of his elegantly proportioned buildings. In his regard for simplification, he expressed the ideal that "less is more."

Surrealism

The major thrust of Fantasy in the period between the world wars was Surrealism, which originated when André Breton wrote the Surrealist Manifesto in 1924. Surrealism was a literary as well as an artistic movement which upheld the value of the world of dreams and other nonrational experiences of the subconscious. It was an outgrowth of the earlier directions in Fantasy, especially the Dada movement. In art, Surrealism had two main stylistic directions. One of them might be called Representational (or Illusionistic) Surrealism. The other is often called Abstract (or Automatist) Surrealism.

DALI

The Spanish artist Salvador Dalí (1904–1989) was the best known of the Surrealists. He developed Surrealism's representational form, which relied on illusionistic devices stemming from earlier academic traditions. While Dalí's painting technique restored Renaissance space, the irrational subject matter was fantastic as well as psychologically discomforting, drawn out of a subconscious world of paranoia.

Persistence of Memory (1931). Dalí's oil painting *Persistence of Memory* is an eerie scene suggesting a bizarre dream. Within a desolate landscape are a dead tree, a limp piece of flesh resembling a human face, soft watches, and ants. Mountains and water are seen in the distant landscape. The forms depicted are modeled in light and shadow so as to make them look illusionistically three-dimensional.

MAGRITTE

Rene Magritte (1898–1967) was a Belgian painter whose Representational Surrealism resembled Dalí's in its illusionistic qualities, but differed in its overall content. His approach often combined wit with

subconscious dream images that juxtaposed reality with fantasy. Objects of the real world are often brought into absurdly strange combinations with each other to produce disturbing psychological effects in the viewer.

MIRO

The Spanish painter Joan Miró (1893–1983) represented the abstract side of Surrealism. His paintings relied on flatly colored nongeometric, organic shapes. These shapes are sometimes referred to as biomorphic, meaning that they resemble biological organisms. His art was based on automatism. This term means "automatic action" and it refers to a painting process whereby the Abstract Surrealists entered a trancelike state, allowing the subconscious to take control of actions while engaged in the act of painting.

OPPENHEIM

Meret Oppenheim (1913–1985) was a Surrealist who is best remembered for her constructed piece, *Object* (1936). This was a Surrealist object, consisting of a fur-covered cup, saucer, and spoon. Its use of altered real utilitarian objects was an heir to the Ready-Mades of Duchamp. (It has also been discussed under "Texture" in chapter 2.)

SOCIAL ISSUES IN ART

Not all art of the twentieth century was preoccupied with formal problems. Some artists attempted to use art as an instrument of social criticism. The Spanish Civil War, for example, provoked artists to denounce the horrors of war as well as fascism (which was a growing threat in Italy and Germany as well as Spain). In democratic countries of the West, abstraction as well as realism were sometimes applied to social and political themes. In repressive fascist and communist countries, illustrative realistic styles, easily understood by the public, were encouraged by governments to serve as tools of propaganda.

Picasso

PICASSO'S *GUERNICA* (1937)

Picasso painted *Guernica* in response to the first use of saturation bombing by airplane. During the Spanish Civil War, the Basque town of Guernica had been attacked by German bombers, in an attempt to demoralize those still loyal to the Spanish Republic. Aside from the specific incident, the painting communicates in general the horrors of war.

The black, bluish black, white, and gray painting conveys a somber tone. *Guernica* conforms compositionally to the principles of Synthetic Cubist constructed space, but the somber color and grotesque distortion of figures reveal a merging of Expressionism, Abstract Surrealism, and Cubism.

RIVERA

In Mexico, Diego Rivera (1886–1957) played a pivotal role in reviving fresco as an important medium of public art. His art tended toward glorification of his native Mexican heritage as well as the revolutionary ideals of Mexico's new government, such as agrarian reform.

AMERICAN ART

In the United States, Modernism had its brief beginnings prior to World War I, but during the 1920s and 1930s American art (like its politics) became more isolationist in spirit. Realism found favor over what was regarded as European Modernist Abstraction.

Realism

O'KEEFFE

Georgia O'Keeffe (1887–1986) combined aspects of Naturalism and abstraction in her art, though she was essentially a Realist. Her subjects ranged from city buildings to animal skulls in the Southwest desert, but she is best known for her close-up views of flowers. Her work tended to stress simplification, usually in the form of near abstract organic shapes rather than Cubistic ones.

Regionalism

Regionalism was a Realist movement of the 1920s and 1930s which optimistically proclaimed the wholesome values of the American heartland, the Midwest. It focused attention on rural subjects. The Regionalists rejected Cubism and other forms of abstraction and nonrepresentation, which were seen as non-American (and therefore undesirable).

BENTON AND WOOD

Thomas Hart Benton (1889–1975) and Grant Wood (1892–1942) were two of the most important Regionalists. Although their paintings sought to reject all traces of foreign influence, an underlying Cubist structure is evident in the use of tilted planes and other distortions in perspective. This quality can be observed in Wood's painting *American Gothic* (1930), which on the surface may appear realistic, but on closer inspection reveals geometric simplification of trees, people, and other objects.

HOPPER AND THE AMERICAN SCENE

In addition to Regionalism, another representational trend which disavowed ties with European Modernism was American Scene Painting. Edward Hopper (1882–1967) was one of the major painters in this trend which focused on city and town themes rather than on country life (as did Regionalism). American Scene Painting, unlike Regionalism, presented a more bleak picture of life. Feelings of alienation and loneliness are characteristic of Hopper's art.

Nighthawks (1942). In *Nighthawks* Hopper presents a disturbing view of the loneliness of city life by showing customers sitting at a diner counter. This mood of alienation is largely achieved through the artist's manipulation of lights and darks. The use of directional forces and dark elements in the composition effectively isolate the lighted interior and its occupants.

SOCIAL REALISM AND SHAHN

During the 1930s many American painters turned attention to social issues as subject matter. One of the most important of these was Ben Shahn (1898–1969) whose representational paintings focused attention on social injustices of the time. Subjects included themes related to the plight of coal miners and their families, the underprivileged in the cities, and victims of political injustice. Shahn's painting, *The Passion of Sacco and Vanzetti* (1931–1932) focused on two Italian immigrants whom many people thought were victims of ethnic prejudice when the American criminal court system sentenced them to death for a crime they might not have committed.

*T*he main stylistic trends of the early twentieth century might be grouped into four major directions. These include Expressionism, Cubism (or formalist abstraction), Fantasy, and Realism.

Within the first two decades of the twentieth century, several major developments in Modernist art occurred. These included Brancusi's abstract sculpture, the Fauve and Cubist movements in France, German Expressionism, Italian Futurism, Suprematism and Constructivism in Russia, De Stijl in Holland, and Dada in New York and Zurich, Switzerland. Matisse, Picasso, Kandinsky, Wright, Mondrian, and Duchamp were among the most influential artists of this era.

Between the world wars, in the 1920s and 1930s, architectural advances occurred in the International Style, and Surrealism emerged as the strongest new movement in European art. In the United States, realist trends such as Regionalism dominated. Among the major artists whose reputations were formed during this period were Le Corbusier, Mies van der Rohe, Dalí, Miró, and O'Keeffe.

Selected Readings

Arnason, H. H. *History of Modern Art*. 3rd ed. Englewood Cliffs, NJ: Prentice-Hall. 1988.

Barr, Alfred. *Cubism and Abstract Art*. New York: Museum of Modern Art. 1974.

Chipp, Herschel. *Theories of Modern Art*. Berkeley: University of California Press. 1968.

Hunter, Sam, and John Jacobus. *Modern Art: Painting, Sculpture, Architecture*. 3rd ed. Englewood Cliffs, NJ: Prentice-Hall. 1982.

Rosenblum, Robert. *Cubism and Twentieth-Century Art*. New York: Abrams. 1976.

Rubin, William, and Kirk Varnadoe. eds. *Primitivism in 20th-Century Art: Affinity of the Tribal and Modern*. 2 vols. New York: Museum of Modern Art. 1984.

Russell, John. *Meanings of Modern Art*. New York: Thames and Hudson. 1981.

Selz, Peter. *German Expressionist Painting*. 1957 reprint. Berkeley: University of California Press. 1974.

Tucker, William. *Early Modern Sculpture*. New York: Oxford University Press. 1974.

12

Art After World War II

1945 United Nations founded

1949 NATO established

1950–1953 Korean War

1955 Warsaw Pact established

1957 Sputnik launched by U.S.S.R.

1959 Castro comes to power in Cuba

1961 First human in space; Berlin Wall built

1963 Assassination of President Kennedy

1964 Civil Rights Act in the United States

1965–1973 Vietnam War

1968 Assassination of Martin Luther King, Jr.

1969 First person on the moon

1974 Abortion legalized in the United States by the Supreme Court

1974 Nixon resigns presidency during Watergate scandal

1979 Ayatollah Khomeini establishes Islamic Republic in Iran

1981 Reagan becomes President of the United States; AIDS comes to national attention in the United States

1985 Gorbachev comes to power; relations improve between U.S.S.R. and the West

1986 Chernobyl disaster in U.S.S.R.

1989 George Bush becomes President of the United States

1991 Persian Gulf war; right-wing coup fails in the U.S.S.R. and the Soviet Union begins to break apart

After 1945, as technological advances accelerated greatly , the cold war politically polarized the world. Space travel was initiated and computers became commonplace both at home and at work. For the first time the United States lost a war—Vietnam. Communism eventually lost its grip in Eastern Europe and the Soviet Union underwent significant political upheavals and revisions.

After World War II, the center of the art world shifted from Paris to New York. Abstract painting dominated the visual art scene into the 1960s. Since the 1960s sculptural forms and various modes of representation have reappeared to challenge abstraction's dominance in earlier modern art. The present time is an age of pluralism in art, when many different trends coexist, without any one claiming obvious leadership. Some call our present time a period of PostModernism.

ABSTRACT EXPRESSIONISM

Abstract Expressionism, a nonrepresentational mode, was the first major development in American painting to receive international renown. The movement evolved through the 1940s, establishing New York as the new art center of the world at the end of World War II (challenging Paris' long held claim to the title). The movement was also referred to as the New York School.

Action Painting and Color Field

Abstract Expressionism remained the dominant direction in art until the early 1960s. It is usually described as having two major currents (though contemporary scholars debate this division). One, called Action Painting, emphasized an energetic painting process. The other direction, which is sometimes called Color Field Painting, stressed a more formal regard for color itself rather than the painting process. In Color Field painting the traditional idea of a composition was replaced with that of a broad color ground upon which other colors were activated.

GORKY

Arshile Gorky (1904–1948) was a transitional painter between Surrealism and Abstract Expressionism. The organic shapes in his compositions resembled Miró's biomorphic forms, but his brushwork revealed an ac-

celerated speed in execution. His method derived from the automatic painting process of Abstract Surrealism.

The Liver Is the Cock's Comb **(1944).** *The Liver Is the Cock's Comb* illustrates Gorky's aggressive painting style. Here, spontaneity is expressed by brilliant color and painterly brushstrokes (reminiscent of Kandinsky's earlier Expressionism), united with Miró-like abstract shapes.

HOFMANN

Hans Hofmann (1880–1966) was an important artist in the development of Abstract Expressionism. Before coming to the United States in 1932, the German-born artist had absorbed traditions of the *Fauves* and Expressionists as well as the Cubists and Surrealists. His approaches to Abstract Expressionism stemmed from all of these earlier directions. His paintings ranged between abstractions stressing spontaneity to others more preoccupied with formal geometric structure.

The Wind (1942). In the early 1940s Hofmann experimented with drip techniques to form entire compositions in small-scale paintings. In The Wind, he dripped paint in curvilinear rhythms. This drip painting process was later applied on a larger scale and made famous by Jackson Pollock.

The Golden Wall **(1961).** In *The Golden Wall*, Hofmann strikes a balance between sensual color and texture, and geometric structure. His rectangular areas of color rested against one another, creating tense relationships between planes. Hofmann conceived of this color interaction as a push-and-pull effect, as warm and cool colors interact.

POLLOCK

The most famous of the Abstract Expressionists was Jackson Pollock (1912–1956). Philosophically, Pollock was affected by the writings of Carl Jung and his emphasis on the archetype. He was also influenced by Navajo sand paintings. Beginning in 1947 Pollock was inspired by Hofmann's earlier experimental drip paintings, which he transformed into large-scale, all-over compositions (meaning all parts of the painting surface were treated similarly without an emphasized focal point).

Autumn Rhythm **(1950) and** *One* **(1950).** *Autumn Rythym* and *One* are good examples of Pollock's Abstract Expressionist mode. The artist aggressively approached the painting process by dripping, pouring, and splashing fluid house paint on an unstretched canvas. Pollock is often referred to as an Action Painter (a term coined by art critic Harold Rosenberg). Action Painting involved an emphasis on gesture, meaning arm movement over the canvas's surface. Pollock literally threw his whole being into his painting process. He described his art as representing the "energy it takes to paint."

KLINE

Franz Kline (1910–1962) was also an Action Painter whose forms are sometimes compared to oriental calligraphy, enlarged to monumental scale. Kline is best known for his large black and white paintings in which broad, sweeping diagonal black brush strokes suggest powerful gestural movement.

DE KOONING

Willem de Kooning (b.1904) was also classified as an Action Painter, although he did not fully abandon the figure. In this respect he stood apart from other Abstract Expressionists, though he shared Pollock's and Kline's regard for energetic involvement in the painting process.

Woman **Series.** During the 1950s, de Kooning did a series of highly abstracted images of women. His violent brushmarks and vivid color conveyed a savage sense of ferocity. The actual meaning of his female subjects has never been fully explained.

KRASNER

Lee Krasner (1908–1984) was married to Pollock but was also influenced by Hofmann. Her early nonrepresentational work resembled Pollock's all-over compositions, but she retained a preference for brush painting and her Action Paintings were done on a smaller scale. In her later works, she successfully integrated the figure into the structure of Abstract Expressionism.

NEWMAN

Barnett Newman's (1905–1970) paintings were conceived as solid grounds of a single color over which one or a few thin vertical strokes of another color were applied (almost suggesting slit openings in the painting's flat surface). The simplicity of Newman's large paintings approached the later trend called Minimalism.

ROTHKO

Mark Rothko (1903–1970) shared some of Newmann's concerns within Abstract Expressionism. Rothko's Color Field paintings consisted of fuzzy-edged softly painted rectangular color shapes floating on contrasting color grounds.

GOTTLIEB

Adolph Gottlieb (1903–1974) combined some of the basic features of Color Field painting with those of Action Painting in his serial paintings. In his series entitled *Bursts*, Gottlieb set softly edged circular color shapes (reminiscent of Rothko) below exploding forms (reminiscent of Kline), placing both against a background color field.

Figurative Painting

Even while Abstract Expressionism was the dominant world trend, there remained painters who never abandoned representation, and nonrepresentational artists who were tempted to return to the figure.

DIEBENKORN

In California, Figurative Expressionists emerged in the mid-1950's. Richard Diebenkorn (b.1922), applied the brushwork of Abstract Expressionism to figurative subjects. Later, in the 1960s, he returned to nonrepresentation.

DUBUFFET

In France, Jean Dubuffet (1901–1985) was a figurative painter whose style was influenced by the art of the psychologically disturbed and by children's art. He often inscribed graffitilike figures onto rough-painted grounds, favoring melancholy tones.

BACON

In England, Francis Bacon (b.1909) painted in an expressionistic mode, often reworking themes of the old masters. Best known are his paintings based on Velázquez's portrait of Pope Leo X. The pope's form is distorted and reinterpreted as a screaming figure in Bacon's *Head Surrounded by Sides of Beef* (1954).

Sculpture and Abstract Expressionism

Abstract Expressionism had parallels in sculpture. While more traditional figurative and abstract modes continued, as in the work of the English sculptor Henry Moore (1898–1986), some sculptors took abstraction and constructivism into newer directions.

SMITH

David Smith (1906–1965) was one of the most important sculptors of constructivism after World War II. He produced welded steel constructions, often with abstracted figurative associations. Later in his career, his art became more geometric in its emphasis.

Cubi **Series.** Smith's *Cubi* series of the early 1960s descends from the earlier Cubist tradition. His outdoor welded steel forms consisted of arrangements of interacting geometric solids set off at different angles to one another. Smith's steel surfaces were expressively scuffed to indicate the movement of the artist's hand across them. This gestural quality links Smith's scuff marks to the work of Abstract Expressionist Action Painters.

BONTECOU

Lee Bontecou (b.1931) was a sculptor of the early 1960s who exhibited parallels with Abstract Expressionism. Her highly original sculptures consisted of constructed reliefs of welded steel, wire, and soiled canvas.

Abstract arrangements of oval-shaped openings created dark craters, sometimes causing a powerful menacing effect.

CHAMBERLAIN

John Chamberlain (b. 1927) constructed his junk sculpture (meaning art assembled from trash materials) out of parts of discarded automobile bodies. Using the material as found (without repainting), he bent the metal into expressive, richly colored designs resembling Abstract Expressionist painting.

POP ART AND RELATED TRENDS

Pop Art was a major art movement of the 1960s. It represented a move away from abstraction toward recognizable objects. Prior to Pop, other developments occurred which anticipated its arrival by challenging the supremacy of Abstract Expressionism.

Pre-Pop

During the mid-1950s, developments occurred in art that were influenced by the spirit of earlier Dada, and by attempts to integrate art more with life. The musical composer John Cage (who made music out of ordinary city noises) was an important influence on visual artists in this regard. These artists are sometimes placed under the category of Neo-Dada.

RAUSCHENBERG

Robert Rauschenberg (b. 1925) developed combine-painting, which incorporated collage and Duchampian objects related to everyday urban life into paintings. He overlaid his assemblaged pieces with Abstract Expressionist brushwork.

Bed **(1955) and** *Canyon* **(1959).** *Bed* and *Canyon* are both good examples of Rauschenberg's combine-paintings. In *Bed*, Rauschenberg splattered a quilt and pillow with paint in the manner of Abstract Expressionism. In *Canyon*, a stuffed eagle projects from a collage background that bombards the eye with an overload of diverse images related to modern life.

JOHNS

In the mid 1950s, Jasper Johns (b. 1930) was also affected by Cage's ideas regarding the fusing of art and life. Some of Johns' combine-paintings anticipated Pop Art in their reference to symbols of American popular culture.

Targets, Flags, and Numbers. Among Johns' works were series of paintings involving targets, flags, and numbers, painted in heavily textured encaustic. Three-dimensional objects were often included in these pieces as well.

Pop-related Art in England

In the late 1950s, some British artists and critics in London were engaged in discussions on contemporary popular culture. Some even made works that anticipated later Pop Art in the United States. It is debatable as to whether Pop actually was invented in England, however.

HAMILTON

The English artist Richard Hamilton (b.1922) was important in the London group of artists who were fascinated with American popular culture. One of his works is sometimes considered to have launched the Pop movement.

Just What Is It That Makes Today's Home So Different, So Appealing? **(1956).** Hamilton's collage, *Just What Is It That Makes Today's Home So Different, So Appealing?*, is considered to contain most of the ingredients of later Pop Art in the United States. The collage includes elements such as commercial labels and product logos and a blown-up section from a comic book. The word *pop* even appears within the work.

Pop Art in the United States

The actual development of Pop Art occurred in the United States during the early 1960s. Pop artists focused attention on mass media and on banal images of the commercial world, often basing their techniques for making art on commercial processes. Several of the Pop artists began their careers as commercial sign painters or billboard artists.

WARHOL

Andy Warhol (1925–1987) was the most famous Pop artist. He began his career as a commercial artist. When he turned to fine art, Warhol decided to make popular culture and the commercial world the source of his subject matter. The images of objects seen in everyday life but seldom really noticed by the public were now to be taken seriously as important art.

Campbell's Soup **and *Coke Bottles*.** Warhol often depicted repetitious rows of commercial products, such as Campbell's soup cans and coke bottles in his paintings. He created his images by incorporating mechanized commercial processes (such as photographic screen printing), giving his art a depersonalized appearance (unlike the highly personalized brushwork of Abstract Expressionism).

LICHTENSTEIN

Roy Lichtenstein (b. 1923) based his pop art on the comic book, taking its small frames and dot color patterns and enlarging them to monumental images. Lichtenstein also wanted to transform his comic strip sources into a more elevated art form by altering and improving their compositions. Like Warhol, Lichtenstein incorporated mechanized processes based on those used in commercial art.

WESSELMANN

Tom Wesselman (b. 1931) is another important artist who worked in the cool mechanical branch of Pop Art. Like Warhol and Lichtenstein he also sought to hide evidence of his own hand in the painting process. One of his most famous series involved what Wesselmann called *The Great American Nude* in which the faceless, nude females were painted in a flat and impersonal manner.

SEGAL

George Segal (b. 1924) represents a more personalized form of Pop Art, in contrast to the mechanical and depersonalized approach already discussed. Segal placed rough-surfaced, white plaster figures cast from live models in real environments. These environments often included utilitarian objects found in junk yards.

MARISOL

The Venezuelan artist Marisol Escobar (b. 1930) creates mixed-media works which assemble sculpture, painting, drawing, and found objects into Pop environments centered on the human figure. Marisol constructs her abstracted figures of Cubistic blocks on which heads or body sections are partially carved or drawn.

KIENHOLZ

West Coast artist Edward Kienholz (b. 1927) also constructs environments, using sculptural figures and real objects. The emotional impact of his themes, often related to brutal and gruesome themes (such as conditions in state mental hospitals), separates his work from the more banal Pop Art.

Color Field and Hard Edge Painting

In the 1960s nonrepresentational painting began to move away from the gestural qualities of Abstract Expressionism. It became less personal in regard to brushwork and surface texture. This trend occurred in two main directions.

COLOR FIELD

One of these directions is sometimes called Color Field painting, but it is also referred to as Postpainterly Abstraction. It continues the nongestural trend established within Abstract Expressionism (exemplified by artists such as Newman and Rothko). Color Field continues as a tradition of pure color painting which does not focus attention on lines or shapes, but only on the color itself.

HARD EDGE

The other trend, Hard Edge painting, differs from Color Field. It emphasized the crisp edges around forms which are often read as precise geometric or biomorphic shapes. Here the emphasis is on the color's shape rather than on the color itself.

STELLA

Frank Stella (b. 1936) is one of the major Postpainterly Abstractionists (or Color Field painters). Though his paintings from the sixties contain arrangements of linear stripes, his intention was not to activate lines or shapes, but to immerse the viewer in the pure visual sensation of his color field.

Empress of India **(1965).** In the *Empress of India*, Stella abandoned the traditional rectangular form of modern paintings, replacing it with the shaped canvas. This striped painting does not attempt to convey figure-ground relationships or any traditional sense of composition. Instead it displays the painting as a flat color field, a self-contained object in and of itself.

FRANKENTHALER

Helen Frankenthaler (b. 1928) invented a process of staining the raw canvas, fusing color and surface as one. The earlier Abstract Expressionists had conceived of their color as painted *on* the canvas; Frankenthaler's approach unifies the canvas *as* the color. This development was a decisive step beyond Rothko and Newman toward eliminating painterliness and texture in painting.

Frankenthaler first used this process in the early 1950s, but developed it further in paintings of the sixties (such as *Interior Landscape*, 1964).

LOUIS

Washington, D.C.–based painter Morris Louis (1912–1962), was one of the first important artists to be influenced by Frankenthaler's canvas-staining method. He applied it to serial images, such as his veil paintings, in which transparent layers of color appear to float on the surface of his canvas, without any traces of brushwork.

NOLAND

Kenneth Noland (b. 1924) was another innovator in Color Field painting working in Washington, D.C. Compared to Louis, Noland's paintings had more distinct linear forms (such as chevrons, circular targets, or stripes), but the work remained absorbed in the issue of color rather than in linear definition.

KELLY

Ellsworth Kelly (b. 1923) might best be described as a Hard-edge painter. The linear boundaries of his color forms are crisply defined. As with the work of the Color Field painters, Kelly avoided all traces of brushwork on his flatly painted surfaces.

Because of their extreme simplicity, Kelly's paintings, such as *Red/Blue* (1964), are also considered Minimal Art.

Op Art

Op Art (also called Optical Art) was another direction which gained popular attention and reached its height as an art trend in the 1960s. It was a type of art rooted in science, relying on optical illusion to achieve its effects, which were often implied movement. Op art was strongly linked in this regard with kinetic art. Hungarian-born Victor Vasarely (b.1908) has been Op Art's major theoretician as well as its leading artist, but several other important artists have developed in this category.

RILEY

The British artist, Bridget Riley (b. 1931) was one of the best known Op Artists. In paintings such as *Current* (1964) and *Crest* (1964), she used closely placed parallel wavy black lines against a white field to create an illusion of rhythmic motion, suggesting the rippling of water currents.

MINIMALISM/PRIMARY STRUCTURES/ ABC ART

Minimalism was a major trend that affected sculpture in particular during the 1960s. It is also referred to as Primary Structures and ABC Art. Minimalism is characterized by an extreme regard for geometric simplification, and often involves the most basic forms, such as a single cube. A Minimalist form, though geometric, is not concerned with planes or traditional Cubist composition. Instead it is meant to be instantaneously perceived in its elemental essence without need for further compositional analysis. Minimalism relates to similar developments in architecture and

followed Mies van der Rohe's dictum that "less is more." Minimalist art is also impersonal and nonsensual, avoiding all traces of the artist's hand. Often, Minimalist sculptures have been factory fabricated from the artist's designs.

Painter-Architect Turned Sculptor

JUDD

Donald Judd (b. 1928) was one of the leading Minimalist sculptors in the 1960s. A painter turned sculptor, he has expressed the view that art should be depersonalized and not reveal the artist's hand. He does not feel it is necessary for an artist to engage in the labor of actual construction, and his own works have been fabricated in industrial foundries. During the '60s his Minimalist sculptures normally consisted of uniform-size metal boxes of aluminum or galvanized steel that were arranged in rows at regular intervals. Usually untitled, they were placed along a wall either horizontally or vertically.

TONY SMITH

An architect and occasional painter turned sculptor, Tony Smith (1912–1980) conceived Minimalist sculptures on a monumental scale. His sculpture *Die* (1962) was a six-foot steel cube of static design. Smith was better known for his more dynamic monumental primary structures which included forms jutting out into space in various directions.

Conceptual Art

In Conceptual art, the *idea* itself is the art. Artists' concepts were often revealed through the use of objects or documentations of experience, but what made a work "art" was the artist's conception of it as such, rather than the product itself.

KOSUTH

Joseph Kosuth (b. 1941) was one of the most important early conceptualists. He produced "wordworks" such as *Art as Idea as Idea* (1967) simply by photocopying and enlarging an entry in the dictionary. This process required no traditional artistic skill whatsoever. The resulting product could not be analyzed in terms of its formal visual characteristics because the artwork was its concept alone. Another Kosuth work entitled *One and Three Chairs* consisted of an arrangement along a wall of a real chair, a photograph of a chair, and a photostat enlargement of a dictionary definition of the word "chair."

Rejection of Art as Commodity

Other directions initiated by aspects of Minimalism, which departed into what has been termed Post-Minimalism, included artists who rejected the basic notion of an artwork as a commodity, which could be bought and sold. Instead, like the Conceptualists, they felt that the essence of art was in the

viewer's experience, rather than in a portable product. These artists rebelled against the commercialization of the gallery system.

Earthworks

One of the directions taken by these artists involved applying the practices of Minimalism to the land itself. Their large scale "earthworks" (or "land art") were constructed of earth but many took similar geometric forms to Minimalist sculpture.

SMITHSON

Robert Smithson (1928–1973) was one of the leaders of the earthworks movement. Smithson's concept of design evolved out of a branch of Minimal art that viewed sculpture as environmental. This meant that sculpture should be a space-articulating medium involving the spectator much as does architecture. He applied this principle to his large earthworks. *Spiral Jetty* is Smithson's most famous work. It was constructed into the Great Salt Lake in Utah (see "Earthworks and Site Works" in chapter 4).

Site Works

Site works (also called site-specific art) are also made in the landscape by artists who carefully choose locations that best convey their ideas. Unlike earthworks, however, site works are not made of the earth itself but of other natural and manufactured materials. Often site works are temporarily constructed, either removed by the artist after a certain time period or reclaimed by nature. They are based on the concept of art as the spectator's experience rather than art as an object. As art, they require human participation to complete them.

DE MARIA

Walter De Maria (b. 1935) was an important Minimalist sculptor in the 1960s who later moved in other directions, including site works. Some of his work might also be classified as Conceptual art.

Lightning Field (1971–1977). The *Lightning Field* is a site work (which might also be considered Conceptual Art) meant to be viewed over a twenty-four hour period. Four hundred stainless steel poles were placed within a rectangular grid (measuring one mile by one kilometer) in the New Mexican desert. During electrical storms the poles attract lightening. At other times they reflect sunlight and contrast as technological forms set against the natural terrain.

CHRISTO

Bulgarian born Christo Javacheff (b. 1935) can be classified as a site-specific artist (and as a Conceptual artist). He is best known for wrapping objects, including buildings, in huge sheets of fabric. Generally the wrappings are removed after a specified period of time and the artwork ceases to

exist. *Running Fence* was one of Christo's most famous works (see "Earthworks and Site Works" in chapter 4).

AYCOCK

Alice Aycock (b. 1946) is a site-specific artist who invests her works with symbolic and psychological content. They reveal a fascination with architectural and industrial construction as well as ancient forms such as the labyrinth, which served as a basis for her constructed mazes.

Installations

While earthworks and site-specific art involved artists working out of doors, some artists turned their attention to temporary indoor installations and environments. These indoor installations were conceived in much the same way as outdoor site works, but were created indoors (see "Installations and Environments" in chapter 4).

PFAFF

Judy Pfaff (b. 1946) uses painting as well as various other materials to provide an assortment of lively textures and colors in her installations. The viewer can literally enter and meander through the space of Pfaff's three-dimensional compositions.

Dragons (1981). *Dragons* was a mixed media installation at the Whitney Biennial (Whitney Museum of American Art, New York). Pfaff attached various colored materials to the wall, among areas of painting. Brightly hued forms of metal, wood, and wire filled the space with active linear movement, suggestive of a Pollock composition thrust into three dimensions.

GILLIAM

Sam Gilliam (b. 1933) transforms painting by removing it from the stretcher and hanging or dropping the painted canvas in the middle of a room, as soft material, draped and swagged. In doing so, he activates the gallery space into a sculptural relationship with his painted canvas.

Niagara and Autumn Surf (1977). In *Niagara and Autumn Surf*, an installation at the Cranbrook Museum (Bloomfield Hills, Michigan) Gilliam suspended large painted canvases from the gallery ceiling, letting the effects of gravity transform them into sculptural forms. The canvases themselves were fluidly painted by pouring and staining techniques.

BARTLETT

Jennifer Bartlett (b. 1941) has been a very productive artist working in a number of modes and media. In installations, such as *White House* (1985), she combines sculptural forms with painted illusion. A small model of a house and a real picket fence are juxtaposed with a painting representing the same subjects.

RECENT DEVELOPMENTS

Happenings and Performance Art

Another direction in art that has gained importance from the late 1950s onward involves performance and audience participatory events combining certain aspects of visual art and theater (see "Performance" in chapter 4).

TINGUELY

The Swiss artist, Jean Tinguely (b. 1925) creates satirical machine sculptures that serve no utilitarian purpose. In this respect Tinguely can be viewed in the context of kinetic art. Sometimes his works have been planned as part of theatrical events, and even designed to self-destruct before an audience.

Homage to New York **(1960).** In *Homage to New York* Tinguely constructed an absurd machine out of junkyard and second-hand materials. Its purpose was to destroy itself, which it did before an excited audience in the courtyard of the Museum of Modern Art in New York.

KAPROW AND THE HAPPENING

The term *happening* was coined by Alan Kaprow in the late 1950s. His concept involved events at which there were no spectators, only participants. Happenings, such as *Household* (which took place in a junkyard in 1964), were partly planned but left room for improvisation so that participants could not fully anticipate the outcome of their actions. As an art form, the happening was short-lived, lasting only into the 1960s.

ANDERSON

Laurie Anderson (b. 1947) is a performance artist who combines aspects of popular musical performance with storytelling and other forms of entertainment including zany humor. She mixes high-technology equipment into her live performances. Anderson's performances have also been recorded as video and film (such as *Home of the Brave,* 1986). Her work often addresses social issues, presented through her fusion of popular entertainment with serious art.

Photo-realist Painting and Related Realist Trends

After the 1960s many artists began to abandon nonrepresentational art in favor of representational modes. Some of the styles were strongly influenced by the photographic image, while others were not. The Super-Realists (who included sculptors as well as Photo-Realist painters) produced works that appeared to be the heirs of Pop Art. They often focused on images related to the world of popular culture. The Super-Realists used meticulous methods to produce cool, objective replications of their sources.

PEARLSTEIN

Philip Pearlstein (b. 1924) developed a Realist painting style based on direct observation of the model rather than the use of photographs. His paintings of nudes are characterized by an interest in harsh Realism. Pearlstein's models are painted in a straightforward, nonflattering manner.

CLOSE

Chuck Close (b. 1940) developed a form of Photo-realist painting with images based on careful representation of a photographic image rather than direct observation of the subject. In his large scale, close-up views of faces, wrinkles and blemishes often create an ugly effect, enhanced by their oversize presence.

EDDY

The Photo-realist paintings of Don Eddy (b. 1944) are often based on black-and-white photographs of cars. The photographic image is transferred to a large scale by means of a grid, then painted in color with a meticulous airbrush technique.

ESTES

Richard Estes (b. 1936), unlike Don Eddy, makes use of the brush in his Photo-realist paintings. His images focus on photographic scenes of city streets and storefront windows. Generally devoid of human presence, his paintings, though Photo-realist, are reminiscent of Hopper's in mood.

FLACK

Audrey Flack (b. 1931) bases her airbrushed still-life paintings on projected slide images. She uses a combination of photographs to create her subjects rather than a single photographic image. Her oversized still lifes have a symbolic significance alluding to both personal and feminist perspectives.

HANSON

Duane Hanson (b. 1925) is a Super-Realist sculptor whose figures are cast directly from impressions made from his models. Unlike the rough cast figures of Segal, Hanson's images—among them tourists dressed in gaudy clothing—look incredibly lifelike. Aside from his realism, his work serves as social commentary on middle-class Americans.

Neo-Expressionism

EXHIBITS LAUNCH NEW TREND

In 1978 there were two important exhibitions in New York that helped to launch a different type of representational art later called Neo-Expressionism. These shows were "Bad Painting" at the New Museum and "New Image Painting" at the Whitney Museum of American Art.

"Bad Painters" and "New Imagists." "Bad Painters" and "New Imagists" worked in intentionally primitive styles, exhibiting awkward drawing and clumsy compositions. As Neo-Expressionism evolved, it was characterized by its borrowing of elements such as expressive color and brushstrokes from earlier Expressionist styles.

BROWN

Joan Brown (1938–1990) was one of the artists who exhibited in the "Bad Painting" exhibition. In her work she deliberately incorporated crude drawing and painting techniques that challenged the academic values of the art world.

KIEFER

The German Neo-expressionist Anselm Kiefer (b. 1945) creates brooding, often monumental, paintings. Their dark tones and heavily textured surfaces are the result of the application of diverse materials such as tar, mud, ceramic fragments, and metal along with paint. Stylistically, Kiefer's paint application resembles that of the earlier Abstract Expressionists. In terms of content and mood the works draw on mythological and archetypal sources in a manner reminiscent of some nineteenth-century Romantic paintings.

Photography, Film, Video

Photography has made great progress in recent years in its effort to gain respect as a serious art form, and to overcome biases that favor more traditional visual art media such as painting and sculpture. Many contemporary photographers have challenged traditional notions of the medium (see "Photography" in chapter 4), such as twins Mike and Doug Starn, whose collaborative collagelike photographs include pieces of film and transparent tape.

Filmmaking has also continued to played a vital role in the art world (see "Cinematography" in chapter 4), and video has emerged as an important and more affordable experimental medium (see "Video Arts" in chapter 4).

CURRENT ISSUES

A number of issues affect today's art world, crossing stylistic boundaries, and in some cases challenging the divisions between various disciplines, including art and science. All of this compounds the conflicting views concerning the stylistic identity of the current age.

Post-Modernism

The term "Post-Modernism" has been used recently to categorize much of the art produced from around the mid-1960s to the present. It literally means "after Modernism." In the twentieth century, Modernism has meant something other than its literal definition. It has designated the type of innovative art made by Picasso, Mondrian, and the architects of the International School. As their styles became accepted by the art establishment, Modernism became status quo. Then younger artists began to challenge Modern art's authority. Post-Modernism suggests a development away from the formalism that had its roots in early twentieth-century Cubism and continued until Minimalism. Included might be such developments as Conceptual art, earthworks, site works, Photo-realism, Neo-Expressionism, and some recent trends in architecture.

HISTORICISM AND DECONSTRUCTION

When discussing Post-Modernism, sometimes the term *historicism* is used in reference to artists turning to earlier historical styles from which to appropriate (borrow) stylistic elements. Another term, *deconstruction*, refers to a process of dismantling the stylistic elements of Modernism and reconstructing them into a new style.

Postmodern Architecture

The term *Post-Modern* as applied to visual art was first used in reference to architecture during the 1970s. Some would argue that it fits architecture better than it does other art media.

VENTURI

The Philadelphia architect, Robert Venturi (b. 1925) was one of the first advocates of Post-Modernism. He is sometimes viewed as architecture's "Pop artist" (although his actual buildings appear too restrained to fit that label) because of his philosophy that architects should incorporate aspects of popular culture into their designs. He felt that the aesthetic dominance exerted by Modernist architects upon society as a whole did not correspond to the complexity of contemporary life.

GRAVES

Michael Graves (b. 1934) has been one of Post-Modernism's most successful proponents. In addition to being an architect, Graves paints, sculpts, and designs furniture as well as dinnerware and housewares.

Humana Building (1982). Graves's Humana Building in Louisville, Kentucky, exhibits Post-Modern characteristics. These include a monumental entrance and lobby that evoke associations with ancient temples, and a colorful treatment of facade surfaces. The building's overall extravagance rejects the Modernist notion that "less is more."

Art in Public Places

GOVERNMENT FUNDING

Since the 1960s, a large percentage of public art has been funded by city, state, and national government agencies. One of the major sponsors has been the General Services Administration's Art-in-Architecture program. This program requires that a set percentage of the cost of newly constructed government buildings be set aside to acquire art to be placed within and around them. The National Endowment for the Arts has an Art in Public Places program which matches a community's funds for outdoor public art works.

CONTROVERSIES INVOLVING GOVERNMENT FUNDING

The issue of what constitutes "good" art for a location in a public space is a controversial one. Recently it has even extended into art galleries and museums, when issues regarding public standards of morality have challenged the art world's right to show whatever it thought appropriate. This has been an especially hot issue when it involved how tax dollars are used to purchase art or support major art exhibitions to which the public is invited. Not everyone is content to leave decisions in the hands of art experts. Often, people less familiar with current art issues feel they also have a right to influence decisions concerning how tax dollars are used for art.

Vietnam Veterans Memorial (1980–1982). Sometimes, issues concerning public art commissions stir considerable debate. This was the case with Maya Lin's Vietnam Veterans Memorial. The commission had been won in a national design competition by Maya Ying Lin, who was then a twenty-one-year-old student at Yale University. Her design was a 250-foot-long, V-shaped Minimalist structure of polished black granite. Its inner wall surface was to contain the names of all Americans who had died in the Vietnam War. Before its actual construction, controversy arose that caused the project to be postponed. Some wanted a more traditional commemorative monument. A compromise was reached when a naturalistic bronze statue of soldiers by Frederic Hart was selected to be placed near the wall in 1984. This decision upset Modernists who wanted to preserve the wall's formal purity.

CORPORATE SPONSORS

Outside of government agencies, corporations have played a major role in support of the visual arts, and corporate collections often are placed on public display.

Noguchi's *Red Cube.* Corporations and other businesses have often commissioned impressive public sculpture, which rarely sparks serious controversy. The Japanese-American sculptor Isamu Noguchi (1904–1988) executed an outdoor public sculpture for Marine Midland Bank in New York, which has become a popular attraction. It is a monumental, diagonally balanced red cube which appears to rest on one of its points. Though its simplicity relates to Minimalism, its bright color and dynamic tilt set it apart from more reserved Primary Structures.

HARING AND STREET ART

Keith Haring (1958–1990) was made famous by another type of public art, related to graffiti, called street art. Haring did white chalk-line drawings on black backgrounds in empty advertising signboards in New York subway stations. His drawings were unsolicited, and lasted only until advertisements replaced them. They were intended to be seen by ordinary people who were not part of the same audience that visited art galleries and museums.

Feminist Art

Since the late 1960s, the issue of women's art has strongly affected mainstream developments in the art world. Not all women's art can be considered feminist, but the feminist movement has focused attention on every woman's art and on the political, economic, and social factors that affect women as artists. Some women have been especially active as feminists. Their art directs attention to the issue of gender.

SHAPIRO

Miriam Shapiro (b. 1923) has been one of the strongest proponents of feminism in the art field. She became identified with the Pattern and Decoration movement of the 1970s and produced highly decorative mixed media works on fabric. Her art celebrates a feminine aesthetic which the male dominated art establishment had long denigrated as unimportant. Generations of women had traditionally created brightly colored quilts and other needlework items with strong abstract design qualities but these had not been considered "art." Shapiro's work upholds that tradition as a vital and important form of artistic expression, transcending utilitarian associations to be fully recognized as fine art.

JUDY CHICAGO

Judy Chicago (b. 1939) was trained as a painter but attained renown through large collaborative projects involving traditionally female "crafts." Her work is politically charged with feminist content.

The Dinner Party **(1979).** *The Dinner Party* was Judy Chicago's most famous collaborative project, involving a large team of women artisans. It consisted of a large triangular table with place settings representing thirty-nine historically significant women. Each place setting included a hand-embroidered fabric runner and a porcelain plate commemorating one of the honored women. The organic abstract designs of some of the plates strongly suggested vaginal shapes, causing considerable controversy.

African-American Art

In recent years, more attention has been given to artistic achievements within America's diverse ethnic communities. There has been particular interest in African-American artists throughout the nation's history. While some of these artists presented themes related to their racial heritage, others such as Sam Gilliam (see Gilliam under "Installations" in this chapter) have only addressed formal art issues.

HARLEM RENAISSANCE

The Harlem Renaissance of the 1920s and 1930s was an especially vital period in visual art as well as writing and music. During this time, attention was focused on African heritage as many black artists expressed pride in their ancestral roots. This can be seen, for example, in the themes of Aaron Douglas's 1934 murals for the Harlem branch of the New York Public Library.

LAWRENCE

After the Depression, Jacob Lawrence (b. 1917) emerged as an important African-American artist. He was self-taught as a painter, developing a primitivistic style, combining decorative flat color shapes with a sensitive awareness of design. His paintings of ghetto life were charged with powerful social content.

BEARDEN

Romare Bearden (1914–1988) painted themes related to African-American life in both the rural South and the urban North, using painting and collage techniques. His style incorporated Cubist principles, combining influences from African sculpture. A musician as well as a painter, he said that he painted out of the tradition of the blues.

SAAR

Bettye Saar (b. 1926) began making mixed-media assemblages within boxes in the late 1960s. Her art conveys much in the way of personal and social content related to the African-American experience.

Native American Art

The heritage of the Native American has also recently been given special focus as an issue of social concern in the United States, as well as in terms of its ethnic artistic identity.

SCHOLDER

The expressionistic paintings and lithographs of Fritz Scholder (b. 1937) address the plight of the Native American in today's society. Scholder, who is part Native American, treats his subject with great sensitivity and respect for Native American traditions. Yet on occasion, he interjects humor, as in *Super Indian, No. 2* which depicts a chief in a buffalo headdress seated with a pink ice-cream cone in his hand.

Folk Art

In addition to fine art, there are also contemporary trends in folk art that do not directly relate to the traditions of the professional artist (see "Folk Art" in chapter 1). The work of self-taught artists has long been appreciated by some who are highly educated in art, as in the case of Picasso's appreciation of Henri Rousseau's paintings in the early twentieth century (see "Rousseau" in chapter 10). Today, however, such folk artists are being given much more serious attention by a broader range of serious art enthusiasts and collectors.

Often, folk artists turn to visual expression in later life, as did Anna Mary Robertson Moses (Grandma Moses), who emphasized color and pattern in her memory paintings of rural farm life. One of the folk artists attracting a large public following today is Rev. Howard Finster (b.1916) whose art might be seen as more eccentric. Finster is a painter of visions who attempts to preach sermons in his painted and sculpted works.

After World War II and through the 1950s, Abstract Expressionism established New York as the art center of the world. By the 1960s, painterly expressionism gave way to more depersonalized approaches such as Color Field painting (Postpainterly Abstraction), Pop Art, and Minimalism.

Sometimes developments in twentieth-century art are divided into two major periods: Modernism, which continued through the mid-1960s; and Post-Modernism, which occurred thereafter and continues into the present. Since the 1960s, trends such as Conceptualism, land art, and performance have challenged the values set by early twentieth-century Modern artists.

Among the important artists representing the diversity of contemporary art are Pollock, De Kooning, Neuman, David Smith, Rauschenberg, Warhol, Stella, Frankenthaler, Judd, Aycock, Gilliam, Anderson, Flack, and Haring.

Selected Readings

Aston, Dore. *American Art Since 1945*. New York: Oxford University Press. 1984.
Beardsley, John. *Earthworks and Beyond*. New York: Abbeville Press. 1984.

Hertz, Richard. *Theories of Contemporary Art*. Englewood Cliffs, NJ: Prentice-Hall. 1985.

Lippard, Lucy. *From the Center*. New York: Dutton. 1976.

Lucie-Smith, Edward. *Movements in Art Since 1945*. New York: Thames and Hudson. 1984.

Polcari, Stephen. *Abstract Expressionism and the Modern Experience*. New York: Cambridge University Press. 1991.

Robins, Corrine. *The Pluralist Era: 1968–1981*. New York: Harper and Row. 1984.

Sandler, Irving. *American Art of the 1960s*. New York: Harper and Row. 1988.

Smagula, Howard J. *Currents: Contemporary Directions in the Visual Arts*. Englewood Cliffs, NJ: Prentice-Hall. 1983.

13

Non-Western Traditions

3000–1800 B.C.	Indus Valley cities of Mohenjo Daro and Harappa; Jomon culture in Japan
1523 B.C.	Shang Dynasty begins in China
ca. 1028–256 B.C.	Chou Dynasty in China
ca. 563 B.C.	Birth of Buddha
ca. 300–200 B.C.	First Buddhist art in India
ca. 100 B.C.–ca. 600 A.D.	Hopewell Culture in North America
ca. 300–ca 900	Classic Mayan period
570–632	Mohammed, founder of Islam
711	Moslems invade Spain
ca. 900–ca. 1100	Kandariya Mahadeva Temple in India
ca. 960–1279	Northern Sung and Southern Sung Dynasties
ca. 1000–ca. 1200	Kingdom of Ife in Nigeria
ca. 1325–1519	Aztec civilization in Mexico
ca. 1400–1897	Benin Kingdom in Nigeria
ca. 1500	Inca city of Machu Picchu in Peru
1644-1912	Ch'in Dynasty in China
1830-1840	United States Congress enacts the Removal Act forcing Native Americans in the Southeast to resettle west of the Mississippi (Trail of Tears)

ca. 1860–1880 Japanese art affects the paintings of such artists in the West as Manet, Whistler, and Cassatt

1890 Massacre of Sioux by 7th Cavalry at Wounded Knee, South Dakota

ca. 1905 African sculpture attracts notice of European artists such as Matisse and Picasso.

1912 China becomes a republic

1924 Dual legal status is given to Native Americans as citizens of the United States as well as members of separate tribal nations

1940s–1950s Abstract Expressionists study Native American art; Jackson Pollock is influenced by Navajo sand painting.

1949 Peoples Republic of China established

1960 General assembly at the United Nations, urged by a strong African and Asian block, passes a resolution calling for immediate steps to end colonialism in Africa and Asia

1970s–1990s Japan strongly challenges the American automobile industry and other technological and business interests

1980 United States Supreme Court orders government to pay $117 million to the Sioux Nation as payment for having taken the Black Hills of South Dakota from them in 1870

In the United States, art history is usually studied in light of the Western tradition. This includes ancient Greece and Rome, Europe in the Middle Ages and the Renaissance, as well as later European and American developments. What is often overlooked is the art of the majority of the world's people. This includes works produced in Africa, Oceania, Islamic cultures of the Middle East, India, Southeast Asia, China, and Japan, as well as by Native Americans.

In the Western world, art is strongly affected by the Judeo-Christian tradition, as well as Classical concepts. At various times throughout the history of civilization, non-Western cultures have also influenced the art of the West. In the nineteenth century, for example, the influence of Far Eastern art helped to shape modern concepts of style and artistic taste. Early in the twentieth century, African tribal art influenced the development of abstract painting and in the 1970s decorative styles, such as Pattern Painting, were strongly influenced by Islamic textile and rug designs.

Even if there were not strong interconnections between the art of East and West, today people are more aware of the need for cross-cultural understanding and communication. Much can be gained by experiencing the art of cultures differing from those dominating the Western world. In

order to do this, however, it is necessary to put aside the Western bias by which art is defined. The concept of art differs sharply from one society to another. This point needs to be stressed if one is to approach non-Western art with an open mind.

AFRICAN AND OCEANIC

The traditional art of Africa and Oceania is generally related to ceremony and ritual. Much of this art relates to the concept of animism, the belief that the life force is contained in every living thing, be it plant or animal.

Africa

The continent of Africa includes many diverse cultures. The earliest art from Neolithic times consisted of figures and abstract symbols in the form of rock paintings and engravings. Later there were developments in realism as well as in abstraction, but the abstract form became the dominant direction in traditional African art.

IFE AND BENIN

There was an early tradition in realism in Nigeria. In the twelfth century, the Ife civilization produced lifelike heads in terra cotta. During the period of the Benin Kingdom (ca. 1400–1900), a somewhat more abstract style (which still retained some realistic qualities) emerged in figurative ivory and bronze cast sculpture.

ABSTRACT AFRICAN SCULPTURE

Later wood carvings, such as those produced by the Yoruba people in Nigeria or the Dogon in Mali, were much more geometrically abstract. It was this type of abstract sculpture that influenced early twentieth-century European artists, such as Picasso.

Masks. Though reduced to geometric forms, African masks were perceived as likenesses of ancestors, or as images of gods. Their purpose was to be used in ritual and ceremony. Some African headpieces were masks worn over the face. Others, such as the elegant antelope headpieces used by the Chiwara Society of the Bambara tribe in Mali, were placed on top of the head.

Oceania

Oceania consists of thousands of South Pacific islands that include many different cultures. This broad region can be divided into three main areas. These include Micronesia (Caroline and Marshall islands), Melanesia (the region that includes New Guinea), and Polynesia (Hawaii, New Zealand,

and Easter Island). The art forms comprising the cultures of Oceania are quite diverse, making use of a variety of materials including wood, bark, feathers, bone, and shells.

POLYNESIA

Among the variety of art forms in Polynesia are enormous carved stone heads at Easter Island, which date from about the fifth to the seventeenth centuries. They were set upright and placed in rows. Their stark angularity is comparable to African sculpture.

The art of the Maori of New Zealand is quite different. Their wood relief carvings are filled with elaborate curvilinear patterns.

MELANESIA

In New Britain, bark cloth is used to make expressive mask forms which have a non-geometric, organic appearance. In New Guinea, elongation and bright color powerfully animate the sculptural forms and other art of the region.

ANCIENT MEXICO, CENTRAL AND SOUTH AMERICA

Important civilizations arose in Mesoamerica (the region including Mexico and Central America) and in South America. As Europeans arrived in the sixteenth century, many of these cultures were destroyed, and others drastically altered.

Olmec and Mayan Civilizations

In eastern Mexico, the Olmec civilization (1000–600 B.C.) produced small stone carvings, relief sculpture, and colossal carved stone heads (some twelve feet in height). Later, the Mayans (Mexico, Guatemala, and Honduras) developed advanced mathematics and a calendar. During the Classic Mayan period (300–900 A.D.), they constructed large temple-topped pyramids faced with stone. Some of these rose to heights of over two hundred feet.

The Aztecs

Later in Mexico, the Aztecs also made advances in mathematics and engineering as well as art and architecture. Their civilization was very warlike and their religion relied heavily on sacrifices of their captive enemies. The Aztec statue of Coatlcue (goddess of earth and death) conveys an intense ferocity as a hybrid form of snakes with exposed fangs, human hands, hearts, and a skull.

Mochican and Inca Civilizations

Along the Pacific coast of northern Peru the Mochican civilization produced clay vessels in the shapes of animals and people.

The Incas arose in the Andes of South America and thrived as a culture for several hundred years prior to Spanish occupation in the sixteenth century. They produced exquisite gold objects (many of these were melted down for reuse by their Spanish conquerors). They were also very accomplished in textiles. Their clothing was noted for its stark geometric patterns.

MACHU PICCHU (EARLY SIXTEENTH CENTURY)

Machu Picchu, in Peru, was an Inca city in the Andes (located at a height of nine thousand feet above sea level). Its walls were constructed of large granite blocks which were precisely shaped and fitted into place without mortar.

NATIVE AMERICAN ART OF THE UNITED STATES AND CANADA

Many different cultures are grouped under the heading of Native American within the region encompassing the United States and Canada. In many cases, whole cultures were demolished after European settlement, but others endure to the present day. Until recently, their diverse cultural achievements had received little attention in comparison with that given to Pre-Columbian civilizations south of the border.

Hopewell Culture

Centered in what is today Ohio, the Hopewell culture was among the more prominent ancient Native American cultures. From the second century B.C. to the sixth century A.D., the Hopewell built large burial mounds. Their culture also produced pottery and carved sculptures using wood, stone, shell, and mica.

The Western Plains

Native Americans of the western plains were nomadic hunter-gatherers who wove baskets with intricate geometric designs. They also made ceremonial masks and elaborately fringed and beaded costumes.

The Southwest

In the southwest, early peoples built cliff dwellings and free standing adobe buildings with kivas (underground sacred rooms).

NAVAJO

The later Navajos of Arizona and New Mexico became sheepherders who wove blankets characterized by geometric patterns. Today they are also the major practitioners of the ancient practice of sandpainting which is part of their religious ritual. Sandpainting involves pouring different colored sand onto a flat sand surface to form traditional designs. These works are destroyed after each ceremony.

PUEBLO

Also in the southwest are the Pueblo tribes (Hopi and Zuni). To honor invisible life-force spirits called kachinas, men of the tribes dress up to portray them in colorful costumes and masks. Small kachina dolls also give visual form to these spirits.

Pacific Coast

The cultures of many west coast tribes were greatly damaged or destroyed. Among these were the northern California Pomo, who were noted for their fine baskets. Pomo women made brightly colored feathered baskets as gifts.

Northwest Coast

Native Americans built permanent settlements along the northwest coast, constructing large wooden-plank houses. They also carved boats and masks. Totem poles carved out of tree trunks contained stacked abstract animal forms related to family traditions.

The Eskimos

The Eskimos in northern Canada and Alaska formerly lived nomadic lives of hunting and fishing. Their art is characterized by its simplicity and formal elegance. They carved masks, figures and utensils, frequently from ivory and bone.

THE ISLAMIC WORLD

The Islamic (also called Moslem) era began in seventh century Arabia, when Mohammed founded a new religion with the Koran as its holy book. Islam quickly spread to encompass much former Byzantine territory, extending across North Africa into Spain. Its eastern expansion included part of India. The Moslems made great advances in mathematics, medicine, and science; their artistic traditions exerted influences on the West. During the Crusades of the Middle Ages, Europeans assimilated cultural information from contact with their Moslem adversaries.

Orthodox Moslem tradition did not allow representational religious art. This led to the development of geometric patterns or arabesques (intricate interlacing designs). The Moslems developed a strong crafts tradition involving carpets, ceramics, metal work, and enamel. They also produced manuscript illumination.

Characteristics of a Mosque

Islam developed the mosque as a house of worship. Typically these had rectangular plans. The mosque's main axis was oriented toward Mecca, Islam's holy city. The outer walls enclosed an open court which was surrounded by aisles that led toward the qibla (the side facing Mecca). The section enclosed by a roof was densely filled with columns, in almost a forest effect (reminiscent of the hypostyle hall of the ancient Egyptian temple). A variety of arched forms (especially horseshoe and pointed arches) were also used to span distances between columns. Outside the mosque were minarets, towers from which the faithful were called to prayer.

GREAT MOSQUE AT SAMARRA, IRAQ (NINTH CENTURY A.D.)

The Great Mosque at Samarra was one of the largest ever constructed, measuring 800 feet by 520 feet. It is now in ruins. Its most noted feature is a spiral minaret recalling the ancient Mesopotamian ziggurats. Originally its interior had many densely arranged columns covered with a wooden roof enclosing a great open courtyard.

MOSQUE AT CORDOBA, SPAIN (786–987)

The Mosque at Cordoba originally had a wooden roof which was later replaced by vaults. Its interior space was constructed with a system of round horseshoe-shaped arches within its many-columned hall.

Taj Mahal (1630–1648)

The Taj Mahal in Agra, India, is a mausoleum built by Shah Jahan in the seventeenth century in memory of his wife. Its design sharply contrasts with the plainness of earlier Islamic architecture. Open arches on the exterior facade and slender minarets help to create a light and elegant appearance to the massive building.

INDIA AND SOUTHEAST ASIA

Indus Valley Civilizations

From about 3000 to 1800 B.C. the Indus Valley was the site of the ancient cities of Mohenjo Daro and Harappa. These were well organized societies (most of this region is now part of Pakistan). The sculpture produced by the ancient Indus Valley civilizations revealed a concern for solid, rounded forms and naturalism similar to that found in later Indian art.

Hindu Art

Hinduism is a major religion, strongly affecting content in art. Hindus do not separate the sacred from the secular in the manner customary in the West. Spiritual love for the gods is often expressed in erotic human terms.

KANDARIYA MAHADEVA TEMPLE (TENTH TO ELEVENTH CENTURIES)

The Kandariya Mahadeva Temple at Khajuraho in north central India was constructed of stone with many towers combined into the effect of a single monumental tower. Its appearance has been likened to that of a French Gothic cathedral in its emphasis on verticality. Unlike a Western church, however, it was intended to be a dwelling for the Hindu gods and not a congregational house of worship. It does not have a large interior space, but an intimate one intended more for individual devotions. The rounded projecting forms on its exterior allude to sexuality. This concept is reinforced in architectural sculpture which decorates the building. Some of the sculpture depicts erotic love scenes to suggest that sex and spirituality can be one.

SHIVA NATARAJA (ELEVENTH CENTURY)

Shiva is a major Hindu god whose existence relates to the cycle of life, death, and regeneration. Shiva appears in various guises such as Shiva Nataraja, the Lord of the Dance who destroys and rebuilds the universe through his dance. The figure has multiple arms to heighten the sense of active movement.

Buddhist Art

The first Buddhist art was produced about 300 B.C. Buddhism is a religion that evolved out of Hinduism, stemming from the philosophy of Buddha, who lived in the sixth century B.C. Much Asian art is Buddhist in nature. Styles vary in different cultures. As Buddha came to be perceived as a divine being, representations were made in which he had long earlobes. This indicated his attentiveness to the mysteries of the universe. The jewel in his forehead represents the "third eye" and inner wisdom.

STUPAS

Early Buddhists of India built domed monuments called stupas which contained relics. Stupas were placed on platforms and surrounded by walled enclosures and large gateways.

CHINA AND JAPAN

China and Japan represent a densely populated region of the world. Both civilizations were characterized by rigid class systems with an emperor as ruler. Great value was placed on customs and respect for family and ancestors. The emphasis on tradition and convention extended to art and architecture.

China

CHARACTERISTICS OF CHINESE ARCHITECTURE

Generally Chinese architecture consisted of tile-roofed buildings constructed in wood using the post-and-lintel system. The posts took the form of columns topped by brackets, which served an ornamental as well as structural function. Walls were formed of plaster over bamboo. Dwellings were usually single-story structures elevated on platforms and often grouped around courtyards.

Pagodas. The pagoda form of Buddhist shrines developed out of the Indian stupa and incorporated its monumental gate structure. The domelike form of the Indian stupa was, however, abandoned in favor of a vertical structure more reminiscent of a traditional Chinese watchtower. The result was a broad-eaved tower constructed in stacked stories, which progressively decreased in size.

CHINESE SCULPTURE

Sculpture in China as well as Japan often had a religious or funerary function. There was a long tradition dating back to the third century B.C. of including lifelike clay figures of people and horses in tombs to serve the needs of the deceased. Buddhist sculpture emerged between the fifth and eighth centuries when images of colossal Buddhas, some as high as seventy feet, were carved into cliffs. Smaller gilt bronze and wood Buddha sculptures were made for temple altars. Aside from representations of Buddha himself, sculptures of the Boddhisattvas, roughly equivalent to the saints of Christianity, were carved and cast. One Boddhisattva evolved into Kuan Yin, Chinese goddess of mercy. Her form was humanized to the point that she resembles the Christian Madonna of the West.

CHINESE PAINTING

Chinese painting evolved as the most important form of artistic expression. The Chinese held nature in reverence, expressing the idea in their painting that every form embodied a spiritual presence. To unify the eye with the mind, meditation often preceded the act of painting. Most painting was done on scrolls, which could be painted either horizontally or vertically.

Chinese scroll painting had its beginnings in the fourth century as artists depicted scenes of courtly life as well as the first landscapes.

Landscape Painting. The concept of monumentality in nature resulted in scenes of majestic mountains overwhelming tiny figures placed within the setting, as seen in the work of Fan K'uan (early eleventh century), who was regarded as the northern Sung Dynasty's greatest landscape painter. Some Chinese painting tended toward naturalism and detailed description through delineation. Other forms of painting, which related to Buddhism, Confucianism, and other religious philosophies, were concerned more with spiritual values. They attempted to capture the essence or spirit of things portrayed rather than to define them in precise detail. During the southern Sung Dynasty (twelfth through thirteenth centuries), landscape acquired a more intimate, softly poetic appearance. Misty effects were achieved through gray ink washes.

Zen Painting. Zen Buddhist painting was characterized by its abbreviated, abstract forms. It was felt by Zen painters that spiritual enlightenment could best be achieved through a spontaneous and intuitive response to nature, rather than a carefully studied one. Mu Chi's *Six Persimmons* (ca. 1270) illustrates this approach in its extremely simple treatment of its subject, capturing its essence without descriptive detail.

Calligraphy. There has been a long tradition of Chinese calligraphy as an art form which does not require any accompanying painted image. The artistic quality of the brushstrokes in calligraphy was as important as the poem or story to which it related. Painters also included calligraphic inscriptions within painted scenes as complimentary elements.

Japan

China greatly affected Japan culturally, often passing stylistic information through Korea. Buddhism as well as Chinese art affected the Japanese art and architecture, especially during the Tang Dynasty (seventh through tenth centuries). Zen Buddhism arrived from China in the fourteenth century.

JAPANESE PAINTING AND SCULPTURE

Like the Chinese, the Japanese made Buddhist sculptures of wood and bronze. Though influenced by Chinese sources, Japanese painting acquired some distinct features. These included depicting landscape and interior scenes from elevated viewpoints (causing higher horizons than in Chinese art) and a flatter and more decorative treatment of compositions overall.

JAPANESE ARCHITECTURE

Though influenced by China, the Japanese developed architecture of a more distinctive national character. In religious architecture, the form of the multistoried pagoda (as developed by the Chinese from the Indian stupa)

was adopted in Japan, where it underwent further revisions, acquiring a more varied and complex appearance. In residential and palace architecture, post-and-lintel construction in wood, provided the framework for sliding screens of paper instead of solid walls. These paper screens opened onto porches and gardens, providing greater integration between interior and exterior spaces. This concept greatly affected the thinking of architects in the West beginning at the time of Frank Lloyd Wright.

JAPANESE PRINTS

The art of printing from wood blocks had first been used in China, but it was further developed by the Japanese who transformed it into a mass medium, popular art form. From the seventeenth century onward woodcuts illustrated folk tales and scenes related to actors and courtesans, as seen in the work of Utamaro (1753–1806). Many of the prints were scenes of everyday life and are referred to as *Ukiyo-e* (meaning "floating world").

Genre scenes and landscapes were brought to the level of high artistic achievement in the prints of Harunobu (1725–1770), Hokusai (1760–1849), and Hiroshige (1797–1858). Japanese woodblock prints stressed flat colored shapes and diagonally foreshortened forms set against a tilted perspective. Much admired for their bold design and abstraction of space, they exerted strong influence on late nineteenth-century Western artists, such as Manet, Whistler, and Cassatt.

Non-Western art has much to offer the West. It includes diverse cultures, representing a majority of the world's population.

While Africa had traditions in realism going back to the Ife in Nigeria, more abstract traditions have prevailed. In Oceania varied abstract traditions developed in Micronesia, Polynesia, and Melanesia.

In the ancient Americas, the Mayan, Aztec, and Inca civilizations produced monumental architecture and stone sculpture. Later Native Americans (such as the Navajo, Pueblo, and Eskimos) have had diverse artistic traditions.

In the Islamic world, Moslems developed a house of worship called the mosque, which is oriented toward Mecca. The Islamic culture has excelled especially in the decorative arts.

In India, Hindu art often combined spirituality with erotic sexual content. Buddhist art featured statues of Buddha as well as domelike monuments called stupas.

In China, basic architectural forms, as well as painting and sculpture, became traditional. Painting evolved to include representational scenes and calligraphy.

Though influenced by China, Japanese painting and architecture developed distinct qualities. Another important art form was the woodblock print. Japanese art strongly affected the West.

Selected Readings

Corbin, George A. *Native Arts of North America, Africa, and the South Pacific: An Introduction.* New York: Harper and Row. 1988.

Franch, Jose Alcina. *Pre-Columbian Art.* New York: Abrams. 1983.

Graber, Oleg. *The Foundation of Islamic Art.* rev. and enl. ed. New Haven: Yale University Press. 1987.

Hoag, John D. *Islamic Architecture.* New York: Abrams. 1977.

Lee, Sherman. *A History of Far Eastern Art.* 4th ed. Englewood Cliffs, NJ: Prentice-Hall. 1982.

Munsterberg, Hugo. *Art of India and Southeast Asia.* New York: Abrams. 1970.

Willet, Frank. *African Art: An Introduction.* New York: Thames and Hudson. 1985.

Wingert, Paul. *Primitive Art: Its Traditions and Styles.* Cleveland: World Publishing. 1970.

Glossary

ABC art See *Minimalism*.

abstract art Art with a basis in visual reality, but without natural representation as its primary concern. Forms observed in the natural world may be simplified or altered selectively to suit the artist's concepts. The term is sometimes also used to describe nonrepresentational works which make no reference to objects or forms in the outside world.

Abstract Expressionism A style of painting, developed primarily in the United States after World War II. The works are characteristically large canvases painted in a bold, expressive abstract or nonobjective style.

acrylic A clear plastic resin used in sculptural casting and as the medium for acrylic paints—fast-drying, water-soluble colors that can be used much like oils or thinned to a watercolor transparency.

Action Painting A particularly active form of Abstract Expressionism that records the dynamic physical gestures of the artist's paint application through active techniques such as spattering, dripping, or broad, spontaneous brush strokes.

additive color mixture Mixture produced by combining colored light. In light mixtures, unlike pigments, red, green, and blue are the primary colors. These three colors produce white light when projected so that they overlap. See subtractive color mixture.

additive process Any sculptural process, such as modeling in clay or constructing in metal, in which the forms are built up or assembled.

aerial perspective See *perspective*.

aesthetics A branch of philosophy that involves the study of the arts in terms of concepts of beauty and the power to exalt human perception.

afterimage The lingering image that occurs after an original visual stimulus is removed. The eye's color receptors become fatigued after staring at an intense color and produce a similarly shaped illusion of its complementary color after the first hue is removed from sight.

airbrush A small paint sprayer that operates on compressed air and produces a fine mist of paint capable of creating subtle gradations of color.

altar A stand or platform used for ritual purposes of worship.

ambulatory An aisle around the apse of a church that allows access to the areas behind the altar. The term may also refer to other types of covered passageways around architectural units.

analogous colors Colors that are next to each other on the color wheel such as red-orange, orange, and yellow-orange.

Analytical Cubism See *Cubism*.

aperture In photography, the opening in a camera's lens that admits light. The aperture size is adjustable and controls the amount of light striking the film.

applied arts Arts which are primarily utilitarian in intent, such as industrial design.

apse The usually semi-circular area or niche, often with a half-dome over it, at the end of a building. The apse is a feature found in many Christian churches and was derived from the Roman basilica form.

aquarelle Transparent watercolor.

aquatint A tonal rather than linear etching method produced by applying powdered resin on a metal plate which is then heated and given an acid bath. The acid bites into the exposed areas of the plate, producing a texture which will hold ink for printing. Aquatint may be used in combination with linear methods

arabesque An intricate, intertwining decorative form.

arcade A series of arches supported by piers or columns.

arch A curved architectural structure spanning an open space, usually constructed of stone or masonry blocks. The arch transmits the weight above it outward and downward through its two vertical piers, or side posts.

Archaic Period The period in Greek art from roughly 700–500 B.C., prior to the Classical period.

architrave The lowest division of an entablature. See *entablature*.

armature An inner support or framework for soft sculptural materials such as clay and plaster.

Art Nouveau (French for "new art") A late nineteenth-century style characterized by curvilinear, organically based ornamental forms.

assemblage An artwork that assembles three-dimensional, pre-existing or found, objects together into a form which usually refutes or has nothing to do with their original purpose.

asymmetrical balance Compositional balance using equivalent rather than identical forms on right and left sides of a center axis.

atmospheric perspective See *perspective.*

automatism Acting without conscious control to initiate artistic activity such as writing or painting. This method was first used by Dada and Surrealist artists.

avant-garde (French "advance guard") The vanguard or leadership in new, experimental or unconventional movements in art and other fields.

axis An imaginary straight line passing through a figure, composition, etc., along which the principal parts are arranged.

balance In visual art, the achievement of equilibrium between the parts of a composition through the harmonious arrangement of the visual element such as color and real or implied mass.

balloon framing A type of prefabricated, lightweight wooden framework first developed for building construction in the nineteenth century.

Baroque Seventeenth-century European art style characterized by turbulent compositions, theatrical use of light and shade, and exaggerated emotion.

barrel vault See *vault.*

basilica A type of public hall originated by the Romans and adapted by the Early Christians for their churches. The basilica is rectangular in form with rows of columns dividing it into center and side aisles. In its Christian form the basilica normally has a semicircular area, or apse, at only one end.

bas-relief See *relief sculpture.*

Bauhaus German art school (1919–1933) founded by Walter Gropius and widely recognized for its influence in the areas of design (particularly as applied to technology) and educational philosophy.

binder Material in paint which allows pigment particles to adhere together and to the support or surface.

biomorphic Having the form of a living organism. Biomorphic forms in art are characteristically curved, abstract forms suggestive of organisms.

bisque Ceramics that have been hardened by a preliminary firing at low temperatures and are ready to be glazed.

buon fresco See *fresco*.

buttress A masonry support built vertically against a wall to strengthen it against thrust pressures from structures such as arches and vaults. The flying buttress characteristic of Gothic cathedrals transmitted the thrust of interior vaults through a strut to a tall, external masonry pier.

Byzantine art Style of art originating in the fifth to sixth centuries in the Byzantine Empire of eastern Europe, following the relocation of the Emperor Constantine's capital from Rome to Byzantium in the fourth century. Byzantine architecture is charcterized by round arches, domes and decorative mosaics. In painting figures are stylized and the colors are sumptuous, including the extensive use of gold.

calligraphy The art of beautiful writing, often referring to Oriental characters written with a brush.

camera obscura Forerunner of the modern camera developed during the Renaissance. A device that permits an image from the outside world to be projected through a small hole onto a surface inside a darkened chamber, where it may be traced.

cancellation proof A print pulled after the printing block or plate has been purposely defaced to indicate the end of an edition, that no more prints can be made.

cantilever In architecture, a beam or slab with a significant projection beyond a supporting wall or post, held in place by the weight on the attached end.

capital The top part of a column or pillar.

Carolingian Referring to the era of the Emperor Charlemagne which was characterized by a revival of Classical culture.

cartoon A full scale working drawing used as a guide for a painting, tapestry, or fresco. Also a humorous or satirical drawing.

carving A subtractive sculptural process in which the image is formed by removing material from a mass of stone, wood, etc., with sharpened tools.

casting A processs of reproducing sculpture by pouring a liquid material, such as molten bronze, into a mold bearing the impression of the original and removing the mold when the material has hardened.

catacomb Underground tunnels used for burial. Roman catacombs were used by the early Christians as places of worship and contain examples of Christian fresco painting on the walls and ceilings.

centering In architecture, the wooden support used while an arch is under construction.

ceramics The art of creating objects of baked clay.

chalk Soft mineral which is easily pulverized and can be used for drawing.

charcoal Carbonized wood which can be used for drawing.

Charlemagne Emperor of the Holy Roman Empire from 800–814 A.D.

chiaroscuro (Italian for light/dark) Gradations of light and dark in a two-dimensional work, especially the definition of forms through the use of subtle light and shade rather than sharp contour lines.

cinematography The photographic art and technique of creating motion pictures.

cire perdu See *lost wax process*.

Classical The art of ancient Greece and Rome, particularly the art of fifth century B.C. Greece. Also any art characterized by rationality, order, balance and proportion.

clerestory A row of windows in an upper part of a wall which rises clear of adjoining roofs and provides illumination for the space below.

coffer In architecture, a recessed decorative panel in a ceiling, which may serve to lighten the weight of the ceiling.

coiling A ceramic technique in which forms are built up by spiralling lengths of clay.

collage A work made by pasting various materials such as paper, cloth, and newsprint onto a flat surface.

colonnade A row of columns supporting a roof or series of arches.

Color Field painting Style of painting developed in the 1950s in which large stained or painted areas of single colors make up the large scale works, filling the viewer's field of vision and evoking a unique aesthetic response.

color wheel A circular arrangement of the hues of the spectrum, with complementary colors opposite each other. See *complementary colors*.

combine painting A contemporary method, combining mixed media and three-dimensional found objects attached to the canvas.

complementary colors Hues opposite each other on the color wheel that strongly contrast when juxtaposed but form a neutral gray when mixed together.

composition The arrangement of forms in a work of art, including the use of the visual elements such as line, color, shape, and mass.

Conceptual art Art in which the concept or idea takes precedence over a created art "product."

constructed sculpture A three-dimensional work built by joining separate parts by gluing, nailing, welding, etc., unlike the more traditional processes such as carving and casting.

Constructivism A twentieth-century art movement in non-representational constructed sculpture which grew out of Cubism and collage.

content The theme or meaning communicated by an artwork.

contour The edge or outline of a shape or object.

contrapposto An asymmetricl positioning of opposing parts of the body in painting and sculture which was invented by the Greeks to gracefully portray ponderation (weight distribution). This results in one hip joint being higher to reveal the weight-bearing leg. An opposing diagonal shift appears in the shoulders and elsewhere across the central axis of the body.

cool colors Hues such as blues, greens, and violets which appear to recede, as compared to warm colors which seem to advance toward the viewer.

corbeled arch Not a true arch but a form built up of masonry courses with each end block projecting further toward the center of the opening until the sides are close enough to be spanned by a single block.

Corinthian order One of the Greek architectural orders. Characterized by slender columns topped with ornate capitals decorated with carved acanthus leaves.

cornice The horizontal architectural member projecting along the top of a wall or building. The uppermost part of an entablature (see *entablature*).

crayon A drawing instrument in stick form such as a conté crayon or wax crayon.

cross-hatching A method of producing tones in drawing, printmaking, or painting by the build up of series of parallel lines, crossed at an angle by other lines until the desired darkness is produced.

Cubism A twentieth-century art movement in formalist abstraction developed by Picasso and Braque beginning about 1908. Analytical cubism was an early stage (from 1909–1912) in which subjects were observed from different angles, shattered, and reconstructed as geometric shapes. Synthetic cubism soon followed. During this stage collage was introduced and geometric shapes were manipulated into abstract subjects which were not based on the artist's direct observation.

cuneiform An ancient form of writing in the Near East, which used wedge-shaped characters.

curtain wall A non-load bearing wall.

Dada The Dada movement originated in Zurich (Switzerland), and in New York during World War I. Dada was a mode of fantasy art based on the concept of absurdity and nonsense. It paved the way for the later Surrealist movement.

daguerreotype Early form of photograph, using a metal plate to record the image.

design The structuring or composition of visual elements in a work of art or commercial object.

De Stijl The De Stijl movement developed in neutral Holland during World War I. It was a formalist trend in nonrepresentation which grew out of Cubism. Mondrian was the best known painter in the movement.

diptych A painting on two panels, usually hinged together.

dissolve A method of fading from one video or motion picture scene into another scene, which gradually grows brighter.

dome A hemispherical roof or vault raised on a base.

Doric order The oldest Greek architectural order, with heavy, baseless columns topped by simple capitals.

drypoint An intaglio printmaking process in which the ink-bearing lines are scratched directly into a metal plate with a steel needle.

earthenware A coarse, porous ceramic ware that is fired at low temperatures.

earthwork Large scale outdoor sculpture created by the moving of large quantities of earth and/or stone.

edition In printmaking, the number of prints pulled from a block or plate, usually given consecutive numbers.

emulsion The light-sensitive suspension of silver salts in gelatin used to coat photographic film and plates.

enamel Ground glass applied to metal and fused by high temperatures into a shiny, hard surface.

encaustic A painting method using pigments suspended in molten wax.

engraving An intaglio printmaking process in which the ink-bearing grooves are cut into a metal plate with a tool called a burin, or graver.

entablature In Classical architecture, the horizontal section above the columns, made up of the architrave, frieze, and cornice.

entasis The gently swelling curve in the shaft of Classical columns that counteracts the illusion of concavity that appears in groups of straight or regularly tapered columns.

etching An intaglio printmaking process in which the image is scratched into an acid-resistant ground on a metal plate. The plate is then given an acid bath which bites, or etches, the exposed areas of the plate, creating ink-bearing grooves in the metal.

Expressionism A major trend in twentieth-century art which opposed formalism. Expressionism was about conveying personal emotion in art.

Fauvism An early French Expressionist movement in painting from 1905–1908, characterized by the use of very intense color and energetic brush strokes. Matisse was its best known proponent.

fine arts Arts whose primary concern is aesthetic rather than utilitarian.

flying buttress See *buttress*.

folk art Art produced by people who are not formally trained as fine artists.

foreshortening A method of representing objects on a two-dimensional surface so that they appear to recede away from the viewer, as if seen at an oblique angle to the picture plane.

formalism An approach in art based on a rational regard for formal organization and a rejection of emotional concerns in art.

fresco A painting technique in which pigments are applied to wet, fresh lime plaster. Over time, the pigments become chemically bound into the surface. This technique is also called buon fresco and is longer lasting than the fresco secco technique of painting on dry plaster.

fresco secco See *fresco*.

frieze In architecture, the horizontal band between the architrave and cornice of an entablature, which is often decorated with sculpture.

F-stop Setting on a camera that determines the size of the aperture opening. See *aperture*.

Futurism An early twentieth century movement concerned with dynanism related to the modern machine age. Italian Futurists depicted people and machines in motion, often relying on Cubist principles in their compositions.

gates In metal casting, the channels that allow the escape of air from within the mold as it is filled.

gesso A mixture of glue and chalk or plaster of Paris applied to supports such as canvas or panels as a base for painting.

glaze The mixture of minerals applied to seal and decorate ceramic surfaces. Also in oil painting, a thin, transparent layer of color applied over another color.

Gothic Style A style in art which originated in the twelfth and thirteenth centuries. It conveyed emotional qualities in painting and sculpture, as well as in architecture. The latter was characterized by a preference for pointed forms, such as arches and vaults.

gouache Watercolor with added white pigment which makes it opaque rather than transparent.

Greek orders A system of architectural ornamentation invented by the ancient Greeks, which also regulated proportions in buildings (see also *Doric order*, *Ionic order*, and *Corinthian order*)

greenware Air-dried clay objects which are ready for kiln firing.

groin vault A vault formed by the intersection of two barrel vaults.

ground A base coat such as gesso applied to a support for painting or drawing, etc.

happening An event produced by artists, usually unscripted and unrehearsed, incorporating chance and audience participation.

Hard Edge painting A term originated in the 1950s to describe abstract paintings with sharp-edged, well-defined areas of flat color.

hierarchic scale Use of scale to show the relative importance of depicted figures, for example, the figure of a ruler would be portrayed as larger than his attendants (see also *scale*).

high relief See *relief sculpture*.

holography A method of producing three-dimensional images with laser beams which record both an original subject and its reflection in a mirror.

horizon line In linear perspective, the line on a two-dimensional surface toward which lines moving away from the viewer seem to converge, equivalent to the point in nature where sky appears to meet land or water.

hue The property of a color which identifies it, belonging to a specific wavelength of the spectrum, for example, blue or red.

humanism Philosophy based on the value of the human being, against whom all things are measured. Humanism was an extremely important factor in the development of the Italian Renaissance.

hypostyle A structure with a roof supported by rows of columns or piers.

iconography Study of subject matter in the visual arts, including the interpretation of signs and symbols.

illuminated manuscript A decorated or illustrated manuscript, particularly those using gold and silver and rich color, as in manuscripts produced during the Middle Ages.

impasto Application of paint with a thick, paste-like consistency, often highly textural in appearance.

Impressionism A style in late nineteenth-century painting, originating in France. It was especially characterized by its use of bright colors to capture immediate visual sensations of things observed out-of-doors. Monet was its best representative.

intaglio Any printmaking technique, such as etching, in which the lines or areas meant to carry ink are recessed below the surface of the printing plate.

intensity The degree of purity or brightness of a hue, also called saturation.

intermediate color A hue located between a primary and a secondary hue on the color wheel, such as yellow-orange.

International Style 1. A style in European art from ca. 1395–1420, during which time the Gothic style was similar both in Northern Europe and in Italy. 2. A formalist style in twentieth-century architecture which originated in Europe in the 1920s and became a dominant world trend into the late twentieth century.

investiture The fire-resistant mold used in metal casting.

Ionic order Greek architectural order characterized by slender, fluted cloumns topped by carved spiral scrolls on the capitals.

keystone The wedge-shaped center stone of an arch.

kiln An oven for baking (firing) clay objects.

kinetic art Art that incorporates actual movement as part of the piece.

kiva An underground structure built by Native Americans for ceremonial functions.

kore (Greek for "maiden") An Archaic Greek sculpture of a clothed, standing female.

kouros (Greek for "youth") An Archaic Greek sculpture of a standing nude male.

lens The part of a camera that focuses and concentrates light.

line In art, a mark left by a moving point such as a pencil or brush.

linear perspective See *perspective*.

lintel A horizontal beam that spans a space between two posts, a doorway, or window.

lithography A planographic printmaking process, based on the fact that oil and water repel each other. Images are drawn in greasy crayon or ink (tusche) on limestone slabs or textured metal plates.

local color The basic or natural color of an object free of reflected color and without shadows from other objects modifying it.

logo Short for "logotype." Company or business trademark created from letter forms.

lost-wax technique A sculptural metal casting technique that uses a wax form around which a heat resistant mold is built. The wax melts and runs out when heated, leaving a hollow the shape of the original into which the molten metal is poured.

Mannerism A development in art following the High Renaissance and continuing until the end of the sixteenth century. Mannerism was characterized by anti-Classical features which departed from the standards of Renaissance art.

mass A three-dimensional form having physical bulk. Also the two-dimensional illusion of weight and bulk.

mastaba A rectangular Egyptian tomb with a flat roof.

medium In art, a particular material, such as oil paint, and its use. Also the component of paint that liquifies it and allows it to be spread on a surface.

megalith A huge stone, often part of a prehistoric structure.

menhir A large standing stone, often part of a prehistoric arrangement of uprights in a circle or other formation.

metope In architecture, the panels between the triglyphs of the frieze, which often contain sculpture.

mezzotint A non-linear form of etching in which the plate's surface is pitted to hold ink.

minaret One of the tall, slender towers of a mosque.

Minimalism A trend in art of the 1960s which stressed elementary forms as the basis of sculpture. Also called ABC art and Primary Structures.

mixed media The use of more than one material or technique in the creation of a work of art.

mobile A form of delicately balanced kinetic art, suspended and set in motion by air currents.

modeling 1. Creating three-dimensional forms of some pliable material such as clay. 2. In drawing and painting, the illusion of three-dimensionality created through the use of light and shade.

Modernism A term designating a major broad trend in twentieth-century art stressing abstraction and nonrepresentation.

mold The hollow cavity into which liquid or pliable material is poured or pressed to cast a shape.

monochromatic A color scheme using only one hue and its variations in tints and shades.

monolith A single large stone.

monotype A method in which paint brushed on a surface is pressed against paper, creating a single print of the image.

montage In filmmaking, abruptly alternating images used to convey the passage of time or an emotional effect.

mosaic A medium in which small bits of tile, glass, or stone are set into a mortar ground to create the image. Often used to decorate walls or floors, particularly in ancient times.

mosque A Moslem building for worship.

mural A large wall painting in any media.

naturalism	A style which attempts to capture what the eye sees in nature.
nave	The large central space of a church. It is often flanked by side aisles.
negative shape	The background or space surrounding the defined, foreground shapes in a work of art.
Neoclassicism	A style of the late eighteenth and early nineteenth century which was influenced by the art of ancient Greece and Rome as well as by the art of the High Renaissance. David and Ingres were among its leading proponents in France.
non-representational	Art without a reference to anything outside itself, nonobjective.
oil paint	Paint in which the pigment is held together with a binder of a drying oil, such as linseed.
one-point perspective	See *perspective*.
Op Art	A style of art which originated in the 1960s, which makes use of jarring optical effects such as illusory vibration or movement created through contrasting color juxtapositions or rhythmic black and white patterning.
optical color mixture	Perceived rather than actual color mix, produced by dots or strokes of colors placed close together. The mixture of the colors actually occurs in the eye of the viewer.
organic	In art, forms that are irregular and curvilinear, like the forms of living things.
painterly	Painting defined by loose brushwork and open forms rather than by linear contours.
palette	The surface on which paints are placed and mixed so that an artist may work from them. Also, the range of colors used by an artist characteristically or in a particular work.
panning	Moving a motion picture or television camera from side to side to take in a more sweeping view of the subject.
panel painting	A work painted on a wooden panel.
parallel editing	In filmaking or video, shifting back and forth between one event or story and another.
pastel	Pigment sticks with a gum binder.
pediment	The gable or triangular section of a building formed by the roof slopes and the cornices.
pendentive	A triangular form which rises from the corners of a square base to support a round dome.
performance art	Art presentation which may incorporate various aspects of performing arts such as dance, theater, and music, but with a strong visual emphasis.

perspective A method of representing three-dimensional objects in space on a two-dimensional surface. Some perspective methods are simple, such as vertical stacking, overlapping, and diminishing size of objects represented in a picture. Atmospheric perspective involves a use of paler color and loss of clarity in distant forms in a picture. Linear perspective was developed during the Renaissance to provide a more regulated spatial scheme in art. One-point and two-point perspective methods involve the use of vanishing points set on the horizon line (which conforms to the eye level of the viewer).

Photo-realism A style that emerged in the late 1960s and the 1970s which was based on replication of the photographic image.

picture plane The flat surface upon which a composition is painted or drawn.

pigment The dry coloring material which is mixed with oil, water, or other binding agents to form paint, pastel, or other color media.

plan An architectural drawing representing an overhead layout of a building's design (also called ground plan or floor plan).

plane A flat surface.

plasticity In visual art, the appearance of solidity or apparent three-dimensional fullness of form.

Pointillism Painting closely placed dots of roughly uniform size to form broader shapes or images. Seurat used pointillism in his Neo-Impressionist paintings.

Pop Art A movement of the 1960s influenced by popular culture and commercial art techniques. Warhol was one of the best known Pop artists.

post and lintel One of the basic construction methods involving the use of upright posts or columns spanned by overhead lintels or beams.

Post-Impressionism Term encompassing diverse art styles of the 1880s and 1890s which departed from the basic tenets of Monet's Impressionism. Cézanne, Seurat, Van Gogh, and Gauguin were among its major representatives.

Postmodern While critics debate the meaning of this term, it might be considered a general heading for any style of the late 1960s to the present that challenges the dominance of earlier twentieth-century Modernism (ie. formalism).

Postpainterly Abstraction A movement that emerged in the 1960s which rejected the textured surfaces of abstract expressionist paintings. Postpainterly Abstraction might best describe the work of raw canvas stainers Frankenthaler, Louis, and Noland.

Pre-Columbian art Art produced in the Americas prior to the arrival of Europeans.

primary colors The basic hues that theoretically can be mixed to produce all other colors. The pigment primaries are red, blue, and yellow; the light primaries are red, blue, and green.

Primary Structures See *Minimalism*.

print In art, an original impression produced on paper from a woodblock, metal plate, stone slab, screen or other art process (including a photographic print).

proportion The relationship in size of individual parts to one another and to a whole.

realism This term is often used to mean the same as naturalism (see *naturalism*). It might also refer to representing existing subjects of an artist's own time and place (rather than historical themes or mythology).

relief printing A printmaking process in which the parts of the printing surface that are not to be inked are cut away. Woodcuts, wood engravings and linoleum cuts are relief methods.

relief sculpture Sculpture which remains attached to a background surface, rather than being in the round. It can be described as low (bas-relief), medium, or high relief depending on the extent of the projection from the background surface.

Renaissance The period beginning ca. 1400 in which humanism replaced the Age of Faith in the Middle Ages.

representational art Art which depicts a subject in a realistic style.

rhythm The ordered repetition of a design element, often in a recurring pattern.

rib vault See *vault*.

Rococo A decorative late Baroque style which began in late eighteenth-century France.

Romanesque A stylistic period of the Middle Ages which preceded the Gothic. Romanesque architecture restored large-scale stone vaulting which resembled the round vaults of earlier Roman buildings.

Romanticism A stylistic trend of the late eighteenth and early nineteenth century that opposed Neo-Classicism. Romanticism was more of an attitude about the importance of human emotion over reason than it was a style.

sarcophagus A stone coffin.

saturation See *intensity*.

scale The size of an object viewed in relation to other objects.

secondary colors A color produced when two primary hues are mixed in equal proportion. The pigment secondary colors are orange, green and violet.

serigraphy This process (also known as screen printing or silk screen) uses the principle of the stencil to produce images. After a screen of silk or nylon is prepared, the ink is forced through the screen's mesh with a rubber-bladed squeegee to make the print.

shade A dark color, produced by adding black to a hue.

shape A two-dimensional area defined by boundaries.

silk screen See *serigraphy*.

silverpoint An old method, now rarely employed, in which a metal stylus is used to draw delicate silver-gray lines on a prepared ground.

sitework A temporary form of land art designed for a particular site where manufactered materials are brought in and manipulated. This type of art is also called site-specific.

skeleton frame In architecture, a standing framework on which thin outside walls are attached.

stele An upright stone slab or pillar carved with inscriptions.

still life A composition depicting an arrangement of inanimate objects, such as flowers in a vase, or a table set with food.

stoneware A gray, reddish, or tan ceramic ware, suitable for dinnerware or sculpture.

stupa Buddhist domed monuments (which contain relics) built on platforms.

style A characteristic handling of media which identifies an individual artist's hand, an artistic period, or a culture.

subject matter The objects or themes represented in art works.

subtractive sculpture Sculpture made by removing material as in carving wood or chiseling a stone block.

Suprematism An early twentieth-century nonrepresentational Russian version of cubism, in which very simple geometric shapes were set diagonally on the picture plane. Malevich was its primary proponent.

Surrealism An art movement that originated in 1924 as an outgrowth of Dada. It was influenced by the writings of Freud and strove to rely on the subconcious and the world of dreams as the basis of artistic expression.

symbol A subject which aludes to a meaning beyond its obvious appearence. In Christian art, for example, a serpent might represent Satan, rather than just a snake.

symmetry The balancing of visual elements on both sides of a central axis within a design.

Synthetic Cubism See *Cubism*.

Synthetism The Post-Impressionist movement led by Gauguin. In painting, it relied on the use of flat areas of unnatural color.

tempera Paint that traditionally uses egg yolk as the binder and water as the thinning agent. Tempera was the preferred medium of Italian artists through the Early Renaissance.

terra cotta A fairly coarse, porous reddish clay which is generally left unglazed after firing.

texture The surface qualities of various materials (i.e. rough or smooth).

three-dimensional Having the dimensions of length, width, and depth.

three-point perspective See *perspective*.

throwing In ceramics, the process of forming with the potter's wheel.

tint A hue with white mixed into it.

transept In a cruciform church, the arm that crosses the nave and projects on its north and south sides.

triglyph Architectural form consisting of a vertical grooved panel alternating with metopes in a Doric frieze. See *Doric order*.

truss In architecture a cross brace, most commonly of three lengths of wood or steel joined in a triangular form. It provides support to span a large space without many interior posts.

tryptych A painting composed of three panels.

tusche An oily ink used in lithography.

two-dimensional Having only the dimensions of length and width.

two-point perspective See *perspective*.

tympanum In Medieval churches, a semi-circular space enclosing an arch above a doorway, which was filled with sculpture.

typography The selection and composing of letter forms for printed material.

unity The working together of various visual elements to achieve order and harmony in combining the separate parts as a whole.

value Distinctions of relative lightness or darkness.

vanishing point See *perspective*.

vantage point The position from which the viewer observes a scene in art.

vault A ceiling constructed on the principle of the arch, conceived as an extension of an arch back in space.

vehicle The medium used to hold the paint's pigment.

video Television. The term video is preferred over television for serious art.

volume Mass-enclosed space. It can be described as positive volume when applied to a solid object, or negative volume when applied to a hollow form.

volute The scroll form which is the most identifiable element in an Ionic capital. See *Ionic order*.

voussoir A wedge-shaped stone used in the construction of an arch.

warm colors colors (such as red) that seem emotionally warm in temperature, and seem to advance in a composition.

warp The threads that run lengthwise in a weaving.

wash Thin, transparent layers of paint or ink.

watercolor Pigment with a gum arabic binder which can be dissolved in water.

weaving Making fabric by interlacing threads, often on a loom.

weft The threads that run widthwise in a weaving.

woodcut A relief process in printmaking. A woodcut is cut along the grain of a board.

wood engraving A relief process in printmaking. Wood engravings are cut on the end grain of planed wood and have characteristically finer lines than woodcuts.

ziggurat In Mesopotamia, a massive mud-brick platform symbolizing a sacred mountain, with a temple on its summit.

Index

A

Abakanowicz, Magdalena, 60
Abstract expressionism, 187–191
Abstraction, 8, 82
Abstract surrealism, 181
Acrylic paints, 34
Action painting, 187–189
Adam and Eve (Dürer), 136
Adoration of the Lamb (Hubert van
 Eyck), 135
Aegean civilization, 94–95
Aerial perspective, 16
Aesthetics, 3
African-American art, 205
African art, 210
Afterimage, 21–22
Agesander, 99
Akhenaton, 92
Akkadians, 86–87
Alberti, Leone Batista, 124
American Gothic (Wood), 183
Analytical cubism, 172–173
Anderson, Laurie, 199
Animation, 44
Aperture, 41
Aphrodite of Melos, 99
Applied art, 1–2
Aquatint, 38
Arch, 70–71
 Roman, 102
Architectural methods, 65
Architectural plans, 64–65
Architecture
 Baroque, 139–140, 144
 Byzantine, 108–109

Carolingian, 111
Chinese, 216
and cubism, 174
early Christian, 107–108
Egyptian, 92–93
Gothic, 114–116
Greek, 97–98
international style in, 180–181
Japanese, 217–218
mannerist, 133
Minoan, 95
Mycenaean, 95
origins of modern, 163–165
Persian, 88
postmodern, 202–203
Renaissance, 123–124
Roman, 101–102
Romanesque, 112–113
Sumerian, 86
Armstrong, Neil, 45
Arneson, Robert, 56
Arp, Hans (Jean), 179
*Arrangement in Black and Gray,
 No. 1* (Whistler), 159
Art
 African, 210
 African-American, 205
 applied, 1–2
 definition of, 1
 fine, 1–2
 folk, 2, 206
 meaning of, 1
 Native American, 206, 212–213
 in public places, 203–204
 purposes of, 4–5

Art (*cont'd*)
 quality in, 6
 representational, 8
 social issues in, 5, 182–183
 visual, 1–2
 as visual language, 8–27
Art as Idea (Kosuth), 196
Art criticism, 3, 6
Art history, 3
Art Nouveau, 163–164
Assemblage, 35, 52
Assyrians, 87–88
Asymmetry, 25–26
Athenodorus, 99
Atmospheric perspective, 16
At the Moulin Rouge
 (Toulouse-Lautrec), 162
*Audience Hall of Darius and
 Xerxes,* 88
Automatist surrealism, 181
Autumn Rhythm (Pollock), 188
Aycock, Alice, 198
Aztecs, 211

B

Babel, Tower of, 86
Babylonians, 87
Backs (Abakanowicz), 60
Bacon, Francis, 190
Balance, 25–26
Balla, Giacomo, 23–24, 174
Balloon framing, 69
Banjo Lesson (Tanner), 156

Baroque
 in Italy, 137–140
 in Spain and Northern Europe,
 140–144
Barrel vault, 71
Bartlett, Jennifer, 198
Basilica of Constantine, 102
Basketry, 61
Battleship Potemkin, (Eisentein) 44
Bauhaus, 180
Bearden, Romare, 205
Bearing wall, 65
Bed (Rauschenberg), 191
Bell, Larry, 54
Benin kingdom, 210
Benton, Thomas Hart, 183
Bergman, Ingmar, 44
Bernini, Gianlorenzo, 139–140
Bicycle Wheel (Duchamp), 178
Binder, 32
Bird in Space (Brancusi), 169
Birthday (Chagall), 179
Birth of Venus (Botticelli), 126
Black, Alexander, 42
Blinding of Sampson (Rembrandt),
 142
Boating Party (Cassatt), 158
Boccioni, Umberto, 174–175
Bologna, Giovanni, 132–133
Bontecou, Lee, 190–191
Book of Kells, 110
Borromini, Francesco, 140
Bosch, Hieronymus, 136–137
Botticelli, Sandro, 126
Boucher, François, 145
Bourke-White, Margaret, 40
Brady, Mathew, 40, 165
Bramante, Donato, 128
Brancusi, Constantin, 9, 168–169
Braque, Georges, 35, 172–173
Breton, André, 181
Brick, 74
Broadway Boogie-Woogie
 (Mondrian), 177
Brown, Joan, 201
Brueghel, Pieter, the Elder, 137
Brunelleschi, Filippo, 123–124
Buddhist art, 215
Buonarroti, Michelangelo, 31, 50,
 128–129
Buon fresco, 34
Bursts (Gottlieb), 189

Byzantine art, 108–109

C

Cage, John, 191
Calder, Alexander, 24, 52–53
Calligraphy, 10, 217
Calling of St. Matthew
 (Caravaggio), 138
Camera, 41
Camera obscura, 39
Campbell's Soup (Warhol), 192
Campin, Robert, 134–135
Canyon (Rauschenberg), 191
Caravaggio, 137, 138
Carolingian art, 110–111
Carracci, Annibale, 137, 138–139
Carving, 50
Casa Mila, 164
Cassatt, Mary, 158
Casting, 51
Catacombs, 106–108
Cave paintings, 81–82
Cellini, Benvenuto, 59, 132
Ceramics, 55–58
Ceramic wares, types of, 57–58
Cézanne, Paul, 160
Chagall, Marc, 179
Chalks, 31
Chamberlain, John, 191
Chaplin, Charlie, 43
Charcoal, 30
Chardin, Jean-Baptiste, 146
Chartres Cathedral, 115, 116
Chasing, 59
Chiaroscuro, 19, 127
Chicago, Judy, 205
Chicago School, 164–165
China, art in, 216–217
Christian art, early, 106–108
Christo, 54
Christ Preaching (Rembrandt), 143
Cimabue, 117, 121
Cinematography
 animation, 44
 early alternative films, 44
 editing, 43
 illusion of movement in, 42
 origins of, 42
 silent films, 43–44
 special power of film in, 44
 technical innovations in, 44

Circular plan, 76
City (Léger), 173
Cloisonné, 58
Close, Chuck, 200
Clothespin (Oldenburg), 25
Clothing design, 61–62
Coiling, 56
Coke Bottles (Warhol), 192
Cole, Thomas, 154
Collages, 35
Collographs, 39
Color, 19–22
 local, 22
 mixtures, 21
 properties of, 20
 schemes, 21
 wheel systems, 21
Color field painting, 187–189, 194
Color modeling, 160
Color xerography, 41
Colosseum, 101–102
Columns, 66
 Greek, 97
 Roman, 101–102
Commercial television, 45
*Composition With Red, Yellow, and
 Blue* (Mondrian), 176
Computer-generated imagery, 46
Conceptual art, 196
Concrete, 74
Constable, John, 153
Constantine, Arch of, 102
Constructed metal sculpture, 52
Construction materials
 brick, 74
 concrete, 74
 iron, 75
 steel, 75
 stone, 74
 wood, 73–74
Constructivism, 175–176
Conté crayons, 31
Content, 9
Continuous narration, 23
Conversion of Saint Paul
 (Caravaggio), 138
Corbeled arch, 70–71
Corinthian order, 68–69
Cortona, Pietro da, 139
Costume design, 62
Courbet, Gustave, 154–155
Cranach, Lucas, the Elder, 136

Crayons, 31
Creativity, 4
Crest (Riley), 195
Cross sections, 65
Cross vault, 71
Crystal Palace, 164
Cubi Series (Smith), 190
Cubism, 172
 analytical, 172–173
 and architecture, 174
 sculpture, 173
 synthetic, 173
Cuneiform, 85
Current (Riley), 26, 195
Cyclads, 94

D

Dada, 55, 177–179
Daguerre, Louis-Jacques-Mandé, 40
Dali, Salvador, 44, 181
Dark Ages, 109–110
Daumier, Honoré, 154
David, Jacques-Louis, 149–150
David (Bernini), 139–140
David (Donatello), 123
David (Michelangelo), 128
da Vinci, Leonardo, 6, 18, 24, 31,
 127–128
Dead Christ (Mantegna), 126
DeAndrea, John, 53
Death of Sardanapalus (Delacroix),
 152
Death of Socrates (David), 150
De Chirico, Giorgio, 179
Deconstruction, 202
Degas, Edgar, 31, 157–158
de Kooning, Willem, 189
Delacroix, Eugène, 152
De Maria, Walter, 197
Derain, André, 170
Der Blaue Reiter, 170
Design and composition, 24–27
 balance, 25–26
 directional forces, 26–27
 emphasis, 27
 proportion, 24–25
 rhythm, 26
 scale, 25
 subordination, 27
 unity, 26
 variety, 26

de Stijl movement, 176–177
Dickson, William, 42
Die (Smith), 196
Diebenkorn, Richard, 190
Die Brücke, 170
Dillon, Diane, 47
Dillon, Leo, 47
Dinner Party (Chicago), 205
Diptych (Warhol), 5
Directional forces, 26–27
Directional lines, 26–27
Discus Thrower (Myron), 98
Disney, Walt, 44
Divisionism, 159
Doesburg, Theo van, 176
Domes, 72–73
Donatello, 122–123
Don on a Leash (Balla), 23–24
Doric order, 67–68
Doryphorus, 98
Douglas, Aaron, 205
Dragons (Pfaff), 198
Drawing, 29–30
 chemistry, 32
 dry drawing media, 30
 fluid drawing media, 31
Dry drawing media, 30
Drypoint, 37
Dubuffet, Jean, 190
Duccio of Siena, 117, 121
Duchamp, Marcel, 26, 53, 178
Dürer, Albrecht, 136
Dying Lioness, 88
Dynamic Hieroglyph of the Bal
 Tabarin, 174
Dynamism of a Cyclist (Boccioni),
 174

E

Eakins, Thomas, 155–156
Earthenware, 57
Earthworks, 53–54, 197
Ecstasy of Saint Theresa (Bernini),
 140
Eddy, Don, 200
Edison, Thomas, 42
Egypt, 89
 Middle Kingdom, 91–92
 New Kingdom, 92–94
 Old Kingdom, 89–91
 perspective in paintings from, 15

Eiffel, Gustave, 164
Eiffel Tower, 164
Eisenstein, Sergei, 43–44
El Greco, 132
Embarkation for Cythera
 (Watteau), 145
*Emperor Justinian and His Atten-
 dants,* 108
Emphasis, 27
Empress of India (Stella), 194
Emulsion, 41
Enamel, 58
Encaustic painting, 34
Engravings, 37
Entablature, 66–67
Environmental design, 75
 circular plan, 76
 problems in modern, 76–77
 rectangular plan, 75
Ernst, Max, 179
Escobar, Marisol, 193
Estes, Richard, 200
Etching, 37
 of Rembrandt, 143
Etruscan civilization, 100
Expressionism, 169, 170
 versus formalism, 4
 German, 170–171

F

Fairbanks, Douglas, 43
Fantasia (Disney), 44
Farnese Palace Ceiling (Carracci),
 138–139
Fauves, 169–170, 171
Feminist art, 204–205
Fertility figures, 81
Fiber arts, 60
Field, Marshall, 164
Figurative painting, 190
Figure (Lipchitz), 173
Figure-ground relationship, 11
Film, 41
Filmmaking, 201–202
Fine art, 1–2
Finster, Howard, 206
Fiorentino, Rosso, 131
Firing, 56–57
Flack, Audrey, 200
Flags (John), 21–22

Flamboyant Gothic, 114
Flashback, 43
Floor plans, 65
Florence Cathedral, 116, 124
Fluid drawing media, 31
Folk art, 2, 206
Foreshortening, 14
Form, 9
Formalism versus expressionism, 4
Fractional representation, 15–16, 89
Fragonard, Jean-Honoré, 145
Frame construction, 66–69
Francesca, Piero Della, 125–126
Frankenthaler, Helen, 194
Freestanding sculptures, 50
Fresco secco, 35
Fuller, R. Buckminster, 69
Futurism, 55

G

Gabo, Naum, 176
Gainsborough, Thomas, 146
Galloping Horse (Muybridge), 42
Garden of Earthly Delights
 (Bosch), 136–137
Garden of Love (Rubens), 141
Gaudí, Antoni, 163–164
Gauguin, Paul, 161
General Services Administration's
 Art-in-Architecture
 program, 203
Gentileschi, Artemisia, 138
Geodesic dome, 69
Geometric shapes, 12
Géricault, Théodore, 151–152
Gérôme, Jean-Léon, 155
Ghent Altarpiece (Hubert van
 Eyck), 135
Ghiberti, Lorenzo, 122
Giant Stuffed Fan (Oldenburg), 53
Gift (Ray), 178
Gilliam, Sam, 198, 205
Giorgione, 130
Giotto, 34, 117, 121
Giovanni Arnolfini and His Bride
 (Jan van Eyck), 23, 135
Glass, 58
 chemical composition of, 58
 methods of shaping, 58
Glazing, 56–57
Gloucester Cathedral, 115

Golden Wall (Hofmann), 188
Good Shepherd, 107
Gorky, Arshile, 187–188
*Gospel Book of Archbishop Ebbo of
 Reims,* 111
Gothic architecture, 71–72, 74
Gothic art, 114–117
Gottlieb, Adolph, 189
Gouache, 33
Goya, Francisco, 152–153
Grande Odalisque (Ingres), 150
Grand Exchange (Knodel), 60
Graphic design and illustration,
 46–47
Graves, Michael, 203
Great American Nude (Wesselman),
 193
Great Mosque at Samarra, 214
Greece, 95–96
 aesthetics, 96
 archaic period, 96–97
 classical period, 97–99
 Hellenistic period, 99–100
 late classical period, 99
 stylistic periods in, 96–100
Greenware, 56
Griffith, D. W., 42
Groin vault, 71
Gropius, Walter, 180
Ground, 32
Grünewald, Matthias, 135–136
Guernica (Picasso), 182–183

H

Hagia Sofia, 108
Hals, Frans, 142
Hamilton, Richard, 192
Hanson, Duane, 200
Happenings, 199
Hard edge painting, 194
Hardouin-Mansart, Jules, 144
Haring, Keith, 204
Harlem Renaissance, 205
Hart, Frederic, 203
Harunobu, 218
Hatshepsut, 93
Hay Wain, 153
Head of an Akkadian Ruler, 86
Head of Christ (Rouault), 170
Head Surrounded by Sides of Beef
 (Bacon), 190

Heizer, Michael, 54
Hermes (Praxiteles), 99
Hiberno-Saxon style, 110
Hindu art, 215
Historicism, 202
Hofmann, Hans, 188
Hogarth, William, 146
Hokusai, 218
Holland, Brad, 47
Holography, 41
Homage to New York (Tinguely),
 199
Home of the Brave (Anderson), 199
Hopper, Edward, 184
Hospital for Foundlings, 124
Household (Kaprow), 199
Houses at L'Estaque (Braque),
 172–173
Hue, 20
Humana Building, 203
Humanism, 122
Hunters in the Snow (Brueghel), 137

I

I and the Village (Chagall), 179
Ife civilization, 210
Illumination, 18
Illusionistic surrealism, 181
Illustrations, 47
Implied light, 18–19
Impressionism, 156–159
Impression-Sunrise (Monet),
 156–157
Incas, 212
Industrial design, 62
Ingres, Jean-Auguste-Dominique,
 150
Ink washes, 31
Installations, 198
Intaglio, 36–38
Interior design, 78–79
Intermediate colors, 21
Ionic order, 68
Iron, 75
Isenheim Altarpiece (Grünewald),
 136
Islamic world, 213–214
Italian futurism, 174–175

J

Jacob, Lawrence, 205
Japan, art in, 217–218
Javacheff, Christo, 197–198
Jeanneret, Charles Edouard (Le Corbusier), 180–181
Jefferson, Thomas, 151
Johns, Jasper, 21–22, 34, 191–192
Jolly Companion (Leyster), 142
Jolly Toper (Hals), 142
Jones, Inigo, 144
Joy of Life (Matisse), 169
Judd, Donald, 196
Just What Is It That Makes Today's Home So Different, So Appealing? (Hamilton), 192

K

Kandariya Mahadeva Temple, 215
Kandinsky, Wassily, 170, 171
Kaprow, Alan, 199
Kauffmann, Angelica, 151
Kelly, Ellsworth, 195
Khafre, 91
Kiefer, Anselm, 201
Kienholz, Edward, 193
Kilns, 56–57
Kinetic art, 24
Kirchner, Ernst Ludwig, 171
Kiss (Brancusi), 9
Klee, Paul, 179
Kline, Franz, 189
Knodel, Gerhardt, 60
Knossos, 95
Kollwitz, Käthe, 172
Kore, 97
Kosuth, Joseph, 196
Kouros, 97
Krasner, Lee, 189
Kurosawa, Akira, 44

L

Lamentation (Giotto), 34, 121
Landscape architecture, 78
Laocoön Group, 99–100
Large Reclining Nude (Matisse), 25
Lascaux Cave, 81–82
Last Supper (da Vinci), 127–128
Last Supper (Tintoretto), 131–132
Léger, Fernand, 173

Le Moulin de la Galette (Renoir), 157
L'Enfant, Pierre-Charles, 76
Le Natre, André, 144
Lenses, 41
Les Demoiselles d'Avignon (Picasso), 172
Les Tres Riches Heures du duc de Berry, 134
Le Vau, Louis, 144
Leyster, Judith, 142
L.H.O.O.Q. (Duchamp), 178
Liberty Leading the People (Delacroix), 152
Lichtenstein, Roy, 193
Light
 as illumination, 18
 implied, 18–19
 and value, 19
Lightning Field (De Maria), 197
Limbourg brothers, 134
Lin, Maya Ying, 203
Lindisfarne Gospels, 110
Line, 10, 27
 directional, 26–27
Linear perspective, 16
Lion Gate, 95
Lipchitz, Jacques, 173
Lippi, Fra Filippo, 125
Lithography, 38
Littleton, Harvey, 58
Liver Is the Cock's Comb (Gorky), 188
Local color, 22
Logotype, 46
London Bridge (Derain), 170
Lost-wax technique, 51–52
Louis, Morris, 194
Luncheon of the Boating Party (Renoir), 157
Luncheon on the Grass (Manet), 155

M

Macchu Pichu, 212
Macrame, 61
Maderno, Carlo, 139
Madonna Enthroned (Cimabue), 121
Madonna of the Rocks (da Vinci), 127

Madonna with the Long Neck (Parmigianino), 131
Maesta (Duccio), 121
Magritte, René, 181–182
Maids of Honor (Velázquez), 141
Maillol, Aristide, 163
Malevich, Kasimir, 175
Manet, Edouard, 155
Mannerism, 130–133
Mantegna, Andrea, 126
Manuscripts, Carolingian, 111
Man with a Guitar (Lipchitz), 173
Marilyn (Warhol), 5
Marinetti, Filippo Thommaso, 174
Marquetry, 60
Martini, Simone, 121–122
Masaccio, 23, 125
Masks, 210
Mass, 12
Massacre at Chios (Delacroix), 152
Mastaba, 91
Matisse, Henri, 25, 169–170
Mayan civilization, 211
Medieval art, 105
 Byzantine art, 108–109
 Carolingian art, 110–111
 Dark Ages, 109–110
 early Christian art, 106
 Gothic art, 114–117
 Romanesque art, 112–113
Medium, 32
Megaliths, 82–83
Melanesia, 211
Merode Altarpiece (Campin), 134–135
Mesopotamia, 85
 Akkadians, 86–87
 Assyrians, 87–88
 Babylonians, 87
 Persians, 88
 Sumerians, 85–86
Metal, 59
 methods of working, 59
Mezzotint, 37–38
Michelangelo, 31, 50, 128–129
Mies van der Rohe, Ludwig, 181, 196
Minimal art, 195
Minimalism, 189, 195–196
Minoans, 94–95
Miró, Joan, 182
Mixed media, 35, 53

Mochican civilization, 212
Modeling, 50–51
Modersohn-Becker, Paula, 171
Mona Lisa (da Vinci), 6
Mondrian, Piet, 26, 176–177
Monet, Claude, 156–157
Monotype, 39
Monticello, 151
Mont Sainte-Victoire Series
 (Cézanne), 160
*Monument to the Third Inter-
 national* (Tatlin), 176
Moore, Henry, 190
Morisot, Berthe, 158
Moses, Anna Mary Robertson
 (Grandma Moses), 206
Moses Well (Sluter), 134
Mosque, characteristics of, 214
Motion, 23–24
Mu Chi, 217
Mummenschanz, 54
Munch, Edvard, 162
Mural painting
 Greek, 98–99
 Minoan, 95
Muybridge, Eadweard, 24, 42
Mycenae, 95
Mycerinus and His Queen, 91
Myron, 98
Mystery and Melancholy of a Street
 (De Chirico), 179

N

Narmer palette, 89
Narrative editing, 43
National Endowment for the Arts,
 203
Native American art, 206, 212–213
Naturalism, 8
Nefertiti, bust of Queen, 93
Negative shapes, 11
Neo-classicism, 149–151
Neo-expressionism, 201
Neo-impressionism, 159
Neolithic period, 82–83
Neoplatonism, 126
Newman, Barnett, 189
Newton, Isaac, 21
Niagara and Autumn Surf
 (Gilliam), 198
Niepce, Joseph Nicephore, 40

Nighthawks (Hopper), 184
Night Watch (Rembrandt), 142–143
Noguchi, Isamu, 204
Noland, Kenneth, 195
Nolde, Emil, 171
Nonrepresentation, 9
Notre-Dame de Paris, 115
Nude Descending a Staircase
 (Duchamp), 26, 178
Nudes, in Renaissance, 122

O

Oath of the Horatii (David), 150
Object (Oppenheim), 22, 182
Oceania, 210–211
Offset lithography, 38
Oils, 33
O'Keeffe, Georgia, 183
Oldenburg, Claes, 25, 53
Old King (Rouault), 170
Olmec civilization, 211
Olmsted, Frederick Law, 78
Olympia (Manet), 155
One (Pollock), 188
One and Three Chairs (Kosuth),
 196
One-point perspective, 18
Op art, 34, 195
Oppenheim, Meret, 22, 182
Organic shapes, 12
Ovetari Chapel, 126
Oxbow (Cole), 154

P

Pagodas, 216
Paik, Nam June, 45
Painting, 32
 Baroque, 137–139, 141–144
 chemistry in, 32
 Chinese, 216–217
 Gothic, 117
 Japanese, 217
 mannerist, 131–132
 media in, 32–35
 Renaissance, 125–126
 Rococo, 145–146
 Roman, 103
 Romanesque, 113
 texture in, 22
Palazzo Rucellai, 124

Paleolithic period, 80–82
Palladio, Andrea, 133
Pantheon, 102
Parallel editing, 43
Parks, 77
Parmigianino, 131
Parquetry, 60
Parthenon, 97–98
Passion of Sacco and Vanzetti
 (Shahn), 184
Pastels, 31
Pattern and decoration movement,
 204
Paxton, Joseph, 75, 164
Pazzi Chapel, 124
Pearlstein, Philip, 200
Pen and ink, 31
Pencil, 30
Pepper #30 (Weston), 3
Perception, and visual awareness,
 2–3
Performance art, 54–55, 199
Persians, 88
Persistence of Memory (Dalí), 181
Perspective, 13–18
Pevsner, Antoine, 176
Pfaff, Judy, 198
Phidias, 98
Photography, 39, 201
 advances in, 165
 film, development, and printing,
 41–42
 functioning of camera, 41
 origins and development of,
 39–41
Photo-realist painting, 199–200
Picasso, Pablo, 3, 35, 172, 182–183
Pickford, Mary, 43
Pigments, 32
Pile weave, 61
Pinching, 56
Plain weave, 60
Pointillism, 21, 159, 160
Points, 10
Pollock, Jackson, 188
Polydorus, 99
Polynesia, 211
Pontormo, Jacopo da, 131
Pop art, 39, 191–195
Porcelain, 57
Portuguese (Braque), 173
Positive shapes, 11

Post-and-lintel, 66
Post-impressionism, 159–162
Post-minimalism, 196–197
Post-modernism, 202
Potter's wheel, 56
Poussin, Nicolas, 143
Praxiteles, 99
Primary color, 21
Printmaking, 35–36
 collographs, 39
 intaglio, 36–38
 Japanese, 218
 lithography, 38
 monotype, 39
 relief printing, 36
 serigraphy, 38–39
Proportion, 24–25
Prud'hon, Pierre-Paul, 18–19
Public television, 45
Pyramids, 91

Q

Quilting, 61

R

Raft of the "Medusa" (Géricault), 152
Raising, 59
Rake's Progress (Hogarth), 146
Rape of the Daughters of Leucippus (Rubens), 141
Rape of the Sabine Women (Bologna), 132–133
Rape of the Sabine Women (Poussin), 143–144
Raphael, 18, 129
Rauschenberg, Robert, 53, 191
Ray, Man, 178
Realism, 8, 154–156, 183
Realist Manifesto (Gabo and Pevsner), 176
Rectangular plan, 75
Red/Blue (Kelly), 195
Red Cube (Noguchi), 204
Red Room (Matisse), 169–170
Regionalism, 183
Reims Cathedral, 117
Relief printing, 36
Relief sculptures, 50
Rembrandt van Rijn, 142–143

Renaissance
 early Italian, 120–126
 high, 127–129
 mannerism, 130–133
 in northern Europe, 133–137
 Venetian artists, 130
Renoir, Pierre-Auguste, 157
Representational art, 8
Representational surrealism, 181
Reynolds, Sir Joshua, 146, 151
Rhythm, 26
Richardson, Henry Hobson, 164
Rietveld, Gerrit, 177
Riley, Bridget, 10, 26, 34, 195
Rivera, Diego, 183
Robie House, 174
Rockwell, Norman, 47
Rococo art, 145–146
Rodia, Sabitino "Simon," 2
Rodin, Auguste, 163
Romanesque art, 112–113
Romanticism, 151–154
Rome, 100–101
 architecture, 101–102
 painting, 103
 periods in, 101
 sculpture, 103
Rondo Electronique (Paik), 46
Rosenberg, Harold, 188
Rothko, Mark, 189
Rouault, Georges, 170
Rouen Cathedral Series (Monet), 157
Rousseau, Henri, 162, 206
Rubens, Peter Paul, 141
Running Fence (Christo), 54, 198

S

Saar, Bettye, 205
Sacrifice of Isaac (Ghiberti), 122
Saint-Denis, Abbey Church of, 115
Saint Etienne, Church of, 112
St. James Led to His Execution (Montegna), 126
Saint Paul's Cathedral, 144
Saint Peter's Cathedral (Rome), 107–108, 129, 139
Saint-Sernin, Church of, 112
Salisbury Cathedral, 115
Saltcellar of Francis I (Cellini), 59, 132

San Carlo alle Quattro Fontane, 140
Sand-casting, 52
San Lorenzo, Church of, 124
San Vitale, 108
Sanzio, Raphael, 18, 129
Satin weave, 60
Saturation, 20
Savoye, villa, 181
Scale, 25
Scholder, Fritz, 206
School of Athens (Raphael), 18, 129
Schroeder Houser (Rietveld), 177
Schulze, Heinrich, 39
Scientific perspective, 16
Scream (Munch), 162
Sculpture
 abstract African, 210
 Akkadian, 86–87
 Baroque, 139–140
 Chinese, 216
 constructed, 52–53
 constructivist, 175–176
 contemporary, 49
 and cubism, 173
 early, 49
 earthworks and siteworks, 53–54
 Egyptian, 92
 freestanding, 50
 Gothic, 116–117
 Greek, 97, 98
 installations and environments, 54
 Japanese, 217
 kinetic sculpture, 53
 mannerist, 132
 modernist, 168–169
 new materials in, 53
 origins of modern, 163
 processes, 50–53
 relief, 50
 Renaissance, 122–123
 Roman, 103
 Romanesque, 113
 soft, 53
 Sumerian, 86
 texture in, 22
Secondary colors, 21
Segal, George, 193
Self-portraits (Rembrandt), 143
Sendak, Maurice, 47
Sequential motion, 24
Serigraphy, 38–39
Seurat, Georges, 21, 159–160

Severini, Gino, 174
Sfumato, 127
Shahn, Ben, 184
Shape, 10–12
Shapiro, Miriam, 204
Shutter, 41
Silk screen, 38
Silverpoint, 30
Sistine Ceiling, 128–129
Siteworks, 53–54, 197–198
Six Persimmons (Mu Chi), 217
Skeleton frame, 69
Sketch I for "Composition VII" (Kandinsky), 171
Slab construction, 56
Sleeping Gypsy (Rousseau), 162
Sleeping Muse (Brancusi), 168
Sluter, Claus, 134
Smith, David, 52, 190
Smith, Tony, 196
Smithson, Robert, 53, 197
Social issues, in art, 5, 182–183
Soft sculptures, 53
Soft Toilet (Oldenburg), 53
Solen, Paolo, 77
Solvents, 32
Space, 12–18
 positioning objects in, 13
Spiral Jetty (Smithson), 53, 197
Starn, Doug, 201
Starn, Mike, 201
Starry Night (van Gogh), 22, 160–161, 162
Steel, 75
Steichen, Edward, 165
Stella, Frank, 194
Stieglitz, Alfred, 165
Stone, 74
Stonebreakers (Courbet), 155
Stonehenge, 83
Stoneware, 57
Street art, 204
Study of Human Proportions (da Vinci), 24
Stupas, 215
Style, definition of, 5–6
Subordination, 27
Sullivan, Louis, 164–165
Sumerians, 85–86
Sunday Afternoon on the Grande Jatte (Seurat), 160
Super Indian, No. 2 (Scholder), 206

Super-realists, 199
Support, 32
Suprematism, 175
Surrealism, 181–182
Symbolism, 159, 161
Symmetry, 25
Syndics of the Cloth Guild (Rembrandt), 142
Synthetic cubism, 173
Synthetism, 159, 161

T

Tahitian paintings, of Gauguin, 161
Taj Mahal, 214
Tanner, Henry O., 156
Tapestry weave, 61
Target with Four Faces (Johns), 34
Tatlin, Vladimir, 176
Tel el-Amarna, 93
Television, 45
Tempera, 33
Tempest (Giorgione), 130
Terra cotta, 58
Texture, 22–23
Theotokópoulos, Doméenikos, 132
Third-Class Carriage (Daumier), 154
Third of May, 1808 (Goya), 153
Three-dimensional art, space in, 12
Three Goddesses, 98
Three Musicians (Picasso), 173
Three-point perspective, 18
Tinguely, Jean, 199
Tintoretto, 131–132
Titian, 130, 155
Titus, Arch of, 102
Tombs
 Egyptian, 91–92
 Etruscan, 100
Toulouse-Lautrec, Henri de, 38, 162
Transition, 43
Tribute Money (Masaccio), 23
Trinity fresco, 125
Triumph of the Barberini (Cortona), 139
True arch, 71
Truss, 69
Tunnel vault, 71
Turner, Joseph Mallord William, 33, 153
Turrel, James, 54

Tutankhamen, 93–94
Twentieth-century photography, 40–41
Twill weave, 60–61
Twittering Machine (Klee), 180
Two-dimensional art, 10
 space in, 12–13
Two-point perspective, 18

U

Unique Forms of Continuity in Space (Boccioni), 175
Unity, 26
Utamaro, 218

V

Value, 20
 and light, 19
van Dyck, Anthony, 144
van Eyck, Hubert, 135
van Eyck, Jan, 23, 135
van Gogh, Vincent, 22, 160–161, 162
Vanishing points, 16–18
Variety, 26
Vasarely, Victor, 195
Vase painting, Greek, 96–99
Vault, 71–72
Vehicle, 32
Veláquez, Diego, 141
Venetian artists, 130
Venturi, Robert, 202
Venus de Medici, 99
Venus de Milo, 99
Venus of Urbino (Titian), 130, 155
Venus of Willendorf, 81
Vermeer, Jan, 143
Verrocchio, Andrea del, 123
Victory Stelae of Naram-Sin, 87
Video arts, 45–46
Vietnam Veterans Memorial, 203
Vigée-Lebrun, Elisabeth, 145–146
Villa Rotunda (Palladio), 133
Vision After the Sermon (Gauguin), 161
Visual art, 1–2
Visual awareness, and perception, 2–3
Visual elements, 9–10
 color, 19–22

Visual elements (*cont'd*)
 light and dark, 18–19
 lines, 10
 mass, 12
 motion, 23–24
 points, 10
 shape, 10–12
 space, 12–18
 texture, 22–23
 time, 23
 volume, 12
Volume, 12
Voulkos, Peter, 56

W

Wainwright Building, 164–165
Warhol, Andy, 5, 39, 192
Washington, D.C., 76

Watercolor, 32–33
Waterlilies Series (Monet), 157
Watteau, Jean Antoine, 145
Watts Tower, 2
Weaves, types of, 60–61
Weaving, 60
Wedgewood, Thomas, 39
Wesselman, Tom, 193
Weston, Edward, 3
Whistler, James Abbott McNeill,
 158–159
White House (Bartlett), 198
White on White (Malevich), 175
Wind (Hofmann), 188
With the Black Arch No. 154
 (Kandinsky), 171
Woman Series (de Kooning), 189
Wood, 59, 73–74
Wood, Grant, 183

Woodcuts, 36
Wood engravings, 36
Woodworking techniques, 60
Wren, Sir Christopher, 144
Wright, Frank Lloyd, 174

Y

Young Woman with a Water Jug
 (Vermeer), 143

Z

Zen Buddhist painting, 217
Ziggurat, 86, 87
Zoning, 77
Zoogyroscope, 42
Zoom lenses, 41